Charles Russell:
Cowboy and Artist

Charles Russell: Cowboy and Artist

by Joan King

Media Publishing
Lincoln, Nebraska

ISBN 0-939644-72-X

Library of Congress Number 96-60764

Cover Photo: Courtesy of the Montana Historical Society, Helena, MT.

Cover Design: Noelle Caplan, finedesign

Printed in the United States of America

Media Publishing
A Division of Westport Publishers, Inc.
2440 O Street, Suite 202
Lincoln, Nebraska 68510

Dedicated to Margery King, Mother-in-law and Friend

List of Illustrations

Foreword

Charles Russell means the West. His life revolved around the closing of this important era in American history. The stories of trappers, traders, Indians and cowboys brought him to Montana just before his sixteenth birthday.

His art pulls you into the West. You rope cattle, hunt buffalo, live in tipis, and camp in the wide open spaces. His art is his biography as well as history. In telling and painting the stories of the West, his own life becomes that romantic period.

We know the old West because of Charles Russell. He gave us our image of the land and the people, the commonplace and the historic, the indigenous and the newcomer. His art not only showed us the West directly, it told others how to show us the West. Will Rogers, Tom Mix, and W. C. Hart were his friends, and, although they were Westerners, Russell's influence may be seen in their early Western movies. The values of the heroes and the invitation extended by the sparsely settled land reflect the West as the frontier closed and the romance opened.

The art of Charles Russell is also his diary, his autobiogrphy. He did not keep journals nor write much about himself. His paintings, sculpture, illustrated letters and stories tell much about the man. They are rich sources about his life and activities. They express his loves and concerns, his philosophy and knowledge. His works make you realized that Charles Russell was a complex man who loved the simpler but more extreme life of the West. He learned beyond his formal education; he knew history and literature. More important, he knew people.

The episodes of Russell's life provide a rich portrait of the man and the times. He reflected those times; living in the West while it was the West; he carried its gospel East, even to England, as no other person could. He created a romantic West which he lived and established a dream for the generations that could not know what had passed.

To really get to know Charles Russell, you have to view his works. They are to be found in a number of outstanding public and private collections throughout the country. To get to know the man and the artist, you should visit the C. M. Russell Museum, home, and log cabin studio in Great Falls, Montana. Outstanding collections of his art may be found at the Gilcrease Museum, Tulsa Oklahoma, the Amon Carter Museum, Fort Worth, Texas, and the Rockwell Museum, Corning, New York.

<div style="text-align:right">

Thomas C. Brayshaw
Executive Director
C. M. Russell Museum
Great Falls, Montana

</div>

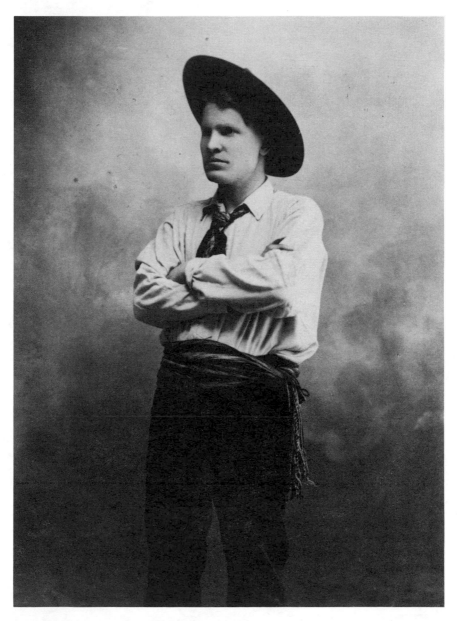

PORTRAIT OF C.M. RUSSELL, *Photograph of the artist taken shortly after his arrival in Montana. C.E. Le Munyon, Photographer. Courtesy of the Montana Historical Society, Helena, MT.*

Chapter 1

Fall, 1881

Raging mad, Charley rode down from the hills raising plenty of dust. No friend of a Missourian should say the South was full of goddamn yellow-bellied savages. No friend of his—even if every man and boy in his family was in the damn Union Army. Armies, Hell!

Charley galloped Monte straight to the saloon in Utica, usually a tiny settlement on the cattle range. But the population swelled now as the cowboys began riding in for the fall beef roundup. Charley took in the activity, though he wasn't thinking about roundup. He was still reeling from Jake's insults.

"Whiskey," Charley yelled, slamming his money down on the bar.

The bartender raised a questioning eye, but Charley only scowled in reply, and the bartender produced the bottle and a glass without saying a word. Charley took the whiskey to a table, poured out a hefty glass and drank a good long gurgle. The rough taste and burning sensation didn't stop him from swallowing another gulp.

As he felt whiskey heat spread through him, he leaned back in his chair, threw his beaten-up hat down on the table and swore. Charley was blonde, square-faced and dusty, almost always friendly, but not today. He finished his glass of whiskey and poured another. Soon his anger softened and fuzzed and he gazed around the room, wishing he could just stay here forever.

Around him cowboys crowded the bar and tables, laughing and joking. He envied them. They had good friends, places to go, a job to do. Not just a job, but the best one in the world. And Charley had nothing now but an enemy. How he could have been fooled into thinking Jake was his friend, he didn't know. He gulped some more whiskey and swore.

Drinking and watching the cowboys cavorting lifted his spirits some. The clamor rose as cowboys greeted other cowboys they hadn't seen since spring roundup with hearty thumps on the back and hollers that came near raising the rafters. Charley sure would like to get a roundup job and show Jake he could do it. But the very thought of Jake made him mad and miserable again.

A poker game at the next table must have been getting more serious. Charley noticed how stony the faces of the men sitting around the table had become. Talk there had stopped. The only sound was the clink of chips being counted onto the wooden table. Stakes were high. Some of the men threw in their hands and sat with somber faces. Charley felt the tenseness of the card players contrasted to the rowdiness of the rest of the room. Intrigued with the picture, Charley pulled a

much-read letter from home out of his pocket and began sketching on the back of one of the pages. As he sketched, poker chips tumbled and plinked. Smoke clouds rose in the air.

Charley was so intent on placing the figures in his drawing, he hadn't seen anything coming and only glanced up when an explosion boomed through the room. A bullet hit the ceiling. The smell of gunsmoke spread as the cowboys shuffled away and swore. Two men from the card table stood facing each other with killing in their eyes. The crowd backed up, some taking cover behind tables. Charley watched, not moving until he felt a hand on his shoulder, a shove. In the next moment, he was watching the fight from the floor shielded from the action by an overturned table top. A hand thrust his whiskey bottle toward him.

"What in hell," he muttered at the crouching cowboy with a bottle in each hand.

"That's Madman Matt Haker with the beard and leather hat. And he's losing. So it's smart to stay out of the way, Kid."

The cowboy was probably right. The whiskey had calmed Charley too much, made the danger seem faraway, though his brain ought to have told him to duck. Tonight though, he wanted to see a pair of enemies fight it out.

Matt grimaced, his glittering black eyes radiated venom at Stud Hoss Davis, but Davis stood ready to defend himself. Matt stopped a few feet away, his gun aimed at Stud Hoss Davis' heart.

"Get your head down, Kid," the crouching cowboy said, pulling on Charley's arm. But Charley strained to see the men before he scrunched down. That was a picture he wanted. He moistened his pencil in his mouth and snatched another page of his letter. His glance had caught Matt the instant before Stud Hoss Davis kicked the gun out of his hand and followed with a fist aside Matt's jaw.

Charley sketched what he had seen in that instant before Davis' boot hit Matt's gun hand. Charley raced his pencil across the page so fast, he didn't notice the cowboy watching him instead of the fight.

Bodies of the struggling fighters pushed against their tabletop shield, and the cowboy inched it out of the way and steadied it as Charley sat on the floor sketching.

"I'll be damned," the cowboy said, shouting above the din. "If that don't truly resemble Madman Matt. A course, his clothes is some torn up now and he don't look near so fierce without his gun, but it sure is what he looked like a couple a minutes ago. What's your name, Kid?"

"Charley Russell." He looked up from refining the stubbly beard on Matt's chin. He smiled up at his companion. "And you, Pal."

"Pat Tucker." They shook hands.

Charley ran his fingers through his unruly blonde hair and took a real look at Pat—small and wiry, so slim his bones stuck out. The first thing Charley noticed

was his nose—bony, freckled and straight, then his cheekbones. The next thing he saw was Pat's wide smile revealing a chipped front tooth, the light in his bright blue eyes and lines at the edge of his mouth all curved deep and sure. He liked Pat already.

"I never saw a cowboy draw like that."

Charley was flattered at being mistaken for a cowboy. "Well, I draw a lot, though I ain't a cowboy. Sure would like to be but I can't get hired. A man who wasn't born on a ranch and brought up on a bronc has got to fool 'em into thinking he was."

Pat laughed. "You're damned right. Nobody wants a fuzzy-cheeked pilgrim out on the range."

As the fighting dwindled around them, Charley turned back to his picture to fill in the details.

"I've been cowboyin' for twelve years now," Pat said, drawing his knees up and putting his arms around them. "It's a helluva good life for a Texas boy like me, but Charley, you gotta be mighty good at it."

"I'd be good," Charley said. "If I ever got a chance."

"I bet you would. You're from down south, ain't ya? What're you doing here in Montana territory anyway?"

"I'm from near St. Louis, Missouri. Came here to work on a sheep ranch, but I...."

"A sheep ranch?" Pat said, moving his tongue around his mouth as though he wanted to spit. He pulled the top off the bottle of whiskey, took a swig and righted the table. Charley pulled a chair up and sat down. "Yeah, ain't it disgusting? I was no good at sheepherdin', worked my way right out of a job."

"Then what'd you do, Charley?"

"Oh, I was lucky. I didn't have to drift hungry too long." Charley sighed, thinking back to before he met Jake, back to the sheep ranch.

The rain had stopped, the job was done, and Charley had been as tired as he'd ever been in his entire sixteen years of life. He'd stretched in the saddle, his square face taut. Light from the setting quarter moon defined the rugged land. After riding through the cold rain chasing sheep most of the night, he was wet and numb but glad all the stinking, muddy, damned woollies were herded back to the grassy hill where they belonged. Though he was tired enough to fall off his horse, the thought of going back to his bunk at Pike Miller's ranch set off a blistering resentment.

Charley had been overjoyed at leaving St. Louis for this job in the Montana territory, but after only a few weeks, he loathed taking orders from Pike Miller. Yesterday Pike worked him fourteen hours cleaning out the sheep sheds, then kicked him out in the thunderstorm to chase sheep. And Pike went right on back to bed.

Charley looked off at the hills, grassy prairie and mountains. This territory was too choice to waste on a bunch of bleating bags of mutton. He recoiled at the rank oily smell of old ewes. That smell hung around him night and day as though it were locked in his nostrils. Damn sheep. Cattle were what he wanted. He shrugged off his fatigue, slid off his horse and wrung the water out of his hat. Through the filmy darkness, he could make out the silhouette of a cabin in the distance—the Babcock place. He remembered meeting Bab at the new general store in Utica. "Sure will be nice to have a store closer than a hundred miles away," Babcock had said. Bab was a talker. He didn't shut up long enough to draw breath.

"Yep, now that we're a gettin' a stage station, supplies won't be so hard to ship." Charley had been too busy packing flour into the wagon to pay any attention, but now he remembered Bab saying they were looking for a man to herd the relief horses over at the new stage station. That ought to be a lot better than herding sheep.

Why shouldn't *he* take the job at the stage station?

Pike Miller was sitting at the kitchen table cleaning his rifle. His small head jerked up and he glared when Charley came through the back door, "I'm quittin'-just wanted to say good-bye."

"What do you mean, you're quittin'? You ain't even had breakfast yet."

"Don't want any," he said, though he wouldn't have minded a few biscuits and a cup of coffee.

"Quitting, ya say? Your pa said you was stayin' the summer. You ain't ready to high tail it back to Missouri already, are you?"

"Nope." Charley said. "What I had in mind was to collect my wages and get another job."

"Oh sure; where's an ornery kid like you going to get another job?" Pike looked mean, though he was half-smiling. Charley wanted to get this quitting business over and done as quick as he could.

"Why, there ain't nobody in their right mind would hire a lazy young cuss like you," Pike said, his voice pitched higher, his eyes wide and flashing. "You don't know the first thing about work. You're just a spoiled city brat who wouldn't make a louse on a real ranch hand." Pike smirked, then threw his head back and laughed.

Miller's laughter set Charley's skin prickling and his temples throbbing. "We'll see about that when I have a job with the Utica Stage. I'm talking about a real job, not just being the kid for you to hand off all your stinking chores that nobody else'll do. I'll take my money now, please."

Pike's eyes narrowed to slits, and he turned back to his task. He picked up the rifle and looked down the barrel. "As I figure it, I did your Pa a big favor to take you off his hands. If the truth were told, you owe me. I've been feeding and bedding

you and all you've done for me is lose a dozen sheep. I don't pay hands for losing sheep."

Charley saw it would be useless to argue. He turned and slammed the door. Couldn't get out of there fast enough. He packed his belongings onto his pack mare, mounted his pinto Monte, and headed for the stage station.

It was slow going because the pack mare was not easily led, but once he left Pike Miller's property, he felt better, figured from now on he'd be working at a decent job and he'd never look at a sheep again.

The sun shone now and the air was so clear he could see 50 miles ahead, maybe more. He sighted a doe grazing in a draw, stopped the horses and reached in his pocket for the wad of beeswax he always carried. Studying the animal intently, he kneaded the wax. His eyes took in the lines as his fingers worked the wax into the shape he saw. When he was satisfied that the head, neck, back and legs were of the right proportions, he took another careful look at the animal, then he put the wax doe back into his pocket. He couldn't work over the details now. He'd already wasted too much time. He had to get to the Utica stage station and get a job.

He dismounted in front of the stage station, shoved his matted hair back with the brim of his hat, set it firmly back on his head and walked inside. "Howdy."

A clean-shaven man with hair as sleek as patent leather, looked up from his table. "Yes. You want something, boy?"

"I heard you needed someone to tend the horses, and I'm looking for a job." His smile widened. But the man at the table raised his eyebrows and looked Charley over from head to toe. For the first time he thought about how he looked. He had dressed yesterday morning and spent the day clearing the barn and sheep sheds, then he was out in the rain most of the night. Without looking down to see, he guessed his pant legs were not tucked neatly into his boots. And his boots were probably pretty well caked with dry mud. He hadn't washed for a while either. He supposed he did look like a drifter. "I'm pretty good with horses. What do you say? Can I have the job?"

"What's your name?"

"Charles Russell."

"Kid Russell? You must be the one worked for Pike Miller?" Charley cleared his throat. "Yes."

"Thought so." He glared at Charley. "Can't use you, Kid. Can't afford to lose hosses like you lost them sheep. Can't have an ornery brat 'round here at all."

Ornery? So Pike had already spread the word about how worthless he was.

"The sight of you would send them hosses running off in all directions." The man laughed. "I heard tell you wasn't worth your grub. Run along, Kid. I'm busy."

Charley left the stage office and untied his horses. He heaved a sigh and patted Monte. He was broke, didn't have a job and didn't know what to do next.

Monte whinnied, and Charley climbed back in the saddle and headed off in the opposite direction from Pike Miller's sheep ranch. The only destination he had in mind was **away**.

He rode for hours out toward the hills, his stomach growling. He couldn't remember when he'd been this damn hungry. He'd been too tired to eat that stinking mutton stew last night, and he'd had no breakfast. No wonder he felt shaky—it'd been a day since he'd eaten. But his biggest problem was what to do next. He rode along looking wistfully at the wild strawberry blossoms and buffalo berry bushes in the gulches, but it would be a while before they would yield anything. Still, there was no need to worry. Game was plentiful, and the streams were alive with fish. A man wouldn't starve. Trouble was he didn't have a gun or anything to catch fish with.

He stopped near a stream, drank deeply, and while the horses drank, he made a fire. Maybe he could sell the mare and keep Monte. He'd been with Pike when he bought the horses from a band of Indians. He'd wanted Monte from the moment he saw him, but Pike advised against buying him. "Anytime an Injun wants to sell a young pinto like that one, something's wrong with it." But Charley hadn't listened and that riled Pike, so Charley also bought the mare Pike had chosen. After that, he spent the last of his St. Louis money on a saddle, a fringed buckskin shirt and a brightly woven sash. He wished now he'd saved a few dollars.

Still thinking about what to do, he took the half-formed wax doe out of his pocket and modeled the head. His stomach moaned now and he thought if he was ever going to eat again, he had to get a job. He'd ride over to Yogo tomorrow since that was the closest town and probably his best chance to find work.

One thing he knew for sure. He wasn't going back home to sit in a damn schoolroom all day like a prisoner. If he did, he'd end up in his father's brick business soon enough—the last thing he wanted. He loved his folks as much as anybody. He didn't doubt they did the things they did—like sending him off to military school—because they thought it was best. Discipline was supposed to make him into the son they could be proud of, but all it did was make him miserable. He didn't study more; he studied less. He filled up the long hours in detention drawing pictures and daydreaming of being out West, roving among the Indians, like his uncles had back in the early days.

Thinking of home made him wonder if his father hadn't expected that he would find himself in a fix like this and come flying on home ready to become a prisoner of the brick factory for life. No sir. He wasn't going back. He wanted to see what this West was like—the whole of it. He wanted to get free and stay free.

The wind blew smoke from his campfire into his face, and he realized all at once it wasn't smart to be up there alone with a couple of horses any sporting Indian would like to steal. He had no way to defend himself. Indians could see smoke for miles. They might come looking to see what's here, and Monte would look mighty good to them.

Even as he threw earth on the blaze to snuff it out, he heard the faint sound of hoofs thumping the rocky ground. His heart skipped and his hands stopped working over the wax doe. He looked quickly to the direction of the sound, and, in the dying light, he saw four horses, but only one had a rider, a man who wore a wide-brimmed hat and a beard. Never heard of an Indian with a brown beard. The rider was carrying a Winchester rifle in a saddle-horn sling. Charley braced himself for trouble. Trying not to show his hunger, weakness and worry, he compulsively worked over the wax doe. The sound of the horses grew louder and slower. Then it stopped, and Charley looked up just as the brawny man dismounted. "Howdy," Charley said.

The man, dressed in buckskin, wore butcher knives thrust in his belt and his boots were splattered with blood. "H'lo." His voice was loud. "What brings ya up here?"

Charley shrugged. "Nothing much."

The man squinted at the wax figure in Charley's hand. "What're ya doin' thar?"

"Making a wax deer." Charley held it up so the man could see. He examined it closely. As near as Charley could judge, he was about forty, wore his brown-gray hair long for a white man. He had bushy eyebrows and ruddy skin that showed years of outdoor living. His features were small and even. A keen-looking mountain lion of a man with pure gray eyes.

"Not a bad doe—a tad heavy, but could be she's pregnant." The man smiled, and stood with his hands on his hips, his feet far apart, his eyes roving over Charley and his camp. "Where're ya headin'?"

"Don't know."

"Where's your grub?"

Charley looked into the man's eyes and shrugged.

"My name's Jake. What's yours?"

"Charley."

"Hungry, Charley?"

"A little."

"I'll cook if you go down to the river and fetch the water fer coffee."

Charley stood up and shook Jake's hand. "You got something to carry it in?"

Jake nodded and led Charley to his pack horses. While Jake was getting a jug from his pack, Charley saw that one horse carried a dressed elk, another held traps and beaver pelts. He glanced back at Jake, and guessed who he was. He must be the hunter and trapper who sold wild meat to the ranchers in the area. Jake Hoover, they called him.

Charley had never eaten anything as tasty as Jake's fried elk steaks, pan biscuits and strong coffee. Jake rolled a cigarette and asked how Charley happened to be here. Charley told Jake his story.

"So I stopped here to figure out where to go next to get a job."

Jake smiled. "Jobs are scarce. And I reckon your folks'd be mighty glad to have ya back fer a while."

"I don't want to go back. I waited a long time to get here. I heard stories about the territories ever since I was old enough to understand. I read everything I could about the West, dime novels mostly, but other things too. It was getting so every time I opened a book my muscles tensed up and wanted to take me flying west."

Jake laughed. "You and about every tenth boy in the states. I've seen 'em. Jest like you—they want to be dime-novel cowboys. But they don't last long. Ranch foremen can spot 'em five miles away. They're trouble to a foreman. He's looking for men who know cattle and grew up on a bronc."

Jake sipped his coffee and looked off. "I was about your age when I come to the territory back in sixty-six. The country was wilder then. It was about this time of year when I made it into Fort Benton. I had gold fever and headed straight for Gold Creek. Every kind of renegade was there. It was no place for a sixteen-year-old kid, but I kept my mouth shut and did my best."

"Did you have any luck finding gold?"

Jake nodded. "Well, thar's all kinds of luck. I found that out at Gold Creek, and I never forgot it. It wasn't long afore I stumbled onto the richest gold strike in the territory. I was such a damned tenderfoot, the folks along the gulch called it the Tenderfoot Bar. Nuggets of pure gold. Thar was nothin' to do but celebrate and ride down the gulch with my head high whilst people tipped thar hats, and pretty dance hall girls wanted to please me. I wallered in it a few weeks afore I got swindled out of it. And that didn't take long. I made other strikes after that, but nothing stuck," Jake looked up dreamily, "except this land, the skies and mountains. Thar's all kinds of luck, and I've had every one."

Charley wanted to hear more. He figured his trouble with Pike Miller wasn't so important—as long as he could get a job somewhere, anywhere. But now all he wanted was sleep. He and Jake laid out their bed rolls near the fire. And Charley looked up at the stars, glad to be where he was. This territory was even more vast and intriguing than he had imagined. And now he was right in the middle of the kind of freedom he craved. He had known it was out there just beyond his reach when he was under Pike Miller's heels. He had looked out at the horizon often and knew. Now that he was free of Pike Miller and his sheep, he wasn't ever going to get caged in again if he could help it.

At sunup Jake's snoring abruptly stopped, and Charley woke up, blinked and remembered everything of the day before. He would walk down to the river and bring the water back before Jake woke up. But Jake yawned. "Mornin', Charley."

"Morning. I'll go get some water as soon as I put my boots on." He fetched the jug and was off running. It was a cool morning. The sky was soaked in lavender light. The dew sparkled and the river bubbled. Charley filled the jug and splashed some of the stinging water on his face and neck. As he scrambled back up the hill

toward camp, he saw the smoke already curling up. This was what he wanted all right.

Jake and Charley hunkered over the fire waiting for the coffee to boil. Charley asked Jake if he thought Yogo would be a likely place to find a job.

Jake looked toward the trailing smoke and shook his head. "The mines are near worked out." He stirred the fire with a long stick, squinted at the smoke and shook his head. "You'd be wastin' yer time riding to Yogo."

Charley glanced at Jake's somber face and knew he was hearing the truth.

Jake closed one eye against the smoke and looked squarely at Charley with the other. "If you're willin' to pull your own weight, you could stay with me awhile and help out till you find somethin'."

"Could I?" Hope rushed back. Charley didn't hesitate. "I'll do whatever I can. But I'm no hunter. I don't have a gun and don't know much about trapping."

Jake's eyes looked pained or disgusted. He shook his head. "You ain't goin' to last a week if you don't carry a gun and know how to use it."

Chapter 2

Pat poured a glass of whiskey for Charley and another for himself. "So you walked out on the sheep ranch and met up with a mountain man. You coulda done worse. How long did you hunt and trap with this fella Jake?"

Charley counted back. "A year and a half. I sure learned the hunting trade and I know my way around the mountains hereabouts, especially the Little Belts, but the Snowies and the Judith Mountains too. Yep, but now I gotta start over again."

"Well, here's to good luck." They drank. When Pat finished his whiskey, he banged the glass back onto the table and glanced around. The tables had all been righted. The cowboys had gone back to celebrating at the bar. "Looks like things are clearing up in here," Pat said. "How about us going fishing? The speckled trout are biting and it's getting close to dinnertime."

Charley stood up, put his sketches in his shirt pocket and his nearly-empty whiskey bottle inside his jacket. "Let's go."

Pat had a good camp set up near the Judith River. They caught grasshoppers and Charley made a willow fishing pole. In a few minutes they had enough trout for supper. Charley made a fire and Pat brought out his long handled skillet.

Later, when he was full of trout and biscuits, Charley thought about Jake up in the cabin and wished he hadn't left like he did. Maybe they were all through, but he wished he'd ended it differently.

"What's the trouble, Charley?" Pat asked.

"Jest thinkin'," Charley said. "Do you ever talk about the war with a Yankee?"

Pat laughed. "Not unless I hate the guy. No, a Southerner's better off never to talk about that. Especially up here."

"You're sure right about that, Pat."

"What happened? Did you get into an argument?"

Charley nodded. "I sure wish I could get a job with a cow outfit. What do I have to know? How can I convince the bosses I'm okay?"

Pat shoved his hat to the back of his head and blew out a breath of air. "If you really want to know, I'll tell you."

Charley nodded. "I want to know bad."

Pat stood up and walked over to Monte. "You got a good hoss, Charley, but the rest of your outfit is all wrong. I noticed it when I first saw you mount your hoss. Your boots are too big. You had one stirrup longer than the other. Your lasso rope is seagrass and not coiled right. And no self-respecting cowboy would wear a hat like yours or use a bridle and saddle bought from a mail-order place. It won't do.

It's not so bad to have fuzzy pilgrim cheeks if your outfit is right. Come on over here, Charley, and I'll show you how to fix your stirrups. This might pass fer huntin' but it won't pass on the range."

Charley listened and watched and asked questions, and Pat talked on, telling him things—important details he'd never read about in his dime novels. They talked long into the night and when they were talked out, they rolled out their bedding.

Charley thought how lucky he was to run into Pat Tucker. Maybe it was luckier than meeting Jake. Maybe. But when he was desperate, Jake took him in.

He remembered riding off with Jake following a trail along the South Fork of the Judith River uphill toward the fir-covered Little Belt Mountains. As they had climbed, the smell of pine overpowered the smell of horseflesh or leather. The sun beat down, tempting Charley to take off his shirt and let the breeze cool his back. He looked over at Jake, sitting straight, eyes glancing all around, his hand not far from the stock of his rifle. He smiled as his eyes fixed on something up ahead. "Thar's my shack, Charley."

Charley could barely see a speck on a distant hilly meadow—a dark shadow among the trees. He squinted until he could make out the shape of a cabin with a stone chimney. "Looks real nice."

Two deer ambled to the front of the cabin to graze. "You have company."

"Yep. Deer come all the time for salt I put out."

Charley thought of drawing them like that, but what about Jake? Would he stand at his doorway and shoot them? "Don't they look peaceful," Charley said, looking back at the grazing deer. "It's too bad to shoot...I mean that they have to die."

"Aw, I never shoot the animals comin' around the cabin. We're friends. I go a mountain or so away to hunt and trap."

Charley felt better. He liked Jake, but then he liked most people who didn't pretend to be something they weren't. An easy kind of trust passed between them as they glanced at each other across the campfire. In the West men should be brothers, his uncle Will had said, and Jake was a man who lived that way.

Gratitude for this chance to stay in the territory flickered in Charley's chest, but he knew better than to talk about it to a man like Jake. Nice words were nothing to him. It was a man's actions Jake would judge.

Jake's cabin was actually two separate cabins under one roof—one side for living, the other for storing meat and gear. Jake showed Charley which corner to stow his bedroll in. Charley nodded and looked around. The place had the smoky smell of a campground. "Did you build the cabin yourself?" Charley asked.

"Sure did."

Charley's respect for Jake grew as he imagined the task. "Chopped down all the trees and everything?"

Jake laughed. "You bet. Ain't no other way to do it."

Underfoot was a bare earth floor, covered in places with thick buffalo hides. He guessed Jake made the furniture, too—a rough-hewn table of poles made flat on the upper side, a couple of stools, and in one corner, a bunk made of rough poles filled with fir boughs. The big fireplace along the back wall was for heating and cooking. This was life reduced to its simplest, and, to Charley, its best form.

"What do you want me to do first?" he asked. "Unpack the horses?"

"Yep, let's haul that elk into the meat cabin and hang it up."

Charley finished unpacking, then took the horses to the stream to drink. When the saddles were stowed and the horses grazing, Charley was drawn inside by a delicious smell—stew and biscuits.

The food was as good as it smelled. "You sure know how to cook. Maybe I can learn. At least I can clean the dishes and keep the woodpile up. I'm not good for much, and that's the truth, but I'm not ornery like Pike Miller says."

"Hey, I know all I need to know about you. Come on, let's skin that elk."

They took the elk out back to a cottonwood tree to skin it. Charley was careful not to look at the eyes. He didn't want Jake to notice how squeamish he felt. He concentrated on the hide, and on holding the knife just the way Jake showed him. The animal was already dead, he told himself, and the skin had to be removed.

When he finished skinning the animal, he was eager to clean up in the cold waters of the South Fork. Jake delighted in splashing around. Not Charley. After a hurried scrub, he sat on the bank and let the sun dry him. Meeting Jake was a lucky stroke. This time he wasn't going to be that onery Kid Russell. He'd care for the horses, skin the animals, and by heaven, he'd learn to hunt and trap. He looked off in the distance at an eye-catching formation set out in the middle of a flat plain, a huge square mesa catching the afternoon sun.

After supper Jake cleaned his Winchester, and Charley took an old gray sock out of his pack. In it he kept his paints and brushes. "Do you have any paper or cardboard you don't need?" Charley asked, sitting at the table across from Jake.

"Watcha want it fer?" Jake asked without looking up.

"Thought I might paint something."

"Lemme see." Jake looked thoughtful. "Maybe between the layers of crackers. Look in the cracker box."

Charley dug into the cracker box. "I got it," he called, glad to have something sturdy for a sketch of Jake's horse Guts. When Charley had unsaddled him, he ran his hands over the horse's back, getting the feel of his contours. Now he wanted to translate to paper what he'd stored in his mind.

"I got a nice old Henry you can use when we go out hunting," Jake said, looking down the barrel of his rifle.

Charley liked the way Jake said *we*, as though he belonged to the outfit already.

Later, Jake set the rifle in the corner, stirred the fire and bent over Charley's shoulder. "Hey, a horse. It didn't take you long to draw that. You put Square Butte in the background. That's mighty good, Charley. Only..." Jake paused and clicked his tongue, "...only the back leg here is too skinny." Charley squinted, and saw Jake was right. He changed the drawing. Then when Jake could find nothing else that needed fixing, Charley started to paint with watercolors.

He was brushing a dark brown into the shadows when a thump on the door startled him. He looked up, saw Jake's face come alert as he grabbed his gun and shoved a cartridge into place. He stepped to the narrow window and looked out into the darkness. "Indians," he muttered.

With gun poised for instant action, he flung open the door. Two Indians holding rifles across their chests, raised their right hands, two fingers extended in a salute. Jake lowered his gun and gestured for the Indians to come in. Charley took in the details of their brown faces, buckskin shirts, leggings, and moccasins. Jake invited them to sit on the buffalo robe. Charley sat next to the taller Indian and watched fascinated as they spoke earnestly to Jake. Charley understood the word *horse*, but most of the talk was with the hands.

Jake nodded, and got up. He took a handful of cartridges from his pouch and gave them to the Indians.

When they were gone, Charley breathed with relief, but then asked, "Why did you give them cartridges? Are you hoping they'll go out and shoot somebody?"

Jake shrugged. "I don't take sides when it comes to Injun feuds. But they're Crows and friendly to the white man. They're chasin' a band of Piegans who stole twenty-five of their best horses."

Charley's heart quickened. So there *were* Indian horse thieves in the area yesterday when he was alone out there.

Meeting Charley's gaze, Jake must have sensed his thoughts. "I'm still here 'cause I've learned to get along with all the Indians, not jest the Crow, though they're the most trustworthy friend the white man has. Blackfeet, Sioux, Cree, Cheyenne all come to hunt, or maybe to do mischief, but I'm friendly to 'em all, if I can be. Most are honorable men, but they don't live by the white man's ways, and it pays to understand them."

Charley had heard many conflicting stories about Indians. "Will you teach me to talk their sign language?"

Jake nodded and turned his attention back to Charley's half-finished painting on the table. "You sure have a good eye for horseflesh. You must've practiced a good while."

Charley grinned. "Enough so I never learned to spell, but...not enough to get everything to go together right." He picked up his brush, recalling as accurately as he could the horse's markings, the way the sun struck its rump, how the ears stuck up straight, the grace of the forelegs prancing to a halt. If he was any good, Jake would recognize this horse.

Ten minutes passed and Jake looked over his shoulder. "This paper hoss has face markings like Guts," Jake said.

"It's supposed to be Guts."

"Lemme look." Jake lowered his face to the picture. "Guts has a patch of white here under the belly, and his tail is longer. The chest oughta be heavier." Charley drew the corrections, surprised at how much better the picture became. He painted it again on the other side of the cardboard and showed that to Jake. Jake took the cardboard and put it on the log wall by his bunk.

Early the next morning Charley and Jake loaded the elk meat on to the pack horses and rode out to sell it to the few settlers who had recently staked claims to the land around Yogo City. They were tough-hided ranchers who had worked as cowboys. Charley asked one of the ranchers what it would take to get hired as a cowhand on a ranch like this.

"A man has to prove he can ride wild hosses and stay in the saddle. There are better ways to make a living."

"Charley's got the makings of a good mountain man," Jake said with a proud smile. "He don't lose his way, don't complain much, and Injuns take to him."

Jake was a patient man, taking time to explain why he did things the way he did them. He seemed not to notice Charley's awkwardness. The more trouble Charley had with something, the more interested Jake would become in telling a funny story on the subject.

At dawn one morning they filled up on oatmeal mush and coffee and packed up the hunting gear. Jake tossed a rifle to Charley. "Take this." Charley took it, noticing that Jake handled his gun as though it were an extension of his hand. Jake was livelier than usual, acted like maybe he was expecting great things. Charley didn't want to fall short. "I'm not too good with a gun," he said, though he had shot his cousin's rifle well enough to hit the flower pots on the fence every time.

"You can practice some today."

They headed back into the mountains, Jake pointing out the trails, and the landmarks to watch for.

Riding along a mountain meadow with purple flowers in bloom, Jake moved cautiously, his eyes roving up and down, left and right and straight ahead. But he didn't seem to notice all the bones strewn out on the ground. Charley reined in his horse. "Buffalo, aren't they?"

Jake nodded. "Hide hunters. Some of 'em can stand downwind of a herd, and pick off forty buffalo in an hour. What they do is keep the herd millin' and confused and shoot every wise ol' cow that tries to break and take the herd with her." Jake gazed at the bleached white bones in the green meadow and his mouth took on a disgusted look.

"How 'bout doin' some target practice?" Jake dismounted and picked up a buffalo skull. "I'll put this skull on the rock thar. You get back by those boulders and aim for the middle, right between the horns."

Charley clutched the .44 Henry. A pistol would have been more to his liking, the kind cowboys wore in their holsters. But Jake was waiting, watching. Charley checked the breech, raised the stock to his cheek, lined up the sights and squeezed the trigger. He heard the bullet's soft cry and then the thwack of a hit. The skull fell over. Jake walked to it and picked it up. "Dead center, Charley." He was smiling when he came back. "Let's ride, Kid."

They rode on, the sound of magpies and meadowlarks punctuating the morning. From the tall grass a bevy of pin-tail grouse fluttered up and in the next moment Jake's gun thundered twice and a pair of the birds fell. Charley picked them up.

Later they camped and roasted the birds. After eating, they set off on foot to hunt. Charley felt right tramping in the mountains behind Jake. This was what he imagined when his uncles told their stories.

Abruptly, Jake extended his arm in a signal to stop. He pointed, and Charley saw a mountain sheep standing above them on the rim of a boulder. "Your shot, Charley," Jake whispered. "Take him."

Charley raised his gun to his cheek, looking down the barrel until the sights were locked on the animal's magnificent horned head. He took a deep breath, feeling Jake's eyes on him. He didn't want to disappoint Jake. All he had to do now was squeeze the trigger and the sheep would fall and Jake would slap his shoulder and say 'well done, Kid,' and they would go and get the meat. Charley's finger tightened around the trigger as he gazed at the animal. How unaware it was up there where everything looked beautiful and right. Charley could almost feel its fur, thick horns and warm breath.

"Shoot."

"I can't," Charley said, lowering the gun.

Jake raised his rifle; his shot stung the air. "Goddamn it to hell, Kid!"

The sheep tumbled over the edge of the boulder. Charley watched its body fall, suspended for an instant in the air before it landed on the haw bushes below. Jake trotted forward and Charley followed, knowing he had failed, wondering what Jake would say, how he could explain. When they reached the spot where the sheep lay, it was peacefully dead.

Charley pulled out his knife and plunged it into the sheep's upper chest. It was just as dead as that buffalo skull he had shot. Still, Charley's vision blurred and he choked on the smell of the animal's warm blood. Jake stooped down beside Charley, mumbling about the size and quality of the horns, but Charley reached inside the cavity and pulled out the entrails. "He has eyes like my sister's cat," he muttered.

They pulled the carcass down the incline and hauled it back to camp. Charley washed in the stream, then helped Jake hang the animal from a tree. "I couldn't shoot it."

Jake frowned. "You ain't supposed to figure out what their eyes look like."

"I'll dress 'em and skin 'em but shooting's another story."

"Chicken-hearted clean through, are ya?"

"Looks like it," Charley nodded and looked down at the ground.

"Well, you ain't the first fella to louse up a good shot, but you wouldn't be much help in a tight spot."

That was true, Charley thought, cold with the feel of Jake's disappointment and his own sense of failure.

Jake shrugged as though it didn't matter so much any more, but it was clear how much it did when Jake continued to avoid Charley's eyes and kept busy doing things around the camp that didn't need doing.

"I'll probably get on to it," Charley said. "I killed a rabbit once, but I sure felt bad. But hey, that was a long time ago."

"Damn." Jake's gaze finally locked on Charley's. "You'd make a hell of a Westerner if you can't even shoot a rabbit without snivelin' over it. I don't want to be hard on ya, Kid. I like ya. But maybe you'd do better in some tamer place. This territory is demandin'. A man out here has to be tough as rocks. He has to outthink every living thing around him. If he can't do it, he oughtn't to be here. I got a couple of brothers who tried it, but soon enough took themselves back to the farm. Plenty of folks ain't meant for this country. And Charley, you might be...well, more suited for paintin' pictures. Not everybody can do that."

"Yeah," Charley said, thinking he preferred Pike Miller's meanness to Jake's disappointment.

Chapter 3

"**A** cowboy travels light," Pat said over the campfire at breakfast. "He takes just what he needs and that's all. I can be saddled up, packed and ready to move in ten minutes." He filled Charley's coffee cup and then his own. "The Indians in this territory learned that lesson long ago. In a few minutes their whole encampment can be on the move."

"I wish I knew more about Indians," Charley said.

"Why's that?"

Charley rested his back against a cottonwood tree and sipped his second cup of steaming coffee. "I've been real curious ever since I talked to an Indian fella just last week. Me and Jake was camped along the South Fork up in the hills. While Jake cooked dinner I pegged out a couple of beaver pelts to dry in the sun. An Indian came out of the brush, solemn-faced, but with his hand raised in the sign of friendship. Three horses and two more Indians waited downstream. Jake invited them all to stay for dinner.

"As we ate, I asked the one called Otter Who Limps what the painted handprint on his horse's neck meant. He acted as though he didn't understand. But the other two Indians said it signified a successful raid. Through Indian English and hand talk I found out that Otter Who Limps had stolen a *Gros Ventres* warrior's prize horse while the warrior rested in his lodge holding the reins in his hand. Otter Who Limps had cut the rope so smoothly, the warrior didn't stir. Not only did he take the horse, but he left a turtle tied in the horse's place." Charley grinned. "We all got a good laugh outa that."

"So I took out a flat piece of worn wood I'd found that morning and drew the Indian cutting the rope of his enemy's horse. The Indians watched. You shoulda heard 'em laughing and urging me on. 'No, rope shorter. Moon bright.' Finally when the picture was done, I gave it to Otter Who Limps."

"After the Indians left, Jake said he figured the sketch saved us a dozen cartridges and a supply of tobacco. It might even have saved our horses. But I have to wonder about the nerve it must have taken to walk up to an enemy's tipi and steal his horse right out of his hand. Had he been discovered, he'd have been killed."

Pat poured out the last few swallows of coffee from his cup. "Yep, Indians can be cunning as hell. But they know how to have a good laugh. They don't cope with nature like we do. They are nature."

Pat fetched a skin case, opened it and showed Charley his fiddle. "It's my one extra. I've a hankerin' for music, so I carry it." He fit the instrument under his

chin and softly played an Irish tune. His eyes twinkled, then gazed off over the range, no longer lush and green, but dry and yellowed.

As Charley listened to the music, he put the camp in order.

"Whatcha going to do, Charley?" Pat asked as he put the fiddle back in its skin bag.

"Gotta find a job." He could help out on ranches a few days at a time for food and a place to sleep. But he wished he could get a cowboy job.

Pat nodded. "I might ride up into the mountains for a day or so till the foreman gets the crew together. You want to come along?" He looked toward the Little Belt range.

"Sure, I suppose I have to go that direction anyway," Charley said. "I have to pick up my belongings at Jake's. Say, I have a trunkful of stuff up there my folks sent to me. Would you help me sort through it and throw away the things a cowboy wouldn't have?"

Pat laughed. "Sure, if you want."

They rode off together toward Jake's cabin. Charley figured he wouldn't apologize when he saw Jake but he would say thanks. He had to do that.

"Beautiful country, ain't it?" Pat said. "Good huntin', I bet."

It was about the prettiest place in the world, Charley thought.

"Jake lived here long?"

"A few years. He found gold at Yogo."

"What's he like when he ain't talkin' about the war? Friendly to strangers?"

"You ain't a stranger. You're another damn reb-but don't mention that. Jake'll be friendly."

Charley had no doubts that Jake would be all cooled off by now. He was a surprisingly friendly man for one who chose to live alone in the mountains. He loved to tell stories. Charley loved to listen, too.

"Let me tell you, Charley, about the time me and an old muleskinner named Sureshot Paddy got snowed in on Prospect Mountain...."

Charley had listened to the tale, wishing he could pay Jake back in fun for all the stories he told. One way was to draw something funny. A few times he tried to illustrate a story Jake had told—only exaggerating it even more than Jake did—or he might draw something that happened on the trail, but with a humorous twist, such as when a rattlesnake startled Guts and he reared and galloped down a steep grade. Charley drew the scene showing Guts with eyes wide and nose snorting smoke while Jake hung on, heels pointing skyward and paraphernalia flying. Jake laughed long and hard at that one, and that made Charley feel glad even after he went to bed and stared up at the darkness.

Sometimes Jake's old friends would stop at the cabin. They would smoke and jaw about prospecting days, fortunes won and lost, stage holdups, wild dance-hall girls, and crooked card sharks.

Jake and his pals drank a lot of whiskey, and sometimes Charley thought they were pretty stingy with it. They'd give him one or two drinks and after that he was forgotten when they poured. "Too young to booze heavy," Jake said. Charley resented it. He could drink just as much as Jake and did on occasion when Jake wasn't looking. He felt even more slighted when Jake and his pals rode to town to get a *breath of fresh air.* Charley knew damned well they were going to find women. They acted as though he was too dumb to figure it out. Didn't Jake know how badly he wanted all that too?

Hollering was Jake's way of letting a person know definitely what the rules were. Dishes had to be washed, utensils put away, the axe kept sharp and in good repair. But the hollering always gave way soon enough to joking and stories. Charley never imagined a real argument would come up until Jake lit on the subject of the war. "The goddamn rebs got my brother's shooting arm," he had said. Charley remembered exactly how mean Jake's eyes looked all squinted up.

"What do you mean, goddamn rebs? War is shooting, ain't it?" Charley had answered. "I could tell you how the damned yankees ruined plenty of good Southern boys," Charley said.

Jake shot him a fiery glance and yelled louder. "I've seen good Southern boys taking the food out of Northern cupboards, raping their women, turning them out of their homes. And when they moved on, they burned everything."

Charley didn't believe it. "Yankee lies. Raping and burning are Yankee tricks. They did it all over Missouri."

"You're just a kid. What do you know about the goddamn rebel dogs and the savage killin' they did of innocent folks?"

As Jake yelled, his face turned redder; the veins in his temple and neck swelled out as he called Charley a rebel dog. Charley stood up and said he was proud to be a Southerner. He stuck his face close to Jake's and said he didn't care to associate with the enemy. Angrily, he had bolted outside, mounted Monte and headed for Utica.

When Pat and Charley got off their horses at Jake's cabin, all was quiet. The horses and traps were gone, and Charley figured Jake had gone out to set traps, probably wouldn't be back for days. Charley got his trunk out of the storage shed and he and Pat carried it over to the river's edge. "Anything a cowboy wouldn't use goes into the river," Charley said. "Then I'm going to ask the roundup boss for a job again."

Pat laughed. "If you're that determined, I'll put in a good word for you with Brewster. It might not help, but I'll do my best."

Feeling hopeful for the first time since he quarreled with Jake, Charley opened the trunk and lifted his clothes out onto the grass a couple of pieces at a time. "These are my Sunday clothes," Charley said.

Pat looked down. "Lord, Charley, we don't have Sundays on the range. Nobody wears fried shirts except gamblers and hoss thieves, and they aren't wanted around cow camps."

Charley tossed the Sunday clothes into the river and pulled out a big white nightshirt. Pat shook his head. "Hell, if you put that on in a cow camp the boys'll think you're an evil spirit and put out your light."

The nightshirt went in the river. When everything had been examined, Charley rolled up his clothes and pushed the trunk into the river, too.

Just being with Pat made him feel like a cowboy. The beef roundup would start in a few days. Until then Pat offered to teach Charley what he could. They rode out and camped in the mountains a couple of days then headed back to Pat's camp.

Pat was an orphan. The only family he had was an aunt. "A man doesn't need a family on the range. We're all brothers. It's a nice bunch. When trouble comes to one, it's everybody's trouble. The boys don't judge, don't ask what you've done or who you are. You do your job the best you can. After that a cowboy is free to do anything he wants as long as it don't hurt anybody."

"That's what I want," Charley said. "As much liquor or women as I want without somebody telling me *not so much, wait a while, or you're too young.*"

Pat grinned. "There ain't nothin' I'd rather do than ride the range with my friends and bust loose when we get to town. Or sometimes I like to wander off in the hills and live like an Indian."

Charley practiced roping and paid attention to Pat's cowboying tips. He wanted to ride with Pat more than anything, to earn some money and buy a fine saddle. But first, he wanted to see Jake, to say he was sorry they argued and to thank him for everything. "I'm going back and say good-bye to Jake," Charley told Pat one day.

Jake was skinning an antelope when Charley rode up to the cabin. Charley dismounted. "H'lo. I came to say I'm sorry about...."

"Aw, forget it. I shouldn't have blown off at you. Glad to see you back. Hey, I had a visit from the roundup cook. He asked if I could supply him with four or five nice elk for the crew. How about it, Kid? You think we can do it? He'll pay a good price."

Jake was smiling at him, pleasure sparking out his eyes as he anticipated a good hunt. Jake would need help handling four or five elk. But Charley thought of Pat back down the mountain at his camp. He'd said he'd put in a good word with the boss. Pat would be leaving the next day for the roundup camp. Jake or Pat? He couldn't have it both ways. Jake would understand it wasn't anything personal. Jake wanted to teach him to be a hunter and mountain man, but Charley wanted to ride the open spaces and be just like Pat Tucker.

"Why're you standing around like a stick in the ground?" Jake asked, smiling. "Get your rifle ready. We can deliver this meat to the general store and head for elk country."

"Sure," Charley said. "I can be ready in ten minutes."

Chapter 4

It was midday and camp was nearly deserted when Jake and Charley delivered four dressed elk to the roundup camp cook. Charley wasted no time asking around about Pat Tucker, but learned he had already ridden out toward the Wolf Creek range. Charley wanted to ride out and find him, but that wasn't permitted, so he sat cross-legged in the grass and wrote Pat a letter, explaining why he didn't come back. He included a sketch of himself and Jake on the trail with four elk loaded on their packhorses. On a separate sheet he did a watercolor sketch—himself on Monte and Pat on White Bird, in front of the Utica saloon before the big spring roundup. "Hope to see ya thar, Pal," he scrawled at the bottom of the painting.

The excitement of the roundup camp lingered in Charley's head as he and Jake rode away. Though most of the cowboys had been spread out over the range leaving the camp nearly empty, the tents and heavily trampled rope corral still held an air of action and purpose—the magic of range life. If he'd gone with Pat, maybe he could be part of it right now. But he put that thought aside. Though he'd learned a lot from Pat, he'd learned a lot more from Jake. Jake treated him much better than he had a right to expect. Regrets were a waste of time anyway.

Winter came on early and yielded more high quality pelts than ever. Before Christmas, Charley's mother wrote a letter pleading for him to come home. His happy memories of Christmas at home affected him, and as he read the letter, he could hear his mother's voice and ached to see her again, but toward the end of the letter her words took on a harsher tone, and he stopped reading.

Jake saw his expression. "Is something wrong?"

"No. She wants me to come home," with a sigh, he read the words aloud to Jake. "'Your father and I both think you should have quenched your thirst for adventure by now and ought to be ready to prepare yourself to enter business life. Your father needs someone to help carry the burden of business. He wishes that someone would be you, Chaz. I know you will not disappoint us. I am enclosing the money for your return passage.'"

Charley put the letter and the money down on the table and stared ahead.

"Go for a visit," Jake said. "You don't have to stay."

"I'd hate workin' there as much as I hated school."

"You don't want to go, then?"

"No. But I haven't been the best son a parent can have, believe me."

"I believe ya, Charley," Jake said, laughing. "If I were you, I'd just chew on it for a while."

When a balmy chinook brought mild weather, Charley and Jake packed their hides and fur onto pack horses and headed for Fort Benton. Charley had heard plenty about Benton when he hung around the harbor in St. Louis watching steamboats headed there. River men said it was a dangerous journey. Some steamboat captains used pretty low tricks to fill out their crews, and Charley had volunteered every so often but was always told he was too young. He tried stowing away. That didn't work either.

But here he was on his way to Benton a better way. The second night on the trail, they stopped at a ranch.

The foreman shook Jake's hand and told them to sleep in the bunkhouse and have breakfast with the cowhands. Charley talked to the men, observing how they walked, how there wasn't a soft inch on any of them. They were rock hard with eyes that reflected the toughness of the life. At breakfast he learned the foreman was looking for somebody to replace a cowboy who quit. Charley rushed out to ask for the job.

"See what kind of a rider he is," the foreman said to a lanky cowboy named Bob. Bob told Charley to meet him at the corral.

Charley was sitting on the corral post when Bob came along. "Are you ready to try some bronc-riding, Kid?"

Charley nodded as he took in Bob's high-heeled boots, sweat-stained Stetson and red silk neckerchief. "These cayuses are still more'n half wild," Bob warned. "Are you a good rider?"

Charley laughed as though that was a silly question and watched while Bob and another fellow gingerly put a halter and saddle on a wild bay. The horse snorted and pawed the ground. "I don't suppose you'd care to try that one?" Bob said.

Charley stepped forward. If the cowboys could ride it, he ought to be able to stay on, though it wouldn't be a cinch. It was a strong horse who didn't care for a saddle on his back and was trying his best to throw it off. "I wouldn't mind trying him," Charley said.

"Best to let him play himself out a while first."

Glad to take Bob's advice, Charley watched the horse humping his back, rearing and stomping, and imagined himself clamping his legs tight around the horse's belly, holding on, staying on no matter what the bronc did. When the cowboys told him to go ahead, Charley walked forward, his mouth dry. "Gotta move fast to get on him," Bob said.

Charley took the reins and hoisted himself up. But there was no time to get his knees into position, or to grab hold of anything before the bay humped and heaved, kicking its back legs into the air. Charley pounded against the saddle and bounced into the air again. Seconds later his face hit the dirt; fireworks went off, and the next thing he knew he was being dragged to the corner of the corral. Propped like a rag doll against the post, he blinked a few times before the scene came back into

focus. Then he saw that damned bay, still humping and jumping, and there was Bob, getting ready to ride him.

Bob sprang onto the saddle; the horse lowered its head and reared up weaving hard. Bob leaned back and swung his arm, holding the reins. The horse jolted into violent gyrations, raising so far off the ground that when his hoofs hit the earth again, Charley cringed at the jarring Bob must have taken, but Bob stayed, and the horse flew into the air again. Bob's hat blew off and his gunbelt raised to his armpit, but Bob stayed, teeth clenched, grinning.

Back on the trail, heading for Benton, Charley recalled Bob's bronc ride. He could still see the horse's sleek neck and open mouth, the thrust of the back legs, the mane flying. He wanted to put it down on paper, fixing the shadow under the horse, the tilt of the cowboy's head and the angle of his arm.

Fort Benton slept as they rode in before noon. Jake went straight to the trading post. He knew the value of his furs, got a fair price and paid Charley well for his share. Charley took a few dollars to buy painting supplies and tobacco and asked Jake to keep the rest for him. "I can't hang onto money, never could."

Later, the streets came alive with bullwhackers, fur traders, cowboys, prospectors, settlers, rivermen, lawmen, gamblers, rustlers and characters whose lives were question marks. The only white women they saw were painted ladies. Dozens of saloons, livery stables, a few hotels and stores clustered near the river front. Charley sniffed the dusty air. So this was Fort Benton.

Inside a noisy saloon with a green swinging door, a cowman clapped Jake on the back and bought a drink. It wasn't long before Jake was telling a story.

Jake took his time in the telling, never wasting words, but painting a vivid picture with his camptalk lingo. Though Charley had heard the stories many times, he still listened carefully and watched the reactions of the men to each turn of the tale.

Later, Jake sidled toward the door. "I got me a hankerin' for fresh air. You stay as long as ya want, pardner. See ya back at the hotel."

"Wait a minute," Charley said and shoved his hat to the back of his head. "I might like some of that sweet air, too, if I knew where it was." He looked straight into Jake's eyes.

Jake frowned. "Do you think you ought?"

"Why not?"

"Let's have another whiskey," Jake said to the bartender. To Charley he whispered, "I can't stop you if you want to go, but you're having a good time right here, so why not stay and enjoy yourself?"

"You know why."

Jake blew air out of his mouth and shuffled around, studying the floor, then looked up with a resigned expression. "Benton gives a man a lot of choice."

Charley waited, then Jake gazed off over the bartender's head. "The fresh air around here comes in all varieties. It's not like buying a hoss. You can't tell a thing by lookin' at their flanks and teeth. Look at her *feet*. The ones with little feet and high arches have a lot of spring, but too much of that can be dangerous. Now, the big flatfooted ones are strong and patient, and they do little extra things a man likes, but they expect darned good performance and you better be up to it."

Charley tipped his glass and spilled some whiskey. "Let's go."

"Drink up, Kid." Jake took a swallow of whiskey. "Another thing to look at is wrists."

"Wrists?" Charley asked incredulously.

"Yep," Jake said. "A man can savvy a lot from wrists. Thar's skinny ones and plump ones...and...I'm partial to plump 'uns myself. Skinny wrists have bony parts in other places; might give ya trouble if you're some tipsy. And they bite and hiss. Plump wrists don't hiss."

"I suppose they're quiet?"

"They gurgle," Jake said.

Charley nodded, his temples pounding. "All right, a girl with arched feet and plump wrists. Let's get going."

Jake took another swallow of whiskey. "In a minute. There's girls that smell like daid flowers and girls that smell like bear grease."

"I'll take flowers," Charley said, his heartbeat quickening again.

"Not unless you want to feel guilty about addin' to her ruin."

"Bear grease then."

"Bear grease won't waste time preachin' as to how much more she's really worth."

Charley could hardly swallow his whiskey. Finally, Jake turned and led the way to Irish Mary's.

In the parlor, Charley sat on the piano bench with Irish Mary as she played tinkly tunes. He watched Sophie, Gussie and Eliza. Sophie had freckles all the way down her neck to where her flimsy lace dress stopped and more or less covered her shapley bosom. She laughed the most, but Gussie had the plumpest wrists. She was plump all right, but in places that made his mouth go dry, and he thought she was the one, until Irish Mary asked Eliza to sing. When Eliza sang, she tossed her thick blonde mane and shook her shoulders until the whole room seemed to shudder. Charley forgot about arched feet, plump wrists and bear grease. He took Eliza by her unplump wrist and went upstairs with her.

A frigid wind buffeted them on the way home. Charley fought cold by memorizing sights—trees sticking out of drifts, rock walls, columns of steam rising from his horse's nostrils. Back at the cabin, the pace slowed. They tended traps, split logs, dressed hides, played cards and Charley painted pictures of scenes he remembered. But as the winter wore relentlessly on, he grew restless. "I think I'll

go home for that visit now," he said one day. Jake gave Charley the money he'd saved for him.

"Gracious, look at you!" His mother's eyes were wide. He looked down at his scuffed boots, well-worn trousers, and frayed voyageur sash, and saw what she meant. He shushed her with a hug and a kiss, and it wasn't until after dinner that she brought up the subject of his appearance again.

"Promise me you won't wear that hat, Chaz. We Russells have a position to maintain, remember. And that red thing tied around your middle.... Well, of course, I don't want to nag at you when you've just arrived, but...."

Charley looked at his mother's face, her brown hair neatly arranged as always, her hands soft and manicured. He would put his hat away if it bothered her. But he prided himself in dressing as a Westerner. His sash was a French explorer's touch, much more comfortable than belt or suspenders, and the dashing color made him feel good.

That night he couldn't sleep because of the heat. Jake's cabin didn't have a coal furnace and Charley was used to the chill. Now he had to open the window and throw off the covers before he could be comfortable.

At the breakfast table, Charley told his sister Sue and brothers Ed, Guy, and Wolfert about life at Jake Hoover's cabin. Charley rolled a cigarette and leaned back. "I ain't much of a hunter myself, but Jake's no more afeard of a grizzly bear than I'd be of a milk cow. Once he killed three together and the noise they made waren't a peaceful song. I took to a safe tree limb, but in the excitement one bear fell not more'n twenty feet away, and Jake looked 'bout a startled as if he was a grinding coffee."

Sue frowned. "I hope you're not going to talk like that this evening when the Falkersons come for dinner. You sound as if you've never been to school a day in your life."

Two weeks at home was enough. Charley itched to get back to Jake's cabin in the mountains.

"Oh Chaz," his mother said. "You can't leave now. You have such a fine mind, such a kind heart. People have always been drawn to you. But what future can you hope for, hunting and trapping animals, especially when you said yourself you hate to shoot them?"

"Some day maybe I'll get a cowboy job. That's what I really want."

"But what about your art? If you don't train yourself now, it'll be too late. You have talent. You'd do well as an artist."

She had hit a soft spot. He wanted to be free—but he wanted to paint, too. "I'll practice while I'm in Montana," he said, sounding confident, but knowing that wouldn't be enough to make him a professional artist, and he hadn't quite abandoned his earliest dreams of becoming a painter. But now all he could think of was getting back to the West.

On the morning he was to leave, his cousin Jim Falkerson came running into the house, his normally neat red hair was uncombed, his face so flushed, his freckles were hardly visible. "I'm going back with you."

Charley was astounded. Jim was a good student and would be graduating high school in June. "What about your folks?"

"If you can do it, so can I. I've got enough money to get outfitted and still have plenty to keep me for a while."

Everything would be twice as much fun with Jim along. Jake wouldn't mind. And maybe he and Jim could build a cabin of their own. Jim liked to hunt. He was smart and good on a horse. "Let's go," Charley said.

On a cold but sunny day in late March the train brought them to Coulson, Montana Territory. Jim shivered. "I've never been this cold."

"You'll be used to it in a week," Charley said. "We ought to spend a lot of time outside so you can be ready when we start the ride back. We'll stay a week or two, look the town over good." Charley winked, knowing Jim would like the rowdy cowtown saloons and dance halls.

Their first outdoor excursion was a hike to the river's edge. They walked along the rocky cliffs and among the willows, pausing on the rimrocks to look across the ice-crusted Yellowstone river, where they would be riding soon enough. Jim was excited, but when he searched the vast expanse to the northwest, he shook his head. "It's so empty."

Charley gazed at clumps of tall dry grass sticking through the stark snow-covered flatland, the blue shadows curling on the hillsides. "Out there," Charley said, "is space to roam in and time to think. There's land that's still exactly the way God intended it to be. It tests you and if you pass the test, it rewards you. You'll see."

They hiked back to town and went to a saloon for a warming drink. There they met some cowboys and drank with them a while until Charley decided to take Jim to a dance hall.

On the way from the saloon to the dance hall, Jim stuffed his hands in his pockets as they walked down the street. "How is it those men in the saloon act like you're their old friend?" Jim asked. "You never saw any of them before."

"I like cowboys," Charley said. "I guess it shows."

"Guess so. I could tell how you liked them. But the way they took to you so quick was what surprised me."

"Folks are friendlier than you might think."

They stayed out late that night, and the next day Jim was sick. "Too much booze," Charley said. "I guess we have to cut that out."

"I've never had such a bad headache," Jim said.

"You'll feel better after you eat," Charley said. But Jim was too sick to go down the street to the cafe. "I'll bring you something back. You stay in bed."

Jim didn't eat much. He slept some, but he moaned even while he slept. Sometimes his teeth chattered; sometimes he would sweat. By the next day, Charley knew something more than booze was bothering Jim. His face was red and hot, his eyes had taken a glassy sheen. And he moaned in his sleep.

Charley spent the night at Jim's bedside. He gave him water, spoke comforting words and wiped his fevered skin with a cool damp cloth. Sometimes Jim cried out, but more often he muttered words that didn't make any sense.

When morning finally came, Jim looked worse, his lips whiter. Charley went for a doctor.

The doctor took one look at Jim, threw off his coat and rolled up his sleeves. He removed Jim's nightshirt, revealing a heavy rash. The doctor asked for wet towels, and Charley hurried to get them. He stood watching as the doctor made a poultice and put it on Jim's head. Hours later the doctor gestured for Charley to follow him to the hall.

The doctor drew a long somber breath. "It looks like mountain fever," he said. "If I were you, boy, I'd send for the relatives."

"You mean he could die?" Charley felt the shock sweep through him. His hands trembled. Jim was only eighteen. He'd always been as healthy as anybody.

Late that afternoon the rash turned an angry purple and Jim said his joints and bones pained him and he couldn't see well enough to hold a glass of water. Charley rushed out to telegraph Jim's parents.

He stayed by Jim's side, watching over him, hoping for signs of improvement, but Jim grew worse. In the night Jim groped for Charley's hand. "I'm going to die."

"No." Charley swallowed his fear. "No."

"I want you to have Gray Eagle. I'm glad I owned him, if only for a couple of days. I know you'll take care of him. But Charley, go back home. Don't stay here and get mountain fever and maybe die, too."

Charley took Jim's hand, and prayed. He had never seen anyone with mountain fever, though he'd heard about it. He hoped it was just a nightmare he would wake from soon. There were times when Jim was still and quiet and his face looked peaceful, but then his moaning started, sending pinprickles through Charley. He could only hope the worst had passed.

In the morning the doctor came, but all he did was give Jim something to make him sleep. While he slept, Charley watched him breathe, his chest heaving up and down. Though Charley was exhausted and could hardly stay awake, he was afraid if he closed his eyes the movement might stop.

He sat on a wooden chair, elbows on his knees, leaning over Jim's bed, talking softly as Jim lay there hardly breathing sometimes, moaning occasionally, unable to answer, unable even to open his eyes. But Charley told him about Jake's cabin, the Indians who came, all the things he knew Jim would like as much as he did. "But you'll be there soon enough and you can see for yourself. Your folks are

coming here first—just to make sure you recover okay. They'll be in on tomorrow's train, I bet. Won't that be fine? And when you feel like traveling again, we'll move on." He didn't know if Jim heard him—no way to know, but as long as he breathed, Charley hoped.

He had almost dozed off talking, but blinked his eyes and waited for Jim's next breath. How waxy Jim's skin looked shining in the lamplight. How long between breaths. Charley watched Jim's chest and listened for his wheezing breath all night. The room was still and cold, and then it seemed Jim's chest didn't move, or if it did, Charley couldn't tell. He reached for Jim's cool hand, felt for his pulse. Nothing. He put his ear down on Jim's chest to listen for a heartbeat.

Jim was...was dead. Charley swallowed back a tight awful lump in his throat. He shivered. What could he have done? His whole body trembled and he walked out into the hall, downstairs, outside into the bitter wind toward the doctor's house. The rest was a blur.

Charley felt old—no longer a kid—no longer the same at all. He couldn't find the words to talk to Jim's parents. They must have guessed the truth when they looked into his eyes, and he could only shake his head when they asked, "How's Jim?"

But even in their grief and tears, they wanted to know everything, and Charley was forced to remember. "Did he suffer?" "What did he say at the end?" Charley relived it, telling them what he could.

"Chaz," his aunt said when they were ready to leave, "we're taking you back with us. Your poor mother is already sick with worry. You can't want to cause her any more pain."

Charley couldn't think of his mother suffering. He wouldn't. Maybe the life he wanted was more dangerous than the one his parents had planned, but he knew which one he had to have. "I can't go back. It wouldn't do any good."

His uncle put his arm on Charley's shoulder. "If you come home, you'll have plenty of choices about a career. You'll be able to travel if you like. And one day you'll have a home and children of your own. Don't throw away your opportunities on a romantic whim that could end in an early death. At least, come back with us and think it over again."

Charley shook his head. "No, I'm staying."

Then his aunt turned on him and glared, hands on her hips, her grief over Jim raw and fresh. "But you're not equipped," she said. "How long do you think you're going to be happy roaming the hills and killing animals?"

He understood what prompted her outburst. And maybe he *wasn't* equipped, but he had to be part of this territory one way or another. It didn't matter what any of them thought now.

Chapter 5

Charley headed Gray Eagle northwest with a heavy heart. Patchy snow covered the ground, and the wind blew relentlessly. It wouldn't be an easy 90 miles. He would be cold, lonesome and have too much time to think about Jim and home. He sure would be glad to see Jake, though, and Monte.

At sunset he scanned the horizon, hoping to see a cabin where he might find shelter. But across the vast distance all he saw was empty whiteness, except where the snow had blown off the high ground. When he brought his eyes back to the trail, he could hardly believe what he saw. A dozen riders and a pack of horses cantered over a rise toward him. Cowboys, judging from their clothes, but there was no sign of cattle.

Curious, Charley spurred his horse and galloped toward the men, reining up next to a big man in a gray coat. "Howdy," Charley said. "Are you the foreman of this outfit?"

The man nodded. "John Cabler's the name."

Charley cleared his throat nervously. "I'll bet your outfit had cattle shipped to Coulson and you're on the way to get them?"

"That's right," Cabler said.

Charley smiled and cleared his throat again. "If you can use another hand, I'll work hard for my keep."

Cabler looked him over. "Where're you coming from? And what're you doing out here by yourself?"

"Heading back to the Judith Basin. I live with Jake Hoover on the edge of the Little Belts. I went to St. Louis for a visit and when I came back with my cousin...." Charley lowered his head a few seconds then looked directly into John Cabler's gray eyes. "Well, Cousin Jim took sick and died. And the long and short of it is I'm broke."

Cabler squinted. "I know of Jake Hoover."

Charley waited, hoped, and felt Cabler's eyes.

"Do you think you could night-wrangle the hosses?"

Charley's hopes soared. "You bet."

Cabler looked doubtful. "I was going to hire a nighthawk in Coulson, but if you handle it all right tonight, you can have the job."

When the outfit made camp, the cook put out a feed of baked beans, fried bread and plenty of coffee. Later, Charley listened carefully as Cabler told him to hold the horses in a close bunch by riding a circle around them, allowing them enough space

to graze, but not enough so they could wander away or get stolen. Charley was determined to do well now that someone had given him a chance.

After a long nervous night, he went into camp, hoping to be accepted by the men. Cabler acknowledged him with a nod. "Sit down and eat." As Charley drank the warming coffee, the cowboys looked him over. One seasoned cowman winked at another. *Greenhorn*, was what their smirky smiles were saying. Charley grinned. Nobody said anything to him. They were all busy eating flapjacks or saddling their horses. Charley ate fast. Then he wiped his hands and pulled out a piece of paper and pencil and started drawing. One of the cowboys paused to look over his shoulder. Charley drew a cowboy piling a mountain of food onto his plate, putting extra biscuits into his shirt. A couple more men noticed him sketching and watched. "Hell, that's Blue Leonard," one man said and laughed. Encouraged that they recognized the cowboy, Charley admitted they were right. Everybody wanted to see the drawing so they passed it around. The men hooted. And Blue Leonard unbuttoned his shirt to prove he didn't have any unnatural lumps.

The next day they drove one thousand steers out of Coulson on the trail to the Judith Basin, where they would be put out on the open range. Charley watched the cattle plodding along, blowing and mooing, smelling of hay and manure. He turned his head this way and that, not wanting to miss anything. He was a cowboy in his heart even if he was just a nighthawk.

That evening before he saddled up to ride around the horses, he sketched the chuck wagon and drew the cook leaning over the stewpot taking out a wolf's tail. The men howled, and the cook laughingly boxed Charley's ears.

He was part of a cow outfit at last. This was no dream. He couldn't wait to tell Jake, write home, holler to the moon.

A miserable freezing rain fell one day and into the night. He was cold to the bone. The horses were skitterish. Then the wind came up and blew treacherously. But none of that took away the joy of being part of the cattle drive. After being on the trail a month, Charley was tired but sorry to have it end when the outfit met up with the spring roundup forming at Ross Fork in the Judith Basin.

Dozens of ranchers had turned their stock out to feed on the lush grasslands. The cattle wandered the far reaches of the vast Judith Basin, foraging all winter, and by spring the herds were so thoroughly mixed, the ranchers had to gather them together, identify them, take the newborn calves and brand them with the same brand as their mother's. For this yearly roundup, each outfit sent its best cowboys to represent it.

Charley was amazed at what a large undertaking this roundup was. One ranch alone had 10,000 head and sent a proportionate number of cowboys and "reps."

Charley's job with Cabler ended, but now that he had that experience, he couldn't wait to get hired to work the roundup. He soon found the boss, a raw-boned, tight-lipped man called Red Harvey. "Howdy," Charley said, and introduced himself. "Could you use another hand?"

Harvey glanced at him and tossed his head impatiently. "Sorry, Kid. Come back in a couple a years when you're dry behind the ears." With that he turned and walked away.

Discouraged, but turning his mind back to the prospect of seeing Jake, he shook hands with Cabler and the cowhands he had lived with for a month.

Riding back toward Jake's cabin, he stopped at Babcock's ranch to say hello and water his horse before he started the long climb up to the cabin. Bab was out back with the stock when Charley reined up. "What a damn dust devil," Bab yelled.

Charley grinned. "You ain't exactly the jack of hearts yourself."

Bab clapped Charley's shoulder. "You look like you slept in your clothes a month straight."

Charley smiled. "That's right, Bab. I ain't had a real bath for over a month now. There ain't nothing on me clean. I been ridin' with the 12 Z and V outfit."

Babcock wanted to know all about how he got the job, and Charley began to tell him the story as they walked to the well. They both stopped when they saw dust on the trail. "Somebody's coming."

"I see that," Bab said. "Rides like a puncher, too."

Charley waved both arms when he recognized Pat Tucker.

"Howdy," Pat drawled, smiling wide, his chipped front tooth gleaming. "And you must be Babcock?"

Pat dismounted, shook Babcock's hand and grinned at Charley, his blue eyes brimming with fun. "Thought you might like to come back to camp with me."

"Why? What's goin' on?"

"Old man Brewster fired the nighthawk for the roundup hosses. Seems he was practicing throwing his rope around the saddle hosses' necks. Well, Brewster's shy a nighthawk, and Cabler put in a good word for you. So I told Brewster I'd find you."

"Yaa Hoo!" Charley threw his hat up in the air. "Jest let me at my hoss." When he was ready to ride off, he turned back to Bab. "Tell Jake I'll see him after roundup if my luck holds."

Back at the roundup camp Horace Brewster turned his granite face toward Charley. "What do you want?"

Charley cleared his throat. "My name is Russell. I heard you needed a nighthawk, and I'm asking for the job." Charley wished he had washed up at Bab's place and tucked his pant legs neatly into his boots. He took his hat off and pushed his unruly hair off his forehead.

"John told me you were green, but I didn't savvy how green," Brewster said. "We've got over three hundred hosses and we can't afford to lose a single one. Some are wild and most would like to quit the bunch and wander back to the home ranch. I need a man who can keep them tightly under control."

Charley knew he wasn't the man Brewster wanted, but he met Brewster's blue eyes with his own. "I did all right for the 12 Z and V. I know what a man's hoss means to him, and I'll do my best."

Brewster turned to Pat. "Ride around with him for a night or two."

"Sure thing," Pat said.

Riding around the herd with Pat that night, Charley saw what a huge job this was compared to riding with Cabler's bunch. But both Cabler and Pat had vouched for him, so he *had* to handle everything right.

Each morning he walked into camp and joked with the cowboys who were just getting up, then he crawled into a tent to sleep a few hours. He spent the rest of the day sketching the action—calf-branding or ear-marking—to the smell of the searing fur and flesh and the sound of bawling calves.

He watched a cowboy lassoing a running calf. It was a scene that pestered him, but the action was elusive. A wax model of the calf helped. Creating action with lines and color took intense concentration, but when he got it, there was nothing so exhilarating.

One morning he dropped down on his bed roll, bone tired. Pulling off his boots was the last thing he knew. When he woke up, he sensed that something was different. He rubbed the sleep from his eyes. Still yawning, he pushed his shoulder through the flap of the tent, looked around, and almost at once, spotted Monte grazing in the meadow beyond the chuck wagon. Letting out a bellow, he ran to his horse. Even as he was giving Monte an affectionate pat, he turned and saw Jake talking to the cook.

Jake laughed when Charley's eyes caught his. "Is it a cowhand or a scarecrow!"

"It's a half-asleep nighthawk," Charley said. They greeted each other with slaps on the back and friendly punches, then they took coffee and biscuits and sat on the grass behind the tent. Charley told Jake about Jim. While he talked about it he felt terrible all over again, but when it was all said, his heart was not so heavy.

"Thar ain't no way to savvy dying. Nobody knows what they're going to draw. Live like you hanker to, and you'll be ready when it comes."

Charley saddled Monte and rode out a ways with Jake. "I'll see you when the roundup's over," he said, a little sad to watch Jake ride on alone.

Whenever he could, Charley sketched cowboys in action, but as the days wore on, he saw more than he could put down on paper. The roundup tested a man's mettle. Out on that shadeless plain when the temperature rose to 100 and the dust floated in the air, stinging eyes, and coating every pore including the inside of the nostrils, the tongue and throat, when water had to be measured by swallows because the creek was far away and drying up, weariness could come on like a sickness. It hung with a person until he closed his eyes and wasn't quite gone when he woke up and had to start over again.

The roundup lasted through July, and when the cowboys were paid off, Charley was one of the first to stand up at the bar of the Utica saloon and order whiskey. "Here's luck," he said to Pat.

The men had been on the range for more than two months and had built up powerful thirsts. The roar inside the saloon grew so loud, the boys had to shout to be heard a foot away. Sheepherder Sam, already drunk, leaned on the bar and yelled for the bartender who ignored him as he poured whiskey for the roundup crew. But Sam didn't give up. Pat and Charley moved away from him, but he yelled louder. The bartender told him to go home and sleep it off, but Sheepherder Sam only bellowed louder.

Finally, Pat nudged Charley. "Hey, why don't you model a little rattlesnake out of that wax you carry in your pocket? We'll put it on the bar next to Sam. It might convince him he's drunk enough to go home."

That sounded like fun to Charley. It didn't take more than two minutes to form a convincing snake, but Charley thought it could use a touch of paint here and there. Pat kept Sam talking while Charley went out back, got some watercolor paint from his saddlebags and gave the snake the final touches. When Charley was satisfied, Pat placed the wax snake on the bar next to Sam, warning the boys and the bartender what was up.

It wasn't long before Sam yelped, edged away from the bar and called the bartender.

"What's eating you now?"

Sam pointed. "That damned rattler."

"What damned rattler?" The bartender said. "There ain't any snakes in here."

"You must be blind." He grabbed Pat's arm. "See that rattler. Whyn't ya shoot him!"

"What rattler? You're drunk."

Sam asked three other men if they saw the rattler but they all shook their heads, looking at him with pitiful expressions.

"I'm leavin," Sam said.

Pat bought the next round of drinks and the celebration lasted through the night. Finally Pat, Charley and four of their friends stumbled to the big attic room in the hotel which was furnished with bunk beds, a big round gaming table and plenty of chairs. They had money in their pockets, whiskey, and time to unwind before they each went their own ways.

Charley lay on his top bunk with his hat down over his face as the others played stud poker. "Come on, Charley. Try your luck," they called. But Charley said he was too tired. He lay still as though asleep and studied them. Pat was braiding a rawhide quirt while he played. It was a friendly game. Nobody really cared who won, but now and then the boys revealed little things about themselves. Charley listened, watched and wanted to save the whole scene.

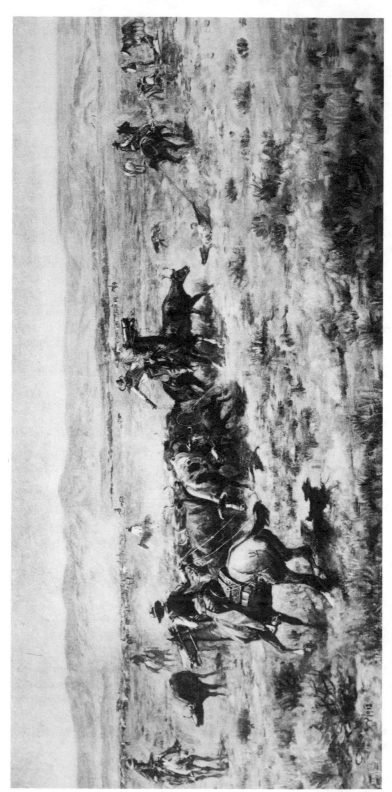

THE ROUNDUP NO. 2, Oil, 1913. Courtesy of the Montana Historical Society, Helena, MT.

In the afternoon, the attic room became too hot and smoky for comfort. Pat suggested they all go out and fish. Fresh-caught trout cooked over a campfire sounded good to the whole gang. "I'll catch up to you later," Charley said.

When they were gone, he sat at the table and sketched the scene he'd been watching. He could close his eyes and see the shape of the shadows and lines defining the men's faces, the contrast of edges, the smoke curling up. It was still alive in his mind, but he found he had to sketch it over and over to get all the proportions correct. After a half a dozen attempts, he opened his tin watercolor box and painted.

Before he was finished, Pat came back and stood across from Charley with his feet far apart, his arms folded across his chest. "That's what I thought you'd be doin'."

Charley laughed. "What do you think of it? It's still wet—can't hold it up."

Pat walked around the table, spurs jangling, and stood at Charley's elbow, looking at the painting. "I'd say it's exactly what you were lookin' at when you was layin' over there watching every move we were makin'."

"How'd you know?"

"I walked to the corner when I got my quirt. I saw your eyes under your hat. You studied every inch around that gaming table. But I still don't see how you could remember everything so dern perfect."

"I didn't," Charley said, pointing to the pile of sketches he'd discarded.

Pat looked them over, compared them to the watercolor Charley was finishing. He drew in a deep breath. "I was wrong about you," he said. "I thought you and me were a lot alike. I had my fiddle and the music that runs in my head—you had your pictures. But my music is nothing like this. I have rhythm and tunes. But what you've got in your head is a lot more complicated."

"Naw," Charley said, "the urge to put it down won't let me be. I can't think of anything else."

"And that's why you couldn't have fished with us if you tried."

"That's right. But now that it's played out, I'm ready to go."

"What I don't understand is why you want to be a cowboy if you like painting this much."

"I didn't say I liked it so much. It's in me to model and paint. What I like is the cowboy life. That's what I'd like to paint. Still lifes and portraits aren't too interesting. Landscapes seem empty. There's no action. But out on the range, the boys liked my pictures okay. Maybe I can paint for them. It's men like you and the boys, the hosses and the range I care about and want to paint. Come on, Pat. I bet if we don't hurry, we'll miss a helluva trout dinner."

The men saved a couple of beautiful rainbows for Charley and Pat. When nobody could take another bite, they put up the camp gear, rolled cigarettes and passed around the whiskey bottle. "Where're you headed?" somebody asked.

"Goin' to Kansas," a big cowboy said. "Help my brother build a house. He got burnt out."

They listened as he told about his family in Kansas. Then a lanky fellow named Tom said he was going to summer in Helena. Charley said he was heading back to the Judith Basin. "What about you, Pat?"

Pat took a long drag on his cigarette and gazed over the campfire. "I got a few things I gotta do here and there."

"What sort of things?" Tom asked. "And where?"

"Southlike," Pat said, turned away and walked toward the creek. "He ain't going to tell us," Tom said. "I bet a stack of blues it's a girl. A man don't get that crazy-eyed look unless he's taking a stupid chance."

"You might be right, but I sure hope you ain't," the man from Kansas said.

"Yeah, it'd be a rotten shame. Pat's a hell of a cowboy. The best."

"Dammit. What's the matter with guys who've been around long enough to know better? Painted ladies ought to be good enough for any cowboy. Helena's full of the finest bunch you ever saw. Why does a man want to put his head in a noose and leave the range fer good. I'll be go to hell."

Charley wondered if he'd ever see Pat again after they parted. They called it a brotherhood, but each man could lose himself forever, anytime. Charley would hate for that to happen to a good friend like Pat.

Chapter 6

Charley ate Jake's venison stew until he couldn't take another mouthful, then pushed back from the table and rolled a cigarette. He was glad to be back to the prettiest spot he'd ever seen.

During the evening though, Charley sensed a change in Jake. Not a big change. Jake was glad to see him, all right, but at times he had felt more like a visiting buddy than the kid Jake wanted to teach everything he knew.

Charley didn't pay much attention to it. He was impatient to paint scenes from the roundup using the oil paints and canvas he had saved ever since St. Louis. He started with his most vivid image, a cowboy on a bucking bronc—the lanky rider twisted at the waist as he swung his shoulders to balance himself. As he drew, Charley was transported back to the rope corral. The sun was straight overhead, casting a dark shadow on the ground under the horse. While that wild cayuse was trying to chin the moon, the rider was light in the saddle. Charley could still see the horse's muscles strain, catching the light of the sun. The scene was slower coming to life with the new oil paints. But if a line or color tone wasn't exactly right with the first brushstroke, it could be endlessly changed.

"Seems like you did all right at the roundup." Jake said.

"I could hold my own. But some of those busters can ride like flies on the wind."

"I suppose you hankerin' to get back to it?" Jake asked with a flicker of disappointment.

Charley shrugged. "Oh, I'm good enough to night-herd the hosses, but I sure ain't a bronc rider or lasso artist."

Jake nodded, inhaled his cigarette and stared off through a screen of smoke.

The next morning they took wild meat out to sell. It was Charley's favorite part of the hunter's life. Cattlemen, eager to build up their herds, didn't want to slaughter their valuable stock for food. But they were often too busy to hunt and welcomed the chance to buy a side of antelope, elk or deer that Jake had shot.

"The Edgars might like some meat about now," Jake said.

"Aw, a sheep outfit," Charley muttered. He was even more disdainful of sheep since the roundup. Calling somebody a lousy sheepherder was a cowboy's worst insult. But the Edgars were from St. Louis, people known to the family. He wouldn't let his prejudices about sheep ranchers get in the way of being neighborly.

The Edgar ranchhouse was a large log building, solid and substantial, but the elegant furnishings looked out of place to Charley. Mr. Edgar shook Charley's hand. "Oh yes, Charles and Mary's boy." He smiled warmly and invited them inside to say hello to his wife and daughter Lollie. Charley had met Lollie in St.

Louis and remembered her as a skinny girl with freckles. But when she walked into the room, shapely and graceful, wearing a blue dress, her light brown hair tied back with a blue satin ribbon, Charley froze.

"It's good to see you again, Chaz. We're giving an informal little party on Sunday. Oh, I hope you can come. Two of my friends from St. Louis are visiting for a couple of weeks. Maybe you know a nice place we could ride to for a picnic." She smiled, and her eyes sparkled while she talked. She asked about his sister Sue, and said she was awfully sorry to hear about his cousin Jim.

When they left the Edgar ranch, Charley was already looking forward to seeing Lollie again.

"Nice folks," Jake said as they headed away. Nothing else was said between them about the Edgars, but on the following Sunday, Jake didn't ask why Charley was cleaning up and putting on his best shirt. Guests crowded the Edgar parlor. Bob and Walt, a couple of neighboring ranch hands he knew stood talking to two women. Lollie took Charley's arm. "And Chaz, I want you to meet my companions, Ellen Gray, and Tillie Winters." Ellen and Tillie smiled to Charley's 'nice to know you.'

"And I take it you boys all know one another."

"Hold on, Miss Lollie," Bob said. "I knew a scruffy renegade cowboy called Charley, who might resemble this tinhorn, but I never met *Chaz* before." Bob bowed from the waist. "Honored to meet you, Chaz."

Lollie frowned prettily. "All Bob means," Charley said, "is that on the range during roundup a man don't necessarily look his best. Sometimes he loses the shine off his boots."

"That's right, Miss Lollie," Bob said. "A lot of us got wilted with the work we did out there, but nobody did a better imitation of a garbage heap after a grizzly pawed it than Charley."

Charley laughed.

"But no rawhide I ever saw could draw and paint like Charley either," Walt put in.

Heat burned Charley's cheeks and the back of his neck. Lollie turned thoughtfully to him. "I remember a picture you painted of a boy on a horse," she said.

Charley was surprised. Horses were always his favorite subjects. She must mean the picture his father had framed and hung in the front hall. It was amazing that she would remember.

"Next Sunday, Chaz, you bring some of your pictures with you. Tillie and Ellen and I do a bit of sketching ourselves."

While the maid served cake and coffee, Charley watched Lollie. Her face was flushed, her wavy brown hair glistened. She wore a western riding outfit, a yellow

blouse, brown riding skirt and fringed vest and a pair of boots with yellow flowers tooled into the leather. "Those are mighty fancy boots," he said.

She stood up. "They're for riding. I can't wait to see the mountains on horseback. Shall we go?" She called Tillie, Ellen and the others.

Outside, when Charley saw the bay Lollie intended riding, he suggested she might want to ride Monte. "He's the best prairie and hills hoss you'll ever find. He's gentle, but he has spirit."

Lollie's eyes met Charley's again. "Why, thank you."

They started off six abreast in the direction of the Little Belts. Charley knew the country well, and guided them toward a hidden valley. They left the open prairie and rode into the hills, two by two, Lollie riding in the front with Charley. She raced off ahead once, urging Monte to a gallop. Monte responded by giving her a swift ride, her brown hair swaying free. "That was great," she said, reining Monte to a walk. "But we'd better wait for the others. Lollie bent over and patted Monte's neck. "Oh, I envy you," she said, "I have to go back in the fall."

"Why? Isn't your father going to stay here and run the ranch?"

"He'll have a foreman. But even if he does stay, I'm enrolled in a college in Virginia."

He looked at her with sympathy, but she laughed. "It isn't that bad. I'll have all my summers here."

Neighboring ranchers gathered in the Edgar parlor again the following Sunday. Again refreshments and small talk preceeded the outing. When the riding party finally got underway, Charley relaxed. After a while they stopped to pick berries. Charley sat in the shade watching till Lollie walked up the hill toward him. "Well, did you bring the paintings as you promised?" she asked.

She hadn't forgotten. "Sure, they're in my saddlebags." Charley hopped to his feet to get them. They sat down together on the grass, and Charley handed her a picture of the wooded nook where they stopped last week to let the horses drink. In the painting Lollie stood among the trees.

"Oh Charley, You paint so well! I remember standing in that exact spot. But you didn't sketch the scene."

"No, but when I looked at it, I wanted to paint it and I remembered."

Lollie sighed. "When I sketch, I have to look before every stroke of the pencil."

Charley smiled. "If I concentrate, I remember pretty well." He handed her a picture of her father's ranch house, horses tied in front. And then a picture of Lollie galloping Monte, one arm raised over her head.

"It's amazing. That's exactly how I felt when I was running Monte, free as a wild thing, a bird in flight." She smiled down at the picture she held on her lap.

"Keep them to remind you of being here."

Lollie's eyes met his. Charley swallowed. "Thank you," she said." I must show them to Ellen and Tillie. How wonderful."

Charley took more care about his appearance. He bought a pair of California trousers to replace his worn buckskins. He bought new boots, bathed often and tried to keep his straw-like hair neatly brushed, though it didn't ever stay put. Two strands of the thick blonde mass inevitably fell over his forehead on either side of his part.

The next time Charley went to the Edgar house, he felt a distinct chill in the air. Mrs. Edgar asked if his father and mother were well? Then Mr. Edgar asked, "And when do you expect to go back to St. Louis and begin your life's work?"

"I expect to stay here."

Mr. Edgar's jaw tightened. "To hunt and trap?"

Charley grinned. "I might work the fall roundup."

"Cowboy jobs?"

Charley nodded. And Mr. Edgar chewed on the end of a cigar and sucked in his cheeks. "More tea, Father?" Lollie said. Her father held out his cup. She filled it. "You, Charley?"

"No thanks." Charley wanted only to move from the parlor to the riding trail. And talking about the fall roundup sent excitement through him. He had enjoyed these weeks of summer, especially the time spent with Lollie. But he wanted to make good as a cowboy. And if he could work the beef roundup, he'd have the experience he needed.

Lollie flitted about a little too busily in the parlor that day, but once they were alone on the trail, she was as friendly as ever. He noticed her staring at him once. When he caught her eye, she laughed nervously, and he wondered if she thought of him like he thought of her...no, it couldn't be.

They stopped the horses to walk by the creek. He stood next to Monte to take the reins and help her down. And as she dismounted, they were unguardedly close, gazing at each other. He wanted to kiss her. And she didn't move away, but lifted her face toward his. He hesitated only a moment before he met her soft trembling mouth with his.

Neither could speak for a moment, then she straightened herself and turned slightly away. Heart pounding, he led the horses to the bubbling creek, hearing her sigh behind him. He glanced over his shoulder and she smiled. After that everything changed. Their eyes sought each other's often. When no one was near he took her hand.

A whole week away from her seemed impossibly long. He was restless, yearning for her touch, a glance, the sound of her laughter. He couldn't keep his mind on anything—not even his painting. Jake teased him. "C'mon, quit your mooning over your St. Louis Miss and let's go hook us a trout for supper."

Charley waded into the river with his fishing rod, imagining catching a basket of trout for Lollie. After an hour though, Jake had four nice fish. Charley had none. They cleaned the four and went home.

The next morning over coffee and biscuits, Charley said he was going to try to get a roundup job. "Pat Tucker told me to talk to Hobson or True a couple of weeks before the cowboys stampeded back to town."

Jake nodded but didn't answer.

The following Sunday Charley rode up to the Edgar ranch, anxious to see Lollie and tell her about his job and ask her to write to him from college. In the parlor he talked to the guests, but Lollie wasn't in the room. He watched the doorway. Ten minutes passed and he grew restless. "Where's Lollie?" he asked Mrs. Edgar.

"She'll be along presently," Mrs. Edgar said, "and when she does come in, I hope you won't take up all her time. She must divide her attentions equally among our guests." Mrs. Edgar turned abruptly and walked away, leaving Charley wondering what was wrong.

Then Lollie strode into the room, smiling at the others, but walking straight to his side. At the sight of her, he forgot Mrs. Edgar's words completely.

"You sure look pretty," he said. "Could we go someplace and talk?"

Lollie twisted her handkerchief. "I'm afraid not," she whispered. "Mother has given me strict orders to *mix*, and scolded me for spending so much time with you. But we can go off by ourselves at the picnic."

Before he could say more, Lollie left him and talked to some of the other guests, It was only fair, he told himself. Men here didn't have much opportunity to talk to respectable women, especially a pretty unmarried girl like Lollie. Naturally she had to mix.

Later, after a ride to a grassy picnic spot they sat together on a log away from the others, Lollie looked up at him and his heartbeat raced. "What did you want to talk to me about?"

"I wanted to tell you...." He cleared his throat, and looked into her lovely face. "I love you."

Her eyes opened wide, her hand fluttered to her throat. He hadn't meant to say it like that. The words sounded awkward, but when his eyes met hers, he melted.

She didn't say anything for a minute, only looked at him with her eyes wide, twisting her hands together. "I love you, too," she whispered then, her face flushed scarlet. "I wish I could stay here. I don't want to be thousands of miles away."

He took her hand. "I'll come to St. Louis for Christmas to see you."

She looked at him with anguish. "Mama and Papa don't approve. They've warned me against seeing more of you than the others."

"Why? At first they were so friendly. What did I do to change their minds about me?"

Troubled lines crossed Lollie's forehead. "It wasn't what you did. It's what you haven't done. You want to be a cowboy. Cowboys are all right, mind you...but...."

"But they don't want you to marry one?"

Lollie sighed resignedly and nodded her head.

Charley winced. "As long as they thought I would be a part of the Parker-Russell Company, I was all right?"

Lollie shrugged her shoulders. "I'm afraid so."

"Well, I won't lie to them, but I thought I left that kind of thinking back in the states."

"Charley. I love you this way."

Her words bouyed him. "Then nothing else matters."

"I wish they knew you as I do," Lollie said. "But they've heard things. And they believe stories that just don't make sense."

Charley stiffened. "What kind of stories?"

"Stupid things."

"Like what?"

"Well, one man told Daddy you were ornery and irresponsible. I was outraged when I heard. He actually had the nerve to say Daddy shouldn't let me have anything to do with you."

Charley's heart pounded in rage. "Pike Miller, I suppose."

"Miller—yes, that was the man."

Charley gritted his teeth as he imagined Pike delivering his malicious warnings to Mr. Edgar.

"It doesn't change the way I feel," Lollie said, squeezing his hand and resting her head lightly on his shoulder.

Charley believed Lollie. Yet, if the Edgars were set against him, their future wouldn't be easy. He understood very well the pressure parents could assert. Hadn't his own parents lectured him, appealed to every finer instinct in him to come home and take up the life they planned for him? He had almost yielded when he saw his mother wipe away a tear. Lollie's parents were much sterner than his, much more insistent. Lollie had spirit, but did she care for him enough?

Confused and uncertain, he gazed at Lollie's face, and saw his own emotions reflected there. Impulsively, he drew her near and kissed her, "I'll find a way to be with you."

"I want to believe that," she said. "I'll write often."

"I'll be leaving soon for the fall roundup. I have a job as nightherder. I have to leave after I see you next Sunday."

She looked down. "So soon, Charley?" She clutched his hand. He kissed her, his fervor blinding him to everything but his love. "It won't be forever."

"No," she said, her eyes glistening. "Now tell me what you'll be doing as a nightherder."

"I meant to tell you all about it," he said. "But it slipped my mind when I saw you. I'll be riding around the beef herd at night, making sure they stay put. We'll drive the herd east to the railroad line, so cattle can be shipped to Chicago."

She frowned. "Oh, Charley, are you sure this is what you want to do?"

He smiled, gazed into her eyes and nodded.

Chapter 7

Charley rode into the roundup camp as the beef herd was starting to form. He found Pat Tucker's grin soon after.

"I see that girl didn't get a noose around your slippery neck," Charley said.

"What girl?" Pat asked. But then he winked. "Well, a man might think about it. But I shied off when I did some figurin'. Besides, the only songs she liked was hymns." He grinned. "Not for me. I'm a cowboy."

Pat took Charley to meet Frank Plunkett, another nightherder. Frank, standing six feet tall and boyishly good-looking in his fancy clothes contrasted sharply with the tough wiry Pat. Frank was a seasoned herder and Charley hoped to pick up a lot of tips from him. The three of them smoked and joked together. Frank called Pat "Tuck" and Pat called Frank the "Cowboy Prince" but that's the way it was with cowboys, Charley noticed. They were as quick to brand their fellow workers as they were to brand the calves.

As the sun set, the summery warmth of the afternoon gave way to biting cold. Charley hunkered with Frank over their last cup of coffee before mounting up and going out to relieve the day herders.

"I'm new at nightherdin' cattle," Charley admitted.

"Yeah, I know. Tuck told me. What we've got to do now is get the critters used to us. We don't want 'em spooky and ready to stampede at the strike of a match. We'll work in fairly close tonight."

Cattle spread out for miles. Charley surveyed the herd with awe as he put his saddle on Gray Eagle, mounted up and started out with Frank.

"These steers have been grazed and watered good," Frank said. "They ought to bed down real easy. Whatcha want to watch fer, Charley, are the lonesome ones that won't lie down with the others, but bed down maybe thirty yards from the rest of the herd. These fellas maybe have been gored or are shy an eye so they want to stay on the outside. You don't want to run into one in the dark. If you ride up to one singing, it won't startle him into running. He'll keep his warm ground after you pass. But if you ride quiet up to one of these loners and startle him, he's on his feet with dew-claws and hoofs rattlin', and quicker than you can bat an eye the whole herd's gone. And that can be a good piece of hell for ya, Charley."

Soon after they parted, he heard Frank singing,

"Sam Bass was born in Injiana,
It was his native home,..."

Charley headed Gray Eagle around the opposite side of the herd, singing a little Sam Bass too.

The herd grew bigger every day, and when the drive began, even Frank was impressed when they rode up on a rise and looked down at the cattle spread out for miles and miles. Most of the ranching outfits were depending on the sale of this beef to survive.

The day crew came on duty and started moving the cattle on the trail. That was Charley's signal to roll out his bedding next to his saddle and sleep. When he woke in the afternoon, he was all alone except for Frank still sleeping nearby. It was peaceful. A man could do a lot of dreaming in this vast open country. Charley sketched and struggled with the shortcomings of paper and pencil. Vast open space could swallow his intended subject. Sometimes it got lost in details, but he worked hard getting the scene exactly as he saw it—space, atmosphere, weather, everything.

Charley and Frank could catch up to the herd in an hour or two. They liked to sit around camp and talk to the day crew when they came straggling in.

One afternoon, Pat and Frank reminisced about their last night in Stanford before the roundup. "You should've been there, Charley," Pat said. "Frank and me were drinking as much as we could hold before the cattle drive. Long about sundown we heard a ruckus and poked our heads outside to see what was goin' on. A bunch of cowboys were smokin' up the town with their six shooters. Three or four of 'em ran their hosses hell bent for leather straight to Hoffman's saloon, and rode through the swingin' door, hoss and all. One hoss punched right through the plank walk in front of the place."

As Pat and Frank added detail upon detail about the incident, Charley pictured the action as vividly as if he had been there. He could feel the wild 'spreedom' that a bunch of cowboys can set loose. That night as he rode the circle around the cattle, he imagined Stanford's main street again. He could almost eat the dust the horses kicked up, smell the gunsmoke, hear the hoots and swearing, and taste the whiskey. He fashioned a wax horse, with one foreleg splintering the boardwalk in front of the saloon. The image stayed with him.

Slowly, the cowboys drove the herd onward, through the gap between the Little Belts and the Big Snowy Mountain ranges, and headed toward the Musselshell River, stopping to let the herd drink at Swimming Woman Creek.

Charley and Frank woke about midday, packed their bed rolls and rode out to catch up with the outfit. They caught sight of the herd along the stream. It was clear to them from a half a mile off that something was amiss. The cowboys bunched in one spot, yelling and galloping around. "I wonder what's wrong?" Charley said.

"Damn if I know. We may have lost a steer or two, but I wouldn't think it would cause that much commotion."

They spurred their horses and galloped to where the cowboys were standing. "What's going on?" Charley asked Pat.

Pat glanced at him grimly. "We just found the bodies of seven Crow warriors, and they was just killed."

Charley caught his breath. "Were they shot? What happened?"

"Some were shot; some took a lance. Piegans, we think, judging from the paraphernalia scattered around. It sure was some wicked battle. They took scalps."

Pat turned away, and rode back to the herd. Charley dismounted and dropped his reins. He knew he had to see it, even though his stomach rebelled.

He tramped to the boulders which must have provided some cover for the Crow warriors. The Piegans would have advanced through the willows by the stream, then snuck up from behind in the night. Charley saw the prints of many unshod horses. Indian horses, probably belonged to the Crows before the battle. He walked up a hill to where a knot of cowhands looked down from their horses. He stopped short when he saw a bronzed leg and a lifeless foot in a moccasin. The legs spread apart, the body twisted, one arm draped across the bare chest painted with bright red lines and pierced with a lance in three places. The wounds had bled profusely. The arm that crossed the front of the body was crusted in dried blood, *and the face!* Charley bit his lip hard at the sight. The warrior's eyes were open as though looking to the sun for pity. The scalp had been cruelly taken, leaving the top of the skull caked in blood. The horror of death had frozen on that face, and Charley would never forget it. He glanced away—only to see the very young body of another brave.

Charley couldn't help looking at all the bodies. One warrior had been shot in the face. When Charley saw, his stomach retched. He walked off and lay down in the grass. The image of death became the image of a fierce battle between men who killed savagely. What were they avenging? Lance to lance, all painted for war. He opened his eyes and tried to erase the picture, but it would not go away. It was too vivid, too bloody and savage.

Nelson True, Charley's boss, called the men around the chuck wagon. "We don't want a fracas with the Piegans," True said. "I don't want this operation to be a good slow target. We're going to turn away from the Musselshell and head south."

It was late when they got the cattle bedded down. As Charley rode the lonely trail around the sleeping herd, his mind, depressed by the savagery he had witnessed, turned to Lollie. He hoped she would never know of such things. He pictured her at college, studying literature and French, and tonight she seemed very distant, almost in another world. When would he hold her in his arms again as he longed to now?

He took her last letter from the pocket of his shirt, rode away from the herd, so he could strike a match to read by. He didn't need to see much; he'd read the

three pages dozens of times already. She said she missed him and thought of him every night before she went to sleep. He wondered if she was thinking of him now.

As they moved the cattle leisurely onward, it was necessary to cross through Crow territory, but since the Crow were traditionally friendly with the white man, nobody was worried. The cattle stayed fat, the weather held cool enough to be invigorating without freezing.

On a sunny afternoon Charley sketched in camp till a group of Indians rode toward them. Nelson True and Matt Price got on their horses and rode to meet them. Curious, Charley followed.

The Crow chief approached slowly, his bronzed shoulders bare, his braided hair swinging, head held high. Slowing his horse on high ground, he held up his right hand, and talked in sign. A spokesman for the Indians could speak some English and True read sign. The Crow chief held up his finger, "You pay toll to cross Crow land."

"Pay a toll?" True repeated. "But Chief, we're just crossing through the edge of your land. We want nothing but to pass through peacefully."

"You pass; you pay toll. Give Crows meat."

True mumbled to Price, then smiled at the Crow leader. "We'll give you a good fat steer. I'll send my boys to pick one out."

The Crow leaders whispered together. When the Chief turned back to face True, he held his long coup stick high in the air. "Not enough. The toll is one dollar for each cow."

True blustered. "That's outrageous! You're asking for thousands of dollars. That's too much. We will give you three steers."

The Crow Chief gestured for the braves who waited some distance off to come forward. The expression on the Chief's face hardened into a scowl. Charley didn't like the looks of the Indians mumbling to each other.

True called Price and whispered to him. "These Indians are not in a reasoning mood. What do you say we make a break for it? Drive the cattle down the river and cross it there at the ford. If we act fast, maybe we could be out of Crow territory before they can mobilize against us."

"It's dangerous, but we can't give him what he wants, and it's gotta be now—before he gets the whole camp together—or never."

"Then get those cattle moving," True said.

Charley's back stiffened. True turned back to the Chief. "Three steers is my last offer."

"Not enough. Pay one dollar each."

"I have no authority to pay that much," True said.

The Crow leaders talked among themselves, their horses prancing, their tone growing impatient. Charley wished they would accept the three steers. Already the

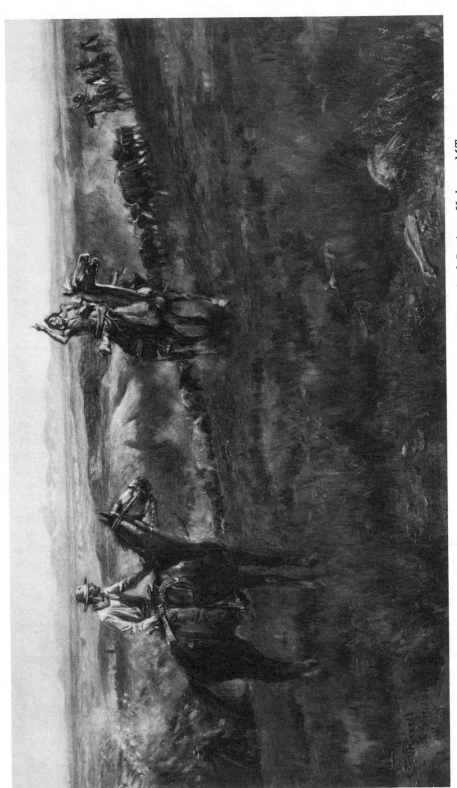

TOLL COLLECTORS, Oil, 1913. Courtesty of the Montana Historical Society, Helena, MT.

cattle were being moved to the river to cross. Charley's muscles twitched. Danger hung in the air.

All at once the Crow leader shouted to the braves to charge the herd. About a dozen Indians quirted their ponies, and yelling, raced toward the herd. "Stampede."

Charley, True and Price raced down the hill to help speed the herd across the river. The cowboys already had the cattle moving forward and were expertly herding them into the river. The Indians shouted, and tried to stampede the cattle, cracking their blankets before the animals.

The cattle moved as fast as possible, some already across the river. The snapping blankets did not upset the moving animals as it would a grazing herd, but a few steers panicked. Two Indians chased them.

Four of the Indians abandoned the cattle near the river and raced to the rear of the herd, shouting and shooting rifles in the air. Small stampedes broke out, and the cowboys raced alongside the herd heading the Indians off. The sound of the cattle thundered over the sound of the Indian shrieks and rifle reports. Charley maneuvered his horse as close to the herd as he dared, pulling his silk neckerchief up over his nose so he could breathe the dust-laden air. He could only see shadows, but he kept his section of the herd moving to the river where the brush and rough terrain should gradually slow them.

An Indian war cry rose above the din, but there was no time to think. Getting the cattle across the river was all that mattered. Charley rode into the shallow water, prodding confused steers across. The animals crossed swiftly. Dust coated his nose and throat, and running cattle shook the earth, but Charley couldn't know what was happening more than a few feet away. Dust hid everything. Steers bellowed and blew. Hoofs pounded now on both sides of the river.

Momentarily the dust cleared about ten feet away, and Charley saw an Indian with a rifle aimed toward the herd. In the next instant that brave wore a cowboy's rope around his chest, his rifle fallen to the ground—and dust billowed once again between Charley and the Indian. The cattle kept coming, and Charley kept them heading straight across the river.

Maybe a dozen head of cattle were lost in the skirmish with the Indians—near as anyone could tell. Wary and tired, the cowboys moved relentlessly on. The next morning the stampede was all but forgotten. Six more days and nights on the trail brought them to Glendive, the railroad cars and their pay.

Charley rode into town with Pat and the boys. They stopped at a hotel, took baths and shaved. Charley bunked in a room with Pat next door to Frank and Rusty.

When he was ready to go to the saloon, Charley lay back on his bunk, hands behind his head.

"What's ailin' you?" Pat asked.

"Feet hurt," Charley said. "Need new boots. But it'll wait till tomorrow. Let's get to the saloon. Frank and the boys'll be waiting."

"I need a new pair of boots, too."

"We'll get 'em tomorrow," Charley said. "Let's go meet the boys." Pat insisted they buy their new boots before they went to the saloons. Charley went along but not happily. It was all right to clean up. They needed it bad enough, but boots could wait.

Determined not to waste any more time, Charley picked out a pair of black boots, put them on, paid for them and threw his old boots in the trash heap. Pat took a long time looking at every pair he saw. Charley paced the floor.

"It's always best to buy what ya need before ya leave your money at the saloons and whorehouses," Pat said as they finally left the store.

Charley moaned with exasperation. "What're you talkin' about? We got over two hundred dollars. That oughta last a year."

"What else did ya fix to buy?"

"Hell, Pat. Who cares? The boys are all warming up with joy juice and we're still standing out in the road. C'mon."

"I'm comin'. But what else're ya going to buy?"

"Some paint, paper, and for wintering, some canvas."

"How much does it cost?"

Charley shrugged. "Maybe fifteen dollars."

"Fifteen for paint and stuff. All right. Gimme thirty dollars."

Charley wished he had gone off with Frank instead of waiting for Pat. But Pat was grinning, and holding his hand out. What the hell, Charley thought and handed Pat the thirty dollars. "Let's go."

A few minutes later Charley and Pat gulped a swallow of whiskey in a crowded saloon. The whiskey quickly erased Charley's irritation. Friends were never friendlier. Then they fell to discussing what they would do if they were stopped again by the Indians and asked to pay a toll.

"It's a safe bet I'd pay it," Charley said. Hardly anybody agreed, but Pat did.

"I got to know the Crows pretty well. They were only askin' for meat to replace the buffalo the white man killed."

Some of the men grumbled, but Charley leaned his back against the bar. "How did you get to know the Crows so well, Pat?"

"Yeah," Frank said. "Most cowboys know enough to trade with them, but no more."

"Well, I was trailin' up from Wyoming headin' for spring roundup," Pat said, a solemn look suddenly clouding his eyes. "It was a cold day in March. I stopped when I heard a terrible racket. I climbed down off my hoss to see what was going on. I peeked from behind a boulder, but I couldn't believe what I was seeing.

Indians in hand-to-hand battle so fierce and with such wild cries, I just stood with my mouth open.

"Piegan and Crow making bullets, arrows and tomahawks fly. Soon though, the Piegans rode away, the victors. That's when I rushed to help any of the wounded I could. The battle had been fought in a small circle. The snow was trampled hard on the frozen ground and steam was blowing off the pools of blood still gathering from the bodies. One warrior had a head wound but was still alive. I staunched the flow of blood, bound up his wounds and cared for him. When he was able to travel I took him to his camp. And the Crows have treated me as a brother ever since. They told me how their lives have changed since the white man."

As Pat talked, they finished one bottle of whiskey and bought another. When that was gone, Pat wanted to eat and look up some women.

Charley thought of Lollie so far away, and he wished he could see her. But for now he'd go along with the boys. A steak dinner, more whiskey and he'd forget all about how lonesome he was for Lollie.

A few days later, Charley woke up with a tongue as fuzzy as a caterpillar. Sore-eyed and weak-limbed, he sat down on his bed. Gloom came over him as he thought how long it had been since he had written to Lollie. And he hadn't even bought her a present yet. That's what he'd do today. He was fumbling in his pockets when Pat opened his eyes. "Whatcha doin'?"

"Looking for my money. I'm going to buy my girl a present."

Pat watched Charley with one eye opened. "Are you findin' any?"

"Not yet."

"It don't take long to burn up a bankroll in this burg."

Charley looked at the coins on the table, glanced at Pat and realized the truth. He had spent everything. "I guess it's time to saddle up and ride."

That afternoon, Charley packed his gear on Gray Eagle and saddled Monte. Pat, Bill, Rusty and Frank loaded up, too. "Come on and winter with us," Pat said. "We'll get a little shack, pool our grub money, fill in with wild meat and be ready to ride out to roundup in the spring. What do ya say?"

Charley sure wanted to go with them. The good times they had together were the best he ever had. But he was thinking of Lollie. He wanted to see her more than anything, and hoped he could earn enough money working with Jake to go back to St. Louis for Christmas. "I got other plans," he said.

Then Pat took off his hat and reached inside the lining. "Here's your grubstake," he said, handing Charley the thirty dollars he had given Pat to hold.

Charley knew it wasn't a gift, but it might as well have been. He figured he had retrieved it from Pat and spent it. "Paint lots of pictures," Pat said. "But don't let Jake or that girl you write letters to pin you down and domesticate you. You're one of the wild ones like us, eh boys?"

"Yeah," Frank said, "one of the wildest."

"Wish you was throwin' in with us," Bill said. "Won't be the same bunch without you."

Charley was mightily tempted. He was sure going to miss their free-wheeling spirit, the pranks, the laughs. But if he went with them, he'd never earn enough money to go see Lollie. No, he'd be better off working with Jake. He smiled. "See you at the roundup."

He turned Monte toward the Little Belts, and Jake's cabin. A few days later, he shoved open the door with his usual hello. Jake was sitting at the table, leaning forward, his elbows propped on the tabletop, his cheeks resting in the palms of his hands. He jumped up when he saw who it was. "What d'ya know! You're just in time to eat."

"Why were you starin' at the wall?"

"*You* should ask? You was mooning like a coon dog last summer over that little St. Louis gal."

"You mean you have a *gal*?"

"No. I jest admire one—a fine lady. That feller Gray's sister Carrie. I wrote her a poem this afternoon—but she thinks I'm the devil himself and maybe she's right." He shook his head and turned to the cupboard. "A good woman is fine to think about," he said, "but 'tain't going to take the place of meat and biscuits. Split a couple logs, would ya, Charley?"

At supper Charley brought the subject back to good women. "I've been thinking I might go back to St. Louis for Christmas."

Jake glanced up. Charley recognized the lonesome look in his eyes. So, even Jake wanted to settle down. Goes to show a man was meant to have a woman. This territory, so full of men, wasn't the natural world. But a man could live here—on a ranch—and have a woman, and everything would be complete. People were settling. "Is it much trouble to homestead some land?"

Jake laughed. "Naw, 'tain't, but you hafta stay on the land and build a place to live in. I'm gonna homestead this place. Might get me a few head of cattle."

Charley looked at the log walls. "Maybe I could build a cabin and raise cattle. Mr. Edgar oughta like that, being a rancher himself."

"Oh, I heard the Edgars were back on the ranch again."

Charley's heartbeat caught. Maybe Lollie would come to Montana for the holidays. "I guess I'll call on them."

The following Sunday, Charley scrubbed, put on his best clothes and went to the Edgar ranch at their usual hospitality hours. The maid served tea. The Edgars greeted him stiffly, but Charley smiled. "It's nice to see you wintering here. Does this mean that Lollie will be joining you for Christmas?"

Mr. Edgar bristled. "It means no such thing." He thrust his cigar into his mouth, and stared ahead.

Charley wanted to ask more about Lollie, but the Edgars turned back to the other guests. Finally, Mrs. Belden introduced herself. "I heard you were a painter," she said. He nodded and she said she had studied art. "Maybe you would show me your work some time," she said.

"Sure. How long are you going to be visiting?"

Mrs. Bellen glanced at her husband. "We hope to stay right here."

"Do you mean you're going to homestead around here?"

"We're going to buy this ranch from the Edgars."

Charley swallowed. If the Edgars sold the ranch, Lollie would never come back. And next summer with Lollie wouldn't happen. Were they selling out because they didn't want Lollie keeping company with cowboys like him?

He rose to leave. Just then Mrs. Edgar's white-haired uncle stopped him. "Sit down, boy," he said. "I've been watching you. And I must say, from all I heard, I expected something much worse—a shiftless cowboy, to be exact. But I see now why Lollie likes you."

"Thanks, but I never knew a *shiftless* cowboy."

The old man smiled. "I like you. When I see Lollie over the holidays, I'm going to tell her."

"You're going to see her? In St. Louis?"

The old man frowned. "Not in St. Louis. At my home. As long as Lollie is east to college, her mother wanted her to see the area during her Christmas vacation."

Charley knew Lollie would have no voice in the matter. It was settled. They were making sure she didn't see him. Well, it was too late. He and Lollie already knew how they felt about each other.

"You look disappointed."

"But her folks are selling the ranch, and even keeping her from St. Louis. What can I do?"

"Be patient. Her parents have plans for her."

"I do too," Charley shot back. "I'll homestead. I'll be able to take care of her." Words rushed forth, and with them came a stubborn determination. "When you see Lollie, will you tell her I miss her? I'd have written more, but on the cattle trail, there aren't many post offices."

"Sure son, I'll talk to her."

That night Charley lay awake, thinking of Lollie. He imagined smoothing his fingers over the soft brown ringlets on her forehead just before he crushed her in his arms. Someday...they'd be together. In the middle of the night he decided he'd get started on his dream. He'd build a cabin—one log on top of another in a square. What could be simpler? Chink in between the logs. Cut out for a door. Put a sod roof on it, and move in. He couldn't just stay on with Jake forever.

The next day he rode out to find a site to homestead. It had to have trees close by that he could chop for logs. It had to be close to water. Everywhere Charley looked, he imagined a cozy cabin with smoke curling up. He chose a grassy site in the Pagel Gulch and couldn't wait to get started.

After his first day's work, he rode back to Jake's cabin, hungry and tired, but eager to warm up by the fire and have a talk about cabin building. First though, he wanted to get his mouth around one of Jake's sourdough biscuits. But when he got to the cabin, it was dark, and no smoke came from the chimney.

He lit the lamp and found a note on the table. Charley held it close to the lamp. *Gone hunting with Dutch and Joe. Be back in a week or so. Jake.*

Charley fixed a meal and stayed the night. Early the next morning he rode back to his cabin site. He had bragged in the saloon what a simple job cabin-building was—so he couldn't ask for help.

Rather than ride all the way to Jake's place at night and back every morning, he took supper at the nearest ranch—for a cowboy was always welcomed at the table. And he slept in the livery stable in Utica. As he worked on the cabin, his enthusiasm dribbled away. After four backbreaking days, he knew his pile of logs was never going to be the beautiful cabin he'd imagined, but he'd get a terrible razzing if he quit. *It doesn't have to be perfect to be a homestead,* he reminded himself. And he was doing it for Lollie, so someday they could get married.

Babcock and some cronies came out to see how he was doing every day. Charley looked forward to the visit, though the men didn't do much but shake their heads and pass a bottle of whiskey around. One cold afternoon, Charley stopped chopping to blow warm breath on his fingers, when he looked up and saw the usual half dozen riders plus Joe Cutting's wagon. Milly Ringgold was sitting next to Joe. Milly was a tough pioneering black woman who had a couple of mines up at Yogo. She worked at ranches when she wasn't working her mines. She loved oranges; ate them whole with the skins still on. Some day she hoped to strike it rich, and buy an orange grove in California.

Jim Shelton opened a bottle of whiskey, and they all looked around. "Hurray, it's head high."

"You're almost ready to put a roof on it," someone said.

Milly had the only serious face in the crowd. "Ain't you gonna have no fireplace?" she asked.

Charley hadn't left a space for it. "I'll have an Indian fireplace. A few stones in a circle is all I need."

Milly led the parade around the cabin, her expression grim. "Lord Almighty didn't make logs that crooked, did he?"

Charley heaved a sigh. "What's wrong with wavy logs? You won't even notice once I get it all chinked tight."

Milly shook her her head and put her hands on her broad hips. "Po' chile, You ain't got a window."

"Don't need it."

Milly muttered. "This cabin is plum sorry so far."

"Wait till you see it with a roof," Charley said.

"And a door?" Milly asked. "You goin' to put a door on it?"

Charley winced. He'd have to go back and look at Jake's door again. And he'd have to hurry if he was going to dig sod for the roof before the ground was solidly frozen.

"I've never seen a cabin as sorry as this," Milly said. "You oughta wait till next summer and get yourself some men to help."

"What about old Jeb's pig house?" Bab said. "It was as sorry."

Milly laughed. "But it wasn't as lopsided."

Bab said he thought Jeb's pig house was every bit as lopsided, and they took a vote. Charley's cabin was voted the most lopsided and they passed around the whiskey bottle.

The next day was warmer, and Charley, sick of chopping trees and stacking up logs, covered the top of the cabin with brush, cut sod and laid it on top of the brush. He had bought a bucket of clay down from the mountains, planning to use it for chinking, but he absently picked up a handful, carried it inside, and modeled a buffalo. Even if his cabin had definite flaws, nobody else in the basin could model a better buffalo. Tired of sitting, he went out and walked around the cabin. It was sorry. But it was *his* and deserved a name. He set his clay buffalo on a log and rubbed his fingers clean of clay. Putting the ball of excess clay down by the buffalo, a name for the cabin came to him. He carved it on a log above the door. THE BUFFALO CHIP. He formed a clay one to hang below the name.

When Bab and the boys came that day they unanimously approved the name and toasted it. Charley brought them inside and built the first fire. It smoked badly but there were enough spaces between the logs and the squares of sod on the roof to let the smoke escape. Charley told the bunch he was moved in and going to sleep there.

And the boys who had bet nobody would ever live in it paid their bets.

Chapter 8

Drafts wailed through the Buffalo Chip and whipped around Charley's head all night long. He couldn't tell when morning came, his cabin was so dark and cold. Still, Charley prided himself on his independence. Opening the door for light, he painted three pictures the first two days there. The food wasn't so good, and he didn't have much for comfort other than the knowledge that he was in his own place. That wore off fast. After three days, he rode out to see if Jake could use some help.

Jake yelled at him for leaving a dirty pan. Charley said he was sorry, but it didn't placate Jake, so he asked about the hunting trip with Dutch and Joe, and figured from Jake's silence it hadn't been perfect.

"I built a little cabin while you were gone," Charley said.

"I heard about it."

"It ain't much."

"Buildin' ain't easy," Jake said. "You can stay here any time." Charley smiled, and chopped a pile of wood.

Finally, they ate. Charley filled up. "I forgot to make a fireplace."

Jake laughed. "I heard about it." Charley guessed his shack was the biggest laugh for miles around and he remembered what his aunt had said *you're not equipped*. It was true.

He stayed and helped Jake with the traps, skinned a deer, loaded the meat on the pack horses, and traveled a ways with Jake. Then he went back to his homestead. He wrote Lollie, telling her of his plans to be a rancher some day and ending with how he missed her.

Could he really live in such a dark and uncomfortable place? He wished he had a window and a fireplace. He felt like a caged animal, lonely and too restless even to paint, so he saddled Monte and rode to the saloon. About halfway there, he saw a rider coming toward him, a familiar silhouette. He squinted, then let out a yelp and spurred Monte.

"Hey, if you ain't a sight, Pat. What brings you?"

"I thought I'd see how you was winterin', and get you to hunt with me. The folks at the saloon told me where to find ya."

Pat had a bottle of whiskey, so they headed back to the cabin.

"I heard about this cabin," Pat said with a wink. "It ain't so bad."

"It don't keep the snow out so good, and when spring comes, it's going to leak like a sieve."

"Waal, you're a cowboy not a damned homesteader. The free life, Charley. Don't forget why you came West to begin with." Pat pulled up a log seat, and brought out the makings of a cigarette. "I collected enough bounty from the wolves I shot to outfit us for a hunting trip. How about showing me what good hunting there is up in the Little Belts."

"You bet I will," Charley said. "Trouble is I'm broke. Damn, I shouldn't be. Just last week I had a commission to paint John Duffield on his best horse in front of his ranch." Charley laughed at the recollection. "You shoulda been there."

"Why's that, Charley?"

Charley grinned. "Jest to warm up my painting hand, I painted him out behind the barn doing his daily dozen. I showed it to John as though it was my best, and you shoulda seen his face fall. Well, a joke is a joke and money's money. So after a laugh, I promised to bury the squatter, and in twenty minutes, John was posing on his Sunday hoss and the fellow behind the barn was covered with paint."

Pat laughed. "He could've drove you off the ranch."

"Naw, he couldn't stay mean long enough to do it. I got paid enough to settle my bill for groceries and have a drink or two and now I'm broke."

"We'll do a little wolfing," Pat said.

Expecting the weather would stay cold, Charley wore two sets of heavy underwear, two shirts, pants and chaps, two pairs of socks, heavy gloves, a woolen cap, and a black mackinaw—in other words, everything he owned.

It felt good to be back on the trail, especially with a good friend. Pat's canvas tipi was easy to put up, and a man could stretch his arms above him when standing in the center, something Charley couldn't do in his cabin. "Injuns really know how to live," Pat said. "A man can learn a lot from them if he takes the trouble."

"I'd sure like to spend some time with them," Charley said.

The next day the sun was bright and by midday they were warm from the exertion of stalking through the mountains. Charley shed his mackinaw and draped it over a dead tree to dry. Then they hunted again, each following a different path.

Charley's mind wandered from the hunt quickly. He memorized the scenes before him, noting the exact color of the sky, its shading from horizon to zenith, the subtle colors in the rocky cliffs, shapes of shadows, all those details that added up to what the land really was. Walking back toward camp, he painted a picture in his mind, but looked up, shocked at the sight of a big bear. Shaken, he readied his rifle, taking careful aim; it would be dangerous to miss. He shot, but the bear didn't fall. He shot again. The animal should have dropped, or at least be wailing loud enough to scare the pants off anything for fifty miles around.

"Great sport, Charley." Pat came from behind a clump of trees by the creek, carrying the coffee pot. "That damned stump didn't have a chance with you around."

"Stump?" Charley squinted, seeing a bear clearly, leaning over on one leg.

"And your mackinaw is going to be well ventilated now."

"You don't mean...? I coulda swore it was a bear." Charley shook his head. "Did you get anything?"

"Yep, a nice buck. And, I got the first shot at the dern mackinaw."

"You...." They laughed. And every so often during the evening they laughed again.

On the way down the mountain, they saw three wolves stalking a doe. Pat raised his rifle, but Charley tapped his shooting arm and shook his head. "Let's watch." Studying animals in their natural surroundings was the only way he could paint them well. He watched the nervous movements of the doe, the stealth and teamwork of the wolves. The wolves spread out and circled her. She moved toward the woods, but the wolves closed in, growling. Fear showed in the doe's eyes as the wolves closed the circle tighter.

Charley dropped to his knees, shot twice. When the smoke rolled away, two gray wolves lay dead. Pat got the third one.

Two days later, standing at the bar in Utica, Pat told the stump bear story while Charley modeled a bear in wax. Then he got the urge to paint. "What d'ya have I can paint on?" Charley asked the bartender.

The bartender looked exasperated. "Dammit, Charley, why do you ask *me*? All I ever get around here is an empty beer keg."

"Well, let me have it, will you?"

The bartender rolled an empty beer keg down to the end of the bar. Charley took it to the corner of the saloon, sat down, and, holding the beer keg between his knees, painted on the ends. Folks around Utica were used to seeing him painting on just about anything. Some of the men looked over his shoulder, kidding and offering advice. Charley had painted three wolves circling the doe on one end of the keg and a picture of an Indian girl wrapped in a blanket on the other.

They stayed in Utica for a couple of days. Charley wrote Lollie a long letter, illustrating it with miniature paintings of mountain scenery, the growing town of Utica, and a picture of a lonesome cowboy thinking of her. He closed saying he loved her and hoped they would be together soon. He meant every word he wrote, but then he thought of what marriage would mean and he froze. It meant he'd have to earn enough money to support her, which meant his cowboy days would be over. He thought of Lollie's face, her soft body, of holding her in his arms. And when his fantasy faded away, he remembered being on the range with friends, riding free, joking and working. Trouble was, he wanted Lollie and cowboy life. And he knew it was impossible to have both.

The next morning sunlight glimmered on the snow-capped mountains in the distance; the cold, clear air beckoned them. Pat drank the last of his coffee and grinned at Charley. "Come on back to the shack," Pat said. "You may as well finish

the winter with me and the boys. We'll hunt along the way, pick up bounty on wolves and keep ourselves mighty comfortable till spring."

Charley thought of being alone in his miserable cabin, then imagined the good times he could have with his cowboy friends. "Let's go."

They headed north, planning to camp a while when they reached the Missouri River. They traveled at a leisurely pace, at night they were snug and cozy in Pat's tipi.

One afternoon, the cold turned bitter and a strong wind came up. They were chilled to bone marrow, and getting warm was their only goal. They carried armloads of wood inside the tipi, and soon had a fire started. They melted snow for making coffee, and while they waited for it to boil, they drank some whiskey and soon felt the thaw from inside.

"Whiskey sure picks a man up," Pat said, "but nothin's better than a red hot fire on a night like this."

"Right. And if it's going to last, we'll have to go out and get some more wood."

"I'll go first," Pat said. "You stay and watch the fire."

"Don't be gone too long." Charley laughed, knowing Pat would be back in ten minutes in that icy wind. They were sure to get a dandy blizzard tonight.

Pat returned with an armload of wood and some news. "Piegans are camped down river from us a couple of hundred yards. Judging from their horses' tracks, they just got camped. Hope they're in a neighborly mood."

"I'll go get some wood now," Charley said.

The wind had grown stronger and he was chilled through after only a few minutes. But he wanted to see the Indian encampment. Collecting wood on his way down river, he came up on a rise, and looking down, he saw a small cluster of tipis.

Back at camp, the coffee had boiled. Charley held his hands near the fire. "Sounds like that wind is getting stronger," Pat said. "It's a good thing we staked the tipi down solid."

Supper was steak, beans and plenty of coffee. Later, they sat cross-legged close to the fire and smoked. They were comfortable though the wind roared. Charley went out to check on the horses in a draw among some trees before he settled for the night.

They put their bed rolls close to the fire and every so often got up and put more wood on it. "It ain't cold in here now, is it?" Pat said, moving away from the fire.

"It's so hot now," Charley said, "I gotta take off the top layer of clothes." He pulled off his shirt. "Think I'll let my socks air out, too."

"Throw 'em clear over by the door flap. Guess I'll shed some stuff, too," Pat said. "This is as big a fire as I've ever had in here."

"We'd better let it go back a little."

"Yeah, when it burns down some, just put one skinny log on it."

Burning logs popped and crackled as they closed their eyes. The wind whistled, and sleep came.

Some time later, Charley coughed in his sleep. He opened his eyes to check the fire, blinking when he saw flames licking up the wall of the tipi. He sat up. "Pat!" He yelled. "We're on fire. Get up!"

Charley got to his feet and roused Pat. "Kee rist!" Pat bellowed. "Let's get out of here."

Fire swiftly consumed the canvas tipi. Even the door flap was afire as they rushed through it. They stood, dressed only in their underwear, staring dazedly at the collapsing tipi.

"Run," Pat said. "To the Indians."

Barefooted, Charley ran, following Pat toward the Indian encampment. They couldn't live in this bitter cold very long. The Indians were their only hope. But how were the Piegans going to like white men intruding into their camp in the middle of the night?

Huffing, they stopped running when they reached the lodges. The howling of the Indians' dogs awakened the camp. "Don't shoot!" Charley yelled. "Down!" Pat shouted at the dogs, yowling and yipping at their heels.

An Indian carrying a rifle came out of the nearest tipi. Charley held up his hand in the sign of friendship. "Don't shoot. Our tipi burned down," Charley said, making the sign for fire and tipi.

Other Indians came running. One of them pointed to Charley's bare feet. Charley nodded and pointed in the direction of the burnt-out camp. Pat explained, using English, Blackfoot tongue, and sign language. Finally, one of the Indians signaled them to follow.

They were taken into the tipi and given blankets. Two sleepy women and a young boy sat at a distance, watching and listening. The Indian lit a pipe and offered it. "Round Eyes listen. You talk."

Charley took the pipe with thanks, feeling relief that Round Eyes spoke some English. Together, Charley and Pat told in more detail what happened. The Indian laughed. "White man builds big fire; sits far away. Indian builds small fire; sits close."

Soon they were all laughing. Round Eyes gave them a place to sleep. Charley closed his eyes, wondering how many white men would do the same for Round Eyes.

The smell of smoke, tanned hides, tobacco and the lingering odor of cooked meat surrounded them. The next morning Round Eyes' woman gave them moccasins. Charley and Pat promised to pay them, but the women shook their heads. With moccasins to cover their feet and blankets to wrap around their bodies, Charley, Pat, Round Eyes and two other Indians went to the burnt-out camp to see what was left.

Everything that had been inside was ashes. Luckily, their saddles and the wolf hides had been stowed outside by a tree, and were unharmed. Their money had been blackened, but silver was silver, black or not, and Charley and Pat immediately gave Round Eyes the price of the blankets and moccasins as well as most of their meat.

They took all that was salvagable and went back to the Indian encampment. The gift of antelope and bear meat was a prize to be shared by everyone in camp. They would feast that night.

After two days Charley and Pat left the Indians and headed directly toward the shack Pat shared with his friends.

The first thing Charley did when they got to the shack was to send for some wax and painting supplies at Fort Benton. Pat knew a stage driver who was willing to buy the things and drop them off at the nearest stage station on his next trip. In the meantime Charley got paper and a pencil and drew all afternoon.

As soon as the stagecoach driver brought his supplies from Benton, Charley painted a scene he remembered at the Indian encampment. As he concentrated on bringing his memory alive, he could feel the chill surround him, see the painted tipi in the middleground, dog tracks and moccasin prints in the snow and smell the smoke from the tipi fires.

Late that evening, as the others were playing poker, Charley sat cross-legged on his bed roll and wrote Lollie a letter. Thoughts of her persisted tantalizingly at the edge of his mind. He wondered if she still clung to those days they spent together, talking, riding and promising things. He illustrated his letter with watercolor paintings he hoped would remind her of those times, and closed, swearing his devotion.

The more he thought of Lollie, the more melancholy he grew. Her folks had good reason not to like him. He had no sense about money. He didn't want to be burdened with it. He couldn't even build a simple cabin. How would he build up a cattle ranch? Oh, but he wanted Lollie.

Brooding silences and long faces weren't allowed in the shack. Charley was yelled at to come join the game, to settle an argument, to make some coffee or open another bottle of booze. "Tell Soapy that story about Jake running into a grizzly bear in his cabin one night." Charley obliged and all his pals listened and laughed. "Nobody can tell 'em like you, Charley," Frank said.

They were all from different parts of the country, but they could have been brothers for the sameness about them. If one had money, they all ate and drank well.

One day when both cash and food were short, Pat suggested they take Bunky to Fort Benton and race him. Pat's horse Bunky was the fastest in the West, according to Pat.

As Pat had hoped, a group of Indians waited on the edge of town for someone to race against their horse. Pat took the bait. "Bunky will leave that Injun's nag in the dirt."

"I hope so" Frank said, "but all the same, some of us ought to go out and take another look at that Appoloosa pony. It's a cinch it's won a few races or they wouldn't be there with it."

"Appaloosas can run like the wind," Soapy agreed.

Pat had no doubts about Bunky, and was ready to bet their entire assets: five wolf hides and fifteen beaver pelts.

"While you're turnin' the skins to cash, Frank and me will look over the hoss," Soapy said. "We'll tell the Indian jockey to get him ready for Saturday."

Pat nodded. "Bill, you and Rusty go to a couple of saloons and talk up the race, tell everybody we're taking bets."

Charley and Pat started out with the hides. Then Pat paused. "Remember that picture you painted yesterday? The one with the three men riding into a gorge. Have you still got it?"

"It's in my saddlebag."

"Let me have it, Charley. If I could peddle it, we could add the money to our wager."

Charley gave Pat the painting and went off with the hides. When he met Pat later at the livery stable, Pat told him the painting brought in $15. "Fifteen dollars? You're joshin'." Charley said.

"Eastern traders want souvenirs of the West to take home," Pat said.

Maybe so, Charley thought, but to find that Easterner so fast seemed a miracle. He couldn't expect to do it again. Still, if he were to work harder and paint better, maybe he could sell pictures, and not have to hunt in the winter. In his imagination he pictured himself painting huge canvases that people flocked to buy. Could he...? Naw. He painted for his cowboy friends and himself.

On the morning of the race, the Indian rider looked confident. The sight of Pat and Bunky didn't faze him. The Indians were betting heavily on their horse. And Frank lured the dance hall girls and gamblers telling them Bunky was a lightning bolt.

"That Appaloosa has beat every hoss he's raced," a tall gambler shouted. "I'm betting on the Appaloosa." Most of the women bet on the Indian horse, too.

The Appaloosa was favored big to win, but the boys from the shack bet every nickel they could scrape together on Bunky. They would either win or be dead broke.

Before the race, Indian women painted red streaks across the Indian rider's chest and forehead. Seconds before the starting gun was to be fired, he stripped to breechclout and moccasins. Charley worried. All the gamblers, Indians and dance hall girls were betting on the Appaloosa. It was a strong-looking horse, agile and

fit. Pat would be devastated if Bunky lost. He believed that as long as he had Bunky, he would never have to worry about a thing.

Bunky was smaller than the Appaloosa, but Pat was a top notch cowboy, lightweight, and tough. Charley had a drink from Sam Pippin's bottle. Sam sat next to Charley and, out of loyalty, bet on Bunky.

"That Indian boy sure looks like a winner though, don't he?" Sam said as the starting shot was fired. The Indian rider leaned forward on his horse, riding as if he were born there, and taking the lead at once. The dance-hall girls squealed and cheered. Pat and Bunky trailed the Indian but not by much, and they didn't let the Indian increase his lead. Then as the horses galloped away from the crowd, Charley noticed the Indian crowding Pat, forcing Bunky over and gaining a few feet with the maneuver. Then Pat lay forward and spurred Bunky. Bunky's legs stretched and blurred drawing him up close to the Appaloosa. It seemed as though Bunky gained speed, closing in on the Appaloosa. For a time it was hard to see which horse was ahead. "They're both bustin' a hole in the breeze," Soapy muttered. Everyone cheered. Charley held his breath. Now Bunky broke out, holding the lead, passing the finish line the clear winner.

Charley, Frank, Soapy, Bill and Rusty, hollered and threw their hats in the air. Then while the others counted their winnings, Charley took out his watercolors and painted a picture of the race while it was still fresh in his mind. He wanted to capture the speed, the fierce competition, the magnificence of the two horses. Sam Pippin stood behind him, watching, commenting. "The Indian's hair was flying straight out behind. And the hosses kicked up more dust. Yaa, just like that."

Sam asked if he could have the painting. "Sure," Charley said, and handed Sam the picture. Sam slipped $10 into Charley's pocket.

At the saloon the boys bought the dancehall girls drinks so they wouldn't feel so bad about losing. They drank to Bunky and called him the greatest horse in the world. The celebration lasted for two days and two nights. Then it was back to the shack to rest up for the roundup. Charley and Pat landed an early job, rounding up wild broncs.

One morning just after Charley read a letter from Lollie, he looked across the horizon to the east and the yearning he felt was unbearable. He decided that when this roundup was over, he was going straight to St. Louis to ask Lollie to marry him. He did hate to lose the free life, but it lacked one thing he wanted—Lollie. For her he'd build a real ranch on his homestead and raise horses and cattle. All he needed now was to hear her say yes.

Chapter 9

Charley and Pat signed on with Horace Brewster's roundup outfit. Pat was a top notch cowboy, while Charley was only fair, but the men liked him, and he so quickly memorized the 28 cattle brands that had to be identified on the range, he was elected, along with Pat, as the outfit's representatives. That meant they'd be paid $10 a month more than regular cowboys. They traveled light. Charley carried his beeswax, watercolors, and sketch books, some small enough to fit in his breast pocket. Pat carried a fiddle in a skin case wrapped in his slicker and tied behind the cantle of his saddle.

Action and camaraderie of the roundup ran high. Charley felt lucky to be there no matter how long or stormy or hot the days became. There were more cattle that year than ever. And the roundup lasted weeks longer than usual. As the days dragged into the heat of summer, tension built. The men wanted to go to town.

Finally, the men were paid off in Fort Benton, and an air of celebration exploded on the town. Charley, Pat and Frank picked a saloon that looked rollicky, and Charley was the first to buy his friends a drink. It wasn't long before the noise in the saloon became a din. Later they went to the dance hall.

When he was sober, Charley knew he danced about as well as a lame buffalo, but on that night amidst the whiskey and good times, he figured he ought to be able to hop around as well as Pat and Frank. And just as he thought he'd give it a try, a pretty dark-eyed girl with thick black hair asked if he wanted to dance with her. He took another gulp of whiskey and followed her to the dance floor. She clicked her heels and hummed. Charley put his hand on her waist, bent forward and pushed.

"Oh my goodness," she gasped. Her eyes opened wide with a horrified look, but she stayed with him, and he stood back far enough so he didn't stomp on her feet. After the music stopped, Frank and Pat showed up.

"These girls don't do anything but dance," Frank complained. "Let's go find a parlor house."

"Maybe later," Charley said.

"What's wrong with now?" Pat asked, finishing his whiskey.

Charley left the dance hall with them, but the dark-haired girl had only reminded him of Lollie. The excitement of holding a woman's waist and chasing her around the dance floor drained away with the fading of the music. He walked down the street with Pat and Frank, but stopped at their hotel. "I'll see you later," he said. He sauntered back to his room and lay thinking about Lollie. She

mentioned in her last letter that maybe she would come to the ranch to visit the Beldens. If she did, he'd see her in a few days.

The next day Charley and Pat stood on the boardwalk out in front of the hotel, rolling a smoke and watching people gather for the Fourth of July parade. The day was sunny but cool, perfect for a celebration. Cowboys drank beer and shouted at the calico queens parading down the street.

The military band from Fort Assinaboin blared and drummed. People cheered. The band played the Gary Owens March. Then came the Northwest Mounted Police in their red coats with shiny gold buttons and glistening gun belts.

After the parade Charley and Pat ambled toward the river and soon heard the sound of distant tom toms. "It's coming from that way," Pat said. "How does an Indian dance sound to ya?"

The drumming beckoned Charley. "Let's go."

They found a band of Northern Piegans camped a mile upriver. Charley and Pat struck up a conversation with a couple of braves. "Do you know Round Eyes?" Charley asked. The Indians said they did. So Pat and Charley explained their friendship with him, and they were taken to Chief Black Eagle.

Struck with the regal stature of the chief, his quick dark eyes, his natural dignity, Charley preserved the image in his mind until dawn the next morning when he painted the chief's portrait. As he was finishing it, he asked Pat's opinion. "Can you see the likeness?"

"Easy. Let's show it to him."

Black Eagle took the paper and examined the picture solemnly then his darting eyes caught Charley's. "Picture Maker has seen the face he looked at, but not the necklace." He handed the painting back with a negative shake of his head. "My necklace has eleven porcupine quills. Here there are only nine."

Charley compared the necklace with his painting, painted two more porcupine quills, and handed it back to Black Eagle.

The chief smiled widely then and called his wife and his friend to look, clapped Charley's back and called him brother.

"Let's get together in Coulson," Pat said the next day as Charley packed up for the ride back to Utica. Pat had taken a job wrangling horses that would end in Coulson in a few weeks.

"Can't. I'm going to see Lollie."

Pat looked disappointed. "If you hafta, you hafta. But afterwards, we could go to the Crow camp and see Chief Plenty Coups. It'll be great. We'll have us a big time."

"I don't know. I'll write you at General Delivery in Coulson." Charley said.

He was three days riding to Utica and thinking of Lollie. It had been a long time since he had heard from her, and too long since he had seen her. What if she

had changed? No, he couldn't believe she would. Not Lollie. He asked for his mail at Utica's general store, but there was no letter from Lollie.

He spent the night in Jake's cabin, talking until Jake began to snore. In the morning he rode over to the Edgar place—now the Belden place. He tried not to let himself hope that Lollie would be there. But the sight of the ranch house brought a stab of recollections.

Ettie Belden sat in her garden sketching the mountain scenery. Charley dismounted and walked toward her, spurs jangling.

Ettie was a hearty woman, tall, strong and pleasant. "I was wondering if you had heard anything from Lollie?" he asked.

"Oh, she wrote about a month ago, said she'd love to see the ranch again, but her mother wasn't well. So she'd be staying in St. Louis."

"Oh," Charley said, turning to go.

"Would you care to paint with me?" Ettie asked. "I'd love to see your version of this scene."

Charley shrugged. He couldn't leave for St. Louis until the stage came through tomorrow morning, so why not? He took a sketch pad and materials from his saddlebags and began to draw the scene.

"This is what I love about summer," Ettie said. She chatted about how difficult it was to get the focus right and still keep that feeling of peacefulness. Charley didn't have any such problems with his paintings. He simply painted it the way it was, and when he said so, she laughed.

"You can't be serious. You mean you don't compose?"

"I just paint."

She stopped her work and looked at his. "Your scene has the very feeling I want, but there's a lot of nothing on the left foreground. Your composition could be much stronger."

"How?"

"Well, you could simplify these dark rocks. You could make this line between light and shadow more pronounced and it would lead the viewer's eye up around here, pick up the light on the rocks here. See how that would lead the eye to this peak...?"

He painted in the changes she suggested, liked what happened to the picture and asked her to look at his other paintings.

"Too many figures dilute interest," she said, looking at an Indian scene. "A close group is better. And diagonal lines cause tension. This line needs to be balanced somewhere." She pointed. "If this figure was leaning the other way, the effect would be better. See what I mean?"

Charley wasn't sure.

"I have a good book on composition. Would you like to borrow it?"

Charley nodded. "I sure would."

"We can talk again after you've read it. And you must come and paint with me again."

"I will," Charley promised. But his mind was already on St. Louis.

His mother flung her arms around him and patted his head as if he were a child. "Such a handsome son, even in those clothes. I hope you'll stay a good long time."

"It all depends."

That evening after supper he put on a new shirt and his best pants, polished his boots and brushed his hair until it shone. When he was ready he looked at his image in the mirror with satisfaction. The Edgars would prefer an eastern suit, city shoes and city hat, but that wouldn't be honest. He smoothed his sash. Lollie should have gotten his letter saying he was coming.

Before he reached the Edgar house his throat tightened. What words would he choose? How would he say it? If she said yes, he must be ready to support her. It would take time to build up a ranch.

He walked down the hedge-lined sidewalk in front of the Edgar house, eyes fixed on the red geraniums and blue delphiniums growing by the porch. The house was big, freshly painted, everything cared for. He cleared his throat as he usually did when he was nervous, and reminded himself that she said she loved him.

He took a deep breath, rapped the door knocker, and waited. "Lollie," he muttered, and now he couldn't remember what she looked like. He couldn't imagine how he ever thought he could support her. Oh yes, he would ask his father to loan him the money to buy some cattle. And in a couple of years, he'd pay it all back. He waited, took another deep breath and cleared his throat again.

The maid answered the door. "I'm Charles Russell. I'd like to see Lollie." The maid left him in the vestibule. In a few minutes, he heard a swooshing on the stairs, looked up and saw Lollie in a summer white dress, her hair piled in curls on top of her head, her figure a little more filled out, a little more beautiful. Her eyes brightened when she saw him. She smiled. "Charley!"

He would have taken her in his arms right then, but her mother appeared suddenly beside her. "Charles, how good of you to call," she said, gently pushing Lollie aside and extending her cool hand.

"Mrs. Edgar, how are you?"

Lollie's smile deepened, but her mother answered. "We are fine, thank you. And how are your mother and father?"

"They're well," Charley said, moving toward Lollie. But again Mrs. Edgar steered Lollie away from him. "Come into the parlor where we can sit for a moment. Though I must say you picked an awkward time. Of course, you couldn't know our guests were arriving at eight."

"I won't stay long. I just wanted to talk to Lollie for a few minutes." He glanced at her, sitting primly, her eyes downcast as she twisted the handkerchief in her lap. Lord, but she was pretty. He couldn't help watching her bosom as she breathed.

"There's something Lollie wants to tell you," Mrs. Edgar said, straightening herself, nudging Lollie.

Lollie blushed. "Oh, Charley, I was going to write you, but then I got your letter saying you were coming. Oh, and it *is* good to see you."

"Lollie." Her mother's cool stare cut off Lollie's words.

Charley wished to heaven Mrs. Edgar would leave. Maybe after her guests arrived, he could find a way to have a little time with Lollie. He couldn't keep his eyes from her face. She glanced at him, bit her lip, then looked away. Why was she suddenly so shy, he wondered. Because they weren't alone? Because her mother didn't approve of him?

"Lollie isn't quite herself today, I'm afraid," Mrs. Edgdr said. "But it's understandable under the circumstances." Her mother beamed at Lollie and reached over and patted her hand. Lollie's eyes looked troubled. Her mother turned back to Charley. "You see, Lollie has an announcement to make. Go ahead, Lollie."

"No, I can't."

"Well, I can," Mrs. Edgar said, her smile disappearing for only an instant. Then she looked at Charley with that air of patience she assumed when she spoke to the servants. "Lollie is engaged."

Charley was sure he hadn't understood. He glanced at Lollie, but her face was vacantly lovely.

"Show Charles your beautiful engagement ring, dear."

Lollie hesitated, then held out her trembling hand. On her finger was a glittering diamond ring. Charley looked at it, then at Lollie, waiting for her to speak. She swallowed. "It just happened. I...."

"He will take good care of our Lollie," Mrs. Edgar crowed. "If you would care to meet his family, they will be here in a very few minutes."

For a few awkward seconds his voice wouldn't work. "Thank you," he managed to say, "but I should be going now."

He rose, and Lollie stood and stared at him, her face pained, but he couldn't look at her. "Good evening, then."

Ten days later he hopped off the train in Coulson, an hour behind schedule. Even before his feet touched the platform he saw Pat leaning against the station house, his arms folded across his chest and a cigarette in the corner of his mouth. His ragged-tooth grin flashed as he waved his hat high.

"Am I glad to see you!" Charley said.

Pat looked him in the eyes. "Bum trip."

"Ther're times a guy needs a good friend to drink whiskey with."

"I'm your man. Let's go."

After three whiskeys Charley laughed. "Hell, this is where I belong. I'm a free-roaming spirit. I'd have a tough time staying put day after day. I'm nothing but a damned cowboy."

Pat clapped Charley on the back. "You're a damned good cowboy, Pal, and you paint hosses better than anybody I know. And Charley, if you ever want to be with a girl who will take your mind off everything else for a while, I'll take you around to a place where you'll be treated right."

"Good idea, Pal. Those little gals are no threat to a man's freedom. That's the kind I want from now on. A man has to be careful he don't step off a cliff and lose the trail."

After a few days in town, Pat and Charley rode west and spent a week with the Crow Indians, then camped along the Madison, fishing and sketching till the end of summer. In the fall they worked the beef roundup. Charley was a hundred percent cowboy, totally committed to the free life.

The cattle drive was going smoothly until they were nearing Miles City. It was late afternoon when a half dozen wild-eyed vigilantes rode into camp and reined their horses near the fire where Charley had been finishing a watercolor.

"Are you after rustlers?" Horace Brewster asked.

A lean brown-eyed young man answered, his voice tremulous. "We're after three renegades who stole my sisters. We need more riders. Anyone care to help?"

The cowboys looked at each other.

"Molly is seventeen, Lou fourteen," the young man said. "They were alone at the homestead, doing laundry. Dad and I were watering the stock on Pumpkin Creek when we heard them scream. We saw three horsemen racing away, the girls kicking and screaming, their petticoats flying. We got our horses and chased them for an hour, but when we lost the trail, we asked for help."

Charley recognized two of the ranchers riding with the boy and his pa. "It'll be tough trailing them in the badland country," the man said, "too many hiding places there."

Charley stepped forward. "I'd sure like to help."

Horace Brewster nodded solemnly. "I can spare three or four men. We'll keep the herd near here for a day or so."

Injun Charley, Billy Page and Chip Erickson volunteered. Charley smiled, knowing Injun was hell on a trail. The four cowboys rode off with the vigilantes. Charley went with Injun, Billy and Chip back to where the men first lost the trial. "If anybody can find those girls, you can, Injun," Charley said.

Angered by the crime, they rode hard and stuck with Injun. It looked hopeless. The way was too rocky. The kidnappers could have followed a dry wash a few miles then turned off anywhere among the rocky outcroppings. Injun walked all around,

eyes down. From time to time he glanced around in a circle. He didn't talk, but he gestured and pointed. The men followed him through the rocks. After hours of riding, Injun pointed to a trail marked by fresh horsetracks and a bit of white cloth, soft cloth, like a woman might wear.

Along about dawn they found a camp in the willows close to the Missouri river. Soundlessly, the four cowboys slid off their horses and crawled on their hands and knees until they could look into the camp.

The kidnappers stood by the fire, one raised a whiskey bottle to his lips, drank, wiped his mouth with the back of his hand. The others, a big bearded man and a glassy-eyed kid, walked around the girls who sat trembling on the ground, their hands tied at their backs and their legs tied at their ankles. Their dresses were dirty and torn, and fear showed on their faces, even from a distance, but they were so far unhurt. While Charley and Injun covered the camp, Chip stayed with the horses and Billy rode out to find the vigilantes.

In less than an hour the vigilantes stood together ready to storm the kidnappers' camp. A man named Ace gave the orders. They surrounded the camp and waited until the kidnappers moved a few feet away from the girls. Then Ace waved his neckerchief. The cowboys and vigilantes rushed forward. The kidnappers, surprised, took a few seconds to reach for their guns. Shots were fired. The girls screamed. But the Injun and the girls' brother pulled them to safety, while the others hogtied the kidnappers.

Injun was an instant hero in Miles City and back at the roundup camp. After the excitement, Charley drew and painted the scenes for the men who had stayed behind. First he drew Injun studying the terrain and gesturing the men to follow. Then Injun pointing to the outlaw's camp. Then the cowboys crawling toward it on their bellies. And best of all—the capture, which was the most detailed scene and painted with the most care and skill. But Charley didn't stop there. He recorded it all, including the on-the-spot trial and the hanging.

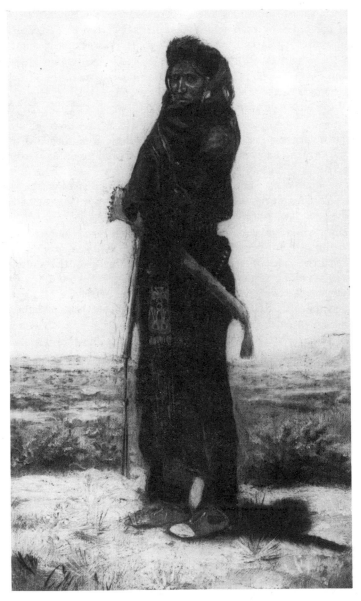

PORTRAIT OF AN INDIAN.
Courtesty of the Montana Historical Society, Helena, MT.

Chapter 10

Charley bragged that he knew everybody in Utica and was liked by one and all. That didn't mean much to the Chicago railroad agents he asked to ship him to Utica C.O.D. like a piece of freight. But he wouldn't quit pleading with them. Over and over he told them about all the people in the Red Onion and Silver Dollar saloons who would be sure to pay the fee. He kept arguing because having to stay in Chicago without money stiffened his resolve. Finally, one of the railroad agents said he would do it just to shut him up and teach him a lesson.

The crate was transferred from the train at Coulson to the stage coach and eventually made it to Utica after dark with a shaken, cramped, hungry and miserable Charley. Frank Bright and a hired boy bent to heave the heavy crate into the post office's end of the general store.

"Hi, Frank," Charley said from within the slats. "Take it easy now. Your cargo's bruised and sore already."

Frank jumped back. "Byjesus, it's alive!" He squinted to peer between the slats. "I'll be... Charley Russell, you damned fool. How in black hell did you get yourself in there?"

"I woke up broke in Chicago. I figured the boys would pass the hat and make me a loan."

"Broke! How come, Charley? You was paid off jest afore you took the cattle to Chicago. Nobody in their right mind would...all the way from Chicago? Like a peck of oranges...soft in the head, byjesus."

"I'll tell you all about it if some decent human ever gets me out."

Frank turned to the boy. "Willy, run over to the Red Onion and see if you can come up with nine dollars and eighty cents. And don't poke."

Frank looked through the slats, then lowered his voice. "How did you relieve yourself?"

Charley laughed. "I told the freight inspector, he oughta pull a couple of nails out so's I could step away, or I'd probably wet down the rest of the load. He cussed, but he done it. Told 'em the same thing when they put me on the stage. But old Sam drove the nails in good before they unloaded me."

"You could talk yourself out of hell, I swear."

"That ain't true, Frank. The man at the Chicago hotel wasn't all that friendly when I checked out. He was downright nasty."

"Well, he probably had good reason."

"Maybe so. I was some tipsy when I came back to the hotel that last night. The room was hot. I woke up once during the night in an awful sweat and went to open the window. Couldn't get it to budge. Finally, I threw my boot at it. The glass shattered and I went back to sleep with a nice breeze blowin' on me. But in the morning, I see it wasn't the window I broke, but a glassed-in cabinet. No amount of explaining satisfied the hotel man, and I ended up paying high for the damage. Either that or go to jail, he said."

"Well, if you'd use good sense, you wouldn't always end up without a cent. You ain't no kid anymore and you ought to know how to stay out of trouble in a city."

"Aw Frank, now that I'm home, I got nothin' but love for all those poor folks livin' in Chicago."

"That's your trouble. You'll booze with anybody you run across. And some of them city cats ain't so all-fired downtrodden, they wouldn't pick a pocket of a hayseed cowboy like you. When will you learn?" Frank lifted the last slat just as Jim Seldon, Bab, and a bunch of the other boys walked in. "Willy says Charley's in a crate," Bab said. "By God, it's true. What happened?"

"Does anybody want to redeem the baggage? It'll cost nine dollars and eighty cents."

"It's in the hat. Here count it out," Jim Sheldon said.

Frank took the hatful of money to the desk and counted it.

"You must be thirsty?" Bab said to Charley.

"Yep, and that ain't all," Charley said, stretching his arms over his head and bending his knees.

"Here's your hat, Jim. And your change. You gave me too much."

"C'mon, Charley," Jim said. "I got whiskey all poured out for you."

An hour later, standing with his high-heeled boot on the brass rail, Charley had never felt so glad to be back home. "I hope I never hafta leave Montana again," he said, one arm around Bab and the other around Bill Quigley. "I'm writin' down what I owe ya'all 'cause I ain't going to forget my true friends." Charley took out his pocket sketch pad and pencil and stood poised to write.

"Shucks, Charley, you don't owe me nothin'," Bill Quigley said. "You gave me a loan once, and I still owed you for it."

"Me too," Dirty Mike said.

"What about you, Jim?" Charley said, looking at the bar owner. "And I'm not forgetting the lunch and drinks here today."

Jim twirled a glass around a dishtowel and shrugged. "A few dollars, three at the most. But I'll tell ya, I've been looking at that painting you left drying in the back room...."

"The roundup picture?" Charley asked, wanting to see it all of a sudden.

"I know you promised that one to Jesse Phelps...but I wish you'd paint just the right hand side, the part with the peaks of the Snowies in it and the horses. I'd like to have a picture like that."

Charley remembered the passage, remembered the Snowies and wanted to paint them again. "I'll do it right now."

"I wouldn't mind taking my loan back that way, too," Bull Nose Sullivan said. "A hoss and cowboy."

Charley gulped his whiskey and walked to the back room. He paused, glancing at his big oil painting, dry now to the touch, an after-breakfast scene at the roundup camp, the cowboys getting ready for the day's work, saddling or mounting their cayuses, some already astride and being tossed and bucked. The early morning light fell on the tents, cowboys and horses—the way it was. As he picked up his watercolors, Charley remembered his parents asking him to send a painting to enter in the St. Louis exposition. Maybe he'd send this one and see what happened. Jesse said he wasn't in a big hurry for it.

Before the afternoon was over, Charley had repaid everyone in watercolors, and went back to the bar.

"I heard you were back in town," a familiar voice said from the door. Charley turned to see Jake.

"I sure am."

"Bab said you got here in a crate. Was he yarnin' me?"

"Not my favorite way to travel by a far sight, but I'm here, and glad to be back. Bring Jake a drink, won't you, Jim."

That night Charley rode up to the cabin with Jake, glad enough to settle into the hunting and trapping routine and to taste Jake's cooking again.

The days passed easily. Then one day as he was riding near the Belden ranch, he stopped to say hello and found Ettie digging her potatoes. She invited him in for coffee and asked about his work. He liked showing her his sketches. Though her drawing wasn't near as good as his, she knew things taught in art school that he hadn't learned. And some of it was worth knowing.

He showed her a couple of watercolors. "I think that buffalo skull is about as good as a signature," she said.

He nodded. "It didn't start out that way. To begin with it was just a detail to give some perspective to the foreground. But now it might as well be my brand."

When spring came, roundup excitement ran higher than ever. There were more cattle, more cowboys. Nobody had ever seen such a big roundup. Over a campfire early in June, one old-time cowpuncher told Charley, "I don't like the looks of it. Too many cattle. They're eating the grass down to root. Hadn't ought to crowd the range this way."

Most of the others laughed. "This land still had good grass after the buffalo left it. And they say the buffalo were so thick you couldn't see ground between them."

"Buffalo only stayed a short time, then ranged north to Canada. It's different with the cattle. They'll eat all summer and go into winter with the grass eaten down. It ain't a good idea."

But as roundup got fully underway, vague worries were forgotten. Cattle owners were happy with their bumper crop of calves.

Brewster and some of the other ranchers started to worry when the June rains didn't come. By July the range was parched; good creeks dried up. As the days passed, the dry spell became a drought. Fires broke out again and again. Renegade Indians were suspected of setting some of them. The cowboys worked long hours fighting the fires and driving the cattle away from them.

One big blaze had Charley, Pat, Con Price, and Kid Amby up before dawn, manhandling the cattle to get them away from the fire and into rocky country where the fire wouldn't spread. They dug trenches around the fire areas, and by the end of the day, dust, sweat and black soot laid on their skin and in their hair and clothes. Their throats were parched and their noses dry.

"Why is it these damned prairie fires always start in places where they can do the most harm, where the poor damned critters are trying to graze and thar ain't no water around?" Con asked.

"Could be Indians," Amby said. "They're mad about what's happening to the range, I reckon. But if I see an Injun lighting a fire, I'll empty my six-gun into him."

"Lots of saddle-pounders would do the same," Con said.

"Well, wouldn't you, Con?"

Con was a tall lanky kid, young but savvy. He shook his head solemnly to that question, and his mouth looked as though he had tasted something sour, but he said nothing more. Charley hated all the talk about getting revenge on the Indians. They had lost a whole way of life to the white man. They were struggling to survive, and didn't have enough to eat. Some were so desperate they thought they could burn the white man out. They were wrong, but it was good to know Con saw it the same as he and Pat did. Still it was a shame; this beautiful land turning into a desert.

"If we don't get some rain soon," Pat said, "the beef cattle won't be fit for market come fall."

"Hell, I never saw cattle in worse shape," Amby said.

Nobody answered. Charley recalled the dead cattle they had seen. There would be more if rain didn't come soon.

By fall the cattle that survived were in bad shape and there was little winter feed on the range. Charley signed on with the O-H outfit for fall roundup. The mood of the cowboys and ranchers was grim. The usual happy hellos were replaced by looks of recognition and tight-lipped silences.

Charley told more stories and drew more humorous pictures than ever. The men needed something to laugh at, and he wouldn't be much of a friend if he didn't try to give it to them. Making fun of these troubles had a bitter taste to it, but it broke the tension. Laughing was all that kept them going some days. Jesse Phelps, the lean dark-eyed foreman, clapped Charley's shoulder before he headed out to his night herding. "I don't know what we'd do without you, Charley."

When fall roundup ended, the cowboys took their pay to town.

Jesse Phelps had a drink with the crew before he rode back to the ranch. Charley liked Phelps. He faced a tough situation, but he pulled the outfit through the drought, and things would certainly improve now.

After Phelps left town, the celebration went on. Charley drank his share of joy juice, some of it with Sallysue, a redhead from Hardrock Ruby's parlor house. Sallysue dressed like most of the prostitutes in town in satin dresses that fit tight and showed a lot of their bosoms, but her bedroom was fixed up with pink-checked gingham and ruffles. She was proud of it, "Don't it look homey?"

"Sure does." Compared to the places Charley had lived lately, Sallysue's second floor bedroom looked like an oasis of pink.

"Someday I'm going to have a house with a kitchen and pots of ivy and ferns on the windowsill. And everything in the kitchen will be yellow—like sunshine."

"Sounds nice, Sallysue," Charley said.

"And I'll bake pies all day."

Charley laughed. He hoped she would get her wish and have that yellow kitchen some day. She was a good gal, full of fun. Charley came around almost every evening until his money ran out. On his last night, Sallysue was especially tender. He was going to miss her.

"I brought you somethin' for your yellow kitchen," he said, handing her a package.

"What is it?"

"Nothin' much. Jest somethin' to say good luck."

She unwrapped the tissue paper carefully, revealing a wooden flour scoop tied with a yellow ribbon. "Thought you could put it on your kitchen wall if you wanted to."

"My kitchen wall! You do believe I'll have one, then?"

"A course, you will."

"Oh, what a beautiful scene!" Delight so filled her voice, he couldn't help smiling. He had painted the Snowy mountains in the background, a meadow dotted with yellow flowers in the foreground and a fawn standing to one side.

Before winter took hold, the cowboys scattered. Con went north, Pat went south to visit an aunt who had raised him. Everyone drifted. Charley rode back toward the basin alone. It was bleak even for November, raining steadily for days

with nothing but mighty ominous clouds overhead. It was so bad Charley stopped at the 0-H ranch a few days.

Jesse Phelps was glad to see him. "I'm short-handed here; was going to hire another man; how about taking the job, Charley?"

So Charley stayed on. The ranch's cattle were thin and the range already overgrazed. Jesse was looking after 5000 head of Stadler-Kaufman's cattle in addition to his own outfit's herd.

During the night the rain turned to snow and it snowed all the following day. The temperature dropped. And when the weather cleared enough to let cowboys get out to check the cattle, the wet snow had frozen into a hard thick covering over what little grass was left. The hungry cattle stood in the icy winds, moaning as they sought shelter. They hungrily tore at the few shrubs that stuck up through the ice. Charley's face stung with the cold; his fingers stiffened though he wore lined leather gloves but he couldn't turn back to the warmth of the ranch house when so many weak cattle were caught fast in the ice. Jesse, Charley and the other hands worked until they were numb and weak themselves. They went back to the ranch for coffee, food and more warm clothes. Then they went out again.

Temperatures continued to drop. Arctic wind blew the snow into deep drifts. They worked long and hard at freeing a single cow, only to look up and find others wandering into fatal drifts. The bitter cold weariness of it all wore away at Charley until he was no more than a set of arms and legs that didn't dare stop.

On a still day in mid-December Charley took Jesse's wagon and headed for Utica to pick up supplies. He stopped in Jim Sheldon's saloon. Three cowboys and a couple of stage passengers from Fort Benton were playing cards. The rest of the men stood up close to the bar, and exchanged stories of the winter's devastation. Jim Sheldon appeared from the back room. "Hey, Charley, I've been waiting to see you. How about painting a picture for me to hang up over the bar, like that one you did for Jesse Phelps."

The idea of painting a big busy roundup scene appealed to Charley. He yearned to recreate those days, especially now when the beauty and excitemnent of the land had been so overwhelmed by devastation. But he couldn't. "Sure, I'd be happy as hell to do it; but all I got with me is a sock full of supplies, not near enough to do a big painting. I'd have to go to Helena or Fort Benton to get paint and canvas, and I can't spare the time now."

Jim looked disappointed, then brightened. "Hold on. I'll be right back. Anybody want another drink before I go?"

Jim left for about fifteen minutes, grinning widely when he returned. "I got some supplies for you, Charley. But I left them at the general store. I'll need some help hauling them."

Charley and some of the boys followed Jim across to the store. First, Jim pointed to a pine slab. "You can paint on that, can't you?"

Charley nodded. He'd painted on wood before, but never anything that big. "It started out to be a door," Jim explained, "but it splintered and was cut down. It'll fit over the bar jest fine."

"It'll take a lot of paint to cover that."

Jim looked up, walked across the floor and pointed to the house paint on the shelf in the back of the store. "I know it ain't what you're used to, but why wouldn't it work?"

"What colors do they have?"

"Look fer yourself."

There wasn't a big color range. But he had a few oil colors left that he could use for mixing. "I'll paint the wood white to start with," he said, his mind already churning with remembered images.

Jim and Charley carried the slab, the others carried the paint.

They took everything to the storeroom behind Jim's saloon. Charley painted the wood slab with a coat of white, then made sketches. If Jim wanted a roundup picture, he was going to get one, and he'd fit Jim's saloon in the picture, too.

One of the stage passengers from Fort Benton came to the back room to watch and talk. Charley liked him and answered all his questions. It wasn't until the next day he learned that the passenger who was so interested in his painting was a newspaper writer.

Another storm rolled in and the situation at the ranch worsened. Mr. Huntley, one of Jesse's partners in the cattle ranch, came to see how the cattle were faring. Huntley was a heavy-set man, who walked swiftly in spite of his size. Jesse showed him around and when they returned to the house, Huntley's mouth was grimly set, his eyes glassy. Charley rose from the kitchen table where he had been sketching on a letter. He poured coffee for Huntley and Phelps. They took their cups to the living room and Charley went back to his letter.

Later, Jesse and Mr. Huntley came back to the kitchen. Huntley's face had lost some of its starkness. "That's a fine painting," he said.

Charley looked up, surprised, then back at the sketch on his letter.

"No, no; the roundup picture over Jesse's mantel," Huntley said. "*Breaking Camp* you called it."

"Oh, thanks."

"Jesse tells me it was shown in St. Louis at the fair."

Charley nodded, and Huntley clapped him on the back. "Fine work."

Jesse asked Charley if he'd mind if Huntley had the painting.

"It's yours," Charley said. "Do whatever you want with it."

"I was only thinking more people would see it if it were hung in his store in Helena."

"Give it to him if you want. I'll do another one for over the mantel." Huntley took the paintings and Charley thought no more about it.

The winter continued severe, and more cattle starved.

Temperatures seldom rose higher than twenty-five below zero. It was crucial to save as many animals as possible, as often as possible. Charley sometimes thought he was rescuing the same cow over and over and over. The animals had already consumed the scrubs as well as the bark off the trees. Their eyes were frozen cries for help.

"One good chinook is all we need," Jesse said. "If the winds would just sweep down on us now and melt the snow, we'd be saved."

Charley caught the desperation in Jesse's voice, and told a long soothing winter story with a happy ending about two storm-marooned cowboys who fought a grizzly bear for an abandoned cabin, then found the dead prospector's cache of gold dust under the bed. It was always a good story, and Jesse nodded happily at the end.

But winter didn't loosen its grip on central Montana. Temperatures plunged even lower. The wind blew at a deadly forty or fifty miles an hour in temperatures forty below zero. Every day was more of a challenge than the day before. The cattle were dying standing up. And the drifts were as dangerous for the cowboys and horses as for the cattle. The terrible cold cut to the bone and slowed every action. The horses suffered. Death surrounded them. Coyotes howled over the mean sound of the wind.

Chinook, oh, please, a chinook! Nothing else could save them. And if it didn't come soon, there was no hope. If only the wind would pull the warm air out of the Pacific, whirl it across the mountains and hurl it onto the plains to melt the snow, to cover the frozen earth with its hot breath and bring saving warmth.

In March a letter came from Louis Kaufman. Jesse read it while they were having lunch. He groaned, tossed it on the table, and got up and paced to the little window in the back of the kitchen. "There's really nothing more we can do out there, is there?"

Charley looked up from his lunch, but Jesse didn't wait for an answer. "I mean, can you think of one more damned thing to do for the dying critters we haven't already done?"

"No," Charley answered. "What's wrong?"

"Everything in the whole outdoors is wrong. Anybody can see what's wrong."

"What's in the letter?"

"Questions. Kaufman wants to know the condition of his herd. Go ahead and read it. He says he feels fortunate to have a stockman like me looking after the herd and so forth and so on."

"It ain't your fault the herd's lost." Charley picked up the letter and read it, understanding Jesse's reaction. "It'd be better to answer it than walk around here like you had a burr on your saddle."

Jesse shoved his lunch plate aside. Charley cleared the table and put the dishes in the dishpan of water heating on the stove. Jesse took out paper and pen and sat down to write. "I'll just say the weather had been much worse than I expected when I wrote last, but I'm sure I wrote him before January. He can read the papers. Doesn't he know what's been happening?"

Charley shook his head. Jesse looked over at him "What do you tell a man when the fortune in beef he left in your care is wiped out? How do you say it?"

"Maybe I can help. If I can find some kind of stout paper that will take watercolor paint."

Jesse sighed. "There ain't much left around here with you around, but I recollect seeing a piece of cardboard in my collar box. Of course, it isn't much bigger that a postcard. Will that do?"

"That'll do fine. I'll get it."

"I'll just explain everything we did to try to save them," Jesse said when Charley came back and sat down.

Charley nodded, and painted a starving steer, standing knee deep in the crusted snow, with no meat left on his bones. He stood humped over, eyeing a coyote a few feet away waiting for him to drop. Charley let the cold winter light shine on those bony ribs that protruded through the hide, bearing the Stadler-Kaufman brand. The stark darkness of the steer's shriveled body against the whiteness of the snow and blueness of the sky left no doubts. The steer was doomed. Charley initialed the card at the lower left, and, as always, added a line drawing of a buffalo skull. At the bottom of the picture, he wrote the words, *Waiting for a Chinook*.

He handed it to Jesse, who was so engrossed in his struggle for words, he had become oblivious of everything else. He blinked, lines still deep on his forehead, as he took the picture.

After a glance, he put down his pen. "Ah ha." He nodded. "Yes, this says it better than anything I could write." He crumpled up his half-written letter and put the card in the envelope. "That little picture doesn't leave any doubts. Louis will understand."

About a month later, Charley stopped in at Jim Sheldon's saloon. Jim greeted him with a big grin and a shout. "Saw your picture in Helena."

"You sure stirred up a lot of stockmen there."

Charley was bewildered. "'What're you talkin' about?"

"*Waitin' for a Chinook*. The Stadler-Kaufman steer. Last of the Five Thousand, some people are calling it. That picture has been passed all over Helena."

"What?"

"That's right, Charley, I saw it myself," Bill Bullard said.

"You mean that little sketch Jesse sent to Kaufman?" Charley asked.

Bill and Jim nodded.

"Why, that's no bigger than a playing card."

"It sure is bigger than that," Jim insisted. "Hell, I had it in my hand. I heard Kaufman had it photographed and was giving the prints around."

"That's right," Bill said. "It was one of the prints I saw. They had some for sale at Ben Roberts' saddle shop."

"For sale?" Jim said. "I'd like to get one. I guess I could send to Roberts' shop and order one. Anybody else want one?"

Charley was puzzled. That little sketch—photographed and copies being sold—and Jim Sheldon sending for more...?

"You're well-nigh famous in Helena," Bill said. "Ain't a stockman around thar who doesn't know about Charley Russell."

"Before you get too damned famous," Jim said, taking Charley aside, "how about finishing my roundup painting?"

Charley had a drink and worked on the painting, enjoying the talk with friends, and a respite from the struggle with winter at the ranch.

Weeks later, when Charley came to town again, Jim pulled out a cigar box and put it out on the bar. "Look here. This came a few days ago."

"What is it?"

"Printed copies of *Waiting for a Chinook.*"

"Well, I'll be...."

"Wait, there's a letter, too—from Ben Roberts. He says you ought to come to Helena. People have seen this as well as the painting in Huntley and Pruitt's store and want to see more." He handed the letter to Charley, pointing to the last line. Charley read. *"This may be a good time for Russell to sell his work in Helena."*

Charley smiled and continued to paint on Jim's roundup picture, but the Helena idea stuck in his mind, and he wondered about Ben Roberts. Why was he so interested?

Chapter 11

Charley rode into Helena and asked directions to Ben Roberts' saddle shop. He found the shop but Roberts wasn't there. His young helper pointed to the cafe down the street. "He'll be there eating lunch."

Charley went to the cafe and paused inside the door, hitched up his pants and smoothed his sash under his gunbelt. He spotted a broad-shouldered man in a green shirt, who answered Ben's description. His face was a little flat, the features large, the jaw and cheekbones jutting. Charley walked up to his table. "Hello, Ben. I'm Charley Russell."

Ben stood up and shook Charley's hand. "Sit down, sit down. You got my letter? I wasn't sure where to send it."

"I got it all right. You said you wanted a painting something like the one in Huntley and Pruitt's store."

Ben nodded. "I hope you're going to stay around town a while."

"Depends on how my money holds out."

"Good. We'll have a lot to talk about. Will you have a plate of stew? It's pretty good today."

"Sure would." Charley said, and Ben yelled to the cook to bring another plate of stew.

Charley propped his elbows on the table and leaned forward. "Hey, Ben, why did you go to all the trouble to have that little sketch of a starving steer printed up?"

"Trouble?" Ben's head bolted up. "Everybody wanted to see it. It struck a chord in a lot of people, especially cattlemen. It summed up the truth about that winter; told what it was like on the range." Ben pointed his fork at Charley. "Then when I saw the roundup picture in Huntley's store, and read that piece about you in the Fort Benton paper, it seemed to me that Montana had the artist it needs. We're going to be a state before long. Have you noticed how fast the territory is changing?"

"Since the railroad? It's changing too fast if you ask me."

"Progress is coming whether you like it or not," Ben said, "but what the territory is changing from is important to a lot of folks. And you have a good eye for that."

Before they went back to the saddle shop, they walked to Huntley & Pruitt's and talked about the roundup painting until Charley thought he knew what Ben wanted. On the way back, Ben stopped and introduced Charley to friends, saying

each time that Charley was in Helena to paint for a spell. The way he said it made Charley sound awfully damned important. Charley kidded Ben about it.

He usually made friends easily, but he couldn't remember a man who he took to as fast or as strong as Ben. By the time they came back to the saddle shop, Charley counted him as a pal on a level with Jake, and Pat Tucker. It was natural to go along with him, meet his wife and have supper.

Charley painted in his hotel room and became so involved in remembering the details of a roundup scene, he didn't notice the knock on his door. Then he heard his name called, recognized Ben's voice and put down his brushes. Ben came to see how he was doing on the painting and ask him to lunch. Charley got his hat and they went down the street to the same cafe they had eaten at the day before.

"When you finish my painting," Ben said smiling, "Calkins & Featherly need one to put in their window. That ought to be a good place to show your work."

Charley studied Ben's face. He was a man who did things for a friend. And if Ben used his influence to get that window space, Charley wasn't going to let him down. "Do you think they'd like Indians hunting in the mountains?"

Ben looked thoughtful. "That ought to be a good contrast to the cowboy scenes. But won't it be hard to paint Indians without models to pose?"

"Naw. If I need a model for anything, I make my own out of wax. I can get the position just right, and draw from that."

"But isn't modeling just as hard as painting?"

"Naw, modeling is a cinch."

"Really?" Ben looked disbelieving, so Charley modeled an antelope for him. "Now suppose I wanted to paint an antelope leaping over some brush. I take the model and stretch it into the shape the animal would take. I work on it till it's right—remembering all the antelopes I've seen leaping over brush, and pretty soon it's about right."

Ben took the wax antelope in his hand and turned it around. "Amazing. Is that what they teach in art school?"

Charley laughed. "Nope I learned to model as a kid. I tried art school once, but I didn't last long. They make ya draw from plaster models of feet and arms and so forth. I drew a pair of plaster feet, and the instructor didn't like it. I asked what was wrong with it and he wouldn't say. So I left. My mother said I didn't give it a fair try." He shrugged.

"She probably worried that you'd have trouble being an artist without the training."

"True. I wasn't much good at anything else. Mother was a good artist herself, and she taught us a lot when we were little. My brother Wolfert drew best. I did better modeling. But Wolfert died a couple years back, and she pinned all her hopes on me. She was never keen about cowboy life."

The cafe was crowded. As they finished a piece of pie, another man joined them. "This is Mark Dawson, Charley," Ben said. "He heard about your painting."

"I'm from the *Helena Weekly Independent*. I just have a few questions."

Dawson's questions were easy ones. Soon, the three men were talking like old friends, laughing, and swapping stories.

A few days later Charley was interrupted by a knock on his hotel room door. "Yep, it's open."

Ben strode in, carrying a newspaper under his arm. "At work already?"

"Light's good this time of day."

"Looks pretty cramped for you over there."

"I've painted in lots worse places."

"You ought to have a studio."

Charley laughed.

"I'm serious. I wouldn't be surprised if the hotel folks didn't object to having you paint in your room."

"Hell, I'm payin', ain't I?"

"Hmm," Ben said, eyeing Charley and the room.

"What brings you away from the shop so early, Ben?"

"Oh, I almost forgot. This piece about you in the *Helena Independent*."

"Dawson wrote something, did he? What did he say?"

Ben opened the paper, folded it, and pointed to the column as he handed it to Charley. The headline stood out, *THE COWBOY ARTIST*.

Charley caught Ben's glance and scanned the column. *A fine oil painting by a range rider....On the wall in Huntley and Pruitt's store hangs a painting...if slightly inartistic in some details, is of fine conception, and in the main, finely colored and executed. It was painted in the seclusion of a cow camp on the Judith Range, and by a cowboy. It represents a roundup camp...The artist is C. M. Russell, a cowboy 21 years of age, the son of a well-to-do family of St. Louis. He is a natural artist....*

Charley handed the paper back to Ben, his hands trembling. "Here, I can't read any more."

"What's the matter? You look like you've gone sick. I hope you aren't upset because he said some details were slightly inartistic. The rest of it...."

"No, it ain't that. It jest feels funny...like I was somebody else."

"Have you had coffee?"

Charley shook his head. "C'mon then. Forget the paper and let's go have breakfast."

Charley didn't forget about the newspaper. It was as though a bell was still ringing in his head. The flapjacks and coffee sat heavily in his stomach. As Ben

talked, Charley looked down, not wanting to catch anyone's eyes, wondering if people in the cafe knew he was the person the paper called the cowboy artist. He felt revealed, exposed and hoped it would be forgotten in a few days.

Ben went back to his shop, and Charley walked to Huntley & Pruitt's store and looked at his painting, searching for the inartistic details. With a sinking feeling, he thought he saw what Dawson meant. Sweat came out on his forehead and he felt his shirt sticking to his back. Maybe the movement of the cowboys *was* exaggerated and wooden. Maybe the proportion wasn't perfect. And didn't the main horse look as if it were stopped somehow in mid-jump. It had looked so perfect to him *before*.

He went to a saloon near the hotel and ordered a whiskey, tossed it down in a gulp, and turned to leave. Before he got to the door, he heard his name called.

"Charley, hallo there." He turned to see a cowboy called Slim. "We were just talking about you. Saw the paper. C'mon back and have a drink." Charley had worked night herd with Slim a couple of years ago. Good with a bronc, rode smooth fork.

Charley sat down with Slim and his friends. He was glad to see Johnny and Ed too, and would have been ready to celebrate any time, but his unfinished painting nagged him. He wanted to get back to it, to see if it was *inartistic*,

By the time Charley got back to the hotel, it was too dark to paint. But he lit the lamp and studied what he had done. With the whiskey in him, it didn't look too bad. He was going to pick up his brush and start painting again in spite of the poor light, when he heard a brisk knock at the door. "It's open," he called. Ben rushed in. "Where've you been? I've got news."

"Ran into some friends. What's the news?"

"That piece Dawson wrote stirred up interest in you. A crowd stopped at Huntley and Pruitt's to look at the painting. People came to my shop looking for copies of *Waiting for a Chinook*." Ben grinned. "You're going to be busy, Charley." Ben walked to the chair where the painting was still propped. "Ah, I see it's coming along."

"Didn't get much done today."

"Never mind. Tomorrow you won't have to work in a cramped corner of a dark hotel room."

"I won't?"

"No, come with me. I've found you a place to use as a studio."

"Hang on, Ben. I can't afford a studio."

"It's not going to cost anything. It's an old stone barn, sits behind the church on Sixth Avenue. It ought to be a fine place to paint. C'mon, I'll show it to you."

Charley followed Ben, taking long strides to keep up. The barn was cool and smelled of hay. Ben flashed his lantern in each of the corners and then stood in the

middle of the barn with the lantern swaying, casting floating shadows around them. "It's perfect," Charley said.

The barn had a window so he would have enough light. Next day he moved his painting things, and got to work finishing Ben's oil painting.

Ben came to the barn one afternoon when he was blocking in a new painting.

"The painting in the window was sold," Ben crowed. "And Calkins sent word that they would like another to put in its place. And that's not all." Ben stood all puffed up and proud of himself.

"That's enough," Charley said, "but what else has got you strutting like a head rooster?"

Ben laughed. "I got my reasons. I said you were the artist Montana needed. Well, Huntley and Pruitt's window is empty now too. The painting was sold. And they want another, too."

Charley was flabergasted. "Do you mean to tell me that one newspaper column could do this?"

"The word's getting around," Ben said, rubbing his hands together.

In spite of the sales, Charley was nearly broke. It cost a whole lot more to live in Helena than the Judith Basin where cowboys could bunk anywhere, and ranch cooks supplied meals to any cowboy passing through. By the time he'd been in Helena a month, he was too broke to stay any longer and was about to head back to the Judith when a man in eastern clothes came strolling into the barn.

"My name is Markley, Mr. Russell." He extended his manicured hand with a diamond-encursted ring on one finger. Charley wiped his paint-smudged hands on the side of his pants before he shook Markley's.

"I like your paintings," Markley said.

"Thanks. Say aren't you the man who bought the painting at Calkins and Featherly's store?"

Mr. Markley smiled. "I am. It shows tremendous promise. I'm no expert on Indians, but I've heard your interpretation is absolutely authentic. At any rate, I would like another—on the same theme—something the same size. In the meantime, have you anything else to show me?"

Charley showed Markley his latest paintings, the bucking bronco, and a picture of a trapper in the mountains.

Markley squeezed a pair of pince nez on his nose and looked at the paintings closely. "Is it true that you haven't had much art training?"

"Yep."

"Hmm, if you do this well without years of training, then with some tutoring, you could become a great artist."

"I reckon I've had all the schoolin' I'm going to get."

Markley looked back at Charley with a wise expression and the beginning of a smile. "Not necessarily. You're still young. This is the time in your life when you ought to perfect you skills and master your art."

"Nature is a pretty good teacher for me. I paint what I see."

"Of course, that's basic, but ways have been developed down the years to achieve the look of nature on canvas. Methods can be learned in a few months that would take a lifetime for an artist to discover by himself—if he ever could. One artist develops a system to make light seem to glow from the canvas, and he passes it to the next generation. Another artist devises a theory of light and shadow for making dramatic impact. He gives it to the world, to people like you, Charley, so you can use it in making your own visions. That's been going on for centuries. It seems to me if an artist hopes to add his own voice, he must make an effort to learn what went before."

Charley blinked. He looked from Markley's earnest face to his canvas and back again. "When I'm in school, I feel like I'm chained to a tree."

"There isn't anything more exciting than learning," Markley said. "I know of an art school in Philadelphia where some of the greatest artists in America studied. Painting is a craft first of all. When a man has mastered the craft, and has the vision for it, he becomes an artist—how great an artist depends on him and his own fervor. You have the seed of genius. I'm convinced of it. And I'd like to see you develop it."

Charley didn't know what to say. Why should a stranger care about him? As his gaze met Markley's, there was nothing he wanted more than to master his craft. His mother had told him if he worked hard, he'd be successful. But Charley wanted to paint the West, not studio pictures. Still Markley's words had a ring of truth. Art had to be learned. "Maybe some day, but now I'm a cowhand."

"Nonsense," Markley said. "You've been blessed with a gift. The good Lord expects you to make the best use of it."

Charley shook his head. "I don't see what more I can do. I try to make my pictures as real as they can be."

"That's good as far as it goes. But it's naive. You need much more and I'd like to send you to the finest art school in the country." Markley's eyes watered.

Charley licked his lips. "I...I don't know what to say."

Chapter 12

Charley rode straight to Jake's cabin when he returned from Helena and was surprised to see Jake clearing land behind the cabin. "I'm makin' improvements. That's what the hell I'm doin'. I'm thinkin' of buyin' a few head of cattle."

"I never thought you'd do that."

"Neither did I, but huntin' ain't as good as it was. Things're changing."

"They look the same to me."

Jake shrugged and propped his ax against a stump. "Let's eat."

After lunch Charley helped Jake with the clearing, and that evening he worked on the painting he had begun for Markley. Jake sat at the table with him. "I heard they wrote about you in the paper. Heard people were buyin' your pictures, and one man wants to send you off to school."

"The newspapers exaggerate."

"Well, I've been known to do the same myself." Jake chuckled. "Is this a picture somebody asked fer?"

"Yep. Mr. Markley. He's the feller offerin' to send me to art school."

Jake smiled. "Ain't that what your ma wanted to do?"

"Guess it is."

"But you didn't want no part of it then."

"I didn't want to be in any school and didn't want to be East when I could be here. But now, I'm wonderin' if I oughtn't to study some."

Jake laughed.

"What's so funny?"

"Nothin'. But every time I've taken a grubstake, it's turned out to be nothin' but a passel of trouble. Everything is honey sweet till they put out their money, and then they own ya."

"Yeah, you told me about some of those times."

"It's a lesson a man don't forget easy."

"Guess I didn't think of Markley's offer as a grubstake, but that's about what it is. I jest thought if I could get paid enough to paint the kind of pictures I like between roundups, I'd be crazy not to do it."

"But Montana ain't full of art lovers, and even artist fellers have to eat every day."

"The cities are growing."

"Ain't it the damned truth."

"Ben said I ought to send some pictures back East to publishers. Jesse Phelps said the same thing, but I don't know."

"Wouldn't hurt none to try it."

"If you was me, you wouldn't take Markley's offer, would ya?"

"Hell no. A man's better off depending on himself entirely."

Charley nodded and turned back to work on his painting. Jake did almost everything for himself, and that was what Charley most admired about him. What he said was right for him, but he was a mountain man.

For an artist, though, it made sense to find out what other artists had learned. He had so many scenes crowding his brain, he wondered if he'd ever be able to put them all down. Even though he was improving, his paintings still had too many rough spots. They seldom satisfied him, didn't measure up to the vision he had in his mind. The word *inartistic* hung over him.

He helped Jake for a few days. But he was broke and needed a job so he signed on with the Bar R outfit.

He kept thinking about Markley's offer and one day when he was near the Belden ranch, he stopped and talked to Ettie about how long it would take in art school to learn just what he needed to know.

She laughed. "You can't take short cuts. You study drawing and anatomy and a dozen other things."

The thought of so many lectures tipped the scale in favor of telling Mr. Markley no thank you. But Ettie looked at him seriously. "You do have talent, Charley. You ought to develop it."

"I want to learn more, but I could never sit through all those lectures."

"There's another way—not so formal. Of course, it would cost quite a bit of money."

"What's that?"

"Study the old masters. The best artists go to Europe and copy masterpieces by Da Vinci and Raphael and the other great artists, and they learn more than they do in school."

Sure. He'd heard of artists doing that. It sounded a lot better than a schoolroom. He could copy what he liked and still stay independent. He had already learned some things from looking at paintings in the St. Louis museum.

He showed Ettie the painting he had done for Markley and she praised the way he placed the figures on the canvas to create the feeling of isolation in the blizzard. "I'm glad you're working so hard at your painting," she said. "Someday people might come to museums to study *your* paintings. Maybe Mr. Markley's offer isn't such a bad idea."

By the time his nightherding job at the Bar R ended, he was ready to go back to Helena and take his paintings to Markley.

Markley shook Charley's hand. His talk had a formal eastern edge to it, but when he saw the painting of cowboys meeting the Indians in a blizzard, he pulled himself up straight and rocked on the balls of his feet. "This painting is the best of them all."

"I call it, *Lost in a Snowstorm-We are Friends.*"

Markley smiled. "Apt, indeed. Let me write that down."

As Markley fumbled at the desk, Charley twirled his hat around by its felt brim, and cleared his throat as he stared down at his dirty boots. "I've been thinking over what you said," he began. "About goin' to school in Philadelphia. I guess you're right. There's a lot more I ought to know. And I'm glad you set me to thinking about it, but I can't accept your offer, kind and good as it was."

"Oh? Why not?" Markley turned, pencil in one hand, paper in the other, and a cigar in his mouth.

"It's just that a man needs to depend on himself entirely."

"Nonsense. That's no way to get ahead in business."

"Here in Montana, if a man can't take care of himself, he don't last."

Markley nodded sadly. "I know it isn't easy to accept help. But you'd be helping me by taking the offer. And I'm not withdrawing it. If you change your mind, let me know."

Charley thanked Markley and left the house, feeling he'd done the right thing. He then made his way to Ben's saddle shop. The smell of new leather stung his nose. Then he saw Ben bent over his work bench. Charley walked toward him, spurs jangling. Ben turned "Glad you're back. Did you decide to take Markley up on his offer?"

Charley shook his head and sat on a rail a few feet away and ran his hand over a new saddle straddling the rail next to him.

Ben concentrated on the leather under his fingers. "Well, you've come a long way without it, and who's to say you won't keep on getting better?"

"It ain't in me to sit in school, but I heard of another way to improve my painting."

"Yeah, how's that?"

"By going to Europe and copying the great paintings they have in the museums."

Ben whistled. "Going to Europe?" Then he looked up and laughed. "I can just see you running up the steps of the great European museums in your cowboy boots with your half-breed sash waving in the wind."

"Why not?"

Still smiling, Ben raised his eyebrows. "It costs a bundle of money."

"I'll have to save it up."

"Are you serious?"

"I really want to be a good painter. And I wouldn't mind copyin'."

Ben dropped the piece of leather he was working on, and squinted at Charley. "Have you finished any more pictures?"

"You bet. I have four finished, another partway done. I was hopin' to paint in the barn again till it gets too cold."

Ben shrugged. "Listen,...if you're serious about saving up to go off to study. Well, remember how people rushed to buy copies of *Waiting for a Chinook*? So why wouldn't they buy other prints if they were available? You could earn money selling prints of your work."

"Aw, I ain't no salesman."

"Well, I am. At least, I'd let folks know they could buy them here—like before. You know how it is in business—one person tells another."

Charley trusted Ben's judgment. And if he was going to save for a trip to Europe, this might be a good way to start. "I'll bring the pictures over and see what you think."

Charley came to supper. Afterward they looked at the paintings and talked more about the idea of selling prints.

"Every one of these pictures has what range people want to see," Ben said. "They all show a piece of what it's really like to be out there on the range. I wish we could print up all of 'em. But we'll settle on two or three for now."

They picked *Buckin' Bronco, On Night Herd* and *Roping*.

"Have you thought any more about sending paintings to magazine publishers?" Ben asked.

"Yep, I thought about it. I figured as soon as I finished something good enough, I'd do it."

"Good. There're plenty of ways to earn the money you need. You just stay here in Helena for a while and I'll help where I can."

Charley wondered if Ben's idea was a little crazy. But as he explained it again, his enthusiasm picked up steam, and a spark caught in Charley's breast. Okay, he'd winter in Helena and see how it went.

But he knew he couldn't afford to stay in a hotel again. If he was going to save any money, he'd have to find a cheaper place to stay.

He asked at the saloon if anybody wanted to rent a shack and share expenses. Slim Stillwell, cowboy turned faro dealer in winter and a couple of other punchers were game. Soon Charley had a place to stay, a barn to paint in as long as it wasn't too cold, and a couple of stores willing to display his work.

For weeks Charley worked as hard on his painting as he ever did working on the range. Ben praised each painting, and Charley believed his work was improving.

After supper he liked to meet his shackmates at the saloons and have a good time. That's where he met Phil Weinard. He was a friend of Slim's, and Slim had told them that Phil could think up the most outlandish pranks to liven things up that could be thought up. Charley didn't doubt it once he met Phil. He was tall with eyes so alive they darn near spoke words. Phil had been a bull whacker, a cowboy, a wolfer, a hand on the river boats, and now was working as a vaudeville actor for Chicago Jo at the Coliseum Theater. He sometimes stayed in the shack with Charley, Slim and the others.

Phil loved Helena—said it was one of the fastest-growing towns in the territory. Phil was a man who wanted open spaces close by, but civilized hotels, laundries, restaurants, theaters and fancy parlor houses near at hand.

Charley wasn't as keen on Helena as Phil was. Living there cost too much, especially when he was trying to save money to go to Europe. Truth was, he shouldn't blame the town because money slipped through his hands. He just couldn't say no to friends who needed a loan. That plus saloon-spending was why his nest egg wasn't building very fast. Toward the end of winter, Charley counted his money and shook his head. He had painted a lot of pictures, and Ben had sold more than two hundred prints. He'd eaten a lot of beans, and wore his clothes down to their last tatter, but his savings hadn't grown much. He laughed about it one day as he sat at breakfast with Phil and Slim. "Looks like it'll be a while afore I step off the boat in Italy."

"Looks to me like you could get about as far as Canada," Phil said. "I'm about to mosey north and look around. Come on along. It's a lot wilder country up there, they say. You'd like that, Charley. No fences. You're always saying things are getting too civilized here. What do ya say? Let's all ride up to Canada now that the weather's decent again."

"You mean you'd leave that sweet little gal you've been runnin' with night and day?" Slim teased.

"You'd ought to be necked by now." Charley said.

Phil slapped his knee with a splat. "That's what we thought," Phil said. "So we did it. My acting career is about to come to an end. Chicago Jo is worse than any German general on discipline, and when she finds out I just married her niece, she'll fire me just for starters, so I'm quitting now and heading north.

"Married?"

"I ain't exactly the kind of husband Jo would have picked out. You know what kind of a roaring temper she's got. I don't want to be around when she finds out."

"Well, if you got a wife, you can't go off to Canada and leave her, can ya?" Slim asked.

"I've got a chance to work as a foreman on a ranch up north. Today I put my wife on a train to the East. When I've got money, and things have blown over, we'll get together again."

"Sounds harebrained to me," Slim said, as he was leaving the shack to go to work.

"Everything I do is harebrained," Phil yelled after him.

"I wouldn't mind visitin' the Indians up north of the border," Charley admitted to Phil after Slim was gone. "I met a few Blood braves ridin' with Pat Tucker." As Charley recalled those times, the urge to ride North increased.

Charley modeled in wax as he and Phil smoked and drank coffee. The figure he was forming bore striking resemblance to Phil, but the stance and clothing was Indian.

"Not bad," Phil said when Charley showed him. He studied the figure for a moment and looked up smiling. "You'd make a damn good Indian yourself, Charley. Let's get made up like braves and have our photograph taken."

Charley scoffed, but when Phil dared him, he went along with the idea. Phil plopped a black wig over Charley's blonde hair. This was going to be fun. They put on the headdress and costumes Phil had borrowed from the theater. As they transformed their appearance, they took on the manner of Indians. Charley tried on a buffalo horn headdress, imitation porcupine necklace, leggings, moccasins, and a blanket, and when he smeared his face with greasepaint and looked into the mirror, he was delighted at the transformation. Except for the blue eyes, he would have thought the image he was seeing in the mirror was of a red man. The imitation was even more striking in Phil as he folded his arms across his chest and strutted commandingly across the room.

"You have such pretty blue eyes," Phil said, "you ought to be a squaw. Me Chief; you squaw."

"You actors really know how to fool the eye," Charley said, and he gamely changed into a woman's buckskin dress. A few dabs of paint and powder, a change in stance, and manner of movement, and they had become Indians. Charley quit using English and talked only in sign. Phil answered in impassioned grunts, and the two strolled toward the photographer's shop, saluting and shouting to people they passed along the way. After posing for the pictures, they stopped at the saloon where Slim Stillwell worked as a faro dealer. Phil accused Slim of living with his squaw while he was away.

"You're crazy? Hey, get this damned Indian out of here," Slim yelled. Phil postured around the saloon, making it clear in sign and gesture he intended to scalp Slim. Charley stood back smiling like a woman in love with Slim. But it wasn't long before Charley had to hide his face to keep from laughing.

Slim looked worried about Phil and disgusted with the sight of Charley. The men at the bar gathered around, and as his audience grew, Phil's performance improved. He was so indignant, so menacing, Slim dropped his cards and couldn't pick them up. Finally, Charley couldn't stand it any longer, and fell against the wall in a fit of exploded laughter.

"Charley Russell," Slim shrieked. "Some goddamned slovenly squaw you'd make! How come you'd bring this crazy fool in here with his damned scalping knife?" Slim still hadn't figured out Phil was not a real Indian.

Though Slim was enraged when he discovered Phil under the disguise, he soon saw the humor of it. After a drink together, Slim was laughing as hard as anyone in the saloon.

Charley told Ben he was riding up to Canada with some friends. "Just wanted to thank you for everything and say good-bye."

"I see." Ben's expression was guarded.

"I didn't save much money—not near enough to go off to Europe."

"Too bad. You worked hard and we sold a lot of prints, but it'd take a long time. What you need to do is put your travelin' money in the bank."

"Aw, Ben. I told you cowboys don't go to banks."

"It's better than putting it in the saloons—if you're serious."

Charley looked into Ben's eyes and held his gaze a few seconds, asking himself how serious he really was about his art. Maybe not as serious as Ben was. And yet, he truly did want to paint as well as he possibly could.

Ben extended his hand. "Good luck. Come back soon."

"I will," Charley promised. Ben was the one man who could help him succeed. Ben believed in him and had horse sense to spare when it came to doing something with his work.

Early the next morning Slim, Phil and Charley set out from Helena together. They were in high spirits even though they had spent most of their remaining money buying supplies. When they ran out of meat, there would be plenty of game. Being without money tended to bring Charley closer to the earth. It made him look deeper at the country around him, its beauty, its dangers. It made him savor every taste of food, every glimmer of sunlight on the precious water.

As the days trailing north passed, town life was forgotten and the challenge of the mountains and plains returned. As they crossed the Canadian border by the Milk River, he looked forward to setting up camp. Phil looked over the terrain wistfully as though he were seeing a scene the others couldn't share.

"Don't tell me, you're missing your sweetheart already." Slim said.

Phil blinked away his wistful look and grinned. "I sure am, and I wonder if she'd like it up here. I've got to start planning things and quit roving around."

"I think she'll like it," Charley said. For a few seconds he envied Phil his new responsibility and the fire in his eyes.

Phil went to work as foreman at the Bar S ranch on Mosquito Creek. Charley and Slim stayed in a vacant cabin near the High River, south of Calgary and rode out to look up some cowboy friends.

One of the cowboys told Charley he ought to meet Charles Blunt. "He's a good artist, and he paints the sort of thing you like." The next day Charley paid him a call. What the boys said was true. Blunt painted wildlife in the western scene.

So, while Slim rode off with his friends, Charley stayed at Blunt's cabin and painted. Blunt was quiet and professional. He sold paintings regularly and worked as an illustrator. He painted vividly realistic pictures, but in a style quite different from Charley's.

After they had painted together for a while, Blunt lit up a cigarette. "Where'd you study, Charley?"

Charley shrugged. "No place yet. Thought I might go to Europe and study the masterpieces in the museums. If I ever save enough money."

"Looks as if you'd studied with the greatest master of them all."

"Nope. 'Fraid not."

"I studied with a good many fine artists." Blunt said. "I learned theories on everything from cave paintings to Benjamin West. I learned short cuts and complicated techniques. I studied anatomy and the chemistry of paint, but what I do when I'm here is try to forget everything I ever learned from all the experts in the world, and just copy nature."

Charley's eyes caught Blunt's and found honesty in them. "But doesn't every artist have to study technique?"

"One way or another, I suppose he does. But nature and experiment are the best teachers."

Charley held Blunt's gaze. "Do you really believe that?"

"I do."

"Don't you think my work needs to be refined—somehow?"

Blunt laughed. "If you want to kill it, refine it."

"But what about technique?"

"Keep practicing. You'll make your own technique, and it'll be better than the borrowed kind."

Charley painted with Blunt often. They sketched the Canadian landscape, and Charley was excited over the sight of the Northwest Mounted Police. They were magnificent horsemen, brave, disciplined, and splendid in their bright red uniform coats. Charley made dozens of sketches of them.

He and Blunt both did an oil painting with the Mounties as subjects, and the Canadian Rockies as background. As the thought of European museums dimmed, the idea of visiting the Canadian tribes of the Blackfeet Indians grew. Charley knew he could paint Indian life better if he knew it better.

Though Charley had gone with Slim to Calgary a few times, he had not met any Blackfeet Indians. Slim was cold to the idea of riding out to find them.

The weeks passed quickly, then Slim reminded Charley they had to get back to Montana in time for the fall roundup. Reluctantly, Charley agreed it was time to go. They rode to the trading post at High River Crossing to get supplies for their return trip. Snow fell in the mountains warning that winter was near.

Outside the trading post, Charley saw a group of Blackfeet Indians. "You take care of getting our supplies, will you Slim? I'm going to talk to those Indians for a while." Before Slim could complain, he was gone.

After a few minutes conversation Charley learned that Black Eagle was one of their band. "I sure would like to see him again." While he talked, Charley modeled the face of Black Eagle as he remembered it. "What do you think?" Charley asked. "Would my friend say I have seen well?"

The Indians passed the small wax bust around. "We will show this to Black Eagle and tell him you are here."

"But I would rather tell him myself. Won't you take me to him?"

"Our band is camped there," the brave said, pointing south along the river. "Come with us."

"I'll get my horse," Charley said. As he picked up Monte's reins, he remembered Slim, and dashed inside the trading post. "I'm going over to the Blood camp a while. See ya later."

"Wait, not now...."

But Charley was already riding off to join the braves who would take him to their camp. Charley rode between the two braves. They were handsome proud men, riding excellent horses. They rode across a ridge above the river. Below, in a protected area a hundred yards from the river, a dozen tipis were set up.

Charley and the braves descended into the camp. A couple of gray dogs slunk silently among the tipis, eyeing them. The women looked up from their work of dressing hides. Then Charley recognized Black Eagle's woman. She averted her eyes. So Charley stared ahead as the brave on his left asked where Black Eagle was. The woman signed that he was inside the lodge. They dismounted, and Charley followed them through the tipi opening.

Black Eagle was seated on a robe, leaning against a willow backrest, holding his pipe. His long black hair was parted in the middle and braided. He wore wide round rings in his ears and an eagle feather in the back of his hair. Caught in contemplation, Black Eagle's face reflected sadness, and proud nobility. When he saw Charley, his eyes lost their sadness. "My friend Picture-Maker. Welcome."

Charley sat cross-legged and smoked with Black Eagle, letting his companions tell of their meeting. He brought out the wax model of Black Eagle and showed it to him. Black Eagle fingered it lightly. "You have kept your friend in your heart."

"I have," Charley answered.

"Why are you in the country of the Bloods?" Black Eagle asked.

Charley explained that he had spent much of the summer visiting and painting in the area. "But I did not want to go back home before seeing my friends. I want to learn more about your People and their ways."

Sadness returned to Black Eagle's eyes. "Our ways are changing. The buffalo is gone. Our People can never be as before."

After a long silence, Black Eagle asked one of the braves to bring Sleeping Thunder and Blood Brother to the tipi. Soon they were all together and the pipe was passed among them. When everyone had smoked, and Black Eagle held the pipe, he announced that they would have a celebration to welcome their friend. Charley was delighted, but he remembered Slim.

Chapter 13

Slim sputtered and fumed when Charley told him he was not leaving yet. "Are you crazy? Everything's loaded up. We can't wait any longer if we want to get back before the snows hit."

"I'm not going. You'll meet up with someone else."

Slim looked menacing. "Hell, you can see as many Indians as you want back in Montana? You can't desert me now."

But Charley wouldn't change his mind. "Good Luck, Slim."

"You bastard," Slim yelled.

At dusk the tom toms beat a savage rhythm. Charley sat in the open camp between Sleeping Thunder and Blood Brother on Black Eagle's right. First, the women danced. Then the men. Charley asked about the dances. He guessed they expressed the Indian's harmony with nature. The movements suggested birds, animals and trees bending in the wind. There was so much about the Indian he wanted to learn. To paint them he had to know more than he could learn by observation alone. He hungered to know them as well as he knew the cowboys he worked with.

As the light of the campfire shone on the bare legs of dancing braves, he noticed the fear-tinged stares of the children and he felt the oddity of his whiteness in this place. Indians had good reasons not to trust white men. He'd heard stories of cowhands shooting Indians that they found on the range butchering a calf or cow, and only wished the cowhands had tried harder to understand.

He turned to Sleeping Thunder. "I would like to learn more of your language."

"Tomorrow," Sleeping Thunder said, "I will teach you many words."

Charley stayed in Sleeping Thunder's lodge. The next day when the others went to the trading post to sell their furs, Charley and Sleeping Thunder went to the river. Sleeping Thunder sat on a large boulder while Charley drew with a sharpened willow branch in the dirt.

"Inniua," Sleeping Thunder shouted in a booming clear voice, making the sign for buffalo. "Inniua," Charley repeated and drew a buffalo in the dirt.

"Imitai," Sleeping Thunder said, giving the sign for dog. Charley repeated and drew.

"Ponokau." Charley drew an elk.

"Apikayi." A skunk.

"Sixtsi." A moose. Charley had no trouble remembering the words, especially when Sleeping Thunder explained. "Sixtsi means Black-Coming-On-Through."

Moose are nearly black in color and when they run, the thickest brush will not stop them from coming through.

On the second day Sleeping Thunder taught him the names of the birds, and the counting of time by watching the moon. "Soon we will have the *Moon when Winter Starts*. That is the time the first big storm usually comes. The next moon will be the *Moon When Geese Fly South*, then the *Moon When the River Freezes.*"

That night as Charley lay down to sleep, he remembered the lessons, going over the words again and again, until his mind wandered, and he recalled the stories Uncle Will told of his life in the wilderness. At age 6, Charley had made up his mind to follow his uncle's footsteps. And the more he had learned of his uncle's adventures, the more firm his resolve became. Uncle Will had married an Indian woman. His eyes glistened as he told about his wife who had died years before. "She was quite a lady, quite a lady," Uncle Will would say.

Sleeping Thunder continued the lessons every day, and by the time the band finished trading and was ready to move back to their winter encampment, Charley could speak the language falteringly. Yet his hunger to learn the history and customs of the Bloods had only been teased. There was much more to know about their traditions.

He wished he could stay with them longer, but they were moving on. He was curious about their winter camp. That was the real Indian life, away from the trading post, away from the white man.

He went with Sleeping Thunder to wash in the icy waters of the High River, thinking how he would miss the People. Vitality and excitement was in each step Sleeping Thunder took. "Why does Picture Maker walk with gloom?"

"Because I must soon say good-bye," Charley answered.

Sleeping Thunder knelt down and splashed himself with water. "My brothers and I want you to come with us and live in our camp as long as you like. At our winter camp many old men who have seen great battles can tell you the things you want to know."

Charley knelt beside Sleeping Thunder, splashed his face and chest with the freezing water as unflinchingly as Sleeping Thunder did. "When are we leaving?" he asked.

By the time they returned from the river, the women were taking down tipis and loading their belongings on their travois. The men were ready to ride.

An undercurrent of excitement crackled in the air, as though a yoke were lifted off the People. They moved with renewed agility. Their eyes held purpose one moment, wild gaiety the next.

The band rode for three days before they saw the smoked skin lodges that dotted the valley. Charley followed Black Eagle and Sleeping Thunder down the slope and into camp. Dozens of dogs slunk silently among the tipis, and the air was heavy with smoke and the smell of meat. The sound of children squealing at play mixed with the squawks of crows.

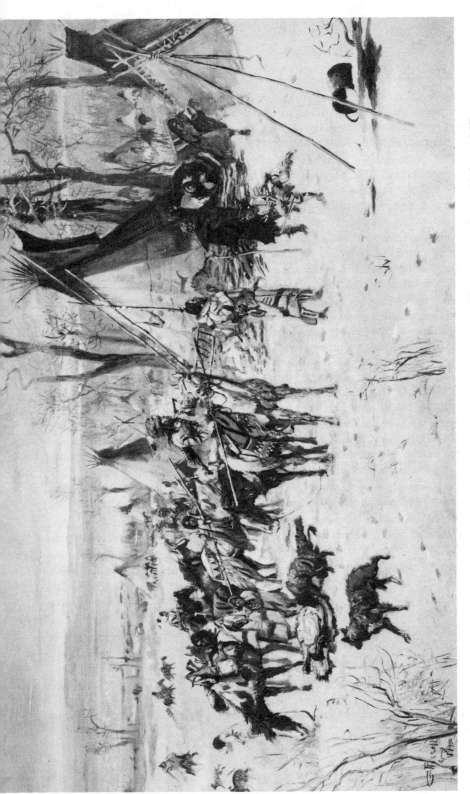

INDIAN HUNTERS' RETURN, Oil, 1900. Courtesy of the Montana Historical Society, Helena, MT.

As they entered the camp, riding toward a center clearing, the People stopped what they were doing to greet them. Soon the quiet village became a swarming, buzzing, giggling, shouting, happy clamor. "And who is this man?"

"He is Picture Maker." The People stared suspiciously at him. Then Black Eagle showed the wax head Charley had made. One by one the knot of people came closer. A small boy laughed and wanted to touch Charley's hands. An old woman put a ring shaped like a butterfly on his finger. "It will bring your dreams to you," she said.

The supplies from the trading post were distributed and as the excitement of homecoming faded, Charley was taken to meet Chiefs Red Crow and Medicine Whip. When he spoke to them in their own language, they called him friend and invited him to smoke with them.

Medicine Whip was the ancient warrior Sleeping Thunder had told him about. He looked very old and bore many scars. A deep gash followed his wrinkled face from his hairline across his left eye, ending at the point of his chin. The bone of his cheek was caved in, his jaw crooked. Another scar spread from under his nose to the corner of his mouth. For a fleeting moment Charley remembered the bodies of the Crow Indians he had seen on the cattle drive. How many such skirmishes had Medicine Whip fought and survived? Charley wanted to know everything about the battles and the hunts.

The next day he went to Medicine Whip's painted tipi, approaching cautiously, calling out, so as not to intrude. A girl pushed open the flap of the tipi and gestured for him to come in. He paused and stared. He had never seen a clearer gaze, a more flawless bronze skin or a more perfectly proportioned figure.

"Come, my uncle expects you." She smiled as though he amused her, tossing her head as she stepped back to let him enter.

Medicine Whip sat cutting red willow and tobacco with a long butcher knife. Without looking up, he made the sign to sit down. Charley sat cross-legged, waiting.

The girl brought some half-boiled beef and a greasy bannock on a tin plate. She set it on the ground before Charley. She did not turn her eyes away, but looked at him squarely as she served him. Her look sent a prickling through him. "I am Swan Watcher," she whispered, then moved away again.

Charley spoke of the tribe's hospitality to him, recounting his first meeting with Round Eyes. Medicine Whip smiled at the story of Pat's burning tipi.

"They say you have fought many battles," Charley began.

"I have counted coup more times than I can remember. My medicine was good and protected me."

"Counted coup?" Charley repeated, wanting to understand exactly. "Does that mean killing the enemy?"

"It means striking the enemy first with a lance, a quirt, a coup stick or the body. To count coup bravely on an armed enemy brings honor."

"Did you count coup when you got that deep scar across your face?"

"Many winters have passed since then," Medicine Whip began. Charley waited, knowing he must be patient. Medicine Whip would speak in his own time. Sleeping Thunder warned Charley not to hurry or prod the old man. Charley cleared his throat and changed his position, but Medicine Whip fell into a sleeplike trance and spoke little more. After a while he asked Charley to come again.

Charley came back the next day at the same time. Swan Watcher was in front of the tipi, scraping an elk hide. He suspected he shouldn't speak to her, but thinking he'd probably be considered ignorant and forgiven, he spoke. "I hope I'm not too early."

She glanced up with an amused look. "Too early for what?"

He smiled. Her eyes teased. "To see your uncle."

"Picture Maker speaks so softly. Is it because he is afraid of being scalped? Is that why his hair is so short?"

"I speak softly because I'd hate to be thrown out of camp for my bad manners."

Swan Watcher's eyes continued to tease. "'Why do you talk to me? I have no war scars."

Charley felt himself redden as he watched the girl scraping the hide. "You're very pretty," he whispered, turning to enter the tipi.

Medicine Whip signaled Charley to come and sit with him.

Charley scanned the wizened old face. "Black Eagle and Sleeping Thunder have told me you are the greatest warrior here. Will you tell me about your battles?"

"Why does a white man care about Indian battles?"

"I want to make pictures so many people can know of your past battles."

"Ah, picture medicine is better than talk. Many will see. Words disappear into a few ears and are gone." The old man nodded his head, and Charley waited.

"My ancestors and relatives were all fighters," Medicine Whip began. "When I had seen only three moons, my mother was killed by a Sioux war party as she gathered berries. When the People found her, I was asleep, soaked in her blood. And it was said to be an omen. I would be a great warrior; it will be bad for the Sioux that meets the boy that slept in his mother's blood. And it was true. I took many Sioux scalps before I was a man.

"I was twenty-five when the Crows burned our People's range and drove the buffalo south. We were hungry for meat, but even hungrier for enemy scalps as we followed the buffalo. After many days we heard the rumble of the running buffalo herd and knew the enemy would be near. At the sight of their tracks, we stripped for war. I painted myself with a red handprint under my nose, showing I had drunk the enemy's blood. To keep the hair out of my eyes I wrapped the foretop in

weaselskin. Then when I was ready, I lit my warpipe, smoked it and held the mouthpiece toward the sun, asking the great father to make our medicine strong.

"Across the next hill we sighted Sioux, riding among the herd, hunting meat. Our war party waited, letting them tire their ponies. Then we slipped into the dust of the herd, and before the Sioux knew we were there, three of them were dead. The rest ran as fast as they could, but their horses were tired, and they had to make a slow running fight. I killed the Sioux medicine man, sending an arrow into his heart. Their party gathered in to defend themselves. The Sioux had guns while we had none. When they shot we could do nothing but take cover and wait. Twice we charged, and twice we lost some of our party. Our arrows and lances were not stronger than their guns. But we were ready to charge again, and were only waiting when we heard one of the enemy shouting in our own tongue. 'It's no credit to a Sioux to take the hair of a Blood. That hair is good only to trim squaw leggings or make wigs for dolls. We take Blood prisoners and keep them to pack water for the squaws.'

"Then this Blood-speaking Indian turned his insults on me, calling me a maggot, and worse. He had to be silenced. I threw my bow and quiver down, lashed myself with my rawhide to my pony and charged. I was among them before they saw me coming. I went after the bad-talker and drove my lance into his ribs. My lance was imbedded in his body, leaving me nothing but my quirt and shield. The last I remembered I struck the chief across the back with my quirt. I did not feel their arrows piercing my legs and thighs. The enemy was scattering when a Sioux hit me with his tomahawk, and I was down, bleeding from my eyes, nose and cheek. For a time the battle left me in silence. But my charge had rallied the other Blood warriors, and when I opened my eyes again, one of my friends put a knife in my hand and told me to take the scalps of those I had counted coup on with my quirt. This I did, crazy with the pain of the wound and the blood of the enemy."

His story told, Medicine Whip leaned back against his willow backrest, his eyes raised and lolling toward the back of his head. His hand came up and touched the long scar on his face. Charley saw the memory of that battle reflected again in the old warrior's expression, and he could smell the blood and feel the echoing pain of the tomahawk's blow. He would paint that battle some day.

Charley painted with a hungry frenzy during those first days in camp. He sketched the children playing, the women cooking and fleshing hides in front of the tipis, the braves riding to the hunt. He sketched Swan Watcher as she went to the river for water, as she rode her pony. He had never seen a woman ride as well as Swan Watcher. She must have anticipated every move her horse would make. Once he saw her standing on a trotting horse's back. It was a sight so amazing he hardly believed his pencil when he sketched it.

For the first weeks in camp, they ate salted meat and bread made with flour, but as the supplies from the trading post gave out, the fare changed. A meal cake made of crushed seeds and berries and fresh unsalted meat became the staple.

Charley missed salt with increasing intensity. At night he dreamed of salt licks, salt mines, mountains of salt, plates of salted haddie he used to eat in St. Louis. But Sleeping Thunder only laughed at him when he asked if he craved salt too. "The People do not need salt or sugar. What Picture Maker needs is a woman to take his mind from his other tastes." He laughed.

Charley wanted a woman, but the Bloods were protective of theirs. There were no sporting women like those he had seen in Montana, where an Indian man might offer his wife to a cowboy for a price. In the Blood camp, he could get in trouble over women if he wasn't careful. No, he'd be better off craving salt.

Charley made toys for the children out of driftwood or twigs. He would carve a face of wood, attach moss for hair and scraps of fur for clothes. One day he fashioned an Indian boy on a rocking horse, and when he finished the toy, several women and children gathered around to see it, Swan Watcher among them.

"Picture Maker's hands are always busy. But how is it he doesn't make pictures any more?"

"My paints are nearly used up. My paper is gone. Even my brushes are not so good."

"Our People paint with buffalo bones on skin tipis, on shields and parfleches, using paint the women dig and bake," Swan Watcher said. "Could you not paint as the People do?"

Charley smiled at her. "I could. I am almost an Indian. Isn't that so, Little Owl?" Charley tousled the hair of the boy with the toy.

Dusty Star, a large quiet woman and mother of Little Owl, stepped forward. "I will give you paint I prepared: yellow and black from the banks of the Marias River, green from the Sweet Pine Hills and red made from clay found two sleeps south. I will give you a buffalo bone to paint with."

Another woman paused for a moment in her work of fleshing a pegged skin. Still holding the bone flesher, she stooped down and examined the toy in the boy's hand. "I have an old tipi that I have been making moccasins of. It is smoky and worn, but there are some good pieces to take the paint."

"Thank you." He rubbed his hands together, anxious to try painting the Indian way.

That afternoon he began a painting of an Indian woman at the river. It was an image of Swan Watcher that had stayed in his head lately. She drew his eyes often as she moved gracefully—like a young mountain lion, sure-footed, proud, ready to leap, ready to strike, but stalking easily through her terrain. He had seen her leap from rock to rock one day, her arms extended for balance, and no dancer could have moved more beautifully.

Charley shared the tipi of Sleeping Thunder and his mother, Two Blue Lakes. He sometimes helped her with her chores, though she scolded him for it. Then he learned to do things for her when others weren't watching.

One morning Charley reached for his pants, groping all around, but couldn't find them. He rubbed his eyes and felt for his boots. Not finding them either, he got up. His boots were worn through the toes and soles, but they were all he had. "I can't find my pants or my boots."

Sleeping Thunder looked up from the fire. Two Blue Lakes laughed. "Not even a hungry dog would chew on Picture Maker's boots."

Sleeping Thunder smiled, then pointed to a package. "What's that in the place where your boots stood?" Sleeping Thunder picked up the bundle and unwrapped it. "Beaver leggings," he said. Something else fell out of the package. Charley reached down for it. "A beaver skin mitten," he said, holding it up to Sleeping Thunder.

"And here is another. And bearskin moccasins with the fur inside to keep your feet warm." Sleeping Thunder gave the things to Charley. "Someone has traded your boots for new moccasins, leggings and mittens. And your pants have been patched with buckskin."

Charley felt the soft beaver fur of the mittens and leggings. He swallowed. "Are you sure this is for me?"

Sleeping Thunder shrugged, but Two Blue Lakes left the pot she was stirring at the fire and picked up the leggings. "These are for you."

"Did you...?" Charley felt a lump in his throat, and had to finish the question with his hands.

"The moccasins—yes, I made them and I mended the pants. But Swan Watcher made the mittens, Dusty Star, the leggings."

He picked the mittens up and brought one to his mouth, feeling the soft fur tickle his lips and nose. "How can I thank you?"

"We are your mother and sisters while you are here."

He put on the leggings and moccasins. "They are perfect," he said laughing. He grabbed Two Blue Lakes and kissed her on each cheek. She laughed and pushed him away.

"I must thank Dusty Star and Swan Watcher."

He went to Dusty Star first, then to the tipi of Medicine Whip. When he came inside, Swan Watcher was grooming her uncle's long gray hair with a porcupine quill brush. "I have come to thank Swan Watcher for these," Charley said, showing the mittens to Medicine Whip.

Old Medicine Whip looked at the mittens indifferently. Charley's eyes met Swan Watcher's. "You are kind and I thank you."

"They will keep your hands warm enough to make your pictures."

"Stop girl, you're pulling," Medicine Whip interrupted.

"I'm sorry."

"Tap my back where it always hurts."

Swan Watcher leaned Medicine Whip forward, and with the brush pulled over her knuckles, she tapped vigorously with the sturdy quill tips between Medicine Whip's shoulders. "Higher," he said. She tapped higher and harder.

After a moment the old man sighed. "The pain has floated off."

Swan Watcher tapped him a few more times. Charley asked if he could see the brush. "You are a curious one," she said, but handed it to him. He tapped his arm with the quills and felt the sharp prickly sensation. "And this takes away pain?"

Swan Watcher nodded, took the brush and put it away. Charley turned to Medicine Whip. "I came to thank Swan Watcher for the fine mittens. Such a kindness earns a kiss where I come from."

Medicine Whip looked away, and Swan Watcher pretended not to have heard. Charley advanced toward her, but she darted away from him. She did not smile, but he sensed she took it as a game, and he dashed in front of the tipi to block her way. She pretended to ignore him but when he moved toward her, she was quick, slipping around him and out of the tipi.

Medicine Whip laughed. "Picture Maker moves like a turtle. But even a turtle can follow the fly to the water."

Charley went outside. The air was bitingly cold, but Swan Watcher was nowhere in sight. Other times he had seen her go to a place behind the rocks. Would she go there?

He reached the river's edge and glanced at the spot where he had seen her before. She *was* there, huddled against a rock, wrapped in her blanket. He hurried toward her, running like an Indian now in his moccasins, and wanting Swan Watcher like a man. She glanced up at him, and did not dart away. Her face was serene as though nothing was going to happen. Maybe he shouldn't, he thought, but in the next moment his arms went around her and he kissed with more force than he intended.

She wriggled away from him, but looked up wide-eyed. "Picture Maker flutters my heart." She drew her blanket around her, covering the lower part of her face. But for a moment her eyes did not move from his. Then she lowered her head and darted away from him. "Swan Watcher," he called softly after her, but she did not turn around.

That evening in Sleeping Thunder's tipi there was very little meat left. It was time to hunt again. This time Charley asked to go. He hoped to earn his keep by bringing meat to Two Blue Lakes.

At daybreak, Charley, Sleeping Thunder, Round Eyes and Black Eagle rode westward in search of meat. A fresh snow had fallen during the night. The cold penetrated quickly, though they wore their heaviest clothes. Charley wore a beaver hat which had belonged to Sleeping Thunder's father before he was stricken in the small pox epidemic winters earlier.

The men took four pack horses and rode steadily, marking the trail often. They joked, galloped and constantly observed their surroundings. While Charley saw the scene in terms of pictures and paint, his friends saw every detail out of their instinct for survival. Though they knew the territory, they stopped and looked around on all sides, noting smells, the direction of the wind, the look of the far hills, the distances between landmarks.

Before sunset they came to a flat knoll in a wooded tract. Black Eagle called to the others. "We will put up our hunting lodge here." They set to work clearing the snow away from the spot and setting up their canvas tipi. With a spring nearby, there was no need to melt snow over the campfire. They ate their dried meat and drank of the sweet water. After their meal the three braves described many great buffalo hunts, and their telling was so vivid, Charley could hear the thunder of a thousand hoofs, smell the clouds of dust and feel the excitement of the kill. They smoked and slept, the cry of wolves and coyotes piercing the night.

Early the next morning they set off with their guns, Charley and Sleeping Thunder rode along the creek, the others took the high ground. The wind was strong and Sleeping Thunder rubbed a mixture of herbs and bear grease on his body to cover the scent of man. Charley did the same. Then, walking some distance from each other, they sighted a large elk. Charley raised his rifle and shot. At practically the same instant another shot crackled. The elk lunged once, then dropped. Charley glanced at Sleeping Thunder who smiled, lowered his rifle and loped toward the fallen elk. Charley followed, breathless when they reached the animal. Sleeping Thunder knelt down and slit the elk's throat, slashing his knife downward through the belly. "This meat will feed many. And now we will have our reward." Charley stooped down beside his companion, noticing the efficient way he gutted the elk. In a moment he turned, holding the dripping liver up close to Charley's eyes. "Our feast," Sleeping Thunder said as he slit the liver in half and handed a portion to Charley. "Eat—before it gets cold." Sleeping Thunder thrust his portion of the still-palpitating organ into his mouth, biting it savagely. A dark sticky redness colored his mouth, his eyes closed as he savored the moment. Charley stared at the raw liver in his hand, still warm from the elk's body. It smelled of blood and life.

"Eat if you are truly Indian," Sleeping Thunder said, then ripped off another piece with his teeth.

Charley hesitated. Was he really Indian, living the natural way? Or was he still a half-hearted white man? Was he as free and wild as he had thought?

"Eat."

Charley tossed the liver into his mouth, chewing off a piece quickly, tasting the oozing blood, savoring the flavor of salt he had craved. Then, feeling Sleeping Thunder's knowing eyes, he chewed and licked his lips.

The two men shared a bond of acceptance and communion. Any reserve that had existed between them was thrown off. Truly they were brothers. Though

nothing was spoken, they lifted the meat onto the pack horse solemnly as one person. The People.

Just before they reached the hunting lodge, Charley shot an antelope. They would have as much meat as they could carry. Round Eyes and Black Eagle had returned to camp earlier with a grizzly bear Black Eagle had shot. "I will get a fine claw necklace from this one."

They clustered around the campfire that night in a happy mood. Round Eyes asked Charley what his white man's name meant. "It means I am Charles Russell—nothing else."

"You deserve a name that means something," Sleeping Thunder said. "It is time you took an Indian name."

Black Eagle laughed. "Yes, a hunter of elk and antelope has earned a man's name."

Charley laughed, walked across the lodge to pick up another piece of wood for the fire. Sleeping Thunder, looking after him smiled. "Antelope would be a good name. Look at him."

The others laughed. "We will call him Antelope."

Charley tossed the wood on the fire and turned to the others. "Why Antelope?"

"You have a light-colored buckskin patch on the seat of your pants. Walking away, your back side resembles the rump of an antelope."

Charley smiled. "Call me Antelope."

They started back to the village the next morning, ready to shoot another animal along the way. The sun was bright and the ride pleasant. About halfway home, Round Eyes shot a deer. Dusk had fallen as they came down the ridge into the camp. The sky was dark and the tipis of the village shone bright against the night sky, glowing from the campfires within. Shadows could be seen moving inside. Even the smoke that floated above the tipis carried some of that iridescent light into the night only to be lost there.

They brought the meat into camp as tom toms drummed and a crowd gathered. Before long, chanting blended with the sound of the tom toms, and dancing began. Swan Watcher was among the dancers. Charley looked on her with his tribesman eyes and saw her beauty and the smoldering fire in her eyes, unmistakably directed at him. Always before he had watched the dancing, but had not danced. Tonight though, his eyes met Swan Watcher's every time she turned her head toward him. She came to him. "Join us in the Sina-paskan," she said. He followed her. The men and women dancers stood in opposite lines. Charley's heartbeat quickened with the drumming of the tom toms. The women swayed and stamped their feet as they eyed the men. The men danced, ignoring the women's stares. Charley watched the rhythmic thumping of the men's feet, the curling of their backs and the thrusting of their shoulders. He thumped his feet and raised his knees as they did, aware of his woodeny performance. As he danced, his heart felt lighter. Soon the women advanced upon the men, each woman singling out one man. Swan Watcher laid her

hands on Charley's shoulder, sending a shudder through him, but he did not stop dancing. Then her hands went to his face. Within the rhythm, she took his face in her palms and kissed him. Each of the women did the same with the man she had chosen.

"And now you must give me a present," she said. "Elks teeth would be my choice."

"You will have them." He would have given her anything she asked for. "Will you meet me tonight where we met before?" he asked.

She laughed, tossing her head back, her eyes teasing him. But she did not say no.

The dancing and feasting lasted far into the night, but finally the People returned to their tipis. Charley waited until Sleeping Thunder and his mother were asleep. Then he went out, and ran down the path toward the rocky shelter by the river. She was not there so he waited. Finally he saw a shadow—her shadow. As she ran along the path to meet him, his pulse pounded, and he anticipated the warmth of her body pressed close to his.

Chapter 14

Blizzards raged. While Sleeping Thunder made snowshoes, Charley wished for watercolors, wax or clay but he used whatever material he could find to form images that crowded his brain. He scratched on rock with flint, modeled in snow, and drew on cast-off scraps of skins with pieces of charred wood. He drew Swan Watcher in many poses. Sleeping Thunder looked over his shoulder one day and laughed. "Why doesn't Antelope marry her?"

Charley's hand stopped drawing. "I have nothing to offer her family."

"It is true; she is worth many horses, but her uncle wants to see her married to someone who will treat her kindly. He does not need horses any longer for he is too old to ride much."

Charley looked off, imagining Swan Watcher's face.

Sleeping Thunder tapped Charley's shoulder. "Many men want her, but her eyes are on Antelope. It is good."

Charley glanced up. He hadn't intended to stay more than one season—just long enough to learn all he could. But the People opened their hearts to him. They admired his picture-making enough to call him medicine man. He hadn't expected to feel like one of them. He smiled at Sleeping Thunder. "A man would be lucky to have Swan Watcher in his tipi."

"I hope my friend will marry her, and remain my brother forever. I can arrange everything with Medicine Whip. But be warned, another brave is about to send his parents to talk to her uncle. If you see her carrying food to another's tipi, it will be too late."

"Another?" Charley felt a stab of alarm. "Who?" he asked.

Sleeping Thunder refused to say more, and went off to check on his horses. The old woman was sewing and dozing against her backrest. Charley looked down at his drawing, a study of Swan Watcher seated on a rock, gazing into a pool. It reminded him of the dreams he had shared with Lollie. His feelings were even stronger now when he took Swan Watcher into his arms. With her, there was more than innocence and talk of some day. Swan Watcher quivered at his touch and did not shrink away from what they both wanted. It was he who shrank. One evening as they talked in the shadows, he instinctively began to make love to her, covering her face, neck and hands with kisses. But then he remembered she was the niece of an important chief who had befriended him. She was a maiden. Charley looked at her lovely face, shook his head and moved away. Swan Watcher was bewildered. He couldn't make her understand. When he looked back at her, she sobbed.

Could he marry her and have a tipi of his own? Uncle Will had taken his Indian wife away to the trading post; had not lived as an Indian. Yet Charley couldn't imagine living on the outside with Swan Watcher. She was a woman of these ways. She would be unhappy in Helena or some cow town, or in a cabin in the woods away from the People. He didn't want to see her eyes clouded with sadness. As much as he loved the People, he doubted if he could stay here like this forever.

It saddened him to think that even the People could not stay as they were now. What had happened to the Indians in Montana would happen here. The South Piegan's life was changing rapidly. The Bloods, too, would be sent to reserves where they could not roam far enough to kill the meat they needed. They thought they could stay as they were, but Charley didn't believe that. The buffalo was gone. Yesterday was gone.

Five moons had passed since he came to live with the People. He became one of them and yet he still wanted to paint pictures for the white man's world. That was why he came—to learn enough to paint the Indian authentically. Now he yearned to translate what he knew to lines and color for that world outside. That world was in his mind even as he painted Swan Watcher gazing into the pool. He wanted others to see the beauty he saw.

He couldn't look at her without swallowing the lump in his throat. He couldn't touch her without feeling a burning need. She knew what her touch could do to him. She laughed at him. But it was a loving laughter that seemed to stroke him and tell him she would be willing.

Then one morning wind from the west brought warming to the plains, and he could hear the chattering of people outside. He went outside too, thinking he would ride Monte to the bluffs. If Swan Watcher were his woman they could ride together.

The break in the cold weather brought smiles to the faces of the People. His eyes sought out the braves. Which one wanted to marry Swan Watcher? Perhaps Broken Arrow, who traded with the Crees a few weeks ago. It was said he bought a love potion from them, though he denied it. Could he be trying to win Swan Watcher?

Reaching the pasture where Monte waited, Charley saw that many of the horses were gone. It was a day for riding after a long cold stretch in camp. Charley swung his leg across Monte's back and saw his shadow on the snow. He was struck by change. His hair had grown to his shoulders. He wore moccasins, leggings, and a buckskin shirt. Though he still wore his wide sash, he seldom put on his Stetson or his old blue pants. He was more Indian than not.

He rode aimlessly, smelling the coming of spring in the air. Spring meant roundup, but that life seemed so far away—another world. Near the bluffs, he saw a roan pawing the ground. That was one of Old Medicine Whip's horses. His heart quickened. He had been here before with Swan Watcher.

He dismounted near the roan and went around the ridge. She was there, her arms extended toward the sun. What a picture it made; the sunlight shining on her face and hair, her womanly figure strained upward. He scrambled down the side of the hill, and she turned to him with a smile. "Did you follow me?"

"I am here."

She looked down. A heavy silence stood between them until he took her hand and walked with her. Her hand lay warm and trembling in his and as wisps of her long hair blew into his face, he kissed her, gently at first, then with growing passion. She tugged at his ears, then let her fingers wander through his hair. She murmured and unfastened the top of her dress, offering him the patch of flesh inside her shoulder. He nuzzled his face there, inhaling her elusive smoky essence as her fingers stroke his back.

He felt the desperation in her kisses, saw a wildness in her eyes. "Be one with me tonight," she whispered. "My uncle will be away. Red Crow and his holy woman will open their great medicine bundle. My uncle will assist. There will be much chanting and dancing; the ceremony will be long."

Charley looked into her eyes and nodded. He could resist no longer. "Be careful," she said. "No one, must see you. And do not worry. I have been drinking the tea of the stoneweed root."

There was no turning back now. His heart beat faster as he watched her riding back to the camp. Then he rode Monte in the other direction.

Charley asked Sleeping Thunder about the medicine bundle ceremony. Swan Watcher had not exaggerated. It would last a long time. Everything had to be precisely performed and each of many spirits invoked through gesture, prayer, chants and dancing.

After the evening meal he painted awkwardly, his thoughts in tumult. "What is tea of the stoneweed root drunk for?" he asked.

Sleeping Thunder smiled. "The women who don't want to have babies drink tea made of the crushed root."

"Oh," Charley said.

Swan Watcher waited with a pipe lit for him. The tipi fire was small and would not cast much light. He sat down on the buffalo robe with her, thinking it could always be like this. After they had smoked and whispered together, he put the pipe aside and drew her near.

Her look told him she had wanted this as long as he had. As they lay naked on the soft buffalo robe, their bodies came together as naturally as snowflakes falling on the earth. She was soft, smelling of fresh sage, murmuring and groaning low, echoing his own great pleasure. Her smooth palms drew him closer and his passion grew and exploded all too quickly into trembling bliss. When it was over, he lay breathless at her side with the smell of sweet pine smoke drifting around his head.

"Is Antelope glad?"

"More than glad." He ran his hand up her arm, across her shoulder and the side of her neck, letting his fingers rest under her chin as he gazed at her. Her eyes shone, and a smile lit her face.

"My heart is in the sky," she whispered.

"And mine is with it." He kissed her hand and the braid of her hair.

"I want to live with you in a tipi of our own," she said.

Looking at her, he could think of nothing he would like more than that. "In a tipi of our own."

She embraced him and sighed. "I will thank the great Sun God every day for sending you to me."

"You won't have to do that."

"I will. And I will thank Him for letting this happen before my uncle arranged a marriage for me with Standing Bear."

"Standing Bear?"

"He wants to marry me, but he does not touch my heart. Antelope does."

Charley knew Standing Bear to be an honorable brave and a good hunter.

"I have made my marriage dress of white buckskin and trimmed it with ermine and bells and with each bell and ermine tail I sewed on it, I prayed the Sun Spirit would send me a man who would take me to the sky." She laughed.

He imagined her in her white buckskin dress. She would be beautiful; the bells would tinkle softly as she walked.

"But listen," she cautioned, her hands signing alarm. "I hear Red Crow's dogs barking. The medicine bundle ceremony might be finished. My uncle...."

Charley got up and pulled on his clothes. "Tomorrow," he said, as he stepped through the tipi opening. "Tomorrow," she whispered.

The next morning he awoke to wind howling outside. Another storm. He smiled, recalling the warmth of the night before, Swan Watcher's body responding to his touch. In his mind she stood before him in a white buckskin dress trimmed with bells. She would be wearing white moccasins and a white feather in her hair. He wanted to stand beside her and take her hand. He would have to act soon.

But the thought of Standing Bear brought another picture to his mind. They said he could bring home meat when no others were successful. His powers were strong. Charley did not like killing animals. It was necessary, and he did his best, but as Swan Watcher's husband he would have to bring in meat regularly. If there were children, he would have to provide for them. And he hadn't always been able to feed *himself*. To keep a wife and children and an old uncle would mean he must hunt well for as long as the game was there to hunt. Dreamily, he saw himself older, and with a family, his picture-making as useless a skill as buffalo-hunting. He would never take charity from the government. All he really knew was cowpunching and modeling and painting.

He had painted to amuse his friends and because it was a challenge to put down what he had seen so others could recognize it. But he had been practicing for something bigger—he didn't know quite what. Then Ben had shown him how his painting could be a way of preserving the West in a time of great change. When he picked up his brushes now, he was seeing scenes as a lover of the land, neither white, nor red. He was seeing a disappearing frontier. And he wanted people to remember the way it was. But what people? Swan Watcher? His mother and father? Ben, Pat, Jake? The People? He sat up and pulled a blanket tight around him. Now the sound of the wind made him shiver.

He painted Swan Watcher in her white dress, but he could not put himself in the picture. The picture was of the beautiful Swan Watcher alone. He could hear the faint tinkle of bells in his head.

He found her waiting for him by the bluffs where he knew she would be. She rushed to him and threw her arms around him, and he held her close. He was so tortured by the pleasure and pain, he could not speak. He choked on the words. Finally, she stood back, looking at him.

Her image blurred before him. "I cannot marry, Swan Watcher. I am a picture-maker and a cowboy. I am not a hunter or a medicine man. I am not right for you. You need a husband...like Standing Bear."

She lowered her head and clasped her hands. "Will you pluck my heart from the sky and hurl it to the ground?"

"Swan Watcher, please, I want you to be happy. Your heart will fly again. I do not belong here. I thought I had become Indian. Part of me will always remain Indian, but there is another part. I am a picture-maker and a cowboy."

She looked at him with such sadness, his own heart felt squeezed and small. He wanted to take her in his arms and change her back to the happy woman of the night before. But it would only hurt her more later. "I'm leaving tomorrow."

"And you will forget you ever knew Swan Watcher." She started to cry and moan.

"No, I will never forget."

When he told Sleeping Thunder of his decision to leave, his friend begged him to wait a few weeks until the weather lost its sting. But Charley would not. His decision was made and now he had to act.

"You will ride three days before you reach the trail to the south. The way will be hard."

"I will sleep here tonight and be rested when I start."

Sleeping Thunder gave him meat and new moccasins. At dawn Charley saddled Monte and rode away, pausing to look back with sorrow at the quiet village.

He had not progressed beyond the bluffs when he heard a horse galloping toward him. He turned to see Swan Watcher, and reined Monte to a stop. She

looked steadily at him, her face serene, more beautiful than ever. He reached out to her.

She took his hand. "I brought you something—so you will not forget me too soon."

He shook his head and started to speak, but she thrust a bundle into his hand, dug her heels into her horse's flank and galloped off. He was tempted to turn Monte around and chase her. But he looked down at the bundle and kept going.

The snow was blown clear on the ridges, making easier footing for Monte, but the wind assailed them with its fury until he had to drop down to the valleys, picking the way more slowly. The bitter chill obliterated the pain of leaving. He stopped only to rest Monte, and all the time he scanned the skies, knowing the open range lay beyond Canada to the south. Cattle country. His home. Montana. The Judith Basin. The roundup. God, he was cold.

Chapter 15

After three exhausting days of riding, Charley turned south onto the Whoop-Up Trail, his head hunched down into the blanket he'd pulled round himself. The pain of bitter cold that had dogged him steadily gave way to numbness as he let himself sleep in the saddle.

A loud grinding noise awakened him. He rubbed his eyes and looked around. The noise grew louder. Then he saw it. Behind him on the trail was a wagon train being pulled up a hill by a team of oxen, the wagonmaster riding beside it. A train that big moved slowly, but it would be warm in one of those wagons. He turned Monte and rode toward the wagon boss.

The boss quirted his husky dun and cantered to the head of the train, turning his hard-joweled, mustached face to Charley.

"Howdy," Charley said, smiling at the burly fellow. "Could you use a hand in exchange for a place to bed down and some grub?"

"How fer you goin'?"

"Montana."

The man scratched his mustache and scowled. "A half-breed renegade ain't goin' to be much help to me."

"My name's Charley Russell. I'm headin' back to the range for roundup."

"You ain't no half-breed?"

Charley shook his head.

"I don't trust strangers with long hair. You could be a damn scout for a robbin' party." The man's eyes glinted as though he prided himself on his gruffness and respected the same in others.

"I could be Buffalo Bill."

The man spat. "Don't care none for long-haired half-breed bigmouths neither."

"And I'd usually walk a mile to stay away from a bastard with such a damn rat's nest under his nose, and reeking of rot-gut whiskey."

"Rot-gut, shit. The best Scotch whiskey is what I drink." He scowled. "What turns my stomach most is a goddamn dirty drifter wearin' Injun harness and smelling like a goddamn lousy mule."

Turning his horse to ride away, Charley shouted back. "I'm glad as hell my Indian friends gave me some clothes to wear."

The wagon boss yelled back. "Do you know how to use that damn Colt six-shooter you're a wearin'?"

"Sure as hell," Charley said, "but I ain't wastin' no bullets on the likes of you!"

"Shuddup now, I ain't takin' no back talk from a man's workin' for me. I'm the boss in this here outfit." The man smiled and extended his hand. "Johnny Mathison's the name."

When Charley felt the firm grip of Johnny's hand, he grinned, too. "Well, I'm too damn tired to talk back anyway."

He rode alongside, listening as Johnny told what needed to be done. The oxen plodded along, keeping their slow pace, the crack of the long whip exploding just over their heads. "Where're ya comin' from?" Johnny asked.

"Visitin' friends." Charley gazed off ahead.

"I'm takin' my cargo to Fort Benton."

That night Charley slept in a wagon with two other men and a wagonload of furs. His stomach was full and he'd drunk coffee strong enough to keep him awake a few minutes to enjoy the luxury of being warm.

The wagon train made painfully slow progress, but Charley was glad of its shelter. The treacherous cold had weakened him and he knew a man could easily lose his way and perish in a March blizzard.

Johnny kept the wagon train going by the strength of his muscles and his will. If a wheel broke down, he saw to fixing it quickly. He watched the animals and knew exactly how much they could do. Charley coaxed some unbelievable stories out of him in the evening, tall tales of single-handedly holding off a whole tribe of marauding Indians out to get his cargo of whiskey. He really did have a supply of the best Scotch whiskey, but he rationed it out among the men carefully. Two drinks a night. "And not a drop more unless it's a hell-blowin' blizzard."

When he saw Charley painting on the side of a wagon box, he yelled loud enough to shake snow off the hills ten miles away. "What in Christ ye doin'?"

"Drawin' a wagon train on this box. What's it look like?"

"I never hearda drawin' on a box. Let's see that damn picture."

Charley stood aside and let Johnny examine it. "Hell, I'll be struck fartless, if this ain't good. When did you larn to draw like that?"

"I'm still learnin'."

"No, you ain't. You're a goddamn artist feller, you sonofabitch."

Johnny's compliment encouraged Charley to finish the painting with all the skill his cold hands could muster. And when it was done, Johnny showed it proudly to the other men. "You don't see pictures that good in them slippery damn magazines." Johnny counted the number of oxen in the painting and checked to see if Charley had the harness right. He nodded. "And I've seen the hills look exactly like that jest afore dusk."

Johnny's praise of his work sparked hope deep in Charley's heart. If he could satisfy a man like Johnny, maybe he could try harder and some day...who knows?...those slippery damn magazines Johnny talked about would print his pictures.

During those days with the wagon train, the painful longing for Swan Watcher and the Blood village faded and thoughts of the roundup, Pat Tucker and the Judith Basin floated in his mind.

They crossed into the United States and slowly journeyed south. Charley was surprised to see so many cattle. It seemed too far north and off the best grass. But it only whetted his appetite to get back to work. Snow still covered the ground, but now there were hints of improvement. The days were longer, the sun higher.

Other cowboys were out there, riding the grub line, going from ranch to ranch, staying a while, doing a few chores, then moving on until it was time for roundup again. Charley had an irresistible urge to join them. As soon as he saw the Bear Paw Mountains in the distance and felt a mild breeze whip the hair off his forehead, he rode up to Johnny, shook his hand and thanked him heartily. "I'll be leavin' now, but I sure hope we meet again."

"If I have my way, we sure will."

As he rode the trail, he searched for landmarks, cattle, cabins and men on horseback. The first cowboy he saw he was going to ask about Pat Tucker. Was he around yet? Where?

He was following a creek through the hills when he caught sight of a rider coming toward him. He was a long way off. But even at this distance Charley saw the man rode like a cowboy. He spurred Monte and raced toward the rider. At first sight the rider looked like Brewster. But this was too far north for Brewster.

It *was* Horace Brewster. "Charley Russell? What in hell? You've gone Indian! Moccasins instead of boots! What happened?"

"I spent the winter in Canada with the Bloods. Can't afford boots till I get a job. What are you doin' up here?"

Brewster took a sad sweeping look around him. "Looking for new range."

Charley's gaze scanned over the horizon. "Well, this country ain't nowhere near as good as the Judith."

Horace glanced at him quickly, as though he had struck a nerve. "The Judith is eaten up with nesters."

Charley had seen the ranchers moving in ever since the railroad was finished, but the basin was so vast, it couldn't matter much, he had thought. "Are there so many nesters the cattle can't range?"

"Barbed wire's goin' up all over," Brewster said. "Sheep ranches are crowding in. If we want open country, we're going to have to move the cattle north after the roundup."

"It's a damn shame to leave all that beautiful grass and come up here to where the grass is thinner and mixed with sagebrush."

They smoked together and let their horses rest. Brewster offered Charley his old job of night wrangler. "And I'll stake you to new duds and a haircut."

"That's mighty good of ya."

"Naw, it's good to have you back," Brewster said. "I just want to see you lookin' like a cowboy."

Charley took the money Brewster gave him and headed straight for Great Falls where he could get cleaned up and outfitted.

Shaved, shorn and dressed in a soft cotton shirt, dark blue pants, a new sash and a sturdy pair of boots, Charley was raring to go when he neared the first saloon. There, he met Windy Bill and Colonel Joe, cowboys ready to ride back to the basin, too. "I think Tucker's in Lewistown," Bill said, so they decided to go to Lewistown and celebrate seeing each other again before they set off for Utica and the roundup.

Charley found Pat in a livery stable soon after they got to town. "So you wintered in Canada?" Pat said, "and it don't look to 'av hurt ya none."

"You should've been there, Pat. You'd have had a swell time with the Bloods."

"Yep, I bet I would, but I had a hankerin' to see Texas again. It's changin' though in parts. Ya had breakfast yet?"

"Coffee and yesterday's beans. We ate on the trail. Jest got here a little while ago."

Charley and Pat headed for a cafe. He had forgotten how fast Pat's walking gait was. No wonder he was such a wiry guy. He never kept still a minute. Over fresh biscuits and coffee Charley and Pat counted out their money. "We ain't goin' to have much of a celebration on that," Pat said. "When we pay for breakfast, we'll have almost a dollar between us."

"I have a ring I won in a card game once. It's gold," Charley said. Pat took hold of Charley's finger and brought the ring close to his eyes. "Possible," he said, "but it's some scratched up." They were thoughtful. "If I hadn't played poker last night!"

"You?" Charley asked. "You never bet, except on a sure thing."

"This was," Pat said. "Three kings and a pair of threes."

"The only sure thing is your hoss. You said so yourself."

"That's right, goddamn. Hey, I know, Charley. You paint one of your pictures and I'll go down to the saloon and peddle it."

"D'ya think you could?"

"Sure. If not, I'll sell your ring."

"Wait right here," Charley said. "I'll get my warbag."

When Charley came back, Pat had a space cleared away at the table and a fresh cup of coffee poured. "Whatcha goin' to paint?"

"Maybe a buffalo hunt with about three near-naked Injuns with lances and bows and arrows. It'd be before they got guns."

Pat grinned. "Sounds all right!" Pat sat with his elbows on the table, watching Charley paint. "I'll just go and remind people about that painting of yours that was in Harper's magazine last year and the ones in Leslie's."

"Aw, don't do that."

"Why not? It don't hurt for folks to know other people like your pictures. I'll remind 'em about Markley's offer in case they forgot."

"Then you'd have to tell them all the rest of it too. Yes sir, all that talk in Helena last year from Markley and the newspapers had me believin' I could be a real fine artist. But it turned out I shouldn't have listened to all that flimflam. I painted like a son-of-a-gun and sent pictures flying to New York and Chicago, thinkin' I'd earn enough to go to Europe. Hell, the pictures came right back to me without so much as a no-thank you. The things they used in Leslie's showed my signature, but the pictures were drawn over by an artist named Smith. They wanted my authentic west, they said, but they had to put it into a form they could use. So, don't talk malarky to anybody. I know what I ain't. If somebody likes somethin' I paint and wants it—fine, but don't pretend I'm something special. I put down the things I care about. That ain't art; that's fun."

Pat squinted and sniffed. "What do those tenderfeet know about the West?"

"They know what they want. I guess that's all they need to know."

"They don't know hosses and Injuns like you," Pat said, smiling as he left.

When Pat came back, Charley gave him the painting. Pat held it up, and looked it over closely. "That buffalo in the front is a beauty. And the Indian on the paint horse looks like he knows what he's doin'." Pat nodded his head. "I'll jest see what I can do with this. Be back later."

Charley started another scene while he waited for Pat to get back. This one was of an Indian brave returning to his village. He could see it clearly. The brave walks his horse to a stop in front of a tipi. The women stop working to greet him. Charley sighed. All too often his heart was still back there with them.

He talked to the men in the cafe and took his time with the painting, but when he had finished it, Pat still hadn't come back. Charley looked at his ring closely, thinking it ought to bring a couple of dollars, when Pat rushed in, wearing a grin.

"What took you so long?"

"I'm talking up your picture." He held up a $10 bill. It ain't polite to take a sucker's money and run away. I told him all about you."

Charley shook his head. "Either they like it or they don't. Why do they want to talk about it?"

"People want to know they bought something good. The more they hear about you, the easier it'll be to sell your paintings."

"I can't see why. I doubt if I'll ever figure the trading game. I like paintin' 'em, but I sure hate sellin' 'em."

"I don't mind. You keep paintin', and some day they'll all be wishin' they had one of them ten dollar pictures ole Charley done."

They laughed. "I guess we celebrate tonight."

"Ten dollars worth. What's this. Another one?"

"As long as I was waitin'."

"C'mon. I know what to do with this 'un."

Pat wouldn't say what, but Charley was curious enough to follow. They went to the general store, and as Charley looked around, Pat whispered to the proprietor. In a few minutes, Pat came back and said. "Pick out one of them hats."

"What in hell for?"

"You ain't got a hat. You can't stay out in the sun all day without a hat."

"I don't hafta. I'm a night wrangler. Thought I might buy an old hat from some poke as had two."

"Pick out a hat. It's yours for the painting."

Charley looked over at the proprietor, who smiled back, nodding. Charley found a Stetson that fit right. "Much obliged."

Back at Pat's hotel room Charley put his gear at the foot of the bunk.

"What's in your warbag?" Pat asked. "You used to carry your paint and some wax and not much else. Looks like you got a lot of extra clothes and stuff now."

"Naw, just a keepsake from one of the Bloods."

"A keepsake? What is it? Let me see it." Pat lifted the canvas bag and rumaged inside.

"Hey, don't," Charley said, but Pat already had the bundle in his hand.

"This must be it—has that smoky Indian smell."

"Put it back. It ain't nothing useful."

"Everything an Indian has is useful." Pat held the bundle up, assessing the weight. "Is it a ceremonial pipe?"

"It ain't. Put it away."

"Shit, if I got a keepsake from my Indian friends, I'd show it to you, wouldn't I?"

"I didn't say ya wouldn't."

"Then let's take a look." Pat pulled the rawhide rope from around the bundle. Charley reached to snatch it back, but it was too late. Pat unwrapped it. Charley saw the white buckskin unfold and gritted his teeth.

"Why didn't you tell me it was a woman's dress?"

Charley stood silent, looking at the fine white garment trimmed so carefully with ermine and bells.

"This is something special," Pat said, his voice lowered, his bony hands lightly touching the dress, causing the bells to tinkle.

"Yep," Charley said, taking the dress and carefully folding and wrapping it into a bundle again. Then he tied it with the rawhide rope.

On Thursday an item appeared in the *Fergus County Argus* about Charley, his paintings and his plans to join the roundup. "How in hell did they get all that?" He asked Pat as they drank their morning coffee.

Pat smirked. "I told them, you dern dumb cowboy. How do you think? But we ain't got time to cash in on it. The roundup's awaitin'."

On the way from Lewistown to Utica, Charley and Pat came onto a stretch of barbed wire fence. They swore at the bastard who would do such a thing. "Pretty soon a man won't be able to ride cross-country anywhere. This is supposed to be open range, ain't it?" Pat said angrily.

"Looks like the range is moving north."

"Hell, it ain't right."

The barbed wire forced them to make a wide circle around a parcel of land. They rode silently, seeing many more cabins dotting the valleys near the dependable water sources. At the roundup grounds, other men complained bitterly about what was happening. "Looks like cattle folk are getting throwed off the land, jest like the Indians were," Charley said with regret. The country was opening up to settlers, changing fast. Before it changed anymore, he wanted to save what he could in pictures.

Charley and Pat went to Chicago with the beef herd that fall. After seeing the World Fair, they took the train to St. Louis.

"It'll be nice to meet your people, Charley. All I have is an aunt, but she's a great little lady. Must feel good to have a momma and papa and brothers and sisters."

"It does. I want them to meet you. You're the first cowboy friend I've brought home. And hey, if you expect my brothers to be like me, don't. They're citified and look and sound uppercrust, but don't pay it no mind. When they were kids, they had holey underwear and skinned shins jest like me. I miss them sometimes, especially at Christmas. We always had the best fun then."

"Yep, that's the time I always wished I had a regular family." Pat sat back in the seat and smiled dreamily as they rumbled along. Then he sighed. "When you leave St. Louis, have you decided yet where you'll be winterin'?"

"Some of the boys going to Great Falls asked me to throw in with them," Charley said. "But I'll probably stop in Helena first—see Ben Roberts."

"You do that. Take your pictures to some of the stores. Don't think about those New York editors, Charley. They ain't your kind of people. Your people are Westerners."

Charley nodded. "Yep, it's my friends that count. I'm not likely to forget that."

"Right. And you've got plenty of friends spread out, people who appreciate the pains you take to get the details jest right."

"What're you getting at?"

Pat drew a deep breath. "Well dammit. I can see you're discouraged. You worked hard, and got nowhere with people who buy pictures. They said your stuff ain't good enough, and you *believed* it."

"I have to. I try as hard as I can, but they want technique and style. That's where I'm lost."

"That stuff ain't important."

"That's what I thought, but I found out different. I paint the truth. That's what Westerners want. But I'm a drifter—not a studio artist. And I won't cheat anybody by passing my pictures off as art."

"Call it anything you want. But what you do with a few cakes of watercolor paint and a couple of brushes is somethin' special, and you oughta keep showing it around...maybe some day...."

"Naw," Charley interrupted. "I paint for my friends, people who know the range. I hafta do it—couldn't stop myself. But there ain't goin' to be any some day with Easterners."

"Yes, there will. Some day people will come to you and want you to paint your way. So when you're winterin', I hope you'll be thinkin' about that *someday* and not drinkin' and whorin' the whole time. A man like you hadn't oughta drink too much."

"There ain't going to be a some day like you say."

"You're a stubborn dern puncher. When I tell you somethin', it's true, and I'll prove it to you right soon. You'll see, you mule-headed sonofabitch."

Charley didn't want to fight, and Pat was riled. So he pulled his sketchbook out of his pocket and drew.

Charley's mother and father made Pat welcome, giving him the finest guest room, showing him around the city, inviting the entire family for special meals. His father stole away from his office in the afternoons to be with them. Then one forenoon, Pat told Charley to get ready. "We're calling on a friend."

Pat was just-shaved and in his best shirt, his boots shining bright. "What friend?"

"The owner of the N Bar N. He told you to stop in and see him when you were here."

Charley remembered, though he hadn't really expected to go calling on him. Charley had worked at Bill Niedringhaus's ranch, and Pat had shown him one of Charley's paintings, pointing out that the cattle in the picture wore his brand, and Niedringhaus bought it.

Niedringhaus was probably the only person Pat knew in St. Louis, so Charley got ready and they went calling. He expected Pat to be intimidated by the size and elegance of the house, but Pat didn't let on if he noticed it. Niedringhaus gave

them brandy and talked about ranching. It wasn't long before Charley was telling a good yarn about Johnny Mathison.

Niedringhaus held his broad shoulders back, his craggy face forward. He had a habit of sucking air into his mouth and frowning as he listened. Then as he suddenly burst into laughter, his whole body swelled in size. As he refilled Charley's glass with brandy, he asked, "How is your painting coming along?"

Charley had no answer to that. Was he thinking of Markley's offer? Had he seen the Helena newspapers?

"Charley's painting is getting better all the time," Pat said. "Some day he won't be able to paint 'em fast enough. Why he painted a picture of some Indians hunting buffalo that had the best-looking buffalo I ever saw. It was really a fine thing. I hated to see him sell it for only fifteen dollars. You don't see many pictures like that. Especially none *that* real." Pat stood close to Niedringhaus and talked with a glazed look about his eyes.

Charley gulped his brandy too fast. Pat was layin' it on again. That picture sold for ten dollars, not fifteen.

"I sure would like to have you paint another picture for me," Niedringhaus said, turning back to Charley.

Charley cleared his throat. "What sort of picture? The ranch, a cattle drive, cowboys?"

"I leave the subject to you. But I've enjoyed that roundup painting of yours, and this is a big house with lots of walls. Send me a couple of things if you can."

"Sure he can," Pat said. "How big do you want 'em?"

"Average size, I think. I wish I had seen that buffalo hunt picture."

When they left Niedringhaus that afternoon, Pat paused on the sidewalk and gazed back. "Didn't I tell you some day people were going to ask you to paint your own way." He smirked. "And I proved it, just like I said I would. Now, don't let me down fer chrissake."

Chapter 16

In 1889 Great Falls was a growing town. The railroad stopped there, bringing travelers. The Park Hotel with its wide board veranda was one of the best hotels in the new state of Montana. The town even had lights along the street, which made it easy for a man to find his way from one saloon to another.

Charley rented a shack on the edge of town with two friends. It wasn't much of a place but it held a stove, a table, a few crates and space for each man to roll out his bedding at night. Other friends drifted in and out.

Soon after he moved in, Charley lay on his stomach making a watercolor sketch for his first painting for Niedringhaus when Bob Stuart came bursting in. "Come on, everybody. Con Price is in town at the Sideboard Saloon, and wants us all to take a few swallers of joy juice with him."

The boys threw down their cards and grabbed their hats.

"Come on, Charley. Con asked 'specially for you."

"I'll ride along and jaw with Con. Trouble is I'm stone broke."

"I told Con we was none too flush. He said he still had some jingle yet. I won at poker over at the Minneapolis House, so let's go."

Bob glanced at Charley's watercolor. "Say, let's take this with us. The boys like to see what you've been doin'."

It was nearly dawn when they rode back to the shack, bringing Con with them. By mid-afternoon Charley opened his eyes. His head throbbed and threatened to roll off and crash when he moved it. Bob grinned at him over the cup of coffee he was drinking. "You sure tell great stories, Charley. Hey, I'd better pour you a cup of java. You look like a mooning calf."

"I'll be fine," Charley said, holding his head with one hand, then taking the coffee cup with the other.

After being up an hour he wanted to get back to work on the Niedringhaus painting. "Where's that picture I had yesterday, Bob?"

"If you mean the one with the cowboy roping the wolf, you gave it to Gabe and he bought a round of drinks."

Well, it wasn't important. He'd paint a group of Indians on the move—crossing a river. He had a glimmer of it in his mind before he woke up completely and now it was coming into focus where the horses broke the water up to their withers, the look on an Indian woman's face as her horse dipped down to the water. He'd get to work as soon as his head quit hurting so much and his hands stopped shaking.

But a week later, Charley had nothing more than a lot of pencil sketches. Every day he started to work, but then someone thought of a new joke—like this morning hiding limberger cheese in Bob's boot. Then there were the daily poker games and gab sessions. And in the evening, they'd ride to the saloons to see their friends. Charley tried to get back to the painting again. He had promised Niedringhaus, and he had promised Pat something, too. Pat would probably kick him in the ass and tell him he'd had enough good times. Now he ought to get to painting.

As Charley rolled up his bedding, the guys were talking about how warm it was for January. "A man can go out in his shirt sleeves."

"Open the damn door and let's air this place out," Bob said. When the door opened, a blast of cool but invigorating air blew in.

A few minutes later Charley packed up his belongings. "I'm riding out to see an old friend," Charley said. "I might not be back for a while."

"Where you goin'?" Bob asked.

"To Cascade. Ben Roberts lives there now."

Cascade was a day's ride down the Missouri River. Ben was running a general store, making saddles in the back room. He greeted Charley with a yell and a clap on the back. "How's the painting?"

"That's why I came, Ben. I need a place where I can finish some paintings I promised to Bill Niedringhaus."

"You're always welcome at our place," Ben said. "There's a shack on my property you can use. And I'll see if I can find a warm studio to paint in. Judge Switzer's courtroom's empty."

Charley hadn't believed he'd be allowed to paint in a courtroom, but by the next day, he was there, and painting. He slept in a shack on Ben's land, and took meals with Ben's family. He helped out chopping wood, drying the dishes, and quieting the baby when she cried. If he swayed her in his arms, she smiled up at him.

After a week Charley completed a large oil painting on canvas—of Indians hunting buffalo. In it he wanted to show the size of the herd, the power of the buffalo and the bravado of the Indian. He had taken great care with the painting, from the beading on the moccasins to the purple brown dust raised by the rushing hoofs. He made a wax model of the main hunter mounted on his horse, and worked with it until every element was right. Only then did he paint, knowing exactly where the highlight on that bronze shoulder had to be.

Ben came to look. "Gosh, you're getting better and better." He paced around behind Charley, pausing often to watch his work. "Niedringhaus will love this. And the country around Cascade has a lot of variety for you." As Ben's enthusiasm bubbled up, Charley awakened to new painting themes too.

When the Niedringhaus painting was dry and ready to ship, he took it to Shepard & Flinn's general store, which was also the post office. Vin Fortune, a

cowboy friend was working there for the winter. Vin wrapped the painting for shipping while Charley watched.

"Let's see," Charley said. "I suppose I ought to write Niedringhaus a letter, and tell him ...well, how much it costs. Does twenty dollars sound too high, Vin?"

"Naw, I'd say twenty-five or thirty dollars. A course, it's good-sized. Maybe forty or fifty."

"I'm serious. Do you think I'd take advantage of a friend?"

"He's a businessman, ain't he? Lives in a big house in St. Louis, didn't ya say?"

"Yep, that's right."

"Well, he ain't going to balk. Hell, he wouldn't think he was getting anything worth much if you asked for less."

Charley took a deep breath. "I hate to write letters. I never could spell worth a damn."

"I don't mind writing. Want me to do it?"

"Would you stick a note in with it?"

"Sure. I do that for the boss. It's no trouble to me. We'll say twenty-five. That's fair, isn't it?"

Charley started to protest, but shrugged. Vin was a good friend. "And when I get paid, you're the first man I'm buying a drink fer."

Charley went back to work eager to start the next painting, a cowboy on a wild bronc. He built the scene carefully, adding a chuck wagon and men standing around watching, but the bronc and rider stayed the center of attention. As he added a few final touches, Ben strode in.

"I been thinking, Charley, and darn if I didn't come up with a swell idea." Ben sat in the judge's chair and put his boots up on the big desk.

Charley stopped to roll a cigarette. "What's that, Ben?"

Ben gazed up at the ceiling. "We'll print a portfolio of your work."

"What?" The tobacco slid off Charley's cigarette paper and dropped to the floor as he swung around to look at Ben's face. He had sounded serious, but...Charley laughed.

Ben ignored the laughter. "If you could paint about twelve pictures of the same size, I'll have them printed and we'll put together some pretty words about the West, tie it all up nice and sell it. It's just what you need now. Granville Stuart agrees with me."

"But what does Granville Stuart have to do with this harebrained scheme?" Charley had met Granville through his son Bob, one of Charley's shackmates. Granville had built up a huge cattle outfit on Arrow Creek. He worked like a man possessed, but treated his hired hands as well as if they were his own family. Every cowboy in Montana wished he could work for the Stuart outfit.

"While you were at the saloon," Ben explained, "I showed Granville some of your paintings. He and I and a lot of people like these scenes. I know it's not easy to sell enough paintings to make a living at it. And I know you give pictures to your friends who like 'em and can't afford to buy 'em, but if you paint some good big pictures and we reproduce them in a set, we could sell the set for a price anybody can afford. That way a lot of people can have your pictures, but you won't have to give them away. It's the up-and-coming way to do things. I haven't forgotten what happened with *Waiting for a Chinook*. The same people who bought that little print would buy a portfolio of twelve pictures."

Though Ben's voice was calm, a twitch around his lips revealed that he was excited about this. "Gee, Ben, it sounds good, but you're a saddle-maker, not a picture-publisher."

"I'll worry about that. Your job is to paint the pictures."

"But a thing like this costs money, and that's something I'm missing."

"Granville and I will put up the money. We'll get it back when we sell the prints."

Charley wanted to do it, but Ben was his friend, and he had to be honest. "I ain't so sure it'll sell. I sent a load of pictures to New York, and most all of them came back because they weren't good enough."

Ben nodded. "Magazines are put out by Easterners. What I had in mind was a front cover that said something like Scenes of the West painted by C. M. Russell. I have a hunch Montana people will love it."

"A hunch? But you're a lousy poker player, Ben."

"No worse than you. But you play your hunches and so do I. Why not reach as many people as you can? When I see a picture of a beautiful horse being ridden by a hard-working cowboy across a stretch of rugged country, it makes me want to be there. It's like having a good dream and waking up and being able to look at it all day long. I'm not so different from a lot of folks, especially ranchers and cattlemen—people like Granville Stuart, for instance."

Charley stared off. Could he really make people feel like they were having a good dream? He smiled at the thought. "Well, I'll be painting anyway; I'll get some pictures together, and we'll see."

Ben clapped him on the shoulder. "All we need is twelve studies of western life—Indians—a bucking bronc...." Ben's voice trailed off as he looked at the painting Charley had been working on. "Something like that cayuse. It puts a man right there on that snakey horse's back, only he knows he won't be breaking *his* neck."

When Ben left Charley finished the painting for Niedringhaus.

He took the second Niedringhaus painting to the general store for Vin to wrap and ship. "Will you write a letter about this one, too?" Charley asked.

"Sure thing. Just like the last one."

"Twenty-five dollars is a little steep for this one. Fifteen, maybe."

"This is a fine picture, Charley. I'd ask twenty-five again."

"Naw, it's too much. Ask twenty."

Charley went off feeling good about sending the painting on its way. And he already had his next subject clear in his mind. He sketched it on the canvas the next day, looking up when Vin Fortune came to the courtroom with a letter from Niedringhaus. "I thought you might be glad to get this," he said, smiling. Charley took the letter. "I hope he liked the painting."

"Well, open it and see," Vin said.

Charley ripped the envelope open. A check fluttered to his lap. Before he unfolded the letter, he picked up the check. "Why, it's for fifty dollars! There must be some mistake. He couldn't have gotten the second painting yet...look at it; it says right here, fifty dollars."

Vin looked over Charley's shoulder. "Yep, fifty dollars. You better read the letter."

Charley read quickly. "He said he's proud to hang it in his parlor." He smiled, glad his work had pleased Niedringhaus. "But that doesn't explain why he got the check wrong."

"He probably liked it so well, he thought it was worth fifty. I'll collect my drink after the store closes."

"You sure will." Charley was ready to start celebrating now.

Ten days later though, another check for $50 came from Niedringhaus. And again the letter didn't explain the overpayment. This time Charley was suspicious. What did Vin write in those letters? He ran to the general store and found Vin packing a sack of flour into a customer's wagon. Charley wheeled him around by his elbow. "Have you been paddin' my prices?"

Vin laughed. "Whatever do you mean? Me? Honest Vin Fortune?"

"Damn, you'll ruin me."

Vin nudged Charley in the stomach. "You don't know a helluva lot about what a thing is worth. And don't try to weasel out of buying me a drink tonight."

Once Charley started the paintings for Ben's portfolio, he noticed Ben was so worked up, he even suggested subjects. "How about a cowboy roping a maverick, and a cowboy herding the bunch in the rain, and maybe riding in the winter, too."

Ben gazed at Charley as though he had visions, but just couldn't put them down on paper. And when Charley thought how it must be to see things and want to save them—but not to have the means, he guessed he was lucky he could put his visions down. Maybe he ought to do a little something for Ben. He painted a cowboy roping a maverick, and Ben was so pleased about it, Charley painted the cowboy in the rain and another riding in winter.

"Some day," Ben said, looking over the pictures, "this will all be past—like this picture of the buffalo crossing the Missouri."

"And it's happening too fast," Charley said. "The Judith Basin is going to the nesters and sheep ranchers. The open range is squeezed up north."

"Looks like there won't be half so many cattle on open range from now on. There won't be jobs for as many cowboys as before either."

"I suppose not," Charley said. "Though a good cowboy can get a job on a ranch easy enough."

"What will you do, Charley when wranglers and night-herders aren't in much demand?"

Charley shrugged. "I can still get a job."

"But the future, Charley. Why not make painting your work. Once you said that was what you really wanted."

"I would if it paid enough. But it doesn't. And I like working on the range. Cowhands make good friends. They like to laugh, and they'd give you their last dollar if you needed it."

"That's so, they say. I've seen this range brotherhood. But the cowboy life gets mighty hard as a man gets older—and too much salooning's bad for anyone. It saps off a man's will to get things done."

Charley laughed. "It's jest relaxin'."

"Well, if you work as hard as you worked this winter, I think you could make your future in art."

Charley *had* worked hard. He had painted three big oils as well as the twelve smaller paintings for Ben's portfolio, but all the time, he was thinking about getting back to the range to see his friends. Ben was a family man and ran a business. What did he know about the free-spirited men of the range?

Still, it had been a good winter. With each one of the finished paintings came a sense of pride and accomplishment much deeper than he had experienced before. Maybe Ben's enthusiasm was part of it, but he had put more effort and thought in his work, and it showed. It was different on the range. There nothing was serious; his painting was done to entertain.

At the end of April, Charley stood gazing out of the door of the little cabin behind Ben's house. In the morning light the bare willows by the river shimmered in a rosy haze. The air smelled earthy and mild though the wind was already coming up. Cascade would be beautiful in the spring and summer. He'd made some good friends in town. But over the hills toward the north, the range life called. His pals all over the state were looking in the same direction. Pat Tucker, Frank Plunkett, Con Price, Charlie Brewster, Windy Bill Davis, Ed, Joe, Johnny, Jack. They were all getting ready to ride. They'd be there. And so would he.

With everything he owned packed on his horses, Charley was ready to go. He stopped at the house to say good-bye. Ben walked back outside with Charley. "We're going to miss you."

"I wish I was going to be here when the portfolio is all done up," he said as he got in the saddle. "But Ben, thanks for everything."

Ben reached up and shook Charley's hand. "Come back soon. The cabin will be waiting for you whenever you want a place to stay and work."

Charley glanced back at the cabin. He'd been comfortable there, happy. Had time to think, model and paint. "I'll be back."

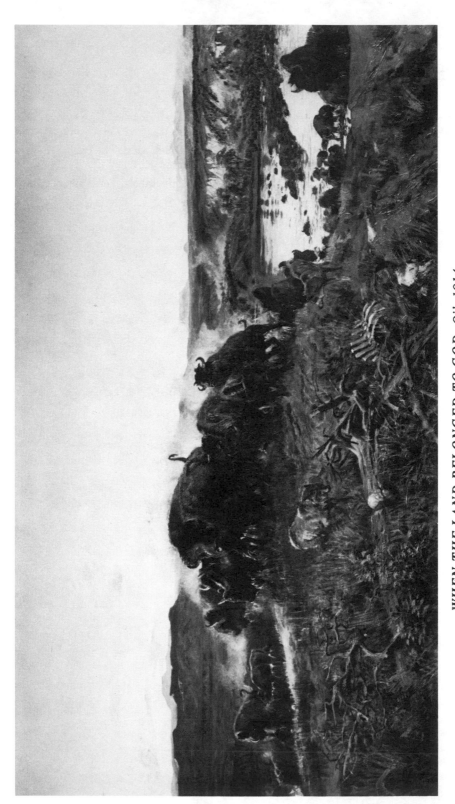

WHEN THE LAND BELONGED TO GOD, Oil, 1914.
Courtesy of the Montana Historical Society, Helena, MT.

Chapter 17

Charley rode with a wild and free bunch when the roundups were over. Bob Stuart, with his dark hair and dimpled grin, may have been the best looking and wildest among them. Pat, Charley, Bob and a couple of other cowboys had finished out the winter of '91 in a shack in Great Falls. In spring they rode back to the range. After roundup, Charley figured he'd head to the hills of Wyoming with the same bunch, but Charley hesitated when Bob backed out.

"Naw, I'm just going to drift awhile," Bob said, standing by his horse with his hands in his pockets, the toe of his boot tracing a circle in the dirt. "I might camp and fish up in the Highwoods. Who knows. You fellas have a good time."

Charley heard something hollow in Bob's voice, and the words, though spoken in a monotone, had a melancholy edge to them.

Bob was usually in high spirits, finding the humor in every situation. He had changed lately, had become less talkative, sullen. There had been trouble with his father a while back, and Bob was intent on guarding his independence. Charley stayed behind and drifted off with Bob.

They camped in the Highwood Mountains. Bob went fishing in the creek and had been gone a long time. Charley stayed in camp, painting a watercolor he hoped would bring Bob a laugh, a picture of two men in camp, one blissfully asleep as a huge grizzly walked up behind him, drooling and ready to feast on manmeat. The other man reached for his gun, seeing he would have to shoot directly over his sleeping partner to alleviate certain trouble. In this moment of frozen action, the sleeper smiled, a bottle of whiskey near at hand.

"Didn't catch a thing," Bob said when he came back. He sat on a log, staring down at his boots, oblivious to what Charley was doing. That wasn't like Bob. Charley guessed what was on his mind.

"I say we ride over to the Arrow Creek ranch and say hello."

"You're crazy," Bob said. "I ain't going near that place."

"They'd like to see you. We don't hafta stay long."

"He doesn't want to see my face again. To him I'm nothin' but a lazy, no-good drifter. And I don't want to be what he thinks I oughta."

"But he's your pa. It'd be good to stop and put your hand out; show him you ain't dead."

"It ain't none of your business, Charley."

"Visitin' a friend ain't my business? I never thanked your pa for writing that introduction to Ben's portfolio."

"You wrote him a letter. And why in hell do you keep calling it *Ben's* portfolio? You painted the pictures."

"Let's go say hello."

"This ain't the time."

"Why not?" Charley asked.

"'Cause I ain't done nothin' but what he said I was doin'. Drinkin', whorin', and gamblin'. If it hadn't been for sellin' your pictures, we wouldn't have had food last winter."

"We ate and drank pretty damn well."

"Sure we did, because I could sell your pictures as fast as you could paint 'em. But if I'd been on my own, I'd have probably starved."

"So would I. I can't sell pictures. I jest can't pull it off."

"Yeah, anybody could talk you out of anything without payin'."

"Here's one for you," Charley said, handing him the watercolor he just finished.

Bob looked at the picture, smiled, then laughed hard. "That's my pa dressed up in the bear suit."

So his father was on his mind! But looming up behind him—like that bear? Charley was more sure than ever that they ought to go to Arrow Creek.

"Let's go to Fort Benton," Bob said.

"Maybe after."

"I told you I ain't goin' there."

"I'm goin'."

Bob kicked the dirt with his heel, and swore under his breath. "Well, if I went, I wouldn't stay no more than one hour."

"An hour's fine. Then we'll go to Fort Benton."

Granville Stuart looked like a St. Louis bank president in his black trousers and vest, gleaming white shirt and silvering hair. He stood back as Bob's sisters rushed around him, taking his hand, squeezing his arm. "We just stopped in to say hello," Bob said.

"Well, come inside," Granville said. His voice was pleasant though his eyes were hard as sapphires. "Looks like you'd want to stay long enough to clean up a bit."

Charley took the hint, leading the way to the wash basin.

Then back in the parlor Charley told a new yarn and the atmosphere thawed some. Before dinner Granville asked them to come into his study for a chat. Charley tried to edge out of it and leave the two alone, but they wouldn't allow it. Charley turned to Granville. "I want to thank you again for writing that nice introduction to the portfolio."

"I was proud to do it. Now maybe you'll sign my copy."

"Sign it? I reckon I can do that."

Granville reached up on his bookshelf and brought down his leather-bound copy. Charley leaned over Granville's desk and opened the portfolio. Though he knew he'd probably misspell something, he wrote a few lines of thanks. But as he picked it up to hand it back, loose newspaper clippings floated to the floor.

"Those are articles about you," Granville said.

Bob picked them up and spread them out on the desk. "I didn't know there were this many," he said. He glanced over a column and laughed. "Listen to this, Charley. ...*That wonderful child of Nature, C. M. Russell, the cowboy artist, has for some time past been with Jake Hoover, on the South Fork of the Judith.*"

Charley had been kidded unmercifully about that piece from the *Lewistown Argus*. "If anyone ever calls me a wonderful child of Nature again, I'll make 'em sorry."

"And here's the one about the time you painted the vault door of the bank in Lewistown. We sure had a good time that night, didn't we?"

"I'll say," Charley said. Then he saw Granville's frown. Bob quickly looked back at the clipping, and read ...*He commenced work on the vault at ten a.m. and finished at 4 p.m, the subject rider and horse have the usual trappings, chaps, revolver, cartridge belt, lariat, trapideros...fine scene...of this eccentric genius. The reported amount received for this is the munificent sum of twenty-five dollars.*"

Charley glanced at Bob, remembering how they rushed straight to the saloon in Lewistown with some other friends, and before the evening was over, the whole munificent sum was gone. Seeing Granville Stuart's frown had made him a little ashamed, but though he disliked words like munificent, he had to admit that after the bank vault story appeared in the paper and the portfolio was offered in the stores, selling his paintings became easier, if not for munificent sums, at least for enough to keep the shack full of cowboys in beans and coffee.

"And look at this, Charley. You didn't tell me about this."

"What's that?"

"It's an article out of a New York magazine."

"Yes," Granville said, "that piece is a result of the portfolio."

Bob read. "It says ...*One of the best animal painters in the world is C. M. Russell of Montana who is popularly known as the cowboy artist....*" Bob smiled.

Charley was getting used to newspaper writers exaggerating everything. At first, he told folks the columns were full of bullshit, but Pat and Ben both warned him to let it alone and just smile when people mentioned the columns. It was hard to do, but he soon saw that the less said the better.

"Ben and I agree," Granville said, "that you ought to follow that New York article by sending paintings and line sketches of your work to New York publications. If someone gives you a boost like that, you can't afford not to take advantage of it."

Charley's head pounded. He had already gotten so many things returned from New York, he didn't care to begin again, and yet...if only they did accept some of his work, maybe.... But he stopped himself from making impossible daydreams. "I'll think about it," he said.

They stayed the night at the ranch and in the morning, Granville Stuart seemed relaxed as he saw them off. He shook Charley's hand and pressed Bob's arm. "The time for following the big herds is over. Now you boys have to take your own direction."

Bob and Charley turned their horses to the trail, waved and started off toward Fort Benton, but rode quiet, each with his own thoughts.

On their second day in Fort Benton, a reporter from the *Fort Benton River Press* came into the saloon and stood up at the bar with Bob and Charley. He said he'd like to ask Charley a few questions. Charley had already drunk enough whiskey to feel friendly toward everyone. Still, when the man edged next to him, Charley slid his boot heel around the brass rail, and decided to play Indian with him and just listen. When he did answer it would be with a yes or a no. The man was cagey though.

"Back east the cowboy has become the most exciting personality in American life. And you're right in the middle of it. People are reading Mark Twain and Brete Harte and articles by Theodore Roosevelt illustrated by Remington, and here *you* are living it as well as painting it. I suppose you feel pretty good about it now?"

"I feel fine."

"People are hungry for authentic views of the West now. Have you thought of devoting all your time to a painting career?"

"Not much."

"But you're painting regularly, aren't you?"

"Yep."

"What have you been working on that people might see in Fort Benton?"

Charley shrugged.

"There's one of his latest pictures," Bob put in, pointing at a picture hung on the wall behind the bar.

The reporter took a closer look at the painting—a group of Indians sending smoke signals. "The country looks like the high line around Fort Benton," the reporter ventured.

"Yep. Another drink?"

The reporter shook his head and held up his glass, still nearly full. "Why not paint full time, Charley?"

"Dunno."

"You've thought about it, surely?"

"Now and then."

"What keeps you from doing it?"

Charley hesitated until his silence seemed rude. "It doesn't bring in enough money to live on."

"Maybe you haven't given yourself a chance," the reporter suggested. "It takes time."

Charley bought the reporter a drink and said good-night.

The next day an item appeared in the paper saying. *He tells us he is fond of painting and the only reason he does not follow it is because there is not enough money in it. We believe, however that in his particular line he has no equal and that his pictures would, if properly handled, bring him a fortune.*

When Charley saw the piece in the newspaper, he turned to Bob. "Looks like I've been here long enough. I'm going to Cascade. It's quiet there, and I've been thinkin' about what your Pa said."

"Me too," Bob said. "Pa left what direction I take up to me this time—so I guess I better do some hard thinking."

"Yep. Driftin' is real nice," Charley said, "but it leaves ya feeling empty with nothing jingling in yer pocket, nothin' but a hoss and saddle to call your own."

"That's what I've been thinking, Charley. A wife and family and a ranch would tie a man down hard, but it wouldn't leave him feelin' as empty as this."

"How does a man change direction," Charley asked. "What d'ya do first?"

"What I might do—leastwise, I've daydreamed about it—is look for a good woman and a good piece of land at the same time." He laughed. "See, I figure it'd be best to find a woman who knows something about ranch life."

Charley smiled. "Your daydreams fit together nice. When I do it, it comes out good in one spot but not the other. Sometimes I think I want to quit the range and paint like hell. But I can't get along without my friends. And so I stay half an uneducated artist and half a second-rate cowboy. And when it comes to women, well, Lollie was too civilized, and Swan Watcher knew nothing of the white man. The rest—well, you know the kind of women I run with."

"Sure, the same ones I run with. They're fun in the hay, but wouldn't make it on a ranch."

"There's got to be a girl out there fer a swell-lookin' puncher like you," Charley said, offering his hand to Bob.

"You'll find one, too. Women always like you," Bob said, shaking Charley's hand.

"But I drink too much whiskey," Charley said.

"So do I. But maybe we wouldn't if we changed our way of living. See ya, Charley."

"Good luck."

Ben's cabin was waiting. And Binny and the kids seemed excited to have him there. After supper, sitting around the Roberts's big oak table, Charley modeled a lump of wax holding his hands under the tablecloth. He told little Hebe a story. When it was finished, he produced a wax figure of a dancing elf and watched her face fill with surprise and delight.

In Ben's cabin the next day, he stopped to roll a cigarette and his mind returned to that reporter's statement in the paper. He *wanted* to be a full-time artist, badly. He couldn't deny it. He needed to paint. It was the first thing he thought about when he woke up in the morning. But he needed his friends around him, too. And he didn't dare believe the reporter's opinion about how much money he could make painting, *IF*.... That reporter just didn't know how hard it was to ask money for something you've painted for yourself as much as anybody else.

He hadn't been in Cascade much more than a week when a letter came from Great Falls. It was neatly written on both sides of a white sheet, and signed by a Charles Green. He couldn't recall the name.

> *Dear Mr. Russell,*
>
> *I have seen the article in the Fort Benton newspaper about you. You were quoted as saying that the only reason you did not follow a career in painting was because there was not enough money in it. I have seen some of your work on display in the Brunswick Saloon in Great Falls where I am employed, and I am of the opinion that the writer was correct in thinking that your pictures could eventually bring you a handsome income.*
>
> *I could make it possible for you to paint full time as you desire, and pay you $75 a month as a wage. You would not be required to do anything but paint as I would take care of sales. If the idea sounds attractive to you, please come to talk to me any evening at the Brunswick Saloon. I will be waiting to hear from you.*
>
> Charles Green

Seventy-five dollars a month! To do nothing but paint! And he wouldn't even have to sell his work. He showed the letter to Ben.

"It sounds a little too good," Ben said.

"Hell, I've talked to those fellas at the Brunswick. They're pretty decent."

"Maybe you could try it for a while and see how it works out." Charley read the letter over again slowly, imagining what it could mean for him. Maybe now he could paint for a living. He packed up and was ready to ride to Great Falls the next day.

As soon as he got to town he rode straight to the Brunswick Saloon, a small place with gas lamps over the mirror behind the bar. Charley walked up to the bartender and smiled. "Are you Charles Green?"

The big man in a white apron laughed. "Me? Pretty Charlie? No sir, you've got the wrong fellow. The name is Albert Trigg."

"Oh," Charley said, and shook Trigg's hand. "Glad to meet ya. My name is Charley Russell. I was told I'd find Mr. Green here. Do you know anything about him?"

"He'll be back. He's just gone for supper. Do you want a beer or anything?"

"A beer'll be fine."

"You must be the artist."

"Well, I paint some."

"I suppose that's what you want to talk to Pretty Charlie about?" Trigg frowned at the glass he picked up from the bar and put in a pan of sudsy water. "Well, don't let Pretty Charlie rush you. A man has to take time to think things over and ask himself some questions."

Charley nodded and drank his beer.

Chapter 18

"It's a privilege to meet such a fine painter," Pretty Charlie said and raised his glass. The gold studs in his shirt cuffs glittered. His dark hair shone. Charley swallowed his shot of whiskey. Then Pretty Charlie put down his glass and nodded toward Trigg who stood at the far end of the bar, his large head bowed as he polished glasses.

"Mr. Trigg is agreeable to your painting in the back room here. Pretty Charlie smiled at Trigg before he led Charley to the back room. "Well, what do you think?"

The room was small but had a window and a couple of lamps. "It looks fine," Charley said.

"And does seventy-five dollars a month sound fair to you?"

"More'n fair."

"Good. Now then, I had a little contract drawn up so everything would be nice and legal. We'll both sign it, and if you want to, you can start tomorrow."

"A contract?"

"It's just a formality. Your handshake is good enough for me, but I was told by my old grandpa who was a judge back in Virginia that all business arrangements should start with a contract, no matter how simple they seem. What this one says is that I promise to pay you seventy-five dollars a month for a year, and you promise to paint every day and let me take care of the details of selling the work. Here's ten dollars as advance to bind the deal."

"Uh huh. I've never signed a contract before."

"Really? Never? Well, there's nothing to it. It just puts it all down in writing. Go ahead and read it if you like."

Charley took the contract and started to read, but it was printed in frilly script and hard to decipher. He wasn't even sure who was the party of the first part and who was the party of the second part, and what it all meant.

"Don't worry about all that lawyer-talk. The main things we care about are the terms. You paint a full day and take Sunday off. On the first of every month, I'll pay you."

Charley nodded, but remembering Trigg's words, decided not to be rushed. "I'll just take this with me, and bring it back tomorrow." Charley went back to the hotel, took the contract and sat under the street lamp on the wooden veranda. The light streamed down on the page, but the contract was still a jumble of words that didn't quite connect to make sense. He read slowly, sentence by sentence, becoming impatient with the confusing language when Bob Stuart and Henry Stough rode up. "Charley, what in hell're you doin'?" Bob asked. "Henry tells me you've been

talking to Pretty Charlie Green. Come on over and have a drink and tell us all about it."

"Can't now. I'm reading this damn contract Pretty Charlie wants me to sign."

"What's it say?"

"Damn if I know."

Bob stepped down from his horse, threw the reins over the rail and sat down next to Charley. "Let me look at it. I've done some fancy reading from time to time."

"Sure, go ahead. See what you can make of it."

Henry looked over Bob's shoulder. "A man would have to be stone sober to read that squiggly shit."

"Seventy-five dollars a month is a lot more than I ever made before," Charley said. "But it ain't cheap to live in a city."

"Uh, oh, Charley, listen to this," Bob said. "Party of the Second Part will work twelve hours every day at the painting of pictures."

"Well, a man works that long on the range," Henry said, "or chopping wood or about anything he does."

"Yeah, but let me finish," Bob said. "Up here in another paragraph, it says he has to do that for one whole year."

"You mean I have to paint twelve hours a day every day of the year?"

"Except Sundays."

"And never have a chance to ride or anything?"

"I've seen you paint on horseback," Henry said.

"Sketch mostly. Well, I ain't doin' it."

"Seventy-five dollars a month, Charley!" Henry said.

"Charley's right," Bob said. "If Pretty Charlie thinks he can make a profit selling the paintings, and still give Charley seventy-five dollars a month, why couldn't he make as much on his own?"

"I have to have my freedom."

"I've sold your paintings before," Bob said. "If you want me to do it again, I will."

"Seventy-five dollars a month is twice as much as a cowboy makes," Henry said.

"Let's have a drink," Bob said.

"Lead me to it," Charley said, folding up the contract and stuffing it into his back pocket.

Charley got happy pretty fast. "A man would be crazy to give up his freedom and live under lock and key. I wouldn't do that for a hundred dollars a month."

"That's right," Bob said. "Tell Pretty Charlie you got plenty of playin' around yet to do."

"I'm goin' to take that damn contract and the ten dollars he gave me and tell...hey, that ten dollars?" He counted the coins on the bar-eighty-five cents. He realized with a sinking feeling he'd just spent the $10 Pretty Charlie gave him as an advance.

"Don't worry," Bob said. "You're all right as long as you don't sign anything."

Charley thought of being closed in a room and forced to paint. He'd been a damned dunce. He finished his whiskey and started back to the hotel. There was nothing he could do but work off the ten dollars he owed Pretty Charlie, but he sure dreaded the humiliation of it.

Bob and Henry caught up with him before he got two blocks away. "Whoa up. We got somethin' for ya."

Charley stopped, and Bob pressed a stack of cool silver dollars into his hand.

"There's ten of 'em," Henry said. "Give 'em to Pretty Charlie."

Charley looked at the dollars in his hand, and his eyes turned hot and watered. "It's damned nice to have good friends."

The next day Charley returned the unsigned contract to Pretty Charlie, and before he left the Brunswick Saloon, he stopped to speak to Trigg. "Say, I think you saved me a lot of hell."

Trigg glanced up. "It wasn't a bad idea to start with. But Pretty Charlie started sounding greedy the last day or so."

"A man don't paint pictures the same way he chops wood."

Trigg raised his eyebrow. "If he did, his pictures wouldn't be worth much."

Charley laughed. "I'll take a handshake over a contract every time."

"So will I. And, if you ever want to have that back room to paint in, I'd be proud to have you." Trigg put out his hand and Charley shook it.

Charley's next thought was of painting something good enough to sell so he could pay back what he owed the boys. Bob and Henry invited him to stay with them in a tar paper shack on the edge of town. Charley decided to do his best to paint for a living. He might not make $75 a month but he'd see what he could do.

Bob had been turned down by a nice girl he was smitten with, Henry confided. That was why he was running hog wild. "He'll settle down after a bit," Henry said. Charley hoped so.

Charley started off working steadily at his painting every day. It wasn't easy because Bob brought home friends and the shack was crowded and noisy. There were arguments and poker games and even at high noon the light was bad. Bob or Henry would take his paintings downtown and most always come back with cash. If they couldn't sell them, they'd leave them on display at one of the saloons.

Charley painted in the back room of the Brunswick. And when Billy Rance at the Silver Dollar heard about it, he asked Charley to paint in his back room, too. Charley didn't play favorites when it came to saloons. He went to the Brunswick, the Mint, the Silver Dollar, the Maverick, and a few others. If he sold a picture or if one of his shackmates won at poker, they all came to town to celebrate.

But if things didn't go so well, and if there wasn't enough money for celebrating, Charley felt irritable. He couldn't stick to his painting. His hands shook and he itched to go to town, see his friends and have that nice warming whiskey that made everything rosy again.

One time when money was short, he bought a bottle of cheap booze and took it back to the shack. But booze without going to town was disappointing. He couldn't bring Billy Rance or the boys at the Mint and Brunswick home to the shack. So instead of cheap booze, he asked for credit at the saloons. Albert Trigg nodded. "Sure, Charley. I know you're good for it."

Charley expected to paint something extra and pay Trigg in a couple of days. But Henry laid his socks on the stove to dry, and instead of drying they smoldered and then caught fire, and in the hustle of throwing coffee on the blaze and stamping it out, two of Charley's watercolors were ruined. One was burnt and the other caught a glop of coffee and a bootprint.

Charley had worked hard on those paintings, but it wouldn't do any good to brood about a little tough luck. He wasn't the only one with trouble. Henry lost his whole pile at poker, so the outlook at the shack was glum and the 3-day old beans were looking none too appetizing. Nobody said anything, but nobody ate much either.

That night they went to town and had a few drinks until their bad luck at the shack became funny. Charley told the story of the fire, laughing until he had tears in his eyes. A little later, Trigg called him aside and introduced him to a man who had come to town to buy wool. "I showed Mr. Mattingly the painting you left here. He wants to meet you."

Charley shook Mattingly's hand. He was tall and talked with a Boston accent. "I'm rather taken by this painting of the Indian women on horseback. Very well executed. Rings with authenticity. Mr. Trigg tells me you studied the Indian culture extensively."

"That's right," Charley said, knowing that's what the Easterner wanted to hear. He sounded like a man who might just buy the painting, and he couldn't have dropped out of heaven at a better time. "These are Northern Piegan Indians, part of the Blackfeet tribe," Charley went on, trying as hard as he could to sound like a real artist.

Mattingly listened. "I wonder if you could paint a companion picture—something showing the male Indian in a parallel pursuit."

Charley hesitated, not wanting to seem too eager. Then he nodded. "When do you need it?"

"I'll be here for another week."

"I'll do my best for you," Charley said.

"Good. Mr. Trigg knows how to reach me."

Charley painted furiously for two days, taking particular care with the work as he didn't want to take any chance in not pleasing the Easterner. The sour beans were almost gone. Their only other option was a chicken coop raid, and their neighbors were already suspicious.

When the painting was ready, Charley dusted off his boots and put on his spare shirt. "Get the stew pot ready," he said. "If this doesn't work, *I'll* steal the chickens."

At the Brunswick, Charley showed the painting to Trigg. "It's fine, Charley, truly fine," Trigg said. "I'll send word to Mattingly at the hotel."

Charley sipped a glass of beer while he waited. Now he wished he'd sent Henry with the painting. Henry just gave a price and then looked solemn and kept his mouth shut. If he could just learn to do that instead of talking so much, maybe he could sell paintings, too. He could never talk up a picture like Bob did, but if he could only learn to stand pat, he'd have a chance. Everyone back at the shack was depending on him. Charley gulped his beer and felt the sweat ooze from his pores. This time he was going to stand pat if it killed him.

Finally, Mattingly walked in, wearing a dapper gray suit with a green Eastern-style tie. Charley was glad he had remembered to put on his spare shirt. His hands shook, so he built a cigarette while the Easterner looked over the painting. He lit up and stood over Mattingly. "That was Medicine Whip as a young man, riding out with his warriors to avenge the death of a brave who'd been ambushed by a band of Cree. They've just spotted the enemy. Medicine Whip has given the signal to charge."

"Excellent!" Mattingly said. "And what is the price?"

Charley swallowed and cleared his throat as he figured again how much they needed. Twenty-five dollars each painting was asking a lot, but this Easterner might not object. If he did, the price could be lowered. Charley swallowed again, but couldn't look Mattingly in the eye. Instead, he looked down at his hands. "Fifty dollars," he said though he nearly choked on the figure. He was braced for outrage and an argument. If he only got thirty dollars for them, they could get enough groceries to last a couple of weeks.

"Here you are," Mattingly said.

Charley watched Mattingly peel off one hundred dollars in bills and pass them across the bar. Speechless and goggle-eyed, Charley noticed Mattingly still had plenty of bills left. "Thank you," he managed to say, taking the bills. "Let me buy you a drink."

Trigg poured them each a shot of whiskey. Charley needed it if he had ever needed a drink in his life. His conscience told him to give back some of the money.

It wasn't right to keep it all—the man misunderstood. Dammit, it wasn't right. But he could picture the faces back at the shack. Especially Henry's. His eyes would pop open.

"It's been a pleasure to do business with you, Charley," Mattingly said before he left with the paintings.

Charley paid Trigg what he owed and rushed outside to the waiting Monte. He galloped back to the shack where the boys were waiting.

"Well?" Bob asked. "Did you give it away? You should've waited for me. You never should have gone alone."

Charley tried to keep a solemn face. "I named my price and kept my mouth shut just like Henry does, and what do you think happened?"

Bob looked worried. "The guy waited until you told him to go ahead and keep it for nothin'?"

"No." Charley still couldn't believe it himself, and to prove it really happened, he reached into his pocket and pulled out the bills, counting them as he put them down onto a wooden box by the stove.

Henry looked horrified. "I hope you didn't hold up the bank?"

"A Hundred Dollars!" Bob's eyes opened and the cigarette dropped from his lips. "For two paintings? I don't believe it."

"Just as brazen as a road agent, I was."

"Damn, I wish I'd a seen it," Henry said.

"Me too," Bob said. "A hundred dollars. What a sucker!"

"He was a real decent sort of sucker," Charley said.

The stew was full of meat, vegetables and gravy that night and there was applesauce loaded with sugar for dessert. After the meal, they rode to town to celebrate.

Charley bought more painting supplies and found out at the supply store that Trigg often showed Charley's paintings to potential buyers at hotels and businesses. That was how Mattingly happened to see his painting. Charley should have guessed he wasn't the ordinary patron likely to walk through the Brunswick's doors. Trigg was a good friend, Charley realized, and he vowed not to forget it.

Toward the end of winter, Pat Tucker came to Great Falls on the train. Charley and the boys were broke, but Trigg put the drinks on a tab for him. Then Charley and Pat settled down for a long talk.

"And you're really thinking of setting up as a full-time artist?"

"Yep. A lot of the bunch are buying cattle or one thing or another. I thought I'd give painting a real serious try."

Pat nodded. "I knew you'd do it sooner or later. Well, here's to luck, Partner," Pat said, raising his shot glass.

"Thanks," Charley said.

"They tell me it's still pretty wild and open up by Chinook and Big Sandy. I'll miss ya, Charley. I've had lots of partners on the trail, but none better'n you."

Pat's words felt strange. He didn't want to be missed. He wanted to be there with Pat and Bob and the others. Still, if he was ever going to do this, he had to stick with it and get his paintings displayed in stores as well as saloons.

As his friends rode off toward Chinook and the Milk River country, Charley could hardly keep from saddling Monte and riding with them.

The earth was waking up again, calling them back to the range. Never mind, Charley told himself. It would be a relief to be alone, let the smoke clear out of the shack. He could sleep without all that damned snoring and the smell of dirty socks. He had plenty of friends in town now. But dammit, he remembered the excitement of roundup. There was nothing else like it.

He painted furiously after the others left and piled up paintings one after another. It was satisfying to look at them even if he didn't have the boys to show them to.

Hell, he missed the company. As the days passed he went to the saloons earlier and stayed later.

Charley ordered a whiskey at the Brunswick. Trigg looked at him and shook his head. "I can't give you any more credit, Charley. Your bill is up to fifty dollars and that's the limit."

"Fifty dollars!" He was amazed. How could it have run up that high so fast? "Are you sure?"

Trigg brought out a notebook he kept behind the bar and showed it to Charley. "I know it's right," Charley said. "I jest didn't know it had jumped that high. And to be honest, I don't have the money to pay you right now."

Trigg put the little book away and turned back to Charley. He lowered his voice. "You're too generous for your own good. You buy a drink for anybody who comes in the door with an empty pocket. Some people take advantage of you, Charley."

"I know, but if I like the guy, I don't mind. Some day that man might do me a favor. A lot of folks have."

"And you buy drinks for men who can well-afford to buy their own. It's been worse since your friends left."

"I'm lonesome."

"You might be better off at a boarding house where there are other people around and you'd have regular meals at regular hours."

Charley nodded. Here was Trigg looking at him like his father did when he lectured him. "You're right," Charley said. "But I don't know what I'm going to do about that fifty dollars...unless maybe I could paint you a couple of pictures and then when you sell them you could get your money?"

"You mean you want to make a sucker out of me, too?" Trigg smiled wryly.

Charley laughed, then turned serious. "It's all I have to offer."

Trigg nodded. "I'll settle for one nice big painting. Let's have a drink together, on me, and then you can go along and get started."

"I'd like to paint it in the back room here if you don't mind. That damn shack is too quiet for comfort."

That evening Charley sat down to plan the work. For Trigg it had to be the finest thing he could do. Something that would be worth at least fifty dollars. In searching for a subject, he remembered a story Black Eagle had told. Now he'd bring it out of the shadows. The central figure would be a young Piegan chief. He would be standing in the middle of the lodge, talking to a council of war made up of Crow and Piegan chiefs and medicine men. The meeting was called to decide whether to have peace among the tribes, or war. Everyone hoped for peace. Then the young Piegan chief found evidence of Crow treachery—a Piegan scalp hidden in a bundle of a Crow warrior's moccasins. The Piegan confronted the council, holding his coupstick in one hand, the evidence in the other. It was a solemn moment that meant there would be no peace now.

Charley modeled the major figure in wax. The next day he began the watercolor painting.

"Absolutely and positively wonderful," Trigg said when it was finished. He gave Charley the page out of his notebook. Over the charges Trigg penned in, *Paid in Full*.

Riding back to the shack that day, Charley thought again about his intention to stick to painting. His art had seemed so important when he was back at the Blood camp—something he couldn't live without. And when he had painted the pictures for the portfolio for Ben, he spawned such high hopes. Sure his work was better now, but though he had sold enough paintings to keep the outfit in food, they hadn't exactly lived well. Now he was broke again, and without someone to sell his pictures, he would be no better off than he ever was. Painting wasn't so much fun when he was alone. He wasn't built to be much of a loner. Maybe he'd have to keep his painting hooked up to his other life—the one he loved. If he left right away and rode hard, he could probably still get his old roundup job back. On the other hand, he'd made a decision to try painting for a living, and giving up so soon didn't feel right either. He thought of going to see Ben Roberts. He wouldn't be lonely in Cascade with Ben and his family around; wouldn't spend so much time in the saloons there either.

The moment Charley stepped inside the empty shack, he knew he had to move on. He was out of debt and he wanted a change.

Chapter 19

Charley packed up and rode Monte eastward, pausing on a rise that overlooked the river. He was leaving Great Falls, but still hadn't decided about where he was going. To the north lay the Milk River, his free-wheeling cowboy friends and the roundup. To the south lay Cascade and Ben Roberts' cabin—a good place to paint. He hesitated. Cowboy life or the discipline of art? Then he turned Monte north. "One more roundup," he muttered.

For two years Charley drifted from one place to another—Chinook, Great Falls, Cascade, Utica, St. Louis and stops between, working as a cowboy, painting western scenes between seasons. He was content. This way he didn't have to choose between his two loves.

Then one day a feisty Texas longhorn steer pinned Charley against the corral fence and drove its pointed horn right through the top of his boot and into Charley's foot.

Dizzy with pain, he let the boys pour whiskey on his wound. It healed slowly, and the doctor warned him his foot would never be the same. He limped if he worked hard and the pain throbbed. No cowboy could pull his load if he couldn't get down off his horse and work on the ground—and Charley couldn't.

He'd been painting in Great Falls nearly three months when the spring season brought Pat Tucker to town. They met in the Mint bar. "How's it going? Ya gotta show me some of your pictures." Pat looked around the saloon. "Looks like the suckers grab 'em up afore they're dry."

Pat's grin came natural—no trace of pity. He had ridden 50 miles out of his way to see Charley and look at his paintings. They had plenty to talk about for an hour or so, then Charley felt the urge to mount up and ride out with Pat to the mountains where they could camp and hunt. But Pat was on his way north to a job and could only stay a few days. "Well, is the painting life agreeing with you, Partner?"

"I haven't done much painting. Oh, I start things, but finishing's another matter. I think about never working on the range again and my mind mixes up. I start to paint but can't get the time of day right or the weather. I can't bring it all together. It fades and changes and my hands stiffen up, and I hafta...stop and go have a drink with the boys. It's been like that a month or two—ever since I got here."

Pat frowned. "Dammit, Charley. You could always finish what you started. Wasn't any trouble at all fer you. I've seen you jawin' and paintin' and jokin' and smokin' and gamblin' all at once and your picture still came out jest fine."

"That's different. Now, painting's the only thing I got to sell. People expect more. It's funny. They think as long as that's all ya got to do, it's going to be better than anything. I can take my time now and get it perfect. See. And it don't work. Sometimes I do a little watercolor here in the backroom when the boys are around and we're some tipsy. But I get to listening to the stories and wanting to be back on the range and my mind curls up...and I have another drink...."

"Dammit, Charley. You're drinkin' too much booze. Your skin is gray and your eyes ain't right. I bet ya come to the saloons to be with your friends every day, don'tcha?"

Charley nodded.

"You ought to know better'n that, you crazy puncher. The only way to cut you loose of this mustang is to ride out into the mountains and drink nothing but creekwater till your eyes clear up and the sun colors your face. We'll leave now. Let's go get your stuff."

Pat was mad, but Charley pretended not to notice. He knew Pat was right. He had wakened a few days ago trembling and seeing fuzzy visions of things that weren't there—buffaloes coming down Central Avenue. Doc Sweet told him he had to stop drinking.

Camping in the hills with Pat worked its cure on Charley, and before they parted, Charley promised Pat he wouldn't get like that again. And he never thought he would, but after a few months he was drifting back to staring at a blank canvas, then abandoning it for a saloon. He remembered his promise to Pat though, and packed up and rode out of town one sunny day in October.

The quiet majesty of the land refreshed him. Bright flashes of red and gold dotted the prairie. Cottonwood trees near the river dropped their yellow leaves while paintings clearly took shape in his mind.

In Cascade, he stopped in front of Ben's store and threw Monte's reins over the rail. Spurs jangling, he walked across the board porch to the front door and looked inside. Seeing Ben leaning over some bins in the back and no one else around, he sounded his war cry, "hieeeee."

Ben sprang up to face him. "Charley! Good to see you again. The cabin's waiting for you."

"Ah, that's great. I've really got to get some painting done."

"Too much chasing the good times in Great Falls?"

Charley nodded. "Especially since the boys have come in off the range for winterin'. I've heard enough new stories to keep your ear busy for a month."

"Binnie will sure be glad to see you, and Hebe's been waiting to show you how she can jump rope. For some reason, she thinks you're the champion rope-jumper in Montana."

"I suppose I lied to her a little on that subject."

"I'll just clean out the till and we can go home."

"I'll sweep up for you," Charley said, snatching the broom from the hook in the back.

They put the horses in Ben's corral, walked up the back steps, and across the porch to the kitchen door. Charley was prepared to lift Hebe and little Viv up, swing them around and give them a hug. He loved to hear their excited squeals when he had them high in his arms. But when Ben opened the door, a young golden-haired girl stood at the kitchen table, dipping chicken pieces in flour. "Mamie, this is Charley Russell. You've heard us talk about him."

The girl nodded shyly and looked at Charley with her wide blue eyes. "How do you do, Mr. Russell?"

"This is Mamie Mann, Charley. She helps Binnie out with the kids and the cooking."

Charley nodded, unable to look away from this unexpected girl, so pretty in her big white apron, and her pure blue eyes. "It's nice to meet you, Mamie."

"What about us?" Hebe said, standing at the doorway, her curls catching the sunlight and her face disappointed. Viv stood beside her sister, clutching a rag doll and waiting.

Charley scooped up the girls one at a time and greeted them properly, causing the usual horrified gasps from Binnie. "Not too rambunctious now, Charley."

Mamie looked on, and when he breathlessly ended his play, he caught her looking at him, smiling. It wasn't a laughing good-time kind of smile; more a smile at what she was thinking. He wondered what it was, and who she was and where she came from. When he looked at her, her eyelids fluttered downward, her sweet round face turned pink and she busied her hands with the chicken again.

Charley and Ben went out back to wash up at the pump, and Hebe followed. On the porch she proudly jumped rope. Charley and Ben stood on the path just below the steps, crossed their arms over their chests, and watched. After a minute Charley noticed the kitchen curtain behind Hebe flutter, and looked up to see Mamie's blue eyes watching him. When she saw him look up, she moved away from the curtain. It was with effort that he turned his attention back to rope jumping.

"I think you're the new champeen," he said, reaching for Hebe's arm and raising it up high as though she had just won a prizefight. She was breathless, but laughing as they all went inside.

At the dinner table Charley sat next to Hebe, across from Mamie and Viv. "How long have you been here?" he asked Mamie at dinner. She looked shyly at him and answered softly. "Two and a half months."

"But she's staying forever, aren't you, Mamie?" Hebe asked.

Mamie smiled. She was the prettiest girl Charley had seen for a long time. Of course, she was awfully young. Not much more than a kid. Several times he looked up from his plate and found her looking at him. Her face would redden when he caught her glance and she would look away again. After dinner Charley told his

funniest story, changing the parts that might offend a young girl. Everyone laughed, including Mamie; she looked so happy that he told another story. She was sure pretty when she laughed and her eyes twinkled. He told one yarn after another until the coffee was all gone, and Binnie started to clear the dishes. Mamie jumped up then. "I'll get some water," she said.

"No, let me do that," Charley said, taking the pail from Mamie's hand. He'd helped Binnie with the dishes plenty of times and there was never a time he wanted to help more than now.

Standing at the sink, Mamie looked sideways at Charley. "And are you going to be painting pictures while you're here?"

"Hope so. That's the main reason I came. I usually stay in the cabin by the river." He stood behind her and pointed out the window.

"I know."

"We've told Mamie all about you," Binnie said.

"I've never seen an artist paint," Mamie said. "It must be very hard to get horses and people to look so natural."

Charley shrugged, and she looked back to the dishpan, her face reddening again.

Charley wondered at her shyness, and he didn't want to make her uncomfortable. After the dishes were done, he played with the children until Mamie took them off to get them ready for bed. Charley talked with Ben a while longer, then went down to the cabin, the image of Mamie peeking through the curtain, teasing in the back of his mind. Before he went to sleep he modeled a fawn in wax for her.

That day he began painting as though his whole future depended on it. In the evening he helped Mamie with the dishes. Afterwards, he asked Mamie to go for a walk with him. Her eyes widened. "I don't think I should."

He thought he understood. "Binnie," he called. "You won't mind if Mamie takes a little walk with me, will you?"

"I want to go, too," Hebe said.

The three of them went. Mamie holding tightly onto Hebe's hand. "Where are you from?" Charley asked.

"I was staying with Mrs. Biggs in Helena. She treated me good, but not like the Robertses. I've never had such a nice home as this."

"Well, where do your folks live?"

"I don't have any. I had a half sister, Ella, but she went to the coast to live with her father. He was my stepfather."

"Mamie's an orphan," Hebe said. "So Mama said she can be like a big sister to us."

Charley tousled Hebe's curly head. They walked along silently for a moment. Then Charley sighed. "My mother died a few months ago, and even though I still

have a father, I ...well, it's sad not to have your mother any more. I never thought how much I'd miss her."

"I don't remember mine," Mamie said.

Charley's heart went out to her. She couldn't even remember her mother. He wanted to protect her. But when he looked over at her and saw her chin held high, her shoulders straight, he suspected she could take care of herself.

On a Sunday afternoon, Charley asked her to go riding with him. She rode Monte and he Gray Eagle. He chose an easy path through a valley protected on two sides by rugged mountains. Here, they were sheltered from the wind and cold and surrounded by magnificent scenery. After they had ridden a few miles, they dismounted and led the horses slowly across some rough ground. Mamie was mostly silent, but smiled when she caught his eye.

"I hope you're not worried about being out here in the hills with nobody for protection but a scruffy cowboy like me."

"No. What could happen?"

"Bobcats, bears, rattlesnakes."

"Oh, I hate rattlesnakes. But it's too cold for them."

Her face was as flawless as the painted china dolls his mother had kept on the parlor mantel.

"Are you going to sketch anything while we're out here?"

When he shook his head, she seemed disappointed. "Course, you never know about sketching," he added. "Do you see anything that would make a nice picture?"

"Me? I don't know anything about that."

"Don't you ever see something so..." he hesitated, studying her face as she listened intently, "...so grand you want to remember it?"

She smiled, and looked off around them in each direction. Then she pointed. "That high cliff with the tree growing right out of the rock, and behind it the higher mountain, and the river down below. All together, that's a sight pretty enough for a picture."

"Would you like me to sketch it for you?"

She hesitated, then nodded. "I love your pictures."

His heart pounded suddenly. It was as though all his work had been for a purpose—so Mamie could say she loved his pictures.

"I've seen the portfolio of your paintings and the pictures in the house and the books you illustrated. I read *How the Buffalo Lost his Crown* to the children. They love your pictures, too. We all sit and look at them when I've finished reading, and...." Her voice trailed off, and she smiled.

He could see admiration in her face, and knew it was undeserved. "Indian legends are fun to illustrate, but my pictures aren't what they call art."

"They certainly are!" she said with a stubborn lift of her chin and a momentary furrow in her brow.

He was surprised at the sudden definiteness in her voice. He looked at her a few seconds, then saw her eyelids flutter downward and her cheeks redden. He reached into his pocket for his sketchbook.

He sketched the landscape she had pointed out and handed the sketchbook to her. She looked first at the sketch, then at the scene. "It's just beautiful, Cha'ley."

She handed the sketchbook back, but he hesitated in taking it from her. If he touched her hand, even with her gloves on, he'd want to kiss her more than he did already. And she was so young and innocent. He was thirty and anything but innocent. He shouldn't touch her or frighten her or do anything at all to change her.

"What's the matter?" she asked, looking into his eyes.

He took the sketchbook from her, and when her hand lingered for an instant on his, he looked into her eyes again, and saw—fearful expectation. Wanting it too much to resist, he leaned over and kissed her softly on the mouth. What followed was nothing like the quick lust he usually felt with women. What he felt now was mysterious and elusive. He wanted to protect her, to keep her innocent. A gentleness awakened in him. He touched her hair softly. "Cha'ley," she whispered.

He could no longer help himself, and he took her in his arms and kissed her again with such fervor, she shuddered against him. He felt an urgency to hold her closer still, then he remembered her youth, innocence. "I'm sorry," he whispered, releasing her.

She lowered her head. He couldn't see her eyes. Did she hate him? Would she avoid him from now on? "Mamie, you're so damn pretty, I forgot myself."

She looked up then and laughed. It was the gayest laughter he had heard from her. They turned back then and rode slowly home. By the time they had reached the corral, Charley knew he was in love.

That night as he lay on his blankets looking up at the cabin's ceiling, he could think of nothing but Mamie. He modeled her face in wax, and told himself his love was outrageous. He should leave here now and forget it? If he could only afford to support her, he would try to win her. But he was always broke. And she had looked at him as though she thought illustrating a few books meant he was successful. It was *something,* and he was proud of the work, but there wasn't enough of that kind of thing to make much difference. If she knew how little he was paid for it, she may not look at him in the same way. He tried to sleep, but he couldn't get that kiss out of his mind. It was becoming part of him, an unsettling part.

As soon as the morning light came through the window, he began a watercolor painting of the scene he had sketched for Mamie. In the foreground he placed the figure of a woman on a pinto horse, a woman with golden hair.

When they went out walking the next night, he gave it to her. "Oh Cha'ley, you mean this is for me?"

He nodded, the urge to kiss her mushrooming again, but he restrained himself and merely took hold of her hand as they walked back to the house.

During the days that followed, Charley's feelings grew more intense. He was sure he loved her. Loved her enough to risk anything. He didn't know how she felt and didn't want to rush her. He would wait. They would walk and talk, and after they knew each other better, he would see if there was any hope for him.

The thing that nagged him was a sense of his own failure, something he had never cared too much about before. If he had only worked harder at his painting, maybe he would be earning enough to support a wife. Others had succeeded. Ben had pointed that out a dozen times. And Trigg had shown him some striking western scenes in magazines. Charley could have done work as well, or at least he thought he could. But could he do it successfully—when he lived in Montana and they published magazines in New York? Maybe his work was improved enough so a magazine would use it. He would do more oils instead of watercolors. A big oil would sell for $25 and if he could sell enough of them, maybe he could live on it.

After he and Mamie returned from a walk along the riverbank, Ben suggested that Charley go over to Cornell's Saloon with him for a drink. Usually, when Charley went to the saloons, Ben stayed at home. This time Binnie didn't look up from her sewing, so apparently she didn't mind. "Sure, let's go," Charley said.

It was a cold night and the warmth of the whiskey was welcome. Charley and Ben talked to friends a while. But finally, Ben and Charley were alone. Ben shuffled his feet. "There's something I wanted to mention to you. Maybe it's none of my business, but Binnie asked me to say something anyway. I hope you'll understand."

Charley knew what was coming. "It's about Mamie, isn't it?"

"It is. You're seeing quite a bit of her, and she's changed since you came to Cascade."

"She has? How?"

"She talks more and laughs more and blushes and stares out the window. It isn't too hard to figure out what's on her mind."

"Do you think she likes me?"

"You know damn well she does. What Binnie and I are worried about is her. She's a sweet young girl, Charley. What's going to happen to her when you leave? I know you don't want to break her heart."

"Of course I don't. The truth is, I...well, I was thinking that someday, when I'm better fixed, if she would, I'd like to marry her."

Ben whistled and shook his head. "I was afraid of that. I mean that you'd *think* about that now. But when it comes right down to it, Charley, you're not the marrying kind. You've had plenty of sporting women you've taken a special shine

to, but Mamie's entirely different. She's not wise to the world. Her life has been tough enough already. What she needs now is stability."

Charley paused thoughtfully, finished his whiskey and put the glass down on the table with a hard thump. "I've never been the marrying kind before, maybe, but that's changing. Trouble is, I just don't know if I could support her."

"You'd have to change your whole way of living if you married. Could you do that?"

Charley shrugged.

"Mamie could be getting too attached to you too soon. She's awestruck by you. I'm afraid we've made a hero of you, and she's flattered by your attention. Binnie thinks she's letting herself care too much. If you leave her, she'll be heartbroken."

"Is Binnie worried I'll do something wrong?"

"No, no. It's just that Mamie is one of us now, and we want her to be happy. Maybe you're a little blinded by her devotion. Could be you'll change your mind about her and drift off. So before it goes any further, maybe you ought to ride to Great Falls a while and think about it. For her sake."

Charley studied the deep lines creasing Ben's forehead. "If that's what you say is best, I'll leave in the morning. I'll think. But I'm warning you I'll be back one way or the other to talk to her."

Charley asked Mamie if she'd ride out to the end of town with him. And when she nodded, he led Monte to her. "I'd like to leave him with you till I get back." She pursed her lips and a tear slid down her cheek. "You will take care of him, won't you? And exercise him?"

"Yes, I will if that's what you want."

"I'll miss our walks every night."

"Me too."

"I'll be back soon."

They rode together down the dirt road to the trail. When the horses stopped walking, Mamie looked solemn, glancing at him as though she wasn't sure she should believe him. He reached across the saddle and kissed her. "Oh, I hate to go," he said, "but I'll be back."

"I'll be waiting," she said.

Leaving her caused a painful ache to settle on him. He hardly noticed the beauty of the winter morning or the snow drifting into the draws. He kept to the trail, thinking only of coming back. The ride to Great Falls seemed long and dismal. He paused on the hill overlooking the town, vowing he'd work harder than he ever had before. He'd try to earn enough to put something aside for the future. He'd paint large oils, take one to the Brunswick, one to the Mint and another to the Silver Dollar.

As he headed down the hill toward town, his mind searched for a subject worthy of a large oil, and he remembered a story of a battle between the Piegans

and Crows that had been fought years ago on about the same site he was crossing. He stopped to look around. There had been hundreds of Indians on both sides. It was a bloody and close battle fought with arrows and lances. As he squinted off, he visualized the melee, heard war cries, smelled the dust thrown up by many rushing hoofs. Still squinting, he could make out the headdress, the shields, the bare and painted bodies of the Indians pulling bows as they raced on their horses.

As soon as he got to Great Falls, he bought painting supplies and started down the street, mulling over where he ought to stay when he saw Sid Willis, who ran the Mint Saloon. "Come on to the saloon for a drink," Sid said. "Everybody's been wondering where you've been holed up. Hey, it's good to have you back."

Charley went along with Sid and drank a few with his friends, but it wasn't long before he wandered to the back room and started to work. He made sketches and modeled two Indians on horseback for the main figures. When the proportion, position and balance were right, he turned the model around, looking at it from all angles, again envisioning the battle—movement to the left from one side, movement to the right background from the other, with a few figures in direct confrontation in the focus of the painting. A dead body, a fallen horse, raised lances, fierce and determined looks, courage. The battle came to life.

After a few days of working steadily, Charley was exhausted. Sid, who had constantly looked on, said he would take care of having it framed as soon as it dried. He cleared a space behind the bar where it could be displayed to best advantage.

"I hope to sell a few things, Sid. I need the money."

"I'll give you twenty-five dollars for it," Sid said. "It's just the kind of picture a man could look at again and again. Lots of folks will come here to see it." He looked again behind the bar. "I might have room for two pictures. Why don't you do another one about the same size. Something with some white men doing battle."

A few days later Charley finished the second painting. Sid liked this painting even better than the other. Everybody knew the story of *this* encounter. Granville Stuart had led the vigilantes to the outlaw's secret hideout below the mouth of the Musselshell. The outlaw band had held out against the vigilantes as long as they could. In the painting, some were wounded, some were dead, their horses were shot, their ammunition gone, so there was nothing to do but surrender. Sid paid Charley fifty dollars for the two paintings.

Charley had been in town over a week when a bunch of the boys burst into the Brunswick, looking for him. "We just talked to a Cascade cowboy over at the Silver Dollar," Henry said, "and he says you left Monte with a girl in Cascade." Henry looked shocked and more than a little curious.

Charley didn't reply. Mamie was not a subject he wanted to talk about here.

"Well, how come, Charley?" The boys looked at each other. "First, let's have us a drink."

Charley drank with the boys, but he wouldn't explain or answer any of their questions. It wasn't long before everyone he had ever seen before wanted to buy him a drink.

He didn't want to slight anyone by refusing, but his main purpose had to be painting. He already knew he wasn't going to change his mind about Mamie no matter how long he thought about it. He had to see if he could earn enough with his painting to live on, and beyond that—he wanted to earn that look he had seen in Mamie's eyes when she talked about his painting. So work had to come first.

One afternoon at the Brunswick, he confided in Trigg. "I can't get any painting done if I'm going to stand here at the bar all the time."

Trigg led him to the back room. "Go ahead and start painting. I'll keep the door to this room closed till nine or so. And if you want me to, I'll make your drinks mostly water."

Charley sighed. He sure as hell didn't want watery drinks, but Trigg was right. This way he could paint. "Let's try it."

Trigg's system worked pretty well, and Charley was completing a painting when Trigg brought a big man with graying sideburns to the backroom. "This is Charles Schatzlein," Trigg said. Charley wiped his hand and offered it to Schatzlein.

"He's an artist, too," Trigg said, "and has a store in Butte. I thought you two Charleys might like to talk a while."

They talked about the changing West and their art. Schatzlein admired Charley's painting and offered to handle his work in Butte. This was unexpected good news. "Do you think you could sell it?"

"Can't say for sure," Schatzlein said. "But I'm guessing my customers would like what you're doing."

Charley took Schatzlein's words as a good sign for his future. Schatzlein took two paintings with him, and promised to send Charley the money when they were sold.

Charley's thoughts turned back to Mamie. If he was lucky and worked hard enough, he might earn enough to support a wife. But what about Mamie? Would she have doubts about him? There must be lots of ranchers around Cascade looking for a wife just like Mamie—men who had a whole lot more to offer than he could ever hope for.

Chapter 20

Charley arrived back in Cascade eager to see Mamie, full of hope that he could support her, and burning with love. Very soon though, he noticed she avoided his eyes. When he spoke to her, she answered so softly he feared she had powerful second thoughts about him. He worried that she was only waiting for the right moment to tell him she'd changed her mind. Binnie had probably warned her not to overlook his shortcomings. And that was only right, but he was more determined than ever to try to win her.

"Let's go for a walk, Mamie." he said after the dishes were washed and put away. It was a cold night, and she could have refused, but she didn't. She put on her heavy coat and went with him.

"You've been awful quiet," he said as they turned down the road. "Aren't you glad to have me back?"

"Oh, I am." She bit her lip, then looked at him squarely. "Mrs. Roberts thinks I'm too young to keep company with you, unless...."

"Unless what?"

"You change some. She says you live from day to day, though I'm not sure exactly what she means. I'm glad to see you anyway, and there's something I've been wanting to ask you—even before you went away."

She smiled excitedly now, and it warmed his heart. "What?"

"Would you mind calling me Nancy? It's my real name. Nobody calls me that, but it sounds nice, doesn't it?"

He nodded and took her hand. "Nancy," he whispered, and she drew in a long satisfied breath. They walked quietly, stopping on the bridge that spanned the Missouri as they had often done in the past. Usually they gazed down into the water, but tonight the river was frozen and Charley looked straight into Nancy's eyes.

"I'll tell you what Binnie meant when she said I lived from day to day. She meant I drink too much whiskey. I swear. I have friends of all kinds, some bad, some good, but most in-between. I gamble, and I go off and live with the Indians. I spend every nickel I make and when I'm broke I borrow money. You ain't likely to see some of the women I've known in church on Sunday, but that don't mean they're worthless. Some are tough, but they've a reason to be. All those things are true, Nancy. I've been a good-for-nothing drifter. And there's a lot more I could tell you."

"Don't." She turned to look over the bridge at the icy surface of the river. "That's not what I've seen with my own eyes."

"But it's all true."

"I don't care."

"Doesn't it scare you?"

"Why should it?"

"Because...." He paused. She looked at him, her eyes wide and inviting. He kissed her gently, holding back the churning passion he felt when he touched her. He would give her more time before he asked her to marry him.

They saw each other every day, and each hour he was with her his desire grew—doubled, multiplied, redoubled until he could wait no longer. He couldn't sleep. He thought of nothing but her and his love.

They walked in the cold toward the bridge. The air was still and the stars bright. She held his hand tightly, and he believed—was almost sure—she cared as much for him as he cared for her. When they passed under a cottonwood tree he kissed her. His passion caught fire at once, and she moaned as though she would swoon.

"I love you," he whispered. "Mamie," he sighed "Nancy," he corrected himself. "You know what kind of a man I am."

She nodded. "You're the right kind."

"Do you *really* think so?"

"I do. You're a man of your word. If you said you were going to quit all that gambling, drinking and drifting, why then you would. That's all there is to it."

"And you believe that, do ya?"

"I said I did. Of course, I do." Her eyes blinked as she gazed into his face.

He cleared his throat. "You know how strong my feelings are about you, don't you?"

"I think I do," she whispered.

"It's not a passing fancy. It's...the kind of love that lasts."

"Oh, Cha'ley, I feel the same."

"You do? Then what do you say?" Love and expanding hope pounded in his heart and at his temples. "Would you throw in with me?" He looked at her beseechingly.

Her adoring look suddenly changed to one of horror. She drew in a shallow gasp of breath. "Cha'ley, how *could* you?" She turned and fled.

Bewildered, he followed. "Mamie, honey. I thought you loved me."

"Don't you ever talk to me again," she shouted over her shoulder, her voice a high-pitched wail. With that, she ran back to the house.

"Wait," he called. As he started after her, he thought about what he said. Did she think...? "Mamie wait!"

But she ran swiftly, and when he caught up with her they were at Ben's porch. The next thing he heard was the door slamming behind her. He stood at the bottom step but did not follow her inside. The family would be there. He turned to

go to the cabin but then the back door opened. He glanced up. Ben walked out onto the porch, and knocked his pipe out on the railing. "Anything wrong?"

"Nothin', except she thinks I'm a damn heel trying to take advantage of her."

Ben didn't look up from filling his pipe. "Why would she think something like that?"

"No tellin'."

"You didn't...?"

"No, I didn't. All I did was try to propose."

"She didn't look like a girl returning from a proposal of marriage. She looked more like a mama wildcat after a coyote."

"Dammit, I ruined everything. It was the way I put it. I didn't make it clear we'd be married *first*. And now she won't talk to me."

"Oh, if that's all it is, she'll be all smiles by morning," Ben said.

"Yeah, if she wakes up and finds the cabin burned to the ground with me in it, she will."

"You don't have a thing to worry about."

"No, she hates me, and I was dumb enough to tell her all about myself so she has dozens of reasons to detest me and figure I'm unredeemable."

"No man is unredeemable to a really determined woman," Ben said.

"Oh Lord," Charley said. "Talk about determined. If Mamie had a shovel, I'd be as dead as a rattlesnake in the outhouse."

"She'll be a mighty pretty bride."

"What're you talking about? She'll never marry me now. She told me she never wanted to talk to me again."

"Wait till morning. A woman so mad the pots and pans shake in the cupboard when she closes the door is a woman in love."

"If she'd only let me explain."

"You won't have to."

"If we did get married, she'd want to reform me. The boys have all warned me about that."

"Never mind the boys. They don't know anything about marriage except what they tell each other."

"There're plenty of women, easy to have any time you want 'em," Charley said.

"But when you find the right one, that's it. The others don't count."

Charley thrust his hands in his pockets and shrugged. "Saving money this last month or so was the hardest thing I ever done. And all I got saved is thirty dollars. Why in hell did I ever think I could support a wife. Dammit, let's go over to Cornell's and have a snort."

"No thanks, and you'd better go on to the cabin and get a good night's sleep, 'cause tomorrow you'll be doing some sweet talking."

"I oughta jest leave now and she won't have to see me again."

"Don't even think of that! If you do, I'll have a crying woman on my hands for a month. And then I'll...." Ben held his fist up menacingly.

"How could she think I'd mean anything but a legal marriage?"

"Go to bed, Charley. And dress up for a reconciliation in the morning."

Ben turned and went into the house chuckling, but nothing seemed funny to Charley. He started toward town and the saloon, but changed his mind. He felt too low to listen to a bunch of cowboys warn him about taking the noose.

He went back to the cabin and drew a picture of Nancy and him on the bridge the way they were before he said what he said. Under the drawing he wrote, *What I meant to say was Will you Marry me*? Maybe he'd show her that and hope she would look at it and reconsider.

After a troubled sleep he woke up early and built a fire in the stove, but hesitated about going up to the house for breakfast. Nancy was probably still fuming. And the family would be there so he couldn't explain. She'd probably drop a brick on his foot, or spill hot coffee on his lap.

Instead of going up to the house, he walked along the path by the river and was heading away from the house out toward the hills.

"Cha'ley, Cha'ley."

He turned and saw Nancy standing on the other side of the snowdrift that he had walked right through. His heartbeat quickened. "Mamie."

Her hands were on her hips, her head leaning sideways. She looked mighty saucy. "Cha'ley, will you please come back here and tell me if what Ben said is really true."

He walked toward her, thinking she was just too damn pretty for a cowboy like him. What Ben told her? Could he have explained? "Ben wouldn't lie to you, would he?"

"He said I didn't understand what you were trying to say last night."

Hope spread over him. "That's right. I was trying to ask you to marry me, but didn't pick the right words. I love you, but I'm not near good enough for you, and I don't blame you for...." He stopped talking when he saw the tears well in her eyes and her arms reach out to him. He rushed to her. "Would you marry me?"

She sputtered, laughing and crying and nodding her head. He kissed her, wondering at her tears. He'd never seen her cry. "I'll work hard," he said, "harder than I ever did, and I'll save enough money so we can be married in a few months."

"Oh Cha'ley. I love you so."

Twenty minutes later they walked up to the house and told Ben and Binnie they were engaged. "Is that so?" Ben said. "I couldn't have guessed. I'll make the flapjacks myself this morning."

Charley held Nancy's hand and gazed around the kitchen, noticing how sunny it was, how golden the very air they breathed seemed.

Hebe cried when she heard the news, and buried her head in Nancy's lap. "I don't want you to go away."

Charley took Hebe gently on his knee and turned her tear-stained face to his. "I know how you love Mamie. I love her, too, and I promise you I'll always take good care of her and try to make her happy."

Hebe dried her eyes but frowned. "Always?"

"Always, I promise."

Charley went back to Great Falls to earn enough money so they could be married. He stuck to his task—working late at night and putting in full days at his easel. He rode back to Cascade when he had saved $75. He spent most of the money fixing up the cabin on the Roberts' property. He had enough money to pay the minister, but after that there wouldn't be much left.

Charley and Nancy were married in the Roberts' home on the ninth of September. Nancy wore a frothy blue dress that she and Binnie had made of material they had gone to Helena to buy. Charley looked at Nancy, standing by the window with the candlelight flickering over her and he doubted if anyone was ever more lovely. Her pretty pink mouth quivered. Her small turned up nose was set off by the softness of her wide blue eyes. And he had never seen such blossoming joy in her before. Her golden hair was curled, swept back and topped with a wide-brimmed hat that shaded her forehead and eyes, giving her an air of mystery.

The minister stood in front of the mantel. His wife and Binny's sister sat on the left; the whole Roberts family on the right. When the minister looked solemnly at Nancy and asked, "Do you, Nancy Mann Cooper, take this man as your wedded husband?" She answered in a strong voice. "I do."

This was the first time Charley had heard her full name. He knew her as Mamie Mann, and then as Nancy. But soon she would be Mrs. Russell. His knees shook at the closeness of what was a monumental change for both of them. And now it was his turn to answer. "I do."

"I pronounce you man and wife."

Charley didn't need any word from the minister to tell him he could kiss his bride. That kiss of exhilaration became a deep pledge, and then they turned and smiled at the others. Nancy hugged Binnie, and tears glistened in Binnie's eyes.

They drank punch, and ate cake and ice cream. Ben made a toast. Everyone wished them well.

A little later, Charley took Nancy's hand and they walked across the dried prairie grass to the newly-painted cabin a few hundred feet away. He put his arm around her waist and drew her near. She paused at the doorway and looked inside. "Oh Cha'ley. You fixed it up so nice."

"Some day you'll have a home with more than one room in it, I promise."

She smiled. "But I couldn't be happier than I am right now." She pulled out the hatpin, took off her hat and laid it on the little table.

"Neither could I," he said, drawing her near, kissing the tip of her nose, and tracing her backbone with his remembering hands. He fingered the buttons at the nape of her neck. Mustn't rush, he reminded himself, but he unbuttoned the top button.

"Never had such a fine dress as this," she said, looking down and smoothing the folds.

"It sure is pretty."

She turned sideways and the skirt swished around her legs. "I love it so, I hate to take it off and put it away." She laughed, twirling another half turn. He took hold of her shoulders and pressed her close. "Don't be afraid," he whispered. "I just want to love you."

She went limp in his arms. "I know," she said taking shallow little breaths. "And Binnie told me I'd be fine. She said as long as we take plenty of time, and I think about making you happy, it would be as natural as swimming."

Charley smiled. "Do you like swimming?"

She nodded, looked up, eyes wide, holding his gaze. He kissed her as a husband, wanting to make her glad she was his wife, allowing free rein to the passion he had been holding back. He turned her around and unbuttoned two more of her buttons. His fingers trembled as he counted ten more. But by the time he finished his slow unbuttoning, he could feel her ragged breathing.

"Do you want to know how I learned to swim?" she asked with a nervous laugh. "How?"

"I jumped into water over my head, and sure enough had to swim or drown."

"That was dangerous."

She pulled the dress off over her head and draped it carefully on a chair. When she turned back to him she looked squarely into his eyes. "I'm not afraid, Cha'ley. Show me how to make you happy."

Her bare arms went around his neck and her soft body pressed against him. Between kisses he removed the rest of her clothes as well as his own. In the darkness, with his hands soothing her, she lost her shyness and her body responded with trembling urgency. Emotion poured out of her as she returned his kisses and embraces.

Loving her was as much rapture as he could stand. He was weak with it, but its richness lulled him to sleep. During the night she curled next to him, sighing softly every so often and grasping for his hand. They woke in darkness, clung to each other, promising to love each other forever, then they made love again.

When the sun rose, Charley awoke and looked at Nancy, sleeping peacefully beside him, then he got up to make the fire and the coffee. She pulled the bedding

up over her head and slept on. When the coffee was ready, he sat down on the bed. "Mrs. Russell," he called. She opened one eye. "Would you like a cup of coffee?"

She woke slowly, but after breakfast she flitted about the cabin putting it in order. The bed was made, the dishes washed, his cigarette ashes swept away. He watched, wondering at her efficiency. Then she eyed his work corner.

"Will you have enough room to paint now?"

"I'll move the table out some when I'm painting."

"Will it bother you if I watch or talk to you while you're working?"

"No, I was hopin' you'd inspire me."

"Ah, stop your teasin' and try to work."

"You want me to paint something."

"A little picture for our home." Her voice trilled with excitement.

He sat down and sketched a picture of the freshly painted cabin with a golden-haired girl standing in the doorway waving. Nancy kept perfectly quiet and leaned closer when he took out watercolors and brushes. As he painted she watched his fingers, his face, and the progress of the drawing. When he finished, he pulled her toward him and sat her on his knee. "How do you like it?"

She nodded and picked up his hands. "What you can do with these is so wonderful, I can't hardly believe it. People ought to know. Oh, some day they will. Your pictures will be in magazines, and people will want to buy them to put in their houses." She kissed his hand and laid her head on his chest. "I can't believe I'm lucky enough to have you for a husband."

"I'm the winner in this poker game."

"No, I am. I've never had anybody of my very own before. I've just been all by myself. And now I've got *you*. I would have liked an ordinary person if it had happened that way, but I'll be forever glad it was you." Her arms tightened around his chest. "I'm so proud," she whispered.

Nancy hummed as she worked around the little cabin. He painted every morning for a couple of hours while she put things right, washing, mending, cooking, making curtains for the window. After lunch if the weather was good, they would ride out to the hills together. When they came back, exhilarated by the ride, Nancy would coax him into talking about the range, the Indians, the West she didn't know. As she listened to his stories, he liked to watch her expression.

They were poor, and though that didn't mar their bliss, Charley worked harder, knowing that money for anything they needed would have to come from sales of his work. He sent two paintings to Schatzlein in Butte with a letter explaining that he was married now and needed to sell a few paintings to make expenses. Ben displayed paintings in his store, and again urged Charley to send more samples of his work to New York publishers. Nancy had the greatest admiration for Ben and took the suggestion to heart, insisting that Charley pick out his best works and

send them out. "I know that sooner or later the publishers will buy what you send them."

Charley did as she wished. She was so sure that *this* was the time—these were the pictures that would open the doors, he began to hope she was right.

The wind turned raw as they returned one day from their ride. Charley put a log in the stove and hovered over it, warming his hands. Nancy hung her coat on the peg and asked him to tell her more about the Indians he knew in Canada. "I love to hear your stories," she said. "Just one, please, before I start dinner."

"And what are you going to start?"

"Umm, the rest of the soup we had for lunch. I'll add some water and make some biscuits."

They sat on the floor by the stove, Nancy seated on a pillow, Charley sprawled out on his stomach, his arms around the pillow she had tossed him.

"The Indians didn't always have it so fat in the winter. Even in the old days before the buffalo disappeared, winters got lean and hungry. The pemican would give out, and since the tribe didn't move around much in the winter snows, the game dwindled around the camp and they just held on, waiting for spring. Hunting parties would go out whenever they could, but a few birds and an antelope now and then wasn't enough to keep hunger away. So when a hunting party first spotted the giant herds of buffalo returning, the joy it caused was like nothing we know of. Imagine a band of six hungry Indians searching the barren country for anything they can take home and eat—a porcupine, anything, and they look down a ridge toward the river and there they spot a cloud of dust, and then the brown specks that tell them their time of hunger is over."

Nancy's eyes grew wide as she listened. But he stopped. He saw the picture as clearly as he saw the room around them. "Are you going to paint it?" she asked.

"Yep."

She watched, standing quietly beside him as he sketched. After a while, he smiled up at her. "How about building a cup of coffee."

"We only have a little left. I was saving it for morning."

"Oh." They were down to their last few coins. The general store would give them credit, but they agreed not to charge food unless they had to. "A glass of water's fine."

She brought him water from the supply she kept in a jar in the cabin, then put her arms around his neck, resting her chin on the top of his head. "Now don't you worry none. It takes time to get known as an artist. If you keep working hard, some day we'll have everything we can ever want. New clothes, a nice house...," her voice trailed off.

He reached for her hand, resolving to paint like hell. He knew she needed new shoes. Her gloves had been mended a dozen times. He had seen in her eyes how she admired the Sunday clothes of the women in town. Pretty as she was, she ought to

have pretty things. Though she never talked about wanting them, he guessed it was part of her dream for the future. He never wanted to make anything happen quite so much as now.

He worked on a painting to send to Great Falls, and when that was finished, he started a watercolor, thinking he would take it to the saloon in Cascade. He had always made his quickest sales in saloons. Of course, most of the men around Cascade who wanted one of his paintings already had one, but it was his best chance. After lunch the weather was too blustery for riding so Charley took a picture over to the saloon. Nancy stood at the doorway and waved as he rode Monte toward the road.

He hadn't been to the saloons much since his marriage, and he looked forward to sitting down with his friends again—having a few drinks—not like he used to; that was too much for a married man, but a couple of drinks and some saloon talk would liven up his spirits.

Vin Fortune bought him a drink and wanted to know how come the little lady let him off the lead rope. Charley laughed and ignored all the jibes. After a while it was as though he hadn't been away. His old friends still wanted to hear jokes and talk about the days on the range.

It was Vin who saw the painting and asked what he was going to do with it. "I thought I'd pin it up somewhere around here in case anyone would like to buy it."

Vin nodded. "It's as good as the ones you sent to Niedringhaus. Maybe he'd like some more pictures. I could write and ask him for you."

Charley hesitated. "I do need a little cash, but...naw, it wouldn't be right." Still, Charley appreciated the offer and bought Vin a drink. They laughed a lot and the glow of the whiskey and the warmth of his friends spread contentment over him. He no longer cared so much about selling the painting. What he cared about was keeping this feeling with his friends smiling around him. Everything was more than all right now. Sure, he'd have another drink.

It was long past their usual supper hour when Charley got back to the cabin. A delicious smell welcomed him as he opened the door, but the sight of Nancy's face put him on guard. "I been waiting supper," she said, her voice forlorn.

"I'm sorry I'm late, Mamie. The time jest went and I didn't notice."

"I baked a duck and stewed some apples. I don't know if it's any good now."

"It smells fine." He walked unsteadily toward her and kissed her. She pushed him away and wrinkled up her nose. He chuckled at her and sat down at the table, which must have been set for hours.

Silently, she served the food. They hadn't had such a meal for quite a while. "Where did you get a duck?" he asked.

"I went out and shot it."

"You shot a duck? And cleaned it and everything?"

She nodded. "I'm not helpless, Cha'ley Russell." Her voice was sharp.

"I'm sorry I was gone so long."

"We won't talk about it," she said. "Eat your supper."

Weeks later when he came home from Cornell's, he found Nancy boiling mad. As soon as he looked at her, he felt guilty. He had spent money they couldn't afford to waste.

"You said you were going to the saloon to try to sell a picture. Did you sell one?"

"Not yet, but I left it hanging at the bar."

"I'm not going to let you waste your time getting drunk."

"Drunk?"

"Yes, you're drunk."

"But a man has to have his friends, too."

"The most important thing you should be doing is painting. That's your profession. But you're wasting your time...." Then the hardness left her voice, and was replaced by a fragile note, "...and you promised me you wouldn't."

The disappointment in her eyes when she looked at him was more eloquent than anything she could say. She was right, he was drunk, but even so, he wouldn't forget that look on her face. He promised her he'd work hard and not waste time. She couldn't tolerate time being wasted, either his or her own. But being with friends was not a waste of time to him.

The next day she was quiet. He went to work on his painting first thing. But he didn't feel so good. He would rather have taken Monte for a ride out in the fresh air. Nancy finished her morning chores and sat down to darn socks. Occasionally, she glanced at him. He wondered if she noticed how his hand trembled. He wanted to leave, to walk over to the post office, or Ben's store, but he stayed at his table and painted. Her eyes filled with tenderness now.

Finally, he put down his brush. "Cascade is too small a place to sell enough paintings."

She looked up startled. "But you send things to Butte. Mr. Schatzlein sent you two checks already."

"It helped, God knows, but we're broke again."

She pursed her lips and looked thoughtful. "It did go better when you lived in Great Falls, didn't it? Do you think we should go there?"

He shrugged. "If we did, we'd have to pay rent. It costs more to live there, but customers ought to be easier to find."

He went back to his work, but Nancy asked more questions about Great Falls. Later she talked to Ben and Binnie, and the following day she said, "Yes, we ought to move to Great Falls."

"Are you sure you want to go? You have friends here. We have a place to live?"

"Your work has a better chance in Great Falls, so I want to go."

"All right," he said. "We'll go."

Chapter 21

Charley and Nancy packed their belongings on their horses and headed for Great Falls. "You'll work hard," Nancy said, "and I just know deep in my bones your time is coming, and those editor fellas back in New York City are going to say, "look, here's an artist who paints as well as anybody. Let's publish his pictures for a change. Then folks all over will see how fine your work is."

Charley laughed. "I hope you're right, but to start with we have to worry about paying the rent and buyin' the beans."

"It won't be easy," she said, "but if it's possible, that's all we care about." Her eyes were bright, her cheeks pink.

They rested the horses on the top of the hill overlooking the town and Charley showed Nancy how the streets of Great Falls ran grid-like from north to south and east to west. "In this town streets aren't old curving trails zig-zagging the hills like in Helena. This town was planned out and it's growing fast. The Missouri River runs through it and the railroad brings travellers."

"Oh, I know this is the right place for us," she said.

Her hopeful mood changed abruptly later when all the houses they looked at to rent cost twice as much as they could afford. Dejectedly, they looked at uninhabitable shacks, and Nancy despaired. Finally, Charley swallowed hard, crossed his fingers and rented a small north side house costing much more than they expected to pay. "Maybe something reasonable will turn up later," Nancy whispered.

As soon as they moved in, Nancy hurled herself into scrubbing walls and floors. Charley went out for supplies and to see people who handled his work. Nancy looked at him worriedly as he left. "Don't lose track of time when you get to the saloons."

"A course I won't. I'll be back in a couple of hours."

He set out thinking that first he'd buy paints and canvas, then stop at the Mint and the Silver Dollar, and go to see Trigg. He didn't expect the Silver Dollar to be quite so lively. Billy Rance, the proprietor, always made a man feel like his long lost brother. And a lot of other people wanted to buy him a drink.

He hadn't forgotten about his promise to Nancy. He told the boys he couldn't stay. But he couldn't refuse when a friend wanted to buy him a drink either.

The sky was dark when he left the Silver Dollar Saloon. Since he had already stayed away too long, he hesitated about stopping again but he couldn't just ride by the Brunswick without going in to shake Trigg's hand.

"Can't stay, but I wanted to say hello anyway. My wife is home alone, trying to get settled. She doesn't know anyone in town and I promised I'd be right back. You're a married man. You understand."

Trigg put his hand on Charley's shoulder and walked him to the door. "I do. I'll tell you what. Bring your wife over to our house for supper tomorrow night. My wife would like to meet her. That way we'll all have plenty of time to talk. How about it?"

Charley nodded eagerly. "Thanks. I'd better get home and tell Nancy."

Nancy was slumped in a chair, strands of her hair straggling around her face, her hands red from soapy water, a weary look on her face. The little house had been so thoroughly cleaned, he didn't recognize it as the same place. He looked around. "Why Mamie, how did you do it?"

She sighed, and when he looked at her, she sniffled.

"What's the matter?" he asked, going to her, stooping down beside her to take her hands. "I should have stayed and helped."

"You shoulda done what you promised." She sniffed.

He felt the tension in her hands. "I couldn't get back sooner. Did you have anything to eat?"

"No. Did you?"

"I did have a couple of boiled eggs at the Silver Dollar. You have to eat something."

"We don't have anything. I'm too tired anyway."

He carried her to the bed and told her to rest while he went out to get something to eat. She didn't want him to leave. But he promised to be back in fifteen minutes. He knew of a place south of town where a woman kept chickens and goats. Though it was late, he went to her house and bought a dozen eggs and a chunk of cheese. When he got back, Nancy was half asleep. She sat in stony silence while he cooked the eggs. When she had eaten a few bites and tasted the cheese, he told her about Trigg's invitation.

Her face brightened at once. "Oh Cha'ley." Her eyes filled with tears. "And I thought you were so busy drinking and joking with your friends, you forgot all about me."

At the prospect of meeting the Triggs, her mood changed back into the hopeful dreamy one that suited her best.

The next day she insisted he begin his painting, while she washed her hair, darned her stockings, laundered her dress and Charley's best shirt, and hung them out in the wind. She cleaned his boots and when he stopped painting, she washed his hair for him and asked dozens of questions about the Triggs. Where did they live? Where were they from?

They lived on the north side in a nice big house and Albert was from England and well-educated. Nancy paused and raised her eyebrows. "This is such a long

way from England. Half way around the world.... I haven't had much schoolin'. Do you think they'll mind? Some folks really look down on people like me with no family, and no schoolin'."

"The Robertses didn't. The Triggs won't either."

"I don't want you to be ashamed of me."

"Ashamed of *you*! Now, if that ain't crazy. How much schoolin' have I had?"

Though Charley tried to reassure her, Nancy nervously wrung her handkerchief as they knocked on Triggs' door that evening, and she clung to Charley's arm as they were welcomed into the house.

Albert Trigg took Nancy's hand, smiled and introduced her to his wife Margaret and his grown daughter Josephine. Margaret was a strikingly handsome middle-aged woman, and Josephine, though not exactly pretty, was tall and graceful with a long face and abundant brown hair, pulled casually back.

She turned her attention to Nancy. "Daddy tells us you're new to Great Falls. Maybe Mother and I can help you get acquainted." Josephine took Nancy by the hand as they walked to the parlor.

"What a beautiful room," Nancy said, looking at the blue and cream furnishings. The parlor was large, full of French style furniture and trimmed with gilt moldings. Nancy touched the tapestry chair back before she sat down. The contrast between Triggs' new house with its sumptuous decorations and the tiny place Charley and Nancy rented was too great not to be felt. He could see from her eyes that this kind of respectability was something she yearned for.

"Daddy has admired your husband's work for quite a while," Josephine said. "His painting in our sitting room gives us a great deal of pleasure, doesn't it Mother."

"Indeed it does."

Nancy beamed. "Could I see it?"

Josephine jumped up. "Come along." She led the way through a pair of folding doors into a smaller room. Charley followed them. He sometimes wondered what happened to his paintings after they were sold. Would they seem too raw for parlors and sitting rooms? He looked up when Josephine paused. There it was over an oak bookcase—a gilt-framed painting of an Indian council tipi. The young Piegan chief, standing in breechclout, moccasins and full feather headdress confronted the Crow leaders with his evidence of treachery. This picture looked much better than he had remembered.

"Show them the pictures in that Harper's magazine you brought home, Josephine," Mrs. Trigg said.

Josephine found the magazine and opened it to the article written and illustrated by Frederic Remington. Nancy, seated beside Charley on the sofa in the sitting room, studied the magazine page, then looked back at the gilt-framed painting on the wall. She cocked her head. "Remington's pictures are fine, but I

think this painting on your wall is better." She sat up straighter and folded her hands in her lap, gazing at the painting. "Cha'ley's has more detail and there's something about it, I don't know what, but something that makes you think you're right there feeling some real emotion—like something important is going to happen."

"Yes," Josephine said, nodding her head. "And what more important thing can art do than give an emotional sense of being there? I could bring home some other magazine pieces Remington illustrated," Josephine continued. "You see, I work in the Art Department for the schools and we save these."

Nancy looked at Josephine with open admiration. "You do? Well, we *would* like to see more western art in magazines, especially by the best artists."

"Remington is the most popular and probably the best. What do you think, Charley?"

"Remington is very good," he said, though he would quarrel with some of Remington's detail. His color was more dramatic than realistic, too, but even so, his work was excellent.

"But in Remington's pictures you can't see the muscles of his horses," Nancy objected. She caught Charley's eye. "Your horses are better."

Trigg laughed. "I think you have a booster, Charley. I agree with you, Mrs. Russell, Charley knows his horses."

"Please call me Nancy," she said, smiling warmly.

Later when they returned home, Nancy could talk of nothing but the Triggs and the Remington illustrations. "I know your pictures will be accepted if you just keep trying. Oh, wouldn't it be nice to have them in a magazine that goes all over the country?"

Charley groaned. "But how many times do the editors have to say no before I stop wasting the postage? You know how many I've sent. And so far, nothing has come of it."

"Well, you're not giving up now, Cha'ley Russell. You're going to send pictures until some smart editor publishes them. It's not just me, seeing things rosy because I love you so much. The Triggs agree."

During the next few weeks Nancy mentioned Remington's pictures often. She read the articles Josephine brought. She saw Remington's illustrations of Longfellow's Hiawatha and learned his bronze castings were selling well. The more she discussed Remington's work, the more she muttered indignantly at his success while Charley was ignored.

"Don't get so worked up," Charley told her. "You said yourself it takes time."

"Oh, I know." She paced from the window to the door. "But I'm impatient. All these little wax figures you make could become bronze statues. Sometimes I think they're even better than the paintings. She picked up a figure of a cowboy on a bronc, and let her fingers trace over the surface. Then she closed her eyes. "Even

if I was blind, this would tell me everything I need to know about riding a bucking bronc." She put the figure back on the shelf and sighed. "Don't mind me, today, Cha'ley. I'll just take these wrapped pictures down to the post office and send them on their way."

He painted until she returned, wondering if he would ever live up to her dreams.

Later, when she came through the doorway she was smiling. "This time I know they won't come back."

Charley needed her faith and optimism. His paintings sold very slowly through the saloons and Schatzlein's store in Butte, and even though they lived frugally, they were in debt.

Though it was early in the afternoon, he had painted seven hours already and looked forward to riding downtown. He needed to breathe the outdoor air and relax with the boys for a while.

"Don't be gone long," Nancy said with an edge to her voice. "Remember, we were going to write a letter to that new editor and decide what to send him. It's important."

"What's the rush?" he said, impatient to go.

Her pretty face turned stern. "The grocer and the butcher are askin' for their money. The more time you waste at the saloons, the longer it will take to break in with the paying New York magazines. You promised you would keep working for it."

"And I will. We'll write to that editor when I get back. But I can't sit still all day. A man has to move around. See his friends." He had said those same words a dozen times, and this time she looked as though she didn't believe it.

She took a deep breath. "I'll work on the letter while you're gone, but try not to be late. No more than two drinks. Promise."

He kissed her, letting his mouth linger on hers. "I promise."

He walked Monte down the street slow-like and as they went along, he practiced tossing his lasso over fenceposts. Riding down Central Avenue, he stopped at the corner and strained to see the horses tied to the hitching posts in front of the Mint Saloon and across the street at the Silver Dollar Saloon, then up the street at the Brunswick. A horse in front of the Mint looked like Pat Tucker's Bunky. Leaning forward in the saddle, he galloped Monte to the Mint and reined up. It was Bunky all right. Charley patted the old race horse's neck and strode through the Mint's swinging doors. Pat was standing with his foot on the rail.

"Here he is now," Sid said, and Pat turned around. Pat still looked every inch the tough rawhide he always was. Still had the same fun in his eyes. Charley poked him on the shoulder and Pat knocked off Charley's hat. "Set 'em up for my friend," Pat said.

Sid poured Charley a shot of whiskey. They had a lot of catching up to do. The old yearning to trail off into the mountains with Pat rose up. But it was enough for now to sit and talk.

"Con Price, yeah, I've seen him, Charley. He's bronc bustin' for an outfit up north. He talked about you." Pat laughed. "He told me he came to see you in Cascade after that story went around that he was killed in a tussle with a bronc. Said you looked like you seen a ghost when he came through the door."

"I thought I had," Charley said. "I jest went right on fryin' my bacon like he wasn't there. Finally, he laughed and said he was nothin' but a ghost, but a damn hungry one and to please burn him some bacon, too."

Pat and Charley had a lot to talk about. Charley forgot all about Nancy and New York editors. Pat asked about Jake.

"Poor Jake," Charley answered. "He got necked, and his wife turned out to be a crazy damn wildcat. Jake wasn't afraid of nothin' till he got tangled up with her. One day she went on a rampage and took a shot at him. She missed. Then a couple a months later, darn if she didn't do it again, missed again too. Jake figured he couldn't stay that lucky forever so he left and went up to Alaska."

"Damn it to hell," Pat said, "Jake didn't deserve a woman like that."

"No, but she didn't pine away for Jake too long. Got married again I heard. And when she turned her six-shooter on the new man, he drew his and stopped her for good with a couple o' bullets."

The hours passed unnoticed. Pat confided to Charley that he'd met someone he wanted to marry.

"Marry and settle down. You?"

"It's about my turn, ain't it."

Charley nodded and they had a drink to Pat's future. Much later, Pat suggested they go out and get some dinner, and suddenly Charley remembered his promise to Nancy. "Hell, I can't," he said. "I was supposed to be home hours ago. I'll have a gun-totin' wildcat on my trail if I don't hurry."

Pat laughed, and they parted, promising to see each other again the next day, but a sickening feeling came over Charley as he thought of Nancy, waiting all afternoon and evening.

"I don't care how long it was since you saw him," she fumed. "Your promises aren't worth spitting on anymore."

"Don't be so mad. Talking to a good old pal ain't somethin' to be so mad at."

"What I'm mad at is your squandering precious money and time sitting in a saloon drinking whiskey. It's ruining your chances, Cha'ley, and it makes me hopping mad. I can't sit back anymore and watch you throwin' yourself away."

He objected, but she turned on him. Her eyes were red and swollen, and there was a hard brittle look in them now. "It's time to make up your mind whether you want to go on working the way we planned or whether you'd sooner go back to

driftin'." She took a deep desolate breath. "I won't nag you anymore if that's what you want. I can get a place with a nice family like the Robertses again, and I'll be all right. I've always gotten along by myself just fine, and I still can."

"Don't, Mamie. You know I couldn't stand that." Maybe he did break his promise, but he wasn't doing anything wrong. Talking to Pat couldn't hurt anything.

"You just don't act right when you drink too much."

"Act right? I was jest talkin' to a friend." People always want to blame whiskey for everything. Today, with Pat, he had told himself he would only have two drinks, but how could he worry about counting with Pat there?

He sat down heavily, searching for the right words to soothe her, when his boot struck something. He looked down and saw the canvas bag she had brought her things in when they had moved from Cascade. It was packed. He looked up at her, but she looked away.

He stared at the pathetic old bag. "Where would you go?" he asked. Her voice came in a hoarse whisper. "To Ben and Binnie until I can find something—probably in Helena."

"You don't want to do *that*." He couldn't move, couldn't think. She couldn't want to leave him.

"'Course I don't *want* to, but if I must, I will."

He shook his head and undid the canvas bag. His hands worked awkwardly. Too much whiskey was still flowing through him. He went to the shelves where she kept her things and put her clothes back one piece at a time. "We'll work out a schedule," he said. "First thing tomorrow, and I'll stick to it."

She didn't answer, or even look at him. After a while he asked her to come to bed. She took a few halting steps, sat down on the edge of the bed and unbuttoned her dress.

The next morning after a somber breakfast of weak coffee and dry biscuits, Nancy laid out her plans for a schedule. He would paint in the mornings, beginning soon after he got up, usually around six, and work until lunchtime. After lunch they would turn their attentions to the business of publishers. Though he made no objection, he inwardly balked. He couldn't understand how she kept expecting him to succeed with publishers when all his efforts so far had been unrewarding. But he would ignore that now, besides she was practical, and insisting on a steady effort was probably wise. It had always been too easy for him to put his work aside and ride out with his friends.

With his work schedule agreed on, he thought they had made great progress, but Nancy wasn't finished. "Now then," she said, eyeing him boldly, "there's the matter of the saloons."

"What about 'em?" he said.

"I'd like you to stay away from them."

"Just a minute." His skin prickled all over. He was alert, threatened. "I promised to work hard every day. And I will, but I'll never promise to stay away from the saloons."

"All right," she said. "We'll bargain. I'll agree to once a week."

He pushed his chair away from the table and jumped up. "Nobody's going to tell me I can't go to a saloon if I want to."

Nancy pushed away from the table and stood up, too, her face flushed. She looked as though she was going to shout right back at him. But then she closed her eyes tight and breathed deeply. "Come back and sit down," she said. "We're not getting anywhere yelling at each other."

Even though he was determined not to promise away his freedom, he was sorry he had yelled. He didn't want her to pack up again, but damn, the boys were already saying he was fighting a tight noose. Of course, he knew Nancy worked hard. She made their money stretch in ways he wouldn't have dreamed of. But this was too much.

He came back to the table, and they sat down across from each other again. "Did I ever tell you about Pretty Charlie Green and his contract?"

She shook her head. Then in a low patient tone he told her about the offer. "Seventy-five dollars a month plus expenses sounded big, but everything I painted would belong to him and I was to work twelve hours a day. I sure coulda used the money, but I couldn't do it." He looked her hard in the eye. "I needed freedom."

"I don't know much about freedom," she said. "Maybe it was worth seventy-five dollars a month." She sighed and looked down at her hands. "The bad thing about the saloons is that you drink too much whiskey and spend too much time talking over the past when you should be working on your pictures and thinking about the future."

"I'm as interested in the past as I am in the future. And I wouldn't be very happy without my friends."

"If it's really your friends you go to the saloon for, and not the whiskey, you could go and not drink."

"What?" He jumped to his feet again, but caught himself and didn't yell. "A man can't go into a saloon and not drink whiskey."

She glanced at him with a beaten look in her eyes, then lowered her head. He felt he'd won. But when she raised her head, she stared at him so penetratingly, he dreaded what she was going to say. "If you really love me, promise me you'll have only one drink of whiskey each time you go to the saloons."

"But how many drinks I have has nothing to do with loving you."

"It does if whiskey is going to be your future—instead of me."

He didn't like what she was doing. Maybe he did crave whiskey too much, but to put it like that wasn't fair. He stared back at her, wondering if she knew how he

enjoyed that first swallow of whiskey as he felt it oozing through him, bringing him that first rush of pleasure. And after that first drink, was it really possible...?

"You can't promise, can you?"

"One drink?" He shook his head. "But if someone buys me a drink, I have to buy one back, and it would be an insult not to drink with a friend."

"Two drinks then. Could you promise to only have two drinks?" He could feel the tenseness in her penetrating gaze as she held her breath and clenched her hands into tight fists. She had given as much ground as she was going to.

"I'll try."

"No. *Promise* me. Two drinks and no more."

It would be for the best, he thought. "I promise."

For the next two months Charley lived up to his promises. He rose early and worked each morning. And it was paying off. Today, he stepped back from a finished painting and looked at it critically. His paintings were better now than they were a year ago. He spent more time on each one to make it worth the price he hoped to get for it. Nancy interrupted his reverie by bringing the mail, something he dreaded because when his paintings were returned, she still bristled with disappointment and indignation.

"Cha'ley, here's a letter from a publisher we sent ten pictures to."

He could see the hope in her eyes, hear it in her voice. "Open it. It's probably a letter saying they're sending 'em back."

"Could be," she said, ripping open the envelope. She pulled out the folded letter and read. "'Dear Mr. Russell. We have selected six of your paintings to illustrate a book called *The Story of The Cowboy.*" Nancy's voice choked. She stopped reading, lowered the letter to her side and looked at him, tears streaming down her face.

Though his fingers were smudged with paint, he took the letter from her and continued to read. "All of your work shows excellent draftsmanship and high action. We have selected the paintings exhibiting the best composition, that is, those with a few figures tightly composed and occupying a definite focus area, usually near the center. We prefer that atmosphere and distance be created with the effect of dramatic color transitions and feel that some of your paintings would be much more effective if color were exploited more boldly. You might find it beneficial to look at art currently being published...."

Nancy stood behind him, her arms around his neck, her chin lowered to the top of his head so she could read the letter, too. The pay for the paintings was $10 each. That was $60 for the six of them. Not as much as they had hoped for, but it was a start.

He turned around and pulled her onto his lap and kissed her. "It's all your doing. I never would have sent anything to that publisher." He sighed. "And those comments about what works best for them might be worth more than anything. I always had the feeling there was something they were looking for I didn't know

about. But maybe this will help. Would you ask Miss Josephine to bring home more books and magazines with illustrations I could look at?"

"Let's ride over to the Triggs' tonight and ask her. Trigg will be glad to hear about this, too."

That afternoon before Charley went off to the saloon, he promised Nancy again he would have only two drinks and would be home at five o'clock. He went to the Silver Dollar and took the precaution of asking Billy Rance to remind him when it was ten minutes to five even though the clock was hung backwards so a man could read the time from the mirror if he was standing at the bar. Charley didn't always stand there and would probably forget to look at the clock anyway.

Billy promised to watch the time and Charley wandered into the back room where he dashed off a watercolor while his friends played poker.

He was a few minutes early getting home. Nancy was wearing her best blue dress and had her hair combed softly back with the long locks twisted into a bun and pinned to the top of her head. Today her eyes were sparkling brightly.

"I've been thinking about the magazine Josephine showed us," she said. "The one with the article and illustrations by Remington. Well, you could do that, too. Write a story and illustrate it. That way the illustrations will be perfect. You won't have to pick typical scenes."

"Good God, Mamie! If it's anything I ain't, it's a writer."

"Humph. You're a wonderful storyteller."

"Tellin' a story ain't like writin' it."

"Why not? You just have to put the words down on paper."

"Naw, when you're telling a story, you're lookin' at someone's face. You wait till they nod and you know they're with you before you go on. You watch so you can say the right thing at the right time."

She looked skeptical. "Well, you could tell your story to me, and I could write it down. Then you could illustrate it."

"Where's supper?"

"I'm serious, Cha'ley. Remington did it."

"I thought I smelled stew when I came in here."

She laughed. "All right, we'll talk about that later."

Chapter 22

Nancy was cleaning the sink in the kitchen. Charley leaned against the door jamb, arms crossed over his chest as he told her about the job.

"No," Nancy said, wiping her hands on her apron and stamping her foot for emphasis. "You're not taking any job on any ranch."

"But it'd only be for a month or so. We need the money, and besides...."

"Besides, you're an artist. And you have to stick with what you're doing. You don't put in your regular hours as it is. Friends always dropping in while you're supposed to be painting."

"Aw, they're no bother. They just jaw a while till I'm ready to stretch my legs."

"That's just the trouble." Her voice turned shrill. "You leave your work and go strolling down to the cigar store as though you didn't have another darn thing to do. It's got to stop." She was fuming now. He wished he hadn't started this.

"Calm down. I'm puttin' out more work now than I ever have in my life. And we finally got a publisher to pay fifteen dollars apiece for twenty paintings, didn't we? And they're almost done, ain't they? Well, ain't they?"

She sighed. "Yes. And I know it's not as much money as you could earn on a ranch, but it's a chance to prove you can do it. Are you almost finished?"

"Almost, I'll have them finished before lunch." He wandered back to the dining area and finished the pen and ink sketches that were to go with the project. It didn't matter that he would only make $2.50 each. He drew with pleasant concentration. When he was through, he went off to meet his friends.

Before he returned, Charles Schatzlein knocked at the front door. Nancy made him welcome.

"We sure appreciate how quickly you sent us the money for Charley's paintings," Nancy said. "We couldn't keep our heads above water without you."

Schatzlein ran his fingers through his thin graying hair. "When I show Charley's paintings to the right people, they sell themselves."

Pride showed on Nancy's face. "Charley can put himself into a scene and copy it as though he was there. He won't rest until every detail is the way it should be."

Schatzlein nodded and smiled. "What's Charley up to now?

"He's working on some paintings for a publisher. He's underpaid for the amount of work he puts into them, but if it helps him to become known, it'll be worth it."

"That's right," Schatzlein said.

"He should be back any minute." She looked up helplessly. "His friends mean a lot to him."

"Yes," Schatzlein said. "Charley draws people like a magnet. I remember the day I met him. I said to myself, here's a man with no false airs, a man who cares about people and sees into them and respects what he sees. He made me feel good about myself because he understood so much without it having to be spoken."

Nancy nodded. "People do come to life when he walks into a room. I've felt the difference he makes."

"His painting draws people too," Schatzlein said. "I think his work is getting better all the time."

Nancy sighed. "I just don't know why it's taking so long to succeed." She tossed back her head. "I know he does this illustrating mostly to please me, but in the long run, it will be important to him. Now, let me show you a painting he's finishing to send to you."

Schatzlein followed Nancy to the dining nook where Charley's easel was set up. "There," she said proudly. "Look at those horses in the foreground."

Schatzlein examined the painting closely. "Anybody would be proud to own that," he murmured.

"I should think so." Nancy smiled, gazing at the painting. "No one in the country paints scenes like this better than my Cha'ley. And that's what I hope those illustrations will prove." Nancy turned to open a drawer. "Even in black and white, a person can almost be there." She handed an illustration to Schatzlein and smiled.

When Nancy had shown him everything Charley had on hand, she warmed the coffee. They chatted idly while they waited another half an hour for Charley to return.

Charley shook Schatzlein's hand, hung his jacket and Stetson on the peg by the door, then rested his hand on Schatzlein's shoulder. "How's it going in Butte? Tell me what you've been painting."

Schatzlein grinned. "I'm working on a huge landscape. When you come to Butte, I'll show it to you. Your wife has been showing me your latest paintings. In fact, we agreed unanimously that your work is better than ever."

Charley sat on the wood rocker. "I hope that means you'll take a few things back to Butte with you."

"I surely will. But tell me, how are you managing your sales generally?"

"It's simple." Charley sprinkled tobacco on his cigarette paper as he talked. "I paint a picture and send it over to you or take it to the Mint or Silver Dollar with the price marked on it." He paused, rolled the paper around the tobacco, moistened it with his tongue and sealed it. "Of course, when we send something to a publisher, we take whatever they offer."

Schatzlein frowned. "And you ask the same price for all your paintings?"

"No." Charley struck a match on the sole of his boot. "The smaller ones are less. But all the large oils go for twenty-five dollars unless...." He lit his cigarette, squinting against the smoke.

"Unless somebody offers him less," Nancy put in with a smile.

Schatzlein's face was serious. "You've priced everything you've sent to me at twenty-five dollars, and I send you that amount when I get the paintings."

"I sure appreciate you doing business that way," Charley said. Schatzlein looked down at his hands. "But I get much *more* than twenty-five dollars for some paintings, and it might be that you ought to think about raising prices on your best."

Nancy's eyes widened. "He spends more time on each painting," Nancy said. "It would only be practical to price each one according to how large and how good it was." Nancy pressed forward, her cheeks flushed, one hand patting the sweep of golden hair at her temple.

Charley frowned. "Nobody's going to buy 'em if I ask too much."

Schatzlein raised his eyebrows. "I asked seventy-five dollars for that hunter and grizzly bear painting you sent. I didn't get it right away, but eventually I did."

"You *did*!" Nancy said, swallowing. "Oh, and I remember how exciting that one was. You could feel the danger in it."

Charley recalled the painting. "But I couldn't ask that much for one painting?"

Schatzlein looked at Charley with a good-humored smile. "Have you ever thought of letting Nancy manage the business end of it? I have a feeling she would do very well."

Nancy blushed. "Thank you. I wonder if I could. What do you think, Cha'ley? Would you let me try it?"

Charley hesitated, glancing from Schatzlein to Nancy. "I never have liked selling. As soon as I hand a picture over with a price on it, I see places in it that could be better. And I feel like I might be cheating the feller." He turned to Nancy. "You already have enough to do around here."

"But if I could help, there's nothing I'd rather do," she said, going to the window, then turning to face him. "Let me try it."

Charley glanced at her eyes as he snuffed his cigarette out in the ashtray. He raised his eyebrows. "Why not? You can deliver the next painting I finish. A cattleman I met at the Mint asked for a picture with the Highwood Mountains in the background. When it's finished, you can take it to him."

The day Nancy was to deliver his finished painting and collect the fee, she got up early enough to have breakfast with Charley. He saw right away she was edgy. She snapped at him for dropping an ash on the table and slurping his coffee. She hardly touched her breakfast, but stared off, bit her lip and mumbled a couple of times. She put on her best dress, took a long time combing her hair and filing her

nails. When she was ready she draped a green crocheted shawl around her shoulders.

"Isn't that new?" he asked.

"Margaret Trigg gave it to me. She said it was the wrong color for her, but she thought it would be right for me."

She looked awfully pretty, but he could see how nervous she was and he hated to send her out on this miserable task. Yet it was too late to change his mind and tell her not to go. Maybe he should go with her. "Here's the painting," he said. "I'll go with you this time if you...."

"No," she shot back with an alarmed look. Then she smiled, pulling on her gloves. "No, please. I have to do it myself." She laughed. "I told Margaret I was going to, and she would think I was quite a liar if after that, I just went along with you." Her look convinced him she was determined to do this alone.

He handed her the wrapped painting. She smiled. "Don't worry. If Mr. Shaw likes it, he'll take it, and I'll bring home the money. If he doesn't, I'll bring back the painting. Either way I'll see you soon."

On her way, Nancy stopped at the Episcopal church, hurried up the steps and went inside the empty vestibule. She put the wrapped painting on a table, quickly unwrapped it and pasted on a label marked $60. Then she rewrapped the painting and hurried off.

Shaw was a tall robust man with a full gray mustache. He led her into his library and offered coffee or tea. Nancy thanked him but declined. Smiling, she untied the string around the painting with trembling fingers. Mr. Shaw took the unwrapped painting from her and propped it on a chair to examine it.

"Ah yes, I recognize that place. I've seen the mountains look just like that hundreds of times." Shaw smiled as he looked at the canvas.

"I think this is one of Cha'ley's best paintings," Nancy said. "I've never seen him paint a finer horse than the white one here. And notice the color in the sky, how gradually the blue changes to pale green. The whole scene has the freshness of early morning in it. It's Cha'ley's favorite time, especially when he's out there riding in the country."

Shaw smoothed his mustache. "And he painted the lasso just above the maverick's head so you can't tell if the cowboy will bring it down in the next few seconds, or if the maverick's running fast enough to escape it."

Nancy smiled. "Cha'ley likes to leave the next crucial seconds to you."

"Makes it exciting," Shaw said. "You wonder who'll win—the cowboy or the maverick. Well, this is fine. What is the price, Mrs. Russell?"

Nancy turned the painting over so Mr. Shaw could see the $60 price label. His smile disappeared. "That's a little high, isn't it?"

"Cha'ley spent a lot of time on this one as you can tell. His work is getting so much better, it's well worth more."

Shaw stood straight and tall, frowning with indignation. "Then why doesn't he ask more for the paintings they sell at the Mint?"

Nancy met his gaze. "He will in the future. Now, if you'd rather have one of those, that's perfectly all right. I don't mind taking this back with me. You're under no obligation at all."

"No, no, Mrs. Russell, I didn't mean that. As you say, it *is* a superior piece of work." He reached for his wallet, counted out the sixty dollars, pressed it into her hand, and gazed back at the painting.

"Thank you, Mr. Shaw. I hope you'll enjoy it."

When Nancy came home, she put the money on the table, and waited.

Charley glanced up. "Sixty dollars! What's this? Dammit, Mamie, that's more'n twice what it's worth."

"It's twice what you ask but not twice what it's worth. I told him there was no obligation. If he hadn't wanted to pay sixty dollars, I would have brought it back. But he wanted it."

"You shouldn't have done it." He felt guilty, ashamed of cheating Shaw. He moved jerkily and a piece of his hair fell over his forehead. He shoved it back and raised his voice. "It ain't fair. Anybody can buy my paintings for twenty-five dollars. Why should he have to pay double?"

"He didn't have to."

"But it still ain't fair."

"I'll make it fair. Don't worry. I'm going to take care of selling from now on."

"Oh Mamie, now don't you go off thinkin' everybody can afford those prices. I could be ruined."

"If you're ruined, so am I. And I wouldn't be likely to bring on our ruin, would I? Stop worrying and give me back that money. I'm going to buy a little steak for supper."

He watched her leave the house, her chin a little too high, her step a little too sure.

Nancy took on her new duties with authority that worried Charley. And she insisted on increasing his prices even though he argued long and hard with her, predicting the day when all his paintings would sit in the corner. Then when they were broke and heavily in debt, they would have to humiliate themselves by cutting the prices in half. How much better it would be to leave things as they were. But he couldn't convince her and finally accepted the fact that she would have to learn the hard way.

In the meantime, he was about painted out. He had the urge to ride out to the range and smell the grass and feel the breezes. "I'm ready for a day off," he told Nancy early one morning. "I thought I'd ride out to Johnny Mathison's ranch. I'll do a little sketching and rememberin' and when I get back, maybe I can think of something new to paint."

Nancy put her arms around him. "You have been working hard. A day off will do you good."

Riding out toward the mountains washed away the persistent worries over sales and prices. He hadn't realized how he had hungered to get out and ride, to see the Highwood mountain range on one side of him, and miles and miles of endless plain all golden in the sunlight on the other, this magnificent land as it always was, beckoned him back in time. This was his natural place. Images poured through his mind as he gazed at the far hills. Action filled the empty landscape. Memories, reality and imagination blended.

He came home two days later, his sketchbook full. Subjects for paintings came alive and begged to be painted. He started one oil, and before that was finished he started another. Painting several pictures at once allowed him to turn away from one when it gave him trouble, then come back to it fresh and able to solve the problems.

Nancy quietly increased prices. When he complained, she raised her chin and put her hands on her hips. "You're working longer on each painting; you're doing better work."

Charley objected, but how could he argue. His income didn't cover expenses. He didn't like seeing Nancy worrying about stretching every penny, and going without enough to eat some days. That wasn't what he wanted for her. He wished he could make up for when she had nothing to call her own, and no one to care. So he defended her decisions when the boys at the saloons acted hurt and asked how come his pictures were so damned expensive.

But as time went on, Nancy became bolder about her increases. She insisted that her prices would be met. Fewer paintings were sold, and they did begin to accumulate in the corner just as Charley had foreseen. The people who wanted his pictures would not buy at the new prices. "They remember when you gave your paintings away," Nancy said. "It's only natural for them to hold back to see if you'll lower your prices. But when you don't, they'll buy again at our price." Nancy was willing to be patient with New York editors, too.

But her patience was wearing thin with Charley's friends who came to the house and took Charley away from his easel. One morning she said she was going to do something about it.

"Aw, Mamie, the boys are just being friendly. I like having them come and see me."

"But they come too often and too early in the morning. You can't keep your schedule anymore."

"I'll ask 'em not to come so early."

Though he intended to say something when the time was right, he never got around to it, and the boys kept coming to the house.

Finally, one morning Nancy refused to open the door to one man. Instead, she went out on the front stoop and pointed her finger at him, her voice strained. "Cha'ley cannot be disturbed. He has a schedule of painting to stick to every morning. He can't see you until later in the day."

Nancy stared firmly into the man's eyes as she stood barring the door until he shoved his Stetson back on his head, turned around and stomped away.

Charley was embarrassed when he heard the furor about it at the Brunswick that afternoon. Nancy had committed a terrible breach of manners, and Charley's friends were all insulted "you shouldn't let a woman keep you under lock and key," they told him. He tried to explain how hard Nancy worked, that he really had to have some kind of schedule or he wouldn't earn enough to buy oats for the horses.

Charley tried to reason with Nancy at supper, but she ignored his scolding, held her chin high and folded her hands on the table. "Something had to be done. And since I started it, I'll finish it."

"But Mamie, George is a good friend."

Nothing Charley could say would persuade Nancy to be kind to friends who came too early. If they came after eleven, she would ask them into the kitchen and give them a cup of coffee while they waited. But anyone who came earlier was sent away.

A lot of his friends couldn't understand how Charley would tolerate this. He could see in their eyes they thought of him as poor henpecked Charley. But he knew, even if they didn't, how lucky he was to have Nancy's strength and devotion, so he laughed it off and entertained them with stories and salty little pictures.

Billy Rance at the Silver Dollar always appreciated these. One afternoon in the back room, Charley drew a four picture cartoon. The first square showed a cowboy on the range sitting in the patch of shade cast by his horse's body, the caption read, *Just a little sunshine;* the next square showed the cowboy in his slicker on his horse being drenched in a rainstorm, the caption read, *Just a little rain*; the next square showed the cowboy, pie-eyed in the bedroom of a soiled dove who was removing his boot with one hand and taking his money with the other, the caption read, *Just a little pleasure*, and the last square showed the cowboy back on the range, sudden pain on his face as he grabbed at his private parts, the caption read, *Just a little pain*. These colored drawings brought screeches from Billy's customers. One day he asked Charley to do the series as full-sized watercolors. Charley was quick to refuse.

A half an hour later, he was at the end of his second drink, and feeling good, when Billy again asked him to paint the *Just a Little Sunshine* series. "C'mon, Charley, do it," the boys urged. "You ain't afraid of the old lady, are you?"

"Course, he ain't," another cowboy said, elbowing the other one. "I'll give you fifty dollars if you paint it," Billy said.

Charley gritted his teeth and looked Billy in the eye. "All right, I'll do it." He wasn't sure whether it was the $50, or the taunt about being afraid of the old lady

that made him agree. They could sure use the $50 as they were behind in their bills again.

The cartoons were simple drawings and he painted with a rush of energy. The first two were completed that day. The third was more complicated and took a whole afternoon, but Billy Rance and the crowd were delighted with it. The next day he finished the last in the series, and everybody had a drink on Charley.

Charley and Nancy hadn't talked much about his dwindling sales, though he would have to do something soon. The paintings that remained unsold were piling up. Then one day he was surprised when Nancy brought it up. "We have enough paintings now to make a portfolio of prints."

"I noticed that," he said with a smile.

That made her bristle. "Did you think I was ignoring them or that I didn't know they were stacking up? Of course, I knew. Remember the portfolio Ben Roberts put together? Well, the paintings weren't nearly as fine as these. I've written to Ben and to Schatzlein and they both think it's a good idea."

"You've what?"

"Stop that, Cha'ley. You heard me perfectly. We're going to have the prints made, bind them in an attractive cover and distribute them ourselves. Schatzlein is willing to be a partner and I have a little money put aside. The pictures will still be available to sell after the reproductions are made. When the portfolio is a success, the paintings will sell easier."

"So that's what you were writing to Schatzlein about. I thought it was about prices."

"Did you think I was going to lower them? I told you I wouldn't. It just takes time. People are too used to your prices being cheap. They're just getting unused to it now."

Charley realized how thoroughly she had taken over the business end of his painting.

After supper, she stood in the middle of the room. "Look at all of those wax figures," she said. "And to think, Remington gets hundreds of dollars for his bronzes. Josephine checked at the library, and found out these wax figures could be made into bronzes, too. Trouble is it costs a lot of money."

Charley scanned the figures cluttering the window sills and tables. They were models he had worked from or something he had come up with as he sat and talked. They weren't anything much, though he did try to get as much expression in them as he could. Sometimes he could push a whole story into them. But he hadn't thought of having them cast in bronze. He was curious now. Maybe he could do something better, something meant to be cast. "How much does it cost?"

"Too much. The price depends on the piece. The bigger and more complicated it is, the more it costs. We can't afford it now, but some day as soon as we can, I think we ought to try it."

"Hmm." He'd like to model a cluster of figures together, Indians, a buffalo....

"This wolf figure would be a good bronze," Nancy said, her voice hopeful. She picked it up and examined it. "It's hungry. Anybody can see it because it's all here." She held it out to him. "You have some special gift in your fingers. And it's my job to make people know about it."

Charley took the wax figure. It *was* hungry. And when he looked at Nancy, he thought she had a hunger in her, too—for success, but that wasn't all, something else was eating at her.

The portfolio of 12 prints was issued five months later. It sold briskly in Montana and led to an assignment to illustrate a book by a Great Falls writer and poet. The published book was a handsome sight, but Charley's name didn't appear anywhere in it. And no new business resulted. Nancy's disappointment was clear. She had hoped that when these projects were finished, more opportunity would come, more of his work would be sold. But as hard as they both worked, their income was still barely enough to pay expenses.

Nancy kept on planning and hoping. A few of Charley's paintings sold at the higher prices. With each sale, she put aside a small amount for having something cast in bronze.

Then one evening as they washed and dried the supper dishes, Nancy said, "I've been thinking. We moved here from Cascade because there were more people to buy paintings. It was the right thing to do. But now sales are slow. People around here already bought their paintings. It's time we moved on to a bigger place again."

"Hold on," Charley said, aghast. "Great Falls is plenty big enough for me. If anything, it's too big. I'd never want to live in a big city. I saw enough of that in St. Louis."

"What was it like?"

Nancy had never been to a big city. He tried to describe it to her, but just to say it was bigger wasn't adequate. People were different. Their way of thinking was different. "Take my sister, for instance...."

"Yes, tell me about your family. Your sister is well educated, isn't she? Is she like Josephine Trigg?"

"Nothing like Josephine." But Charley was at a loss to explain the difference. He had told Nancy very little about his family and often thought he ought to take her back to St. Louis to meet them. "We'll go back some day and you'll see," he said, hoping they'd be able to afford it before long.

Nancy was curious about the Russells and slightly in awe of them, seeing them as larger than life. St. Louis had become a promised land, full of opportunity. Charley laughed at such ideas until one evening when he came into the kitchen after putting the horses in the shed for the night, Nancy seemed agitated.

"St. Louis would be a good place to exhibit your work. You have connections there and it's a bigger city."

He whistled. "In St. Louis, people aren't as easy to deal with as Sid Willis is at the Mint. You have to make arrangements."

"I know. If we go there, we can find out how it's done."

Finally, Charley decided they had to go, before she built things up too much. He should have taken her back to meet the family long ago. And now there was enough money from the sale of the portfolio to afford it.

He came home with the train tickets a few days later. "Pack your bags, Mamie. We're going to St. Louis."

When he showed her the tickets she was overjoyed, hugging him and kissing him and tousling his hair. But that night long after she should have been asleep, she got out of bed and paced from the window to the stove. He watched her for a few minutes, waiting for her to come back to bed. He saw her shudder.

"What's the matter? Can't you sleep?"

Startled, she turned toward him. "Oh, did I wake you?"

"What's the matter?" he asked.

"Nothing," she said, straightening up, but in the next moment, she rushed to the bed, and threw her arms around his neck. "Oh Cha'ley, what if they don't like me?"

He held her gently. "Why wouldn't they?"

She inhaled deeply. "I'm so plain and well, ignorant about things. Your sister is a fine society lady. Your father is a rich businessman. Your brothers and their wives have all been to college."

"That doesn't matter. I haven't been to college either and they still like me." He could see from her frightened eyes, she wasn't satisfied with that, he took her face in his hands and kissed her. "Nobody else matters but you and me."

She clung to him then. "Oh, I know. I know, but it would be so wonderful to be part of a real family. I want them to like me so much it gives me a stomach ache. I like them already. I...." She sobbed, and he soothed her, whispering how he loved her, whispering how some day they would have a family of their own.

"Oh, I hope so," she said, responding now to his kisses and caresses.

Chapter 23

Charley's father stood on the platform as the train puffed into St. Louis. "There he is," Charley said pointing out the window of the train to a gray-haired man with the black umbrella and bowler hat.

"He looks so important," Nancy said, "shall I shake his hand when I meet him, or what?"

"Just say hello."

Nancy patted her hair in place, and Charley tucked in his shirt and smoothed his sash around his waist. He realized that his clothes, western riding boots and bow-legged gait, so commonplace in Montana would not fit in St. Louis so well, but it would have to do. They stepped onto the platform to his father opened arms. "Welcome home."

His father seemed frailer; his face lined. Charley regretted having waited so long to come. But the glad look in his father's eyes erased any sense of guilt. And the warm smiles his father turned upon Nancy put them all at ease.

Soon they were seated in a handsome buggy, heading toward Oak Hill. Nancy craned her neck to look at the tall brick buildings on both sides of the wide boulevard. The city was familiar to Charley but he felt no excitement at returning to it. He already sensed the constraint that was absent in Montana. But Nancy was seeing it for the first time. He pointed out buildings and church spires along the route. Nancy tried to see everything, smiling constantly, but saying little, except "oh yes, oh yes."

Charley had described the house at Oak Hill while they were on the train, but Nancy exclaimed, "Oh, it's much more beautiful than I imagined."

"I hope you like it," Charley's father said.

"Like it? Why I've never seen so fine a home."

They had coffee in the parlor, and Charley's father asked her to call him Dad. Nancy looked away, tears welled in her eyes and she had to blow her nose. "I'm sorry," she said. "But I never expected to ever call anyone Dad." Tears trickled over her cheeks. Charley put his arm around her shoulders.

Mr. Russell looked concerned. "You're probably more tired than you thought. That was a very long train trip."

Nancy sniffled and shook her head. "I'm just so glad to be here at last, to meet Cha'ley's family."

"Your family, too," Mr. Russell said, and that started Nancy's tears again, but she wiped them away with the back of her hand and smiled.

That evening, Charley's sister Sue and her husband were the first to arrive for dinner, followed soon by brother Bent, his wife and son, then by the others until the parlor was full. Nancy stayed close to Charley's side, and when she talked, it was about him, his paintings, or about Great Falls. If asked about herself, she answered with *we this* or *we that.* He supposed it was natural. His family must seem intimidating to her, the women with their fancy gowns and clever quips, the men with their suits and starched collars. Charley was sorry for a man who had to dress like that. But Nancy could be viewing it differently.

Charley felt the absence of his mother heavily. She would have loved Nancy and welcomed her into the family at once.

Sue, seated on Nancy's right, asked what she would like to see in St. Louis first.

"The museums and galleries," Nancy answered. "We hope to arrange an exhibition of Cha'ley's paintings. I want to see how these things are done in a city like St. Louis. I know it won't be like Great Falls."

Sue laughed politely. "Things are rather more formal here. I understand from what Chaz tells us, your little town is rather roughhewn. Do you find life drab and difficult there, Nancy dear?"

"Oh no. Great Falls is a fine town. It has an opera house, a variety store, nice schools and pretty churches. The streets are lit with electric lights, and some parts of town are just as pretty as St. Louis, though there aren't so many trees."

"It sounds charming," Sue said, raising her eyebrow at Charley as though she thought anyone was crazy to want to live in such a remote place.

"What kind of clothes do they sell in the stores?" Guy's wife asked.

Nancy looked puzzled.

"I mean practical clothes as opposed to Paris fashions. Or things suitable for the hard winters and the Indian population?"

Nancy gazed down self-consciously at her dress.

"I'm sorry. That was naive of me. I forgot the railroad stops there. You undoubtedly have a great variety of things to choose from."

Nancy nodded.

"I guess the men don't all tramp around like my brother in cowboy boots and red sashes," Bent said.

"On the range, they do," Nancy said. "Not so much in town nowadays." She smiled across the table at Charley.

"People at the museum here might think the cowboy look a bit bizarre," Sue warned.

Nancy nodded. "Cha'ley paints the West so if he dresses like a Westerner, people ought to understand."

Charley saw the strain on Nancy's face and launched into a story about a man he met on the train.

Later that night when they were alone in their room, Nancy sat down on the edge of the bed and sighed. "They think I'm funny and dumb."

"No, they jest think they're smarter."

"They don't like me."

"Sure they do. Everybody likes someone they can show off to. And you took the bait. You let them know you were impressed. Now, they'll adore you."

"Oh Cha'ley, don't make fun of me—just like they did."

"Anybody could see how much Dad likes you."

"Oh, I didn't mean him. He's wonderful. He's so very kind. He didn't even notice I didn't know what to do with the finger bowl. And when he said good-night to us, he put his arm around my shoulder the same as yours."

"Yes he did. So, you forget about the others. All you need is a little shut-eye and things will look brighter in the morning."

"I hope you're right," she said. "When they see your paintings hanging in a nice gallery, they'll be so proud, they'll quit acting like small town people are all—what was it Sue called us—rustics, wasn't it?"

"That was supposed to be funny. Brothers and sisters always joke and tease. I don't mind; neither should you. And don't get your heart too set on a nice gallery. That could take time. And we don't know a damn thing about it. Let's talk to somebody who does."

"I know we don't know anything about it," she said, jumping to her feet. "But we soon will. I'm not going to wait around for people to try to discourage us. And neither are you, are you?"

He smiled at her earnestness, the despair that flashed across her face for an instant. He kissed her forehead and chucked her under the chin. "No, I'm not waiting for discouragin' words. I'm here to show you the city."

Charley's father drove them to the museum. He had a business appointment but promised to be back in a few hours with the carriage to take them to lunch. Charley and Nancy waved and turned to walk up the museum's steps. Nancy clutched his arm.

"It's just a museum," he said, pretending indifference, though he was surprisingly anxious to see it again.

Nancy studied every picture and wanted to know the artist and date it was painted. Charley looked at composition, handling of paint and details that made the illusion convincing—the depth of a shadow, the highlights on a fingernail.

Early portraits intrigued her, and she wanted to know why some seemed flat while others almost breathed with life. But after a while she paused. "These are all paintings from long ago. I'd like to see something newer, wouldn't you?"

Charley smiled. "I wouldn't mind. I'll go ask the attendant where the new things are hung."

He left her standing before a battle scene, and when he came back she was tapping her foot and pursing her lips. "Don't you like it?"

"The horses look like they're stuffed with cotton."

He laughed. "The attendant said there was a special showing of something they call impressionist art from France. It's changing everybody's mind about what art should be."

"Well! I expect we'd better not miss that."

"It's what everybody wants now, according to the attendant."

Nancy pulled Charley's arm. "Come on."

"Wait a minute. Look at this. It's by Winslow Homer. Say, isn't it the best thing we've seen yet?"

She paused while he studied the painting, but soon her foot started tapping again, and he went along to see the new French exhibit.

"So much color," Nancy said as they entered the room and glanced at the walls. A jangle of color, he thought. Much of the drawing was crude. Many canvases looked unfinished. Charley was bewildered. "I don't like it," he said.

"Shh." She glared at him.

"But Mamie, if I tacked something like that up on the wall of the Mint, people would say I was drunk and painted with my toes." He pointed to one portrait. "If I ever saw a color like that on a girl's neck, I'd never touch another drop."

"But listen." Nancy edged him over to one corner away from the crowd. "Didn't you hear people saying how beautiful these pictures are? What is it they like so much?"

"I don't know. It doesn't look real. A course, I ain't been to France, and maybe there the leaves have purple stripes in them and the women have green necks and red noses, but it's hard to believe. Now, that Homer fella knows his woods."

Nancy insisted they see everything in the French exhibit, and though there were things among the wildly-colored scenes he admired, by the time they had seen everything, Charley was agitated by it.

He walked back to the Homer painting, while Nancy weighed all they'd seen. "Did you notice how often artists paint people in red clothes? Did you notice the number of white horses? They stand out more than the brown ones. Did you notice the size of some of these paintings? Much larger than what you've been doing." Nancy noticed hundreds of details he missed. And she was convinced there was something good about the French artists she simply didn't understand.

She tossed her head back. "Sue said the museum holds exhibits by contemporary artists. Let's go talk to somebody who knows about that."

"I don't know, Mamie. If museum people value this impressionist stuff so much, I'm lost."

"Your paintings are better than half the ones we've seen and as good as any of them. And don't forget it." She raised her chin high. "Let's go."

They were directed to a small office and told that Mr. Cummings would speak to them.

Charley shook Mr. Cummings' soft white hand. His voice was as soft as his hands, and though he didn't appear much more than forty years old, he had a deep line across his forehead. He smiled and asked what he could do for them.

Nancy brightened, her eyes sparkling. "I understand you arrange exhibitions."

Cummings nodded.

"My husband is an artist." She passed the portfolio of Charley's work across the desk. "We would like to exhibit a few paintings in St. Louis since this is where he was born and grew up."

"I see," Cummings said, opening the portfolio. He looked at the first few prints. "Interesting," he said, and Nancy beamed.

Charley shuffled his feet and would have preferred to be anywhere else. "Where did you study?" Cummings asked.

"All over Montana," he said.

The lines deepened in Cummings' forehead. "Where did you study art? In New York? Philadelphia? The continent?"

"Oh, I didn't go anywhere special."

Cummings glared, but Nancy smiled at him, and his expression softened. "My husband's paintings have been printed in New York magazines and books."

"You mean you're an illustrator?" Cummings asked, his eyes narrowing, his mouth sour.

Charley nodded. "I guess you could say that."

"Similar to Frederic Remington," Nancy said.

"He studied at Yale, I believe." Cummings said, and pushed the portfolio back across the desk. "I'm afraid the museum couldn't allow your husband to exhibit under its auspices. The paintings are interesting, but we only exhibit the work of recognized artists, *not illustrators*. Good day to you both."

Nancy's fingers fluttered around the portfolio. Her face turned pink, but by the time she reached the door, she regained composure and turned back to face Cummings. "My husband is a fine artist," she said. "And I intend to prove it."

By the time they climbed into the carriage, Charley wanted to put the incident out of his mind. But Nancy was still fuming. Mr. Russell noticed her furor at once. "What happened?"

Nancy flounced down on the seat next to him. "I wished I could have socked that skunk in the eye. But I'm going to show him who's an artist and who isn't."

"Mamie, don't get mad," Charley said. "You have to expect that kind of thing."

Nancy took a deep breath and turned to her father-in-law. "Dad, do you think we have to expect to be thrown out of there just because Cha'ley didn't go to art school in New York, Philadelphia or the continent?"

"Ah ha," Mr. Russell looked as though he finally understood. "Did they refuse to give Chaz an exhibit?"

Nancy sniffed. "Mr. Cummings said he was *only* an illustrator, not an artist. That's what makes me so mad. Why he's a better artist than most who have their pictures hanging in there."

"Now, be fair, Mamie. We saw some fine paintings in the museum. Only they're not the sort of thing I do. Maybe he's right. I *am* an illustrator."

"Well, I don't understand why a good illustrator isn't an artist, too. Is there a difference?"

Mr. Russell took Nancy's hand. "I don't blame you for being upset, my dear. I agree with you completely. Chaz's work is deserving of better treatment, but it doesn't do any good to thrash so about it. His work can be exhibited elsewhere. And that's what we'll do. We'll find a nice gallery and you can have your show. It's too bad the museum is so stuffy, but art arbiters are often that way. There was an article in the paper a few days ago about the impressionist artists who have become the new sensation. Twenty years ago they were roundly rejected by the Paris Salon, and had to look elsewhere for their exhibition, too."

Nancy laughed. "So you see, Charley. It can be done. And we'll do it, by golly."

Charley shook his head. "I still don't see why it matters so much."

"Of course, it matters, son. Nancy is right."

They settled on the Strauss Gallery. Nancy was satisfied with all the arrangements, and her growing excitement about the exhibition gave her more to talk about with the family. Charley was less enthusiastic. He wouldn't deny her the pleasure this whole idea brought her, but he didn't like inviting public judgment in a place like this—totally outside of what he painted. He didn't need approval of people like Cummings. It would be fine to have an outlet to sell paintings. But he wished Nancy wasn't so obsessed with proving he was an artist. And his father was right at her side, agreeing with everything she said.

One day after lunch at the house in Oak Hill, the three of them were talking about the exhibit, the hanging, the rooms, and details that Charley had no interest in. While Nancy and his father talked, he let his mind wander to other things. He was back on the range roping a wolf, and the voices in the room were only a distant buzz.

"There ought to be a way to let people know about the exhibit and get them interested in Cha'ley's work," Nancy said.

"We could send invitations," Mr. Russell said.

"That would be nice, if we had a likely list of people. But what about the newspapers; wouldn't they reach even more people?"

"Mr. Cummings, for instance?" Mr. Russell said.

Nancy laughed. "Yes, that skunk. I really want him to know he can't squelch everybody he wants to step on."

"I think I could inform the newspaper and get the right response."

Charley heard their words like something in a dream. Saddle dreams. A man is riding along seeing so much space, voices swim around him and dream images float through his head. Sometimes he's almost asleep, but the horse keeps going and the voices change, and nothing matters much.

It wasn't until he was introduced to the newspaper reporter, and asked to sit down and answer a few questions that the conversation came back to him clearly. Too late to put a stop to it now.

The reporter shook Charley's hand and said to call him Ed. Nancy thrust the portfolio of Charley's work into Ed's hands at once. Then as he looked it over, she stood twisting her handkerchief. This newspaper thing meant a lot to her. She needed approval, especially now since Mr. Cummings' remarks. She couldn't forget them until they were somehow rebutted.

Charley smiled at Ed and started talking. Ed asked the usual personal questions. What was it like to be a cowboy? How did he manage to keep up with his painting, too? He answered all Ed's questions as thoroughly as possible, honestly telling him he had not stayed more than a few weeks in art school, but learned to paint by constant practice. Nancy shot him a warning look, but Ed seemed to view that information with interest, writing furiously in his notebook.

"I never could have done anything without my wife. She encouraged me to stay at my easel, and took care of all the details."

Nancy blushed and smiled at him. It was true, he insisted, and there was much more he could say in praise of her. She ought to be the one to get the recognition. She worked for it. Charley hoped Ed would put in a few good words about her. He did seem impressed and asked her a few questions.

Four days later, the newspaper article was published, along with reprints of his paintings. The piece was everything Nancy could have wished for, and Charley was especially glad there was so much written about her. She modestly insisted that Charley had given her too much credit, but he knew she was pleased, and nothing more was said about Mr. Cummings.

Nancy shopped with his sister Sue, and in a remarkably short time, she transformed her appearance, wearing her new clothes with what Sue called natural flare, and in some mysterious way, sophistication settled on her lightly. Her speech sounded more refined, more eager and natural. She laughed and seemed to enjoy herself during the family get-togethers. She was so blissful she didn't notice, that although the gallery show was well attended, paintings weren't selling.

Charley's father casually handed a letter to Nancy when they gathered in the parlor for coffee. "It can't be for me," she said.

"Yes, it's addressed to you," Mr. Russell said. "It came from Granite City, Illinois."

"I don't know anyone in Illinois," she said. "Who would write to me? And at this address?"

"Open it," Charley said. "It might have something to do with the exhibition."

"Oh yes. It must." She sounded relieved, tore at the envelope and pulled out a long letter written in small nervous-looking script.

"Dear Mr. and Mrs. Russell. It's written to both of us," she said looking up at Charley. She read it aloud.

> *I have read the article about Mr. Russell's exhibition at the Strauss Gallery, and after mulling over what was reported about Mrs. Russell, it seems as though we might be related, of course, I can't be sure. Twenty-two years ago I was married to a woman named Mary Mann from Mannsville, Kentucky, the same as Mrs. Russell's mother's name and town. As Mannsville is not a very big place, naturally I wondered at this. My wife and I were very young at that time and after a couple of months, we had a disagreement and I left her and went to another city. If she was expecting a baby, I did not know it. When I cooled down I wrote to her, asking if we could get back together, but my letter was returned. I then wrote my brother who lived close to Mannsville, and asked him to find out about my wife. He wrote back to say she was again living with her folks. They insisted she get a divorce and said they didn't ever want to see me again. That was the last I knew of her. When I saw the article I wondered if Nancy Russell, who was known as Mamie Mann could be my daughter. I have never remarried and have few relatives left. I would like to talk it over with you if you would care to. I run a hotel just across the river in Granite City, Illinois, so while you're visiting in St. Louis, we could meet and talk about it if you'd like to.*

Nancy looked as though she would faint. She dropped the pages of the letter to the floor and seemed to waver. Charley rushed to her side and took her hand.

"It couldn't be true," she whispered. "Could it?"

"I don't know," he said, picking up the letter.

"Will you read it again—out loud." Her voice was thin and shaky. Charley read the words slowly, and when he finished, she blinked and swallowed. "Did you ever feel like the world was spinning too fast? And things that couldn't happen were happening?"

"We ought to talk to him before we decide what to make of all this," Charley said. "There could be a mistake."

"It must be a mistake." She sighed and looked away again. "But if it's true—what a waste those lonesome years were. Do you know how I cried for

someone—anyone? And while I thought they were useless tears, this Mr. Cooper...was somewhere...of course, it probably is a mistake." She uttered another long sigh. "But if it was true, if all those years ago he had just not been so stubborn...but now, he comes, by accident.... Now, when I have you, and don't need anyone else." She sniffled and Charley took her in his arms.

"Do I want a father? Especially one who left my mother alone?" Nancy broke off as sobbing overtook her. Charley held her close and let her cry.

The next day they traveled to Granite City, arriving there in the afternoon, planning to stay overnight at the hotel as Mr. Cooper had suggested. Nancy paused at the entrance to the hotel, paused so resolutely that Charley thought she wanted to turn back, but then she shook her head and took his arm more firmly. "Let's go."

Charley knew when they walked into the lobby that the man who looked at them from behind the desk was Mr. Cooper. He was not a big man and not much older than Charley. He had dark thinning hair, even features, but hollow cheeks and lines around his mouth and across his forehead, an agile, nervous, haunted-looking man.

"You must be the Russells," he said, smiling and extending his hand. His smile for an instant looked familiar. But his hair was dark while Nancy's was light. Then Charley realized that his own hair was light, too, while his father and mother both had brown hair.

"I hope I haven't caused you trouble by writing you all this, now, after so long."

Nancy smiled at him. "I was awful surprised, being an orphan for so long, then suddenly to think that maybe...I mean...we came to talk."

Cooper called a young man to look after the desk and he showed them to a small parlor just off the lobby. It was a prosperous-looking hotel, and Mr. Cooper was well-dressed and respectable. He had coffee brought in and tried to put them at ease, but his eyes constantly darted back to Nancy's face.

"Your mother...." He shook his head. "I mean my wife was a pretty woman with long blonde hair. She had long fingernails and liked to wear bangly bracelets. She and I were a lot alike, wanted everything. Yes, we did, and planned to get it. She was so pretty men stared at her, and I was jealous. So it was my own fault if I lost her. I was to blame for being blind and stupid. And I always regretted it—every day of my life." Desolation rose in his eyes, then he looked seriously at Nancy. "Do you remember your ma?"

Nancy shook her head. "Hardly at all."

"That's too bad. Do you remember Mannsville, your mama's people?"

"No. My mother married Mr. Allen when I was small. We went to Helena, Montana to live and they had another little girl, Ella. My mother died when Ella was a baby. I remember being told she had died, and soon after that, Mr. Allen went away, too. Ella and I lived with families around Helena. When Mr. Allen said good-bye to us, he squeezed my hands and told me to take care of Ella for him. He

got married again in California and said some day he would send for us. A few years later, when his wife in California died and he had other children, he sent for Ella to help take care of them. I stayed in Helena."

Cooper shook his head. "Oh God!" he said. "Oh God, if I had known."

"What year did you marry?" Charley asked, more to ease the agony in the man's face than to get the date.

"Eighteen eighty—November." He stood up and poured them all another cup of coffee. Charley watched him, noticing the way he moved, the quick determined steps. He'd seen Nancy move around their kitchen in Great Falls the very same way.

Everything Cooper told them fit with the facts Nancy knew of her background. Charley was convinced. It took longer for Nancy and Mr. Cooper to admit it.

"If only I had gone back to Mannsville to see for myself instead of just believing she didn't care for me anymore, I would have known...but I'm a terrible restless man, always on the move, pushing ahead. It's bad to push as much as I do, and I can't help it, seems like. Always looking for something more. I might have been a pretty sorry father."

Nancy smiled. "It would have been all right with me," she said. "I'm restless, too. I know how that is."

"I bet you were a sweet little girl, all right."

"That's all so long ago now. And here we are. I'm glad we found each other. It can't be like other fathers and daughters who've known each other all their lives, but it's nice."

"Yes," he said. "The nicest thing that's happened to me for a long long time."

As they left Granite City, Charley shook his father-in-law's hand. "Now, Coop, we want you to come to St. Louis and meet my family as soon as you can. Maybe next week if you can make it. And you and Nancy can get better acquainted."

Mr. Cooper promised to come, and when they said good-bye, his eyes were shining. Nancy sat tall in her seat, calling over her shoulder. "See you soon."

With all the excitement of meeting her father, Nancy took the failure of the exhibition more calmly than Charley expected. Only two of his paintings sold, not bringing enough money to pay expenses.

They went together to the gallery to pack up the paintings and bring them back to Oak Hill. "I would have thought the newspaper article would have helped more," she said, "but maybe we made a poor choice in picking the gallery. Sue said the people who ordinarily go there want the newest thing, especially if it's from England or France. We didn't know that. Your art is a special kind. We'll have to think of that the next time."

The very thought of another such exhibition appalled him. Nancy must have read his expression.

"Now, we aren't giving up after one little try. We have a lot to learn about this business. A farmer is not going to sell his corn if he leaves it in the barn."

He seldom argued with Nancy when she stood with her feet apart like that and her hands on her hips. He didn't want to think about exhibitions anyway. It was plain enough to him that the people in St. Louis didn't care for his kind of art. Mr. Cummings had said it first. But at the gallery he had watched people's expressions as they viewed his paintings. Many were uninterested, or outright bored. What do they care about the West? They were city people. He knew logically he didn't have any cause to feel bitter because his work didn't count here, but he did feel a lot worse than just let down. He wanted to get back to Montana where he belonged.

He told his father they would be leaving in a couple of days.

"So soon?" his father said. "Well then, we must talk seriously." He led Charley and Nancy into the library and closed the door.

Chapter 24

His father, in his beautifully tailored gray suit, looked frail sitting in the tall brown wing-back chair.

"Your mother left you a legacy. It's in trust," his father said, pressing his fingers together. "She asked me to manage it until you were settled enough to use it wisely. You should take it now."

"A legacy," Charley said. "Maybe we should save it for a house of our own some day."

"Yes," Nancy said. "We'll have a family one of these days and when that time comes, it sure will be nice to have a house."

"That's fine," Mr. Russell said. "Nothing would have pleased Mary more. But I want you to get started now. Take the legacy and pick out a big lot in a good location and I will finance the house-building as a wedding present."

Charley hadn't expected anything like this. His need for independence surfaced again. "Thanks, that's real generous, but we couldn't let you do that," he said. Then when he saw the disappointed look on Nancy's face as well as the hurt on his father's, he paused. He shouldn't ask Nancy to wait until he earned enough; how long would that be? She ought to have a home to call her own. And since it was intended as his father's wedding gift to *her* as much as to him, did he have the right to refuse? "Dad," he said, "on second thought, a little home of our own would be the best gift we could ever hope for." His father's proud eyes met his.

"How can we ever thank you?" Nancy whispered.

A home of her own would occupy her restlessness and distract her from her obsession with promoting his work. And she would quit thinking about New York City altogether when there were children.

Nancy and Charley settled on the location of their house even before the train arrived back in Great Falls. If the property was still available, they wanted the big lot next door to the Triggs. Nancy beamed. "Then when I want to talk to Josephine or Mother I can just go next door."

The lots were still available. Charley bought them and left the planning of a simple house to Nancy, while he worked out the details of a stable for the horses.

Nancy's excitement over the house-building lasted for weeks, but after she made her decisions on plans and materials, her excitement turned to impatience.

To offset her impatience over waiting for the house to be built, she concerned herself more deeply than ever in the sale of Charley's work. If the exhibition in St. Louis had not been a financial success, it did spur Nancy on—the possibility of ultimate success tantalized her as she reviewed all the things she could have done

better. "The next time we'll ask a lot of questions before we make any arrangements," she said, and he reminded her that they were doing fine without any damned exhibitions.

The sale of his paintings in Montana picked up in spite of the higher prices. More stores displayed his work. In Great Falls, Ward's Cigar Store put paintings in its large window and so did the store where Charley bought his art materials. The Park Hotel hung some. So did Ben Roberts in Cascade, and Charles Schatzlein in Butte. Now stores in Helena, Lewistown and Anaconda took paintings.

Still Nancy was not content. She never tired of discussing future exhibitions where she could test her ideas about the best way to manage them. The more she talked about it, the more Charley resisted the idea. When she mentioned going to New York City, he couldn't hold his feelings back.

"It's a waste of time and money to go to eastern cities with my western pictures. People don't know if a scene's right or wrong, and they don't care. I won't do it. So you can stop talking about it right now."

She glared at him and called him pig-headed, but for the next few days she said nothing more about exhibiting in eastern cities. He was glad of that, but he didn't like her so quiet and hurt-looking.

He was the first to admit they lived better since Nancy managed things. And though they still received regular rejections from the eastern markets, occasionally there were sales. A calendar publisher in St. Paul bought six of his paintings, saying he would have taken more but the delicate colors in the sky and light areas simply would not reproduce well enough.

"That's one more thing we needed to know," Nancy said.

Charley thought about it, and painted a few dusk scenes, a time when colors were at their most intense. They sent them off as soon as they were dry. Two weeks later he received a check for them.

This acceptance fired Nancy's interest in expanding Charley's sales area. "It just proves what I've been saying. It's time for an exhibition. And I've decided on a perfect western city to try next." She stood with her hands on her hips while he waited. "Denver," she said proudly.

"Denver?" he repeated. He argued against it, but Nancy went on with her plans.

The exhibition in Denver was plagued with problems. The gallery rooms were so cramped and drafty, people were not inclined to linger and look. But at least, the newspaper had written a long piece about the show. Nancy was thrilled and expected wonderful things. She waited in the gallery from early morning until closing time. As the days passed and nothing was sold, her spirits sagged. One day it rained, and no one came. Charley was ready to pack up and go home, but Nancy wouldn't hear of it. In the end they hadn't sold enough paintings to cover their expenses. On the train heading back toward Great Falls, Charley stretched out in

his seat, his hands clasped behind his head. "Exhibitions jest ain't for me," he said. "I hope we've seen the last of 'em."

Nancy laughed. "We didn't do so badly. Some people saw your work for the first time and liked it. We're learning plenty about what not to do."

"Sure, we learned not to go to all the work and trouble of holding exhibitions; it doesn't pay."

Nancy raised her chin. "We found out for sure it isn't easy. You have to have good light and not be too hard for people to find, and you have to smile and talk to people. Not just talk, but talk about the pictures, but not too soon. You have to give people time to get interested first. Most of those folks I talked to were pretty nice."

"I don't doubt it. But I hate sitting around watching people looking everything over."

Nancy looked at him with exasperation. "You're impossible. You love to talk to people—*any other time.* You're full of range talk, except when you're at an exhibition of your painting. Then, you stare off into space and don't have anything to say. It's maddening."

"Well, I don't need anymore damn exhibitions. We're makin' out fine at the home camp, selling at your gawdawful prices. So let's jest be glad it's goin' so good and forget exhibiting in the big cities."

Nancy shook her head. "You don't think Frederic Remington got where he is by shying away from cities, do you?"

"I'm not him. Besides, he was a New York kid, and probably likes it there. That ain't so for me."

"You've never been there so how do you know whether you like it or not?"

Charley just shook his head.

But Nancy wouldn't be quieted. "New York is the center of the art business in the whole United States. It's where publishers and magazine editors and the biggest galleries are. Some day, Cha'ley, we're going there."

"That's the last place I want to be."

"I'm going to see your name make a difference in that town."

Her voice took on a fighting ring. He glanced at her, but she tossed her head and smiled. "Don't look so worried. I'm not going to drag you off to New York next week or the week after. We're going to be busy enough getting settled into the house. And, after that you'll be taking your hunting trip in the north woods so you don't have to think about New York just yet."

Charley sat up straighter and gazed out the window at the mountain scenery, thinking ahead to his long-planned hunting trip. "That's some fancy country we're ridin' to, Mamie, a true wilderness garden of Eden. Indians come to the lake every year to hold their ritual dances. I'd sure like to take you up there. Too many grizzlies and bobcats in those hills now, but if we had a cabin to stay in, you could go." He had forgotten Denver already, and was deep in the mountains of Montana,

up near the Canadian border, filling his lungs with fresh air and his mind with the rugged scenery.

Moving into the new white frame house on Fourth Avenue North was a great occasion for both of them. Nancy worked hard making the dining room into a good place for Charley to work. She sewed white lace curtains that softened the light, and arranged his work table so he could take best advantage of the windows. He could have had a room all to himself upstairs, but he felt too cut off from everything there.

The dining room was between the parlor and the big kitchen. It was curtained off from the vestibule near the front door, where Nancy set up a writing table for herself. She said it would be the best place to take care of her correspondence because she could stem the flow of visitors that might otherwise congregate around Charley. She put a wooden bench along one wall. If any of Charley's friends stopped by before noon to go to the saloons with him, they waited on the bench in the vestibule between the curtain and Nancy's writing desk.

The boys called it a seat on death row; some said it was goin' to a church funeral. Charley couldn't see through the heavy curtain, but he could hear, and would let his friends sit there only a few minutes before he'd poke his head through the curtains and invite them in.

As it turned out though, the dining room wasn't a good place to paint. His friends occasionally spilled over into Nancy's kitchen. And when Nancy's friends called, the tittering and moving with tea things from the kitchen to the parlor right past his easel was a nuisance. One day, after the ladies had left, Charley laid down his brushes and put his arm around Nancy's waist, drawing her close, and pointing out the dining room window. "I sure hanker for a cabin to paint in, out there in that clearing between our house and Trigg's. Then you could have your ladies in without worrying about me. And my old rawhide friends could smoke and chew the fat while I paint."

Nancy moved closer to the window. "There's room for it. I think I know exactly what you'd like—a cabin like Jake Hoover's place."

"You know me pretty well, that's a cinch. I must've showed you enough old cabins I stayed at so you savvy what I miss about the old cowboy life."

"I think I do. With that kind of a painting place you could have all your Indian souvenirs spread around you."

He imagined it and smiled. "Everything I've saved means something. Jest lookin' at a skin shield or a backrest or a pair of moccasins puts me in the middle of an old scene."

"A small log cabin shouldn't be too hard for us to manage."

He shrugged, "Someday, maybe."

To Nancy, some day meant some day soon, and it wasn't long before she made arrangements to have the little cabin built. Charley worked harder when he learned what she was doing. It was an extravagance. They were still struggling to

make ends meet, but he wanted that cabin badly, and if Nancy could figure out a way they could afford it *now*, he promised himself he would produce more and better work to earn it. He even smiled tolerantly when she spoke of New York City, though he never expected that he was soon to soften considerably in his attitude toward New York.

He was talking to Sid Willis at the Mint when the stranger came in. "Howdy. New in town?" Charley asked.

"Sure am. Only going to be here a couple of days. I'm playing over at the Grand Theater. The name's Hart—Bill Hart." They shook hands. "I'm Charley Russell and this is Sid Willis. Have you seen enough of our burg yet to know if you like it?"

"I saw the railroad station, the dressing room of the theater and a room with a bed at the Park Hotel. I got no complaints."

"Where're you from?"

"New York."

"Hell, you don't look like a New Yorker," Charley said.

Bill laughed. "What'd you expect?"

Charley laughed along with him. "Not such a decent-looking fella."

Sid winked. "Charley thinks New Yorkers are all editors or publishers with horns sticking out above each eye. You see, he's an artist, painted this picture sitting above the bar."

Bill glanced at the painting, then back at Charley.

"Charley illustrated some things for New York editors," Sid explained. "His wife is as set on New York as he is against it."

Bill smiled wryly. "Don't blame you for liking the West better; I'm partial to it myself, but New York has its own charm." Bill studied the painting, an oil showing an outlaw holding up a stagecoach, the passengers, with arms in the air, were being relieved of their valuables by one of the bandits. The main figure in the left foreground stood, neckerchief pulled over his nose, gun aimed at the passengers, his saddled white horse standing behind him. After a moment Bill looked back at Charley. "That's a damn good painting."

"Glad you like it."

"How did you happen to paint it?"

"Oh, a guy I knew was travelin' from Miles City to Deadwood when Big Nose George held up the stage. This friend told me all about the hold-up, and the passengers and Big Nose George, and after a while it was as though I'd been there myself."

Bill bought Charley a drink, and they talked. Then Charley bought Bill one, and it seemed like no time before Sid came over to remind Charley what time it was—a good thing, too or he would have been late for dinner, and Nancy would have been mad. "I've got to go home. Good luck with your show. Sounds like a fine

one." He put out his hand, but Bill was fishing in his pocket. "Here's a couple of tickets for the performance. Maybe your wife would like to come."

"Why, that's mighty damn neighborly. I bet she would."

"And come on backstage after the show and we can talk."

The men shook hands and Charley rode home in such a good mood he couldn't keep from lassoing fence posts on the way.

"Let's ask the Triggs to go along," Nancy said. "I've been wanting to do something nice for them. They've been awful good to me. I must pester them to death sometimes with all my questions."

Charley smiled. "Good idea. Trigg is always quoting from plays and books. And he'd like Bill Hart."

The play was fast-moving and entertaining and Josephine was particularly interested in meeting Bill Hart later. They went backstage with the glow of the play still coloring reality.

Bill was a small man, but with a voice and manner that reached out beyond the stage and into the hearts of the audience. In his dressing room off-stage, his aura dimmed, but here, he was real and even more likeable playing himself. When he mentioned he'd like to see more of the countryside, Charley offered to show him around. "I've got a couple of nice saddle horses," Charley said. "We could ride along the river to the falls...."

"Then later, maybe you'd have lunch with us," Nancy put in. Charley smiled and Bill said he would be delighted.

Charley smelled the tangy beef and onion aroma as they walked up from the horse stables to the kitchen door. Nancy baked meat pie with a sourdough crust on it, and for desert, Mother Trigg's spice prune cake.

"How was your ride?" Nancy asked, standing in the kitchen in an apron almost as pink as her cheeks.

"Splendid," Bill said. "Haven't enjoyed myself so much for a long time."

"I hope you brought a healthy appetite with you. I thought we'd eat here in the kitchen, if you don't mind."

"I spread out a mess in the dining room," Charley explained, glad Nancy set the table in the kitchen. Here the coffee pot was always within reach. And the east window gave a cozy glow.

Bill plowed into his plate of meat pie with a cowboy's appetite. "You cook as well as Charley paints." Bill said as he folded his napkin and placed it on the table. "But you said you'd show me some more paintings. I sure would like to see them."

They went to the dining room. A nearly completed night scene was on the easel there, an Indian on a white horse leading a herd of horses across the moonlit prairie. "That's White Quiver," Charley said. "He's a famous Piegan horse raider. In this picture he's been on a horse-stealing jaunt in Crow country. That's one

Indian who's stolen a lot of horses, including that little pinto you saw in the corral."

"Monte?"

"Yep, he stole it from the Crows and traded it to Bad Wound, who sold him to me when we was both kids twenty years ago."

Bill shook his head. "It makes a man want to see that country in the moonlight. Though I don't know if I'd want to run into White Quiver." Bill looked at all the paintings. "You really ought to come to New York, bring some of your work and meet those editors and publishers face to face."

"I've been telling Cha'ley that's what we ought to do some day," Nancy put in. "Shaking a person's hand and looking into their eyes is better than sayin' things in letters."

"That's a certainty," Bill said. "If you decide to come, I'll do what I can to see you meet a few good people in publishing."

After meeting Bill Hart, New York had taken on a softer look to Charley, but he was not inclined to pack up his paintings and move camp. He had no stomach for knocking on doors. But to please both Bill and Nancy, he smiled and said he'd think about it.

For those first days after Bill Hart's visit, Nancy was unbearable with her talk about going to New York. Charley repeated his objections over and over. Nancy was stubborn, but no more than he was when he had made up his mind. When things didn't matter much, he'd let Nancy have her way, but not always, not this time.

They sparred about it, but gradually the subject faded away, though he doubted if she'd given up completely. He was determined to resist if the question surfaced again. Luckily, it didn't, at least, not until summer.

Charley was riding from the saloon when Mr. Coburn came out of his house, ran to the street and waved Charley down. "Hey Charley, I want you to meet somebody."

Coburn was a writer. His stories were of the old West, the kind Charley loved. He and Charley talked often. Coburn's young friend was leaning over the railing on the front porch. Charley dismounted.

"Charley Russell meet John Marchand, an illustrator from New York. Both of you fellas are tryin' to paint the same thing as far as I can see, so you ought to be acquainted."

Charley was the first to put out his hand. Marchand took it firmly. "I've admired your paintings hanging in the Mint. It sure is a pleasure to meet you."

"John illustrates for a lot of publishing houses in New York." Coburn explained. "He has a studio there."

Charley sat down on the porch steps and rolled a cigarette. "What brings ya here to Montana?"

"An illustrating job. I've been at the Coburn ranch for a couple of weeks making studies."

"I'd sure like to see your sketches," Charley said, wanting to see how a New York artist handled his subject. Marchand brought out a couple of sketch books and handed them to Charley. Charley flipped the pages, then studied the drawings one by one. The sketches were clean, with small studies put in along the sides and bottoms of the pages. There were things Charley wanted to talk about—but he could smell dinner cooking inside the Coburn house.

"I sure wish we could talk a while."

"Same here," Marchand said.

"Tell you what. I live up the trail a ways. How 'bout sittin' around my campfire after supper?" He turned to Coburn. "And bring the missus."

Coburn and Marchand said they'd visit later. When Charley got home, he told Nancy only that the Coburns were coming that night and bringing a friend.

It wasn't until Marchand asked to see Charley's work that Nancy took much more than casual notice of him. They had talked about Marchand's boyhood in Kansas, not about New York, but she must have scented something; she began dragging sketchbooks out of cupboards to show him. Then she learned the full story.

"We thought of going to New York once," she said, avoiding Charley's eyes. "I think it would be smart to meet some of the publishers there, but Charley didn't think it would be worthwhile."

"Oh, it definitely would," Marchand said, turning to Charley. "If you're serious about illustrating, there's no better way than to show your paintings around and meet the people who publish them. I had to knock on a lot of doors before I got any jobs."

Nancy's cheeks flushed and her eyes glazed. "Why don't you two artists ride out toward the Highwoods for a sketching trip tomorrow. I'll pack a picnic lunch for you." Charley understood Nancy's great interest, but the sketching trip sounded like just the thing, and John wanted to do it.

Before they went to sleep that evening, Nancy traced the outline of Charley's square jaw with her fingertip. "You're a better artist than any of those other illustrators. But John is a nice fellow and it wouldn't hurt to give him a few tips when you're out sketching."

He laughed. He hadn't expected that. John was twice as successful as he ever hoped to be, but he wouldn't argue. He kissed her again, long and with a purpose.

It was John who brought up the subject of New York again. "You really ought to come if you can. I'll introduce you to the editors I know. And if you want to work while you're there, you can use the studio I share with a couple of other artists. We all do the same kind of thing. It isn't easy to get jobs even when you're known around New York, but it sure helps to know a few people."

Charley liked Bill Hart and John Marchand. But he remembered St. Louis and Denver. New York would be even tougher. Nancy argued ceaselessly for going. He countered every argument. But she always came back with something else, until finally, he'd had enough. "We just can't afford it now," he said, and that was true. She couldn't argue with that.

The months passed and Nancy gradually raised the price of his paintings. His heart sank when he saw she was asking $75 for one small oil. It couldn't go on, he told her. "We'll see," she said. "You just paint them and leave the selling to me."

He worried about what she was doing. People were whispering about her prices. He'd heard words like holdup artist, claimjumper, bandit. He warned her. And she listened to him but with a blank stare as though her mind was busy with something else entirely. He didn't know what else he could do short of selling the paintings himself.

He woke at sunup each morning and crept out of bed, letting Nancy sleep. He fed the horses and fixed breakfast for himself, then went out to his cabin to paint. Alone there with his precious souvenirs all around him, he could put himself into the time and place he wanted to paint. But he demanded more of himself these days, and sometimes a painting didn't satisfy him, and he would have to fight it until everything fit together right. Often when he finished his painting day, he was as weary as if he had ridden twenty hours on the range. But when a painting was finished and worked out right, there was no greater satisfaction.

In the fall, a letter came from Schatzlein along with a check. He had taken six of Charley's paintings, at the higher prices. Charley was flabbergasted at the amount of the check. "Six hundred dollars," he roared. "There must be a mistake!"

Nancy folded the check and put it into the drawer of her writing table. "I think we have enough now to take that trip to New York."

"No," he gasped.

"Yes."

"No." He shook his head.

She sighed. "All right. If you're going to be stubborn, you don't have to go. I'll take the paintings and go by myself."

"What?"

"I am not a helpless woman, Cha'ley Russell. I'll talk to those editors myself. It won't be as useful this way, but I'll do what I can. I just hope I don't get raped or hit on the head."

He closed his eyes and nodded. "We'll go."

Chapter 25

In the chill of a late November day in 1903 Charley and Nancy said good-bye to the Triggs at the railroad station and hurried to board the train. Their borrowed luggage was stuffed with enough clothes to see them through three months away from home, first stop St. Louis for a family visit, and then on to New York City. Nancy's eyes shone. Charley tried to warn her not to pin too many hopes on this trip. He dreaded seeing her disappointed again, and all his intuition told him that New York couldn't lead to anything but disappointment.

She'd been practicing her diction every night. That was for St. Louis as well as New York. He guessed she remembered some hurting remarks from the last visit that had to be put right.

"It'll sure be good to see our fathers again, won't it?" she said when they were settled in their seats. "I hope my father likes the socks I knitted for him."

Charley assured her that everyone would like everything and if they didn't, it didn't matter. As the train rattled along, Nancy read, and Charley modeled a wax buffalo, a mountain goat, a family of bears, and by the time they reached St. Louis, his wad of wax was an Indian on horseback.

"What a stunning outfit," Sue said, at the family gathering that first day, and Nancy smiled as though she had spent her entire life in stunning outfits. Charley hadn't noticed any difference in her appearance, but Sue seemed impressed, and so did the others. At supper everyone asked Nancy's opinion about whatever subject came up. And she gave answers that brought genuine smiles and nods.

After dinner she showed the family Charley's newest paintings while he threw in a yarn or two. His father clapped him on the back. "Your work is still improving, son. You ought to enter a piece in the World's Fair competition. The fair attracts thousands."

"The World's Fair," Nancy repeated. "You're right, Dad."

"Aren't you both forgetting last time?" Charley said.

"This is a fair, not a museum," his father said as though there was a big difference, but Charley expected Mr. Cummings' attitude to dominate again.

"There's no harm in submitting a few things," Nancy said softly.

Maybe not, he thought, but she would be hurt and angry when his work came back rejected.

They had only been in St. Louis three days when Nancy set up a one-man show. They needed the practice in exhibiting, she insisted, but as the arrangements fell smoothly in place, he realized she had been planning this for some time.

The exhibition of Charley's work attracted little attention, and sales were few. Undaunted, Nancy watched carefully, making notes on ways to improve. After the gallery closed one day, and Nancy and Charley were walking down Locust Street, she squeezed his arm. "Do you know what, Cha'ley? I think I can tell the look now."

"What look?"

"The look of a person who wants one of your paintings. There's a certain expression that comes on their faces."

"Naw. Everybody's different. Some praise a thing to high heaven, then turn their back on it, while others don't say a thing, but shell out the price."

"But there's a particular look people get when they see what they want and are thinking about buying."

"I don't know how you could tell; there haven't been enough buyers."

"There don't have to be many."

He took her arm to cross the street. "A city can sure make a fella feel squeezed. And I hear tell New York is worse."

She looked at the buildings. "It's fun for a change."

Several paintings were accepted for exhibition at the Fair. The Sunday section of a St. Louis newspaper carried the story. The headline read: *Cowboy Artist Who Has Lived Among the Indians for 23 years Will Exhibit Studies at World's Fair.* "Twenty-three years!" Charley whistled. "Jake could take lessons here on how to exaggerate." He had learned to suppress his horror at inaccuracies of reporters and laughed instead as Nancy read the piece to him in her proud sing-song voice.

New York was cold and windy on the morning they arrived. John Marchand met them at the station and took them to the Park View hotel where he had made reservations. The hotel was small, reasonably priced and only a block from John's studio.

Charley's first impression of New York was of drab grayness. "The sun can't shine in a hollow like this with all these tall tipis crowding together."

"Never mind the sunshine," John quipped. "Look at all the nice shade we have."

Charley's interest perked up when John showed him the studio and introduced him to Will Crawford, an artist who shared John's work space. Paintings were propped on easels and against the walls. The smell of turpentine and linseed oil filled his lungs. This was what he understood, paintings of horses and mountains, a world far away from New York, but captured pretty damn well on John's and Will's canvases.

"Who's turn is it to make coffee?" Will asked.

John groaned. "Must be mine."

"I'll do it," Charley said, wanting to pull his own weight. "I'll make some good old camp coffee."

The studio was a large warehouse-like room with a hot plate. "This is handy. You can have your beans and coffee here instead of going to a restaurant."

"We do it, but the chow is not gourmet." John said.

"I've got me a log cabin studio now," Charley said longingly. "Sits next to the house, has a nice big fireplace to cook on and stay warm by. My friends can stop by if they want to sit around and smoke and talk while I'm working. It's a chunk of heaven."

"It sure sounds fine," Will said. "This is no log cabin, but you make yourself at home. You want to set up an easel, go ahead. And I've some clay in the corner. John tells me you're a hell of a sculptor."

"Well, I'd sure like to get my hands around a wad of clay now."

Minutes later Charley was modeling a horse and rider as he talked and watched the others at their work. He had been watching John's painting with growing concern. "Aren't you going to cover that bright yellow in the sky?" he asked.

"That's the kind of thing they like over at *Outing*. Lots of editors like bright-colored skies. Guess blue is too ordinary. They want something that catches the eye. We did pink sunsets last year. Then orange. The yellow here goes with the story I'm illustrating. It's a hot day on the desert—no water."

Charley looked again. "What else do these editors like?"

"They usually don't want too many figures. Over at *Leslies* they absolutely won't take anything with four figures. They'll take one, two or three, but any over that has to be an odd number."

Charley laughed. "You're joshin' me. Now is that a way to treat a friend?"

"He isn't joshing, Charley. We laugh about it, too, but you don't find us painting a scene with six riders in it."

"I'll take you around to meet some editors next week," John said.

Charley braced himself. "I've sent paintings to all of 'em."

"If you got most of them back, don't feel bad. We get ours back, too. There's a lot of competition now, and editors have their favorite illustrators."

Charley did not look forward to calling on busy editors, and put it out of his mind by concentrating on the clay in his hands that was becoming a drunken cowboy on horseback, pistol raised over his head, shooting up the town. As he worked he became totally immersed in the clay—the mood of his cowboy and the mood of the horse.

Will Crawford's voice brought him back to the present. "That is a helluva good piece of work. Hey, come and look at this, John."

Will put the clay model on a work table and they all inspected it. John whistled. "Wish I could mold that kind of action."

Early the next morning Charley and Nancy called on an agent to help in their search for suitable gallery space. Nancy's face went white when she heard the price of the places she wanted to rent. She smiled tightly and asked the agent for something cheaper, but still respectable. The man gave them a pitying look.

Nancy's temper surfaced at that. "Well, can you or can't you show us something?" she asked.

"I'll show you what I've got, but you aren't going to like it."

He showed them a basement room on a grim-looking alley. Nancy didn't like it. The room itself wasn't too bad. "With work, it could be made attractive," she conceded. "But the address...."

"Look folks," the agent said. "I know, it stinks. But you aren't going to do any better for the price."

Nancy bit her lip, and Charley could read her disappointment as she raised her chin and said, "We'll take it."

The next few days were busy ones. Nancy swept and cleaned. Charley moved the furniture out and painted the walls. The next day they would hang the paintings. But that evening they were invited to have dinner with Bill Hart and his mother.

Bill's mother cooked boiled beef and horseradish, western style, and was willing to let Nancy help with the last-minute preparations. After dinner, they lingered over an apple dessert, and Bill promised to do what he could for Charley. "I don't know many people in the publishing business, but I do know a fellow who knows the editor of the Sunday *New York Herald*."

Charley didn't greet the suggestion with much enthusiasm. "But western art ain't goin' to interest Sunday *New York Herald* readers much." Charley said.

"You might be surprised," Mrs. Hart said. "Frederic Remington is all the rage. His book was made into a Broadway play. We went to see it a couple of weeks ago and loved it, didn't we, Bill?"

Bill raised his eyebrows and drawled. "It would've been better if I'd been the star, of course, but people liked it the night we were there."

"And," Mrs. Hart added. "Remington's statues of horses and soldiers are in the window of Tiffany's."

"They are! Really?" Nancy's eyes opened wide. "His book was a success, his paintings and illustrations are in demand and even his bronzes are at Tiffany's!"

"The West is an adventure to most eastern folks," Bill said. "Western art is popular. I heard that Remington gets five hundred dollars regularly for his paintings and has gotten as high as a thousand."

"Oh my *gosh*!" Nancy gasped.

"Well, he's a special case," Charley said.

Two days later Charley, Nancy and Bill went to call on Mr. J.I.C. Clark, the *Sunday Herald* editor. As soon as he stepped inside the plush office, and saw Mr.

Clark, dressed like a millionaire and seated at a huge desk with books lining the walls behind him, Charley knew this was no ordinary reporter. Bill's tone with Clark was respectful, maybe a little nervous. Charley hadn't expected Bill to wangle an interview with an influential man he obviously didn't know at all.

Bill talked about Charley's cowboy life and his work, and Nancy showed a few photos and a painting she brought along. Clark talked as though he went to Oxford. His clothes were fit for a prince, his nails manicured, and he behaved graciously—not patronizing, but Charley felt totally out of his element. He was so used to talking in cowboy slang, he figured if he opened his mouth, Clark would peg him for a hopeless clod, and he didn't want to embarrass Bill; he was only trying to help.

Clark examined the painting Nancy had brought. "What's it about?"

Bill leaned over the desk and turned to Charley. "Tell Mr. Clark about *Roping a Grizzly*," Bill said. And when Charley tried to collect his thoughts—to phrase them in correct English, he froze. When he didn't respond, Bill kicked his leg.

Charley cleared his throat, but looked first at Clark, then at the picture. No proper words came to him. Mr. Clark frowned, then Nancy's thin voice rose. "The cowboy has roped the bear here, but the horse is fighting it."

"Is this a possible feat, Mr. Russell?" Clark asked, not unkindly.

"Not if the hoss can help it," Charley said.

"Go on," Bill prodded. "Tell him about it."

Nancy looked up nervously, and Mr. Clark waited. Charley felt the pressure to explain. "Here's how it was. As soon as the cowboy tossed his hackamore around the bear, it was a deadly tug-o-war. Now you have to wonder who's going to win, the bear or the cowboy. The cowboy won't have much chance without the hoss's help, and the hoss is about as skittish as I am this minute and jest wants to roar on out of there with or without the cowboy."

Nancy sighed. But Mr. Clark smiled.

That week a full page presentation of Charles Russell and his work appeared in the *Sunday Herald*. Nancy was sure it was just what they needed to boost the exhibition.

On the day the exhibit opened, Nancy and Charley were ready at nine o'clock to greet viewers. They waited, but by ten after ten no one had come. Charley rolled cigarettes and smoked them one after another. Nancy walked around the room, looking at paintings, picking up pieces of lint she saw on the floor. "People don't get started so early in the morning in a city like this."

"Yep, that's probably what's happening." He heard her sigh behind him. All her big expectations were coming to nothing again. He wanted to go to her and put his arm around her, but she wouldn't like that. She still wanted to believe people would soon be here, that they were just late getting started.

A few people did come about eleven. Nancy smiled, then sat at a table and began writing. He wondered what she was writing—a list of things to do next? One man recognized Charley from his picture in the paper and stopped to shake his hand and say the paintings were fine. Then some people John had invited came, and Nancy walked around the gallery with them. The place was never crowded, but at least people were looking, and Nancy was smiling. Charley grew restless, and went to see John.

There were no sales that first day, but Nancy wasn't in the least discouraged. The next day, a few people looked, but again there were no sales.

The next day Charley and John called on editors. Nancy would have liked to go, but didn't want to close the exhibit that long. She gave John photographs of the paintings. "And don't forget to invite them to come to the show."

At *Outing*, Mr. Whitney impressed Charley as a hard-working man, maybe because the cuffs of his sleeves were rolled back and his desk was piled with papers. He was congenial, though his eyes rested on Charley's sash and high-heeled boots an instant too long. John did most of the talking. "Charley just came in from Montana; brought some of his paintings along. Here, you'll want to look at these photos."

"Yes, I recall seeing your work before, Russell. Good to meet you. Are you staying in New York long."

"No longer than necessary," he answered.

John laughed nervously. "Charley is a mountain and range man. Cities make him nervous. Right?"

"A hundred percent."

"I thought you might like to see some of his work," John said.

"I'll consider it," Whitney answered. "These all look good enough." He turned to Charley and his expression became more solemn. "We have a lot of artists working for us, you understand, so I can't promise you much."

They shook hands and left. Charley didn't like the feeling he had when he left the office. Nothing had happened he could object to. John had stayed the proper length of time, said what he meant to say, and Whitney had been more than decent, but it was *business,* and he knew nothing of that. They saw three editors that afternoon, and when he returned to the exhibition gallery about closing time, he couldn't think of much to tell Nancy about it. "They were nice, they looked at the pictures and said they'd keep me in mind. They said they had other artists already, but they'd see."

Nancy wasn't satisfied, so he changed the subject. "How did it go with you?" he asked.

"The same. People said they liked the pictures, but there weren't any sales. Of course, sometimes people go home and think about it, then come back and buy later."

She held his hand as they walked back to their hotel. He was tired and needed a little of her hope and optimism. When they climbed the stairs to their room and closed the door behind them, Nancy took off her coat, put her arms around him and laid her head on his chest. Breathing the faint flowery scent of her warm skin, he stroked her hair until she lifted her head and smiled. "We'll be all right, Cha'ley." Then she lowered her head to his chest again. "As long as I have you, I'll be fine."

A tenderness welled up in him. She awakened so much love, touched depths he didn't know he possessed.

The next day Nancy decided to go along with Charley and John when they called on editors. The meeting at *Colliers* began with warm smiles and handshakes. Nancy charmed people when she wanted to, and this editor was charmed. But even though he was in no hurry to send them away, his words were predictable. "We have a commitment to other artists. Remington is under contract for a series of full-page color plates. That doesn't leave much room, I'm afraid."

Nancy smiled as they left, but when they were outside on the sidewalk again, she muttered, "Remington. Damn him anyway."

Charley and John laughed. "He got here first," Charley said.

John and Will wanted Charley to go to a Players Club dinner with them. This, they said, was a chance to meet the right people. Nancy brushed his clothes, telling him she wanted to hear every single detail later.

Though the affair was a fancy dinner, Charley knew he looked like a curiosity to the other guests, in his western boots and sash. But at least he had the black jacket he borrowed from Trigg and figured that ought to be enough of a concession to formal attire. John introduced him to a roomful of people, some he'd heard of before; painters, writers and a story-teller. Will Rogers had a drink with Charley and John, and before long, Charley and Rogers were swapping yarns, and the ice was broken. A crowd of people gathered around them and it seemed just like being at the Mint Saloon. By the end of the evening, Charley was inviting them all to come and see him in Montana.

Yet, the basement showroom didn't attract the crowds Nancy hoped for. She advertised in the newspapers, and telephoned people who might be interested in seeing the exhibition. The work was admired by some, but sales didn't develop. Nancy smiled and held her chin high, but it was determination that kept her smiling, nothing else. He longed for a sale—something. Nancy needed it.

During the mornings when things were slowest at the showroom, Charley painted with Will and John. One morning while he was at the studio, invitations were delivered for a party given by a Mr. Gold. Charley remembered meeting him at the Players Club. His invitation was addressed to Mr. and Mrs. Russell. "Well, what do you think, boys? Are we going?"

"We're going," John said. "It's *the* place to be, and I doubt if any of us would have gotten an invitation from Gold if it hadn't been for you. You were a big hit. You made a lot of friends that night."

Back at the hotel room that evening, Charley showed Nancy the invitation, but even that failed to raise her spirits.

She lowered herself slowly onto the chair by the window and blinked. "I thought I was going to make a nice sale today," she said and sighed. "A man was interested but he didn't buy. And it looks like we won't be able to keep the showroom much longer. We can't afford another month's rent."

"Well, we can't go home soon enough to suit me. It could've been better, but what the hell; we've had fun. We saw the ocean for the first time. We've made some friends. I've already learned a lot of techniques from John and Will. And you're goin' to have plenty to tell Josephine after the swell party Mr. Gold's throwin'."

She smiled, but she was blinking back tears. Something else was on her mind. He waited.

"I walked over to Tiffany's today and saw the Remington bronzes in the window. And Cha'ley, they aren't nearly as good as your figures. Honestly. Don't laugh at me. I know they're good. I'm not saying they're not good, but not as good as yours."

She looked forlorn, sitting on that chair, her shoulders sloped over, her hands clenched in her lap. He tried to think of something to cheer her up. But then her head shot up and her eyes focused on him. "We still have a little time. I'm going to go and see those editors that didn't come to the exhibition. I still have quite a few things left to do."

At the showroom early next morning, Nancy smiled as brightly as ever and held her back even stiffer than before. Charley hunkered over in the corner rolling a cigarette and talking to Will Crawford. He noticed a man, who had been standing nearby for some time, had walked up close to them and cleared his throat. "Excuse me," he said, looking at Charley. "But could you tell me how much that painting is?"

Charley raised himself up to look first at the man then at the painting. "Which one?"

"That one." He pointed to a picture of a hold-up. It wasn't one of his more serious paintings. Con Price posed for it, and it didn't look bad hanging there. He looked at the man and smiled, wondering if he dare ask as much as seventy-five dollars. He'd sure like to get that much for Nancy's sake, but he didn't want to scare the fellow away either. The man was middle-aged and well-dressed, but didn't look rich. Probably lived in a house like Trigg's. He had just about decided to go ahead and ask seventy-five dollars anyway, then lower it if that seemed too much, but Nancy showed up, smiling.

"That painting, Sir," she said, "is six hundred dollars."

Charley couldn't believe his ears. His mouth opened; he stammered, expecting her to correct herself. Six hundred—that was what she said, wasn't it? He looked at Will's face, but Will looked amazed, too. The man turned away, and Charley shook his head. "She's gone crazy," he whispered to Will.

But the man pulled out his wallet and counted the bills into her hand. Dumbfounded, Charley walked away, puffed his cigarette, and shook his head. He shouldn't let her take that money, he thought, but when he glanced back, the man was smiling and taking the painting.

Then he saw that Nancy had gone as pale as the morning snow. She looked as though she would faint. He rushed to her and helped her to a chair. "He had the look," she whispered. "And I knew that painting was worth as much as a Remington."

Nancy paid their bill at the hotel and set aside enough money for their expenses for another two weeks. Though Charley disapproved of her pricing, he knew better than to scold her for it. Instead he teased her, calling her a bank robber, or one of the James gang.

"It proves I was right," she huffed. "So you can just be quiet about it and come with me. I have something I want to show you."

Charley picked up his Stetson held it out in a sweeping motion and bowed low. "Where're we goin'?"

"Shopping. You haven't forgotten the party tomorrow night, have you? Well, there's a coat in a window and my brown coat is so worn, I thought maybe now I could buy a new one."

"Why not?" He opened the door with another bow.

Nancy sewed most of her clothes, and ever since her first visit to St. Louis, she had taken a great interest in her dresses, studying the fashion magazines with Josephine Trigg and copying the styles of some of her favorites. She had never owned a new coat. Hers had all been made-overs or second-hand. He was ready to admire the one she showed him and tell her to buy it.

But before they got to the store, she stopped in front of a jewelry store window. "I don't see any coats here," he said.

She poked his arm and took a ragged breath. "There." She pointed at a bronze figure in the window. "Some day your bronzes are going to sit there."

The Remington bronzes. He looked at them critically. The proportion and shape of the horse and rider were correct, but he would have gone further and refined the details, made the figures more lifelike. But what did he know about bronzes? He worked in wax and clay. All the extra detail and refinement he did on his models would probably only make casting more complicated.

"I like the stance on his cavalry man there, don't you, Mamie?"

She smiled. "Not only are your bronzes going to sit there some day, your stories are going to be in some of those magazines, too."

"My stories are for tellin', not writing. Now where is this goldarned coat, you brought me out to see."

They walked at a fast pace, their heels striking the pavement at the same time, the only sound they made until Nancy stopped again, and pointed to a beaver fur coat in the window of a big store. When he saw it he was reminded of his trapping days with Jake, and a strong yearning to be back in Montana struck him.

"Don't you like it?"

"Sure, it's real nice and ought to be good and warm. Let's buy it." She smiled. "But you need a coat to wear to the party, too."

"Naw. My coat's fine."

"Let's go inside and look."

She took his hand and pulled him straight over to the men's coats. "There. Which one do you like?"

"Not a damn one. Let's get the one you came after."

A salesman approached then, and the next thing he knew, the man was helping him into a coat. "This is the Prince Albert style that's so popular now."

"It's perfect for you, Cha'ley."

"Maybe so, but I like my old one better. Forget this dude coat and let's get what we come fer."

Nancy looked down at the clasp of her purse. "No, if your old coat is good enough for you, mine is good enough for me."

"One thing has nothin' to do with the other. Let's go."

She sighed, helping him off with the coat. "It's just as well. This way our money will last a lot longer and we can stay until we see all the publishers and galleries in New York."

"This coat's jest what I'm lookin' fer," he said. "Wrap it up."

They arrived at Mr. Gold's mansion on time, Nancy in a beaver fur coat, Charley in a Prince Albert. John Marchand and Will Crawford were already there. Some of the guests out-glittered the heavy chandeliers in the great hall. Though Charley knew that his fancy coat didn't make him any less of a curiosity than he had been at the Players Club, he didn't feel in the least uncomfortable. He had been invited because Mr. Gold wanted him, and that was enough for him. Many of the faces were familiar now, though many weren't. His spirits rose when he saw Will Rogers and Bill Hart. Their smiles were like the ones that usually greeted him at the Mint, and it wasn't more than a few minutes before Charley stood in the middle of a group of new friends, telling a favorite yarn.

A few days later, a newspaper reporter came to the basement showroom to interview Charley, having learned about him from someone at Mr. Gold's party. Nancy hoped the reporter would interest people in coming to see the exhibition. But Charley was very tired of the exhibition, tired of cooperating, and tired of New York. He wanted to get back to Montana. Still, Nancy's excited smile was hard to

resist, and the reporter seemed a nice fellow. So Charley sat down with him at the back of the room and they talked.

The headline of the article in the *Press* read: *SMART SET LIONIZING COWBOY ARTIST*. According to the article everyone at Gold's party loved Charley's homespun philosophy. He thought back to what he had said at the party. His yarns had morals maybe and told something about the people he knew. But nothing philosophical. Nancy thought the piece was fine and bought several copies of the paper so she could send one back home to the Triggs. The article carried pictures of Charley, and his paintings and a long description of his *Massacre of Custer*. He had explained to the reporter that he had heard the story from of an Indian who had been there, and painted it accordingly.

After the article, more people came to see his work. But Charley was very glad when the rent on the showroom finally expired, and the exhibition was over. He longed to climb into the saddle and ride, to put his foot on the brass rail at the Mint and the Silver Dollar, to catch up on all the news.

Nancy wasn't ready to go home yet. "Now that the editors and publishers have seen that article about you, they'll be more receptive."

"I've seen all the editors I care to see," he said. "I've said everything I have to say. And I ain't goin' any further."

She argued, but he would not be moved to knock on any more editor's doors. Finally, she gave up. "All right, you can paint with John and Will. I'll go and see people myself."

He quit arguing because she was as determined as he was. They would soon be out of money and she would have to go home. He painted at John's studio, offering to cook lunch and help out wherever he could. Now that they knew each other better, Will and John often offered criticism and pointers on technique. Though Charley knew his draftsmanship was as good or better than theirs, there were many things he could learn from them.

Nancy left the hotel room every morning with a bundle of paintings and a sheaf of photos under her arm. She called on galleries, editors of magazines, and book publishers. She was relentless. But the galleries had enough western artists already. Gallery directors said their biggest demand was for Remingtons. Magazine editors were too busy to give Nancy much time, but she did promote a story about Charley with reproductions of his paintings. *Outing* promised to use several pictures and one of Charley's stories.

Finally, their funds were exhausted, and they packed up to go home.

As they waited at the hotel lobby for a cab to take them to the station, Nancy looked around, brushed her new fur coat and sighed. "It wasn't so bad, was it? Maybe we didn't get everything we hoped for, but it was interesting and I learned plenty."

He nodded. "But I can't wait to get back to the cabin. And you're going to have to blast to get me to leave it again."

Chapter 26

New York was only a fading memory in Charley's mind months later as he sat with Nancy in the parlor, reading as she sewed. She looked up and said, "It has to happen in New York first."

"What does?" He had been engrossed in his book.

"Success," she said with an impatient shimmer in her voice. "I know we were getting very close. You were making good friends in New York, and now with the article about you in *Leslie's*...."

His stomach tightened as he turned back to his book, and she went on talking. He didn't like the breathless little pauses between her rambling about what they could accomplish in New York *next time*. He was content with the way things were. He loved going out to his studio every morning. He didn't want to hear talk of visiting New York again.

But from that evening on, Nancy brought it up regularly—casually at first, then more insistently. He ignored her until forced to say no. But even after that she continued to talk about it. There was a fateful flavor to her entreaties so he usually remained quiet and let her talk. There were times when he let her New York babble float right over his head. He couldn't remember ever saying he'd go. He may have said *maybe* when he was thinking of working in clay and pursuing his ideas for bronzes in New York. But somewhere along the line he must have agreed.

They stopped in St. Louis first for a short visit. When Nancy got off the train in her teal-colored wool suit and matching hat, waving and smiling, she was something to see. The family raced to help carry her packages. After dinner she held everyone's attention with her excited commentary as she showed the paintings that were printed on Brown and Bigelow's calendars.

"Anybody can afford the calendars," she explained. "They're plastered all over Montana. Thanks to them I doubt if there's anyone in the state who hasn't heard about Cha'ley. And what's nice about it is that after the pictures have been reproduced, the company sends the original paintings back, and we can sell them."

Nancy was the businesswoman. Everyone in the family recognized it. He wondered if they guessed the awful prices she asked now. A $100 price tag was nothing to Nancy.

They stayed two weeks in St. Louis, then went directly on to New York, arriving in mid-afternoon.

The city was pleasantly familiar this time, Charley reflected as he stepped out of a cab on 42nd street in front of the Park View Hotel. A gentle snow was falling,

obscuring the mass of tall gray buildings. He helped Nancy down, paid the driver and took the suitcases.

Settled in their hotel room, Nancy began immediately to make a list of people to call. This time she didn't try to persuade him to go to the publisher's offices with her. Next morning she put on her best dress and her fur coat, and armed with photographs and two paintings, she climbed into a cab, and waved to Charley as he stood on the corner. Standing there watching the automobile disappear down the street, he felt a stirring of guilt. He should have gone with her, he supposed. But he turned his mind back to Remington's bronzes and his own ideas for figures. With a purpose then, he strode to the corner and walked to John's studio.

Within an hour he was working and thinking in clay—Indians hunting buffalo. He remembered watching a small herd of buffalo soon after he came to Montana. He remembered the stories Indian braves told of how they killed their meat. It took incredible skill and courage for an Indian to gallop to a few feet of a running buffalo herd and shoot arrows with absolute accuracy into the chosen animal, a near-impossible feat, but the Indians perfected their skill in order to survive. As Charley recreated the scene, his fingers pulled and pushed at the clay. On one side was the Indian on his horse, on the other, two of the massive buffaloes running for their lives. The Indian was leaning over his horse, his arms taut as he pulled the bow back and aimed carefully at the animal's heart.

Charley saw the scene, smelled the sweat of the buffaloes and felt the steam rising from their nostrils, while his fingers translated it all into clay. Three figures curled in desperate action. It would make a good painting, but would it come across as a sculpture the way he imagined? At the end of a three-hour stretch, the main figures were formed, and the horse and Indian were roughly finished. He left it alone for a while and cooked lunch for John and Will. When he was satisfied with this piece, he was going to start another. It was already shaping itself in his mind.

As Charley worked on his clay statue, Nancy sold one of his paintings and signed a contract with *Outing* for several more of his stories. "Not somebody else's!" Nancy emphasized, "But your own." She fluttered around their hotel room. "Oh, I know things will work out fine. You won't be sorry you came, Cha'ley; I promise you that."

They went to a play with Bill Hart and his mother. Another night they had dinner with new artist friends, Phil Goodwin and Bill Krieghoff. Bill did cartoons, but said he really wanted to paint portraits. Serious portraits.

"Then you will do it," Nancy said with such sureness that Bill gasped. "You really think so?"

"I'm sure of it. Some day I'll have you paint my Cha'ley's portrait." Bill smiled and Nancy had another admirer.

While he was in New York, Charley decided he ought to see what other artists were exhibiting. He visited the galleries and museums and looked particularly at bronzes. By the time he finished his second clay figure, he really believed in the

superiority of his work. He was so excited about it, he brought Nancy to the studio to show her.

When she saw the foot-high figures, her face turned pale and her mouth opened. What was wrong, he wondered. But then she turned sharply. "Cha'ley, why didn't you tell me?"

"I told you I was working in clay, didn't I?"

"But these are better than anything you've done before. Sometimes it scares me to see your genius."

"Don't say that. I'm jest lucky to have the knack." He was glad John and Will hadn't overheard her.

"This group with the three Indians in battle is the story you heard from Medicine Whip, isn't it?"

He nodded. As Medicine Whip struck the enemy with his coup stick, another enemy warrior charged him with a tomahawk poised to strike a deadly blow.

Even as he showed the two pieces to Nancy, another Indian scene came to him. He sketched it while Nancy talked with John and Will. The new piece would be of a pair of Blackfeet warriors dancing in celebration of victory in battle. In this he wanted to capture the undulating rhythm of the tom tom and the near-naked bodies of the men in breechclout, headdress and moccasins. One warrior crouched, his hair flying, the other danced on one foot, knees bent, lifting his rifle over his head with the fresh scalp attached to it.

Nancy continued to call on publishers as Charley finished the figures and made arrangements to have them bronzed. If he hadn't been so intent on his sculptures, he would have paid more attention to what Nancy was accomplishing.

Little by little a few doors were opening. A magazine illustration here, a few line drawings, a possible article about Charley to go with one of his paintings.

"You're hitting it too hard," he told Nancy. "Now that you've got us in the game with the publishers, it's time to enjoy ourselves. Bill Krieghoff is having a party at his place next Saturday. In the meantime, we'll do some sight-seeing. We'll buy some presents for the Triggs and some of our pals."

Nancy shook her head and assured him she had no intention of slowing down. "This is the time to push harder," she said. And he saw it wouldn't do to argue.

After Charley delivered the clay models to The Roman Bronze Works to cast, his days passed slowly. He wanted to surprise Nancy with the finished bronzes. They had talked about having them cast, but she didn't know it was already being done. He painted at the studio with John and Bill. He went with Nancy a few times but he grew impatient. It seemed to take forever to get everything in motion. Finally, after weeks of waiting, it was done, and he was pleased. But he wanted Nancy to see them in the best light.

Charley and Nancy were invited to another party. There had been many, and this night Nancy was taking a long time to get ready.

"Don't be in such a rush," she said. "It seems to me getting to these places on time is what they call a *faux pas*."

"Never mind that," he said. "There's something I want to do along the way."

"What?" She looked at him expectantly.

He shouldn't have said anything. Didn't want to get her suspicious. "What did you want to do along the way?"

"Oh, it was just something I wanted you to see—something that might make a nice present for the Triggs. In a store window."

"Oh, what is it?"

"You'll have to see it yourself."

"Well, you can tell me what it is, can't you?"

"Uh...it's just a do-dad. Trigg might like it, but I don't know about Margaret."

By the time Nancy was ready to go, she was asking dozens of questions about the gift Charley had in mind, and he couldn't think of what to tell her. In the taxicab, he described a trick lamp he'd seen at a novelty store that honked when the switch was turned on. Nancy looked disgusted. "How could you even think of such a thing?"

As she lectured him on taste, he began to wonder why he didn't just tell her what he was doing from the start. But he had gone this far, so he sat back and listened and defended his choice of a lamp that honked.

Finally, Charley leaned toward the driver. "Stop here."

He took her hand and led her to the window of Tiffany's where his bronzes were displayed. "There," he pointed.

He could hear her take a long startled breath. Light showered down on the figures, catching the rippling muscles of the scalp dancers, the buffalo hunter, the braves in the battle. The effect was striking. The figures looked better than he ever hoped.

"Cha'ley," she whispered. A tear rolled down her cheek as she squeezed his arm. "*Your* bronzes in Tiffany's window! They're beautiful." The tears came heavier all of a sudden. "Oh, it's happening. It's happening just the way I dreamed it would." She leaned her head against his shoulder.

He couldn't move her from the spot. She wanted to stand there and just look, though the wind blew and the people passing by stared. "And the prices," she said. "Four hundred and fifty dollars is more than they asked for Remington's."

"That's because it cost more to cast mine. Mine had too many details."

She shook her head. "No, it's because yours are worth more."

When they finally left Tiffany's window, it was with an air of victory. If he'd been an Indian, he would have done a scalp dance himself. But today he wasn't an Indian and he was in New York City, and on his way to a party with Nancy.

The party was in full swing when they arrived. It was just the right kind of celebration. Charley took two glasses of champagne off a tray that was being passed. He handed one to Nancy and proposed a toast. "To you. You're the best thing that ever happened to me."

She held her glass out. "And to you, the one person who really matters to me."

They drank. Then Bill Krieghoff joined them, and Nancy told him about the bronzes at Tiffany's. She laughed at herself for wanting to tell everyone she saw. He had never seen her look quite so happy.

It was indeed a night to celebrate. This time she had accomplished what she set out to do in New York. He had opened up a new avenue for his art. They were here among friends, though far from home. He felt a heady lightness.

The evening glowed with conversation, dancing, canapes and champagne. Charley told stories. People laughed, crowded around and asked for more. But as the evening wore on he had drunk so much champagne his ears were ringing and his vision blurred. He still felt wonderful though. He didn't want it to end.

"It's getting late, Cha'ley. I think we better leave."

"Not yet."

Nancy's eyes flashed, but people still urged him to stay, to tell one more story. Another drink was put in his hand. "A little later," he said, gesturing with his glass and spilling some of the drink directly onto the woman who was standing nearby. He didn't know who she was, but she was pretty and smiled about it. He turned to help her, and his hand brushed over the softness of her bosom. Startled, he spilled more. Finally, she pushed him away. "You're dangerous," she said, "even without your six-gun blazing." But she laughed.

That was the last he remembered until he woke up the next day. Nancy was standing over him, dressed in gray, glaring at him as though she would gladly choke him. "What's the matter, Mamie?"

"We have a lunch date with Bill Hart," she said, turning away.

He looked at the clock, but the numbers were blurred, his head whirled around and he sank back on the pillow. "What time is it?"

"Almost noon."

"And when do we meet Bill?"

"At one. Can you make it?"

As he raised his head, the ceiling swirled around. He closed his eyes tight. His head throbbed and his chest pounded. He tried putting his foot down on the floor, but it only started the room spinning again.

"I'll meet him and tell him you're sick," she said.

Her tone sliced like a knife through the belly. And he tried to remember last night. What had he done? There was a milky wall in his mind, but through it came a sense of shame? He could only wonder why?

Could he stand? Or would he fall, his head splitting open like a watermelon on a rock. He was miserable, stomach churning, head spinning.

He put his feet over the edge of the bed and forced himself to sit. Nancy watched him, but said nothing. He tried to stand, but the room shook. *It couldn't have.* Rooms don't shake. He focused on the wavy form of the bathroom door, but when he took a step toward it, it moved. He stepped again. Was he staggering? Somehow he got to that damned door. His head throbbed and floated as nausea rose fast, robbing him of his strength. His hands shook. He bumped his head. Nancy groaned and guided him to the stool. As he smelled her rose-scented perfume, he threw up. She stood over him, her fists clenched at her side. He could feel her scorn. Later, she'd scold and threaten and beg him to stop drinking. He wished she would do it now while he was giving every bit of himself to tearing his insides out, retching and tasting sour bile.

Somehow he bathed and shaved and walked with Nancy to meet Bill. He drank coffee while Nancy and Bill talked. He tried to smile now and then, but the smell of their food thrust the nausea back on him and he swallowed the taste of bile; he sweated and trembled.

"I'll be back," he said, when he could sit there no longer. He went to the men's room and lost himself in the misery of dry heaves. He knew he needed a stiff drink to steady himself. He couldn't get through another hour without it. He went across the street and ordered a shot of whiskey, drank it and wanted another. He bought a pint of whiskey, hid it in his pocket and went back to the restaurant.

Nancy and Bill both smiled uneasily at him. "Feeling all right, now?" Bill asked.

"Fine, you bet."

Chapter 27

After New York, Charley learned about deadlines. Most of the time they were no trouble, but one April morning the sunshine awakened his urge to ride off to the hills. He stood at his easel in the cabin studio wishing himself in the saddle, when his eyes rested on the table covered with drawings for a book on Lewis and Clark he was illustrating. Nancy wouldn't hear of his heading for the hills until that project was finished and the deadline met.

He sighed, set the wood in his fireplace, wadded up newspaper, struck a match and watched the fire blaze up. Staring into the flames, he remembered another spring morning. He had been wolfing with Con Price. Bitter cold had given way to sunny warmth, though the snow was still deep enough to make travel slow.

Con stood at the campfire alerted by an Indian family coming out of the woods, wanting to trade a fresh-killed antelope for coffee and ammo. Con moved carefully, waiting to see if there were more Indians, if they were hostile for one reason or another—always a tense moment—until you know. Indians resented wolfers and the strychnined meat set around the range as wolf bait. Charley saw the scene again clearly now—Con with his back to the fire, listening, tense, his gun hand ready for trouble. Even after Charley roused himself from his reverie and went back to work, the scene remained with him.

On the easel, one of the illustrations for the Lewis and Clark book waited. He had searched through books at the library for the design of the canoes that would have been used, the clothes of the explorers and the Indians. But in spite of the struggle or maybe because of it, the picture was turning out better than he expected. Still, as he painted beading on Sacajawea's clothing, he felt the north country he had just glimpsed coming around him again.

Con's coat had reflected the flames of the campfire, the Indian in his feathered beaver hat approached with sureness, his squaw and horses standing behind with an Indian boy wrapped in a blanket, each of them watching Con. The scene filled itself out—wolf traps, saddles, blankets, hides hanging out to dry.

Charley took out a fresh watercolor sheet, anxious to go back and live that time again. It wasn't necessary to make sketches for this one. He already knew where Con stood, where the Indians stood. Even the pattern on the Indian woman's blanket was clear. He sketched the main lines lightly, washed color into the foreground and sky, drew the horizon lines and the distant mountains, and when that much was done, he could smell the antelope's blood, the wolf hides, and hear the crackle of the pine twigs just thrown on the fire.

He was completing the scene, working on the detail of a saddle hanging on the limb of a tree when he heard someone coming into the log cabin. "Who's there?" he said without looking up. "It's me," Johnny Mathison's gravelly voice answered. "I see you're pretty damn busy."

"So you finally came to see me," Charley answered, stretching his hand out. "Well, how do you like my medicine tipi?"

Johnny grasped his hand. "Damn if it ain't everything you said. Must be why you hain't ridden out to my place this spring. Thought I'd see you last week when we got the chinook."

"I'd have come if I could've. Nancy's been cracking the whip around my head to finish some pictures before the deadline. But sit a spell. I'll brew us some coffee. Whatcha in town fer?"

"Supplies."

"Don't tell me ya drank up your Scotch whiskey."

Johnny laughed. "Plenty left for when you ride up. But I thought we'd slip down to the Mint later."

"Sure. I'll fix us some grub right here, and we'll go after we eat." Johnny looked around at the walls of the cabin, where Charley had laid out his souvenirs—an Indian pipe, a pair of beaded moccasins, a parflesche, a tomahawk, a skin shield. And in the corner an Indian dress of white buckskin decorated with silver bells.

"What d'ya do with all this goddamn junk ya collected?"

"Look at it," Charley drawled. "Helps me remember times with my friends."

"I always said you was half Injun. When I first seen you on the trail up in Canada, I thought you was pure renegade. 'Course you ain't pure anything and that's a goddamn fact. I wish to Christ I'd a had you paint a real picture of my wagon train before your shit was so damn high-priced. But who'd a thought a damn dirty drifter like you would go to New York and come back with contracts stickin' out your goddamn ears. Sheeit, I thought you'd be lucky jest not to get yourself shot. You was a wild damn fool up to Geyser one night."

"Yeah, when was that?" Charley filled his blackened coffee pot with water, dumped a handful of coffee in it and set it on the fire, eager to hear Johnny's story about some wild night at Geyser. He went back to his work table and picked up his brushes again so he could paint on the wolfer's camp while Johnny talked.

Later, they squatted down Indian style in front of the fire, Charley poking at the meat with his long-handled fork until it was cooked to Jake Hoover perfection. After lunch, they saddled up to go downtown. Nancy came to the kitchen door and warned Charley before he left to leave the whiskey alone. He nodded, and he and Johnny rode off.

"What'd the little lady mean about leaving the whiskey alone? Don't she know we're a goin' to the Mint?"

"She knows. But I don't drink much anymore."

"Don't tell me them damn moralists have got to *you*. I don't believe it, not a hard-hided sonofabitch like you. You was always a man's man, fer Chrissake. Now what?"

Charley smiled, but he wished he was the hard-hided sonofabitch Johnny thought he was. He used to be able to drink with the best of them and never suffer for it. He would get the shakes now and then, but it soon left him and he'd be all right. But now, it was better not to have that first drink. When he had one, Sid always mixed it up with lots of water. Over at Billy Rance's place it was the same thing. The faint smell of whiskey, but the taste of water.

Charley and Johnny drifted to the back room of the Mint. Charley thought he might paint up a quick watercolor of Johnny's wagon train. He had a pretty good start when Ace Jeremy, a cowboy from Shelby way, came in. "Thought I'd find you back here tellin' dirty stories."

"Hell, you've heard 'em all, but sit down and have a drink with us." Johnny knew Ace from his train-driving days. "What's new?" Johnny asked.

"Same old shit," Ace said. "I got me a new spread. Sold the old place 'cause the water was so damn bad, and moved further north. See Con Price now and then. He's havin' a rough time. Bad breaks. But you know Con. If he don't make it, he'll start over again. He works like hell, God knows. I hope he don't lose his place."

Charley straightened up. Con had been working for three years now to get that horse ranch going. Ace was right; no man ever worked harder than Con. Charley decided to ride up and see Con as soon as the weather broke. Maybe he could help. If things kept going as well as they were now, he'd have money to invest. Why not invest it in a good horse ranch?

"Charley, do you remember Rusty Meredith, used to ride with Brewster's outfit, didn't he?"

"Sure, I remember him. Wintered in a shack with him and some other punchers up at Chinook."

"Well, did you hear about his accident?"

"No, what happened?"

"Throwed off a bronc. Broke his neck. We put him away a couple of weeks ago. Thought you'd like to know."

Charley was stunned. Rusty was always so full of life, had a million plans. He looked around the room at the faces of the other men and he thought about death, how it comes sometimes without any warning.

"Let's have a drink for Rusty," Johnny said. They all nodded and Johnny ordered a bottle of whiskey and three shot glasses.

Charley recalled Rusty sitting on a roan when they were over on the Musselshell one time and the wind was blowing a fierce one. Charley had shivered and wanted to find shelter and make a campfire, but Rusty only grinned. Nothing bothered him. Then another picture came—of Rusty sprawled out on the ground

with a broken neck—dead. How fragile it is. How easily it ends. And then...what really matters? The friends? The time wasted? The struggles to paint perfect pictures? What? Johnny solemnly handed him a shot glass so full of whiskey it sloshed over and wet the outside of the glass.

"To Rusty. May he rest in peace."

They drank, letting the whiskey scald, gazing off for a few seconds with private thoughts of Rusty. Then Ace described the funeral and they drank another shot. The empty futility that had pierced Charley was no longer so sharp. And the question of what mattered answered itself. This did. Johnny and Ace, and all the men standing around. They needed each other. And a little whiskey brought them closer together. It cut through the stiffness and let them talk honestly and get to know each other so they wouldn't go out to rest in peace without their friends really knowing them.

When Charley woke up he didn't know where he was, except that he had been in a cabin in the Snowy mountains, a bear was ripping at his chest and scalp. He had run and fallen over a precipice, striking his head on rocks, but still tumbling, and he couldn't get a hold on anything to stop his fall. And now here he was in a bed with smooth sheets. There had been a storm, he remembered that now—the kind of violent thunderstorm they had in Missouri when he was a kid. Lightning all around him, blinding brightness for a second, then pitch blackness. And the noise of the thunder shook the earth. His eyes were closed, but he opened them, and saw a bedpost, and across the room, a wall with wallpaper on it—little pink worms—oh no, they were roses. Just like the wallpaper at home.

He stared at the room. It was quiet and he was alone. Grey light filled the square on the other side of the little window, but he didn't know what time it was. He felt for his clothes. Searched for them. Everything was so neat, he had the feeling something was wrong. The dresser was never that bare with the white dresser scarf starched stiff as though nothing out of his dirty pockets had ever been thrown down on it.

How did he get here so soon after being up in the mountains? He closed his eyes. He *had* been there! And it had gone badly. But there was something else he was starting to remember, something about Rusty. Then he remembered Ace and Johnny and the glow around them as they drank. Could he have...imagined, dreamed it? And not really have been up in the mountains and tumbling down? His mouth was dry. He lifted his hand and saw how it shook.

He was afraid to see Nancy's face. Afraid to try to get up. He wanted a drink. Whiskey. He wanted to die. Tears washed down his cheeks as he felt awful desolation. Then he knew he had to be sick. He threw back the covers and got up. His head seemed to explode, his vision blurred and disappeared when everything went black, but instinct and his two hands groping for the doorways led him out of the room, across the hall and down to the toilet where he heaved up every rotten

thing inside. He was still hanging his head over the toilet when he heard footsteps on the stairs.

"Doctor Edwin is here," Nancy said.

He flushed the toilet and raised his head just as Nancy and the doctor mounted the top step. "No need for a doctor," he said, but then his body crumpled.

He felt their tugs, their lifting of his lifeless arms. He was conscious, but couldn't speak, couldn't tell them he'd be all right in a few minutes. He could feel their shoulders under each of his arms. Nancy's familiar soft body on one side, the doctor's rough woolen suitcoat on the other. His feet swept lightly across the floor, back to the bedroom.

Sometimes he could hear their voices and then they would drift away. Then he'd hear them again. They were talking to him. Nancy rubbed his hand, slapped his cheek until he could feel a sting there. He opened his eyes and tried to focus on their faces. Their solemn faces.

The doctor put his stethescope next to Charley's chest. He shined a light in his eyes. When all the thumping and feeling were over, the doctor snapped his bag shut, glared down onto the bed and spoke much louder than necessary. "If you keep this up, you'll be dead in six months."

He said a lot more, but he kept coming back to that. Any more heavy drinking was going to kill him. Even moderate drinking was dangerous. Of course, Charley knew it was all bullshit. Nancy put him up to it. She wanted him to stop drinking. Well, he didn't mean to drink so much. He was just going to have one or two drinks for Rusty. And what happened then, he couldn't remember.

The doctor left, and Nancy came back up to the bedroom. He braced himself for an all-out tongue lashing. He had broken his promise once again, and she wouldn't be easy on him. She'd unleash all the anger she'd been saving up while he was sleeping it off. He closed his eyes and when he looked up she was standing by the bed, her head bent, fingering her handkerchief. When he did catch her eyes, he saw how red they were. "I'm sorry, Mamie."

She glanced at him, but went to sit across the room on the window seat. It seemed like she'd lost her steam. He waited but she stared out the window. "Well, say it, why don't you," he prodded. "I'm like a damned animal when I get drunk. I'm disgusting. Say it. I'm disgusting."

She sniffled.

"Well, damn. I know you don't believe I'm sorry, but I am."

"Are you sorry enough to stop completely?" She turned then and the anger he had expected was heaped up in her eyes.

"If you mean—did that doc scare me? No."

"Then are you sorry enough to stop drinking because I'm asking you to?"

"Aw, Mamie, don't you know how I try?"

She stood, walked to the bed and sat down. "I know you try. I shouldn't get so mad. I know, but it's so important. You *have* to stop drinking. Absolutely. No whiskey whatever."

"No."

"Look what it does to you. If you don't stop, it'll kill you. Why won't you listen?"

"I've told you how it is a hundred times. My friends are saloon people. We go back a long ways. That doesn't mean I'll drink heavy."

"And I've told you a hundred times you can still have your friends without the whiskey."

"We can't talk about it because you can't savvy what it's like for a man like me."

She sprang up from the bed and stood still, but anger radiated from her. He didn't want to talk about it anymore. His head hurt, his stomach hurt and his body trembled.

She left the room, and he pulled the covers around his head. In a little while she brought him a tray of food. Hot farina, hot coffee, a banana, warm biscuits. "Eat something now," she said, and went out. He didn't care a thing about eating. But she had fixed the food just for him and brought it all the way upstairs. He ate the bowl of farina, and drank the coffee.

He slept, and then when he woke up, he called her. She didn't answer. Must have gone out. It was getting dark. He'd better get up and get dressed, try to make peace. It wouldn't be easy. It was harder every time, but at least it hadn't happened for a long while. She admitted he was trying.

When he was dressed he took the tray downstairs. None of the lights were lit. He glanced out the window to the Trigg house. She must be having dinner over there. He just hoped they weren't talking about him. But he wasn't going over to find out. He turned on the light in the kitchen, thinking he'd heat the coffee and have a biscuit when he saw a letter on the table. His hands shook again as he picked it up.

Dear Charley,

I'm going away for a few days. If I stayed, we'd just fight, and that wouldn't be good for either of us. I can't change my mind. I only see it one way. You have to stop drinking completely. Some can't do it. Trying isn't good enough anymore. Dr. Edwin was telling the truth.

The letter didn't say where she went, but he thought he knew. Maybe it was a good idea. He didn't like arguing a damn bit. And once Nancy got started, she snarled like a wildcat. But there was no sense in promising something he couldn't live up to.

Trigg quit drinking. Sold out his interest in the Brunswick and went to work at the smelter's office. The only time he ever talked about it was when Charley offered him a drink, and he said booze was poison to him, and he didn't take it anymore. If Trigg went downtown with Charley, he drank spring water. But Trigg was a lot older than Charley, and he didn't have so many friends around. Come to think of it, just a few; Charley and George Calvert were the ones he saw the most. He read a lot and spent most of his time with his family. But Charley couldn't live like Trigg—not yet. At 40 his hair was turning gray, but his heart still hankered for fun and friends and that meant saloons. He couldn't promise never to drink whiskey again.

It was too quiet in the house. After he had something to eat he went to the cabin to paint. *The Wolfer's Camp* waited on the table. It seemed a long time since he worked on it. The main figure needed details. As he squeezed paint onto his palette, he tried to remember whether he finished the wagon train picture for Johnny. His mind was fuzzy about that. Surely he did, but try as he might, he couldn't remember.

He turned his attention back to *Wolfer's Camp*, picked up his brush and mixed a little blue-gray pigment, but he couldn't hold his hand steady enough, so he painted on the background to loosen up. Then he saw that Con's gunbelt needed a bit of glitter. Not too much. He touched brush to canvas. Damn! It was too much. He had to be careful, concentrate. He sponged out the excess paint and redrew some of the area. He tried again to get it right, but his hand still hadn't steadied. He worked on the rest of the painting, using his lightest touch. Then with painstaking effort he finished the gunbelt. He was sweating when he put his brush down. His body felt weak, exhausted. He cleaned his brushes and went back to the house and up the stairs to bed. He lay there feeling too tired to move. His heart thumped wildly. Why should he be so exhausted? What was wrong? He remembered Dr. Edwin's words, but that was ridiculous.

He woke in the middle of the night and wished Nancy were home. If she had stayed, they would have had their argument by now, and it would be all over. He read and fell asleep again. At sunup he went downstairs, feeling fit and ready to paint. He fed the horses and went to the studio.

Wolfer's Camp was finished. He put it aside thinking how he'd like to explain it to Nancy; tell her about that winter with Con. She'd be back in a few days. It was the way they parted that bothered him—a note on the table. They'd been separated plenty of times, but usually it was he who went off, hunting, or camping with friends or just riding away from town to think and sketch. Sometimes they went off together. She was as good a camper as he was now, though she always wanted to take too much stuff. He remembered the fun they had when they camped on the Dearborn River with the Triggs last summer. Nancy and Josephine identifying trees and stalking animals.

He started his last illustration for the book. He had already decided on the composition and sketched it quickly. Today his hand was sure and steady, which gave him a great deal of satisfaction. He'd hate to paint very often like he did yesterday.

He was soon engrossed in his work, but paused when he heard church bells. Strange, they only rang those bells on Sunday. He stood up and stretched, walked out the cabin door and stood on the lawn. The bells were clear and loud. Church bells for Sunday services. Two women in dressy hats and gloves and carrying their prayer books crossed at the corner. Sunday? It couldn't be—could it? Then he saw Trigg come out on his porch—wearing his Sunday clothes. "Nice morning," Charley said.

"You painting this morning?"

"Yep, I was. I thought it was Saturday."

Trigg took his pipe out of his suitcoat pocket and poked at it. "Nancy still gone?"

"Yep."

"Come on in and have breakfast with me and Margaret."

"I've had breakfast. But thanks."

"Sure. Come for dinner then."

Charley said he would, then went back to his studio, thinking it must have been Thursday when Johnny came to see him. He had looked at the calendar and thought to himself it was the day Sid Willis was going over to Butte. Charley had considered going with him, but couldn't spare the time. He was sure Johnny came on Thursday. So where had the extra day gone? How long had he slept?

He walked back to the house, though it echoed with its eerie quiet now. He had lost a day. It was just gone. He sat with a magazine on his lap until he couldn't stand the quiet anymore then he saddled Neenah and rode downtown. But everything was dead quiet on Sunday. Saloons were closed, cigar store was closed. He rode down to the park by the railroad station. After a while he turned to ride past the Park Hotel then back on Central Avenue.

Just as he turned on Central, a wiry man with graying hair wearing a black suit ran after him. "Are you Charles Russell?" he asked.

Charley reined up and said he was. "I'd like to talk to you," he said. The man looked like a preacher in his black shirt. Charley shrugged and got down off his horse. "My name is Newell Hillis."

Charley shook his hand. They walked up the street toward the cafeteria, Charley leading Neenah.

"You sound like a New Yorker," Charley said.

"I have a congregation in Brooklyn, New York," he said. "I've just seen your paintings in the Park Hotel, and that's why I ran after you when the young man pointed you out to me."

"I have pictures hanging in the hotel *bar*. You don't mean those?"

"Of course, I mean those. They're just magnificent."

They went into the cafeteria which was so empty the sound of their footsteps echoed off the walls as they walked to the coffee urn. Charley bought the Reverend's cup of coffee. "What brings you to this part of the country?" Charley asked when they sat down at a table.

"I'm on a lecture tour."

Charley had met plenty of preachers. Some were so puffed up with zeal, he couldn't talk to them; some were decent men who happened to be preachers. This one wasn't showing his zeal yet, though his eyes shone with some excitement. Maybe he was just looking for company, probably missed his congregation.

The Reverend spooned sugar into his cup, and added cream. "As I was saying, I was impressed with your paintings. I wonder if you considered having them exhibited back in New York. People are interested in the West."

"Well, now you see, Reverend Newell...."

"Hillis," he corrected, smiling. "Newell is my first name."

"Reverend Hillis. I've been to New York for that very purpose, but I wouldn't care to do it again real soon. New York is all right, but I'm staying right here."

"But your paintings don't have to stay with you, do they? If you would send them, I would exhibit them for you. Quite a few people in my congregation would be interested. I have a prosperous flock."

Charley smiled at the strangeness of the proposition. He imagined telling the guys at the Mint about this. The man was so serious though, he couldn't laugh. "It's nice of you to be interested, but my wife takes care of things like that."

Reverend Hillis pressed Charley to promise to talk it over with Nancy and let him know what he decided, but the more Charley thought about it, the more ridiculous the idea seemed.

"I'll be in the state for another week," Hillis said. "You can reach me care of the Park Hotel." He wrote his name on a slip of paper and gave it to Charley. "Think it over now, and let me know." Charley promised he would.

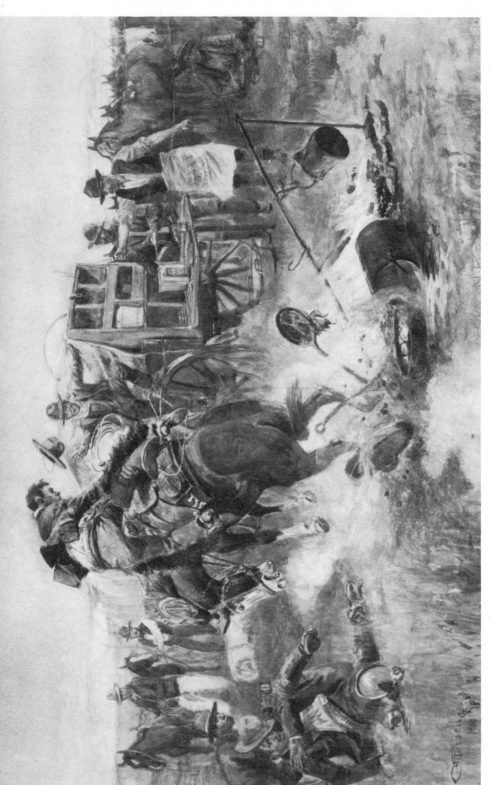

BRONC TO BREAKFAST, Watercolor, 1908. Courtesy of the Montana Historical Society, Helena, MT.

Chapter 28

Charley went to Triggs for dinner. After dinner, he and Trigg walked north toward the river. "You know, Trigg," Charley said. "I can't account for Saturday. And it's sure nagging me. I wish I knew just what happened."

"Didn't Nancy tell you?"

"No. She told me I ought to quit drinking. She wanted me to promise I'd never take another drop. But I couldn't."

Trigg stared down at his feet as he walked. "It's not easy for a drinking man to stop."

"No, it sure ain't."

"Being a bartender for so long, I've seen all kinds of drinkers," Trigg said. "Most don't have problems, at least most of the time, but I've seen others that don't come out so good. Missing a whole day is a bad sign, Charley."

"I know. I don't know what I did."

"You passed out at the Silver Dollar. Billy Rance bedded you down in the back room and sent word you were there. I went down and brought you home and helped Nancy get you to bed. Your color was bad, and you woke up screaming a couple of times. Nancy was worried and called the doctor."

"That's the first time in a long time."

"Sometimes that's the way it turns, and when it goes on a while, a man can wake up some morning without anything left, no wife, no money, not even any real friends and even his abilities can disappear. I've seen it happen too many times. That's why I quit drinking and got away from it altogether. I'm no moralist, but some people can't drink without hurting themselves and people around them, and when it comes to that, a man ought to quit, if he can."

The next morning Charley rode out of town. He didn't know what he'd tell Nancy until he was at Ben Roberts' back door. But when Binnie let him in, and he saw Nancy sitting at the table having coffee, he knew what to do.

He took off his hat and held it across his heart. "I'll not drink another drop of booze," he announced, "unless some bully knocks me out and pours it between my clenched teeth."

Nancy rushed to him. "That's good enough for me." she whispered.

"I mean it, Mamie. Not a drop."

Nancy listened to Reverend Newell Hillis' strange proposition, but she didn't laugh. "I'd like to meet him," she said. Charley handed her the slip of paper Hillis had given him. The next day Nancy went to see him.

When Charley came into the kitchen for lunch, Nancy smiled and served up chicken soup with a flourish and a pat on his shoulder. "It's all arranged. We're sending at least ten paintings to Reverend Hillis' church."

Charley lowered his spoon into the steaming soup, wondering how she could have overlooked one important thing. "We don't have ten paintings that aren't spoken for."

"Yes, I know," she smiled. "Remember the time when we had dozens of them. You were sure they'd never sell because I was asking too much. Now I'm asking three times the price of those, and there are none gathering cobwebs. Makes me think I ought to raise prices again."

He cringed, but kept his voice calm. "No need for it, Mamie. We're living fine."

"But there's the future to think about. What if one of us gets sick? What if we have a big family some day, and the children are sick? What if disaster strikes—an earthquake? The country's whole outlook could change. The *future*, Cha'ley."

Charley sighed. "You're the one lookin' to the future, Mamie. I look to the past." He smiled at her. "I guess that makes us a pretty good team. But I'll tell you one thing. I can't paint ten pictures for you right now. Too many other things on the fire."

"I wouldn't ask you to paint anything new. No, you have plenty to do, but we *could* borrow the paintings. It will only be for a couple of weeks. It's done all the time. The point of an exhibition is to let people see how fine your work is. Then if anybody wants a painting done, they will remember you and ask for it. Reverend Hillis' congregation is made up of people who can afford to commission paintings. Did you know that when he was a young student at the theological college he wanted a parish in the West? That was his dream. But he said the Lord had other plans for him."

Charley remembered Hillis' eager face. Maybe a lot of people dreamed of coming West. Maybe he was painting their dreams as well as his own best memories. At least, he'd been lucky enough to have made his dream come true. But one thing bothered him. "Where are you going to borrow enough pictures."

"Sid Willis and Bill Rance have several, and Senator Gibson owns about ten paintings now. He probably wouldn't mind lending some since he's going to be in Washington for the next six months anyway."

Charley nodded and turned back to his soup. Nancy was at her best when she was arranging exhibitions.

Hillis wrote later that his flock loved the exhibit as he knew they would. Soon after that, a man from the congregation commissioned a painting, leaving the subject to Charley. An order for a painting to be hung in a bank came from another of Hillis' flock. Charley enjoyed this work. He looked up from his newspaper one afternoon and told Nancy she was the smartest woman he ever knew.

Nancy dropped her sewing in her lap. "Oh Charley, do you really think I'm smart? Like Josephine Trigg?" She looked at him, eyes wide, breath held.

"You're every bit as intelligent as Josephine, and you're shrewder. You're a real businesswoman."

He watched her expression change. Her cheeks reddened as she smiled. The sight of her so happy with his compliment, touched him, and he reached for her hand. "Without you, I wouldn't even have a roof over my head. I'd be nothing." It was the truth, and the realization humbled him. "Instead of being a happy man, I'd be broke and probably a drunk."

She put aside her basket of sewing and put her arms around him. Charley kept his promise not to take another drop of whiskey. He painted every morning, and went out in the afternoons, perhaps to the Como store where he had his paintings framed, or to the Cigar store, or to the Mint or the Silver Dollar. Everyone knew he would drink nothing but pure spring water. As long as he had his friends, his life intact, he had no wish to taste whiskey again.

His friendship with the Triggs became even closer. If he thought about the drinking days too fondly, he could talk to Trigg. Trigg understood. Charley's days had never been so pleasant and productive. His only complaint was that they were too much the same. That made him restless. It was during a restless spell as he reminisced with Trigg and George Calvert about his hunting trips near the Canadian border that he imagined having a cabin in that mountain wilderness. The idea grew until it was all he thought about.

With George Calvert to help him plan it, Charley had a cabin built on the shores of Lake McDonald near the Canadian border. This became his favorite place, a rugged wilderness, surrounded by mountains, forests and the crystal clear lake. Nancy was a wild-eyed girl when she was there. They invited their friends to enjoy it with them. Charley liked to get up early in the morning before anyone else stirred. The air was cool and invigorating on summer mornings as he wandered along the trail. It was like being an Indian again. And often he rode out to visit his Blackfoot friends at the nearby reserve.

Nancy arranged winter trips to New York. And in between trips she lined up more exhibitions. Charley quit fighting it. She must be doing something right—the paintings sold, and he didn't have to think about that. All he had to do was paint and model whatever interested him. He was damned lucky and kept reminding himself of it.

Galleries wanted his bronzes, which hadn't meant much to him until they were exhibited at the very institution Mr. Markley had wanted to send him to so he could perfect his skills. A deep sense of pride struck him then—here was proof that nature was the best teacher for him after all.

After that he understood what it meant to Nancy when she arranged a show in St. Louis made up mostly of the Niedringhaus paintings, 10 oils, 11 watercolors. With this show Nancy laid to rest any doubts in St. Louis about the status of

Charley as an artist. She read the reviews and hugged Charley hard. "It does my heart good to show that skunk who threw *us* out of his office just how wrong he was." Charley doubted if Cummings even remembered him, but he laughed as she enjoyed her vindication. She bought an expensive red dress and looked prettier than a stage star in it. For Nancy the shows were a necessary part of life.

One morning he had been painting furiously for hours, grinding his teeth and squinting at the canvas. When a muscle spasm ran up his arm, he stepped back from his easel to assess his work. Old Utica was the subject of his oil painting. Simple frame buildings lined the street. The townfolk gathered in front of the general store watching three cowboys on horseback, one horse tangled up with a dog whose tail was tied with tin cans. The horse bucked; chickens flew and the stage coach horses reared out of the way. Charley painted Jake Hoover, Millie Ringgold and a dozen of his friends in that picture. He would love to be there again, too, he thought. Then he went back to the easel and painted himself leaning over the hitching rail.

As he lingered over the details on the near horse, Nancy burst into the studio with a letter in her hand. "Charley, we're going to have an exhibition at the Folsom Gallery."

He looked up from the scene on canvas to the excitement in her face. "Is this something special?"

She clenched her fists and groaned. "The Folsom Gallery is about as special as we could hope for. It means you've arrived—all the way, Charley."

"New York?"

"Not just New York, but high New York. And it's a one-man show, with all the trimmings, fancy catalog, me in an elegant new dress, you in a black suit. This is what I've dreamed of. Isn't it wonderful?"

He said it was, though he thought wonderful in this case could be a lot of headaches, including the black suit. When anything meant that much to Nancy, she could turn very demanding. "How much time do we have to get ready for the great event?"

She didn't notice his teasing tone. "Oh, it's not for six months yet. That should be plenty of time. We'll need a few new oils. Something like that one you have on the easel, for instance. It has everything, colorful figures, plenty of beautiful horses, cowboys, the town, the big landscape in the background."

"This one's spoken for. But I'll come up with something for you."

She looked off and he guessed she was seeing the opening of the show in New York. Smiling, she brought her gaze back to meet his, and rushed to him and kissed him. She was as happy as a wild bird singing at dawn, and he wanted to hold her longer, but she darted away, mumbling, planning.

After she left he wondered if she wasn't celebrating too soon. He was a western illustrator, after all, and not of the New York art scene. He couldn't imagine his rawhides and horseflesh hanging in the same neighborhood as the Impressionists

and Post-impressionists so dear to the art circles of New York. She might be in for another disappointment.

Nancy was undismayed even when he reminded her she might find this league a little tougher than the others. "These people are used to dealing with the best artists in the world."

"You just paint a couple of your best, and we'll hold our heads proud. Don't be gloomy. And you might write to some of your friends and tell them we're coming in April. It'll help spread the word around. I'm going to do the same."

There was no warning her. She was blinded by the glitter in her imagination. The closer the exhibition date drew, the heavier his misgivings became. He was still trying to warn her as they sat on the train heading for New York. "Even if things don't go just as you planned for this show, remember we have everything we want and money in the bank. I can't paint 'em fast enough—so this one-man show isn't important at all."

"Isn't important! You are not backward enough to really believe that?"

Backward? He never expected to hear that from her. "Yes. I guess I am. It's just another exhibition to me."

"I hope you don't take that attitude when we're in New York. I hope you'll try to look your best, and Charley, please don't smoke those ugly brown cigarettes you roll. And if you must smoke, don't do it in the gallery. Go outside."

Already she was fretting and nagging. He dreaded the whole ordeal and looked forward to getting back to Montana, taking it easy at Lake McDonald where everything was serene, even Nancy.

In New York, Nancy started telephoning people immediately.

Charley looked in on John Marchand, Bill Krieghoff and Ed Borein. Ed was particularly interested in seeing how Charley's show went. Being a western artist himself, he wanted to see how western art was accepted at the Folsom.

Charley and Nancy arrived at the opening a little late. Nancy looked beautiful and at home in the elegant gallery with its special lighting and crystal vases of flowers. But Charley was uncomfortable in the crush of sophistication.

When Charley spotted Ed's face in the crowd, he couldn't get to him fast enough. They stood at the end of the long room.

"It looks good," Ed said. "Twenty-five paintings is just about right for this space. And the bronzes are causing a lot of comment."

After a while Charley and Ed went out to have a smoke and when they came back in about an hour, Nancy was bristling. "The least you could do is stay here and talk to people," she said.

"She's really nervous, isn't she?" Ed said.

"It ain't worth it," Charley confided.

"Chin up."

Ed proved to be a good friend. He came back the next day and brought the *New York Times* with him and showed them an article about the show. Charley handed the paper to Nancy, lowered his head and looked down at the floor as she read. It talked of cowpunchers and redskins—lonely trails, wolves, gunplay, bony, wise-looking horses, gaudy trappings and blankets, feathers and buffaloes. Anybody who came to the show after reading that half-page spread would have no doubt as to what kind of paintings would be seen. When Nancy finished reading, she held the paper close to her breast, and looked off, "*The New York Times* likes it."

Charley and Ed wandered around and finally hankered over in the corner in a little alcove out of the way. They could watch the viewers while remaining nearly hidden. "Nancy won't find us here," Charley said. "Let's have a smoke."

Ed shrugged doubtfully, but took a cigarette paper and let Charley pour a few shakes of Bull Durham tobacco on it. Before they lit up, Ed mumbled, "That dude in the silk hat has been looking at *Whose Meat* for the past ten minutes." Charley lit his cigarette and turned to look.

"He won't find anything too far out of place. I had Johnny Mathison look it over one day, and Frank Linderman another. Either one of 'em could spot a flaw a half mile away and they passed it."

"He doesn't look real critical. I think he likes it."

Charley looked up again, and judged the man as a New York dandy by his stance, clothes, hair, and diamond stick pin. Definitely not the sort to give a damn for his kind of painting. But he was clutching a catalog in his hand. Charley turned back to his smoke.

"Ed, you ought to come to Montana and spend a week or so with me at the cabin on Lake Mc Donald. Phil Goodwin came out last year and we had a good time sketching and riding."

"I heard about the wild horse your partner gave poor Phil to ride."

"That was a mistake. But Phil asked for a spirited animal."

"I would like to see your paradise, especially if I could see mountain country as pretty as in *Whose Meat*, though I'd skip the grizzly bear, thank you."

Charley ditched his cigarette behind his back and looked up when he sensed a presence nearby. He looked up and was glad to see it wasn't Nancy. It was the dude who had been looking at the painting. "You must be Mr. Russell, the artist."

"Yep." He nodded.

"How much is that one?" He pointed to *Whose Meat*.

"Can't tell you, Friend. You see, I paint 'em, but my wife sells 'em. She's the pretty lady in the violet dress."

"Well, that one's...unusual...exciting," the man said.

"Thanks." Charley smiled. "Maybe he'll keep her busy a minute or two so we can finish our smoke in peace."

They had safely finished their cigarettes when Nancy strode across the room straight toward them. She was smiling. "Well, I just sold *Whose Meat*."

Charley looked at Ed, then at the wall where the painting still hung. "The dude is gone, and the painting is still there."

"Naturally, I didn't let him take the painting. It's listed in the catalog and it stays until the show is over, but it's his as soon as I cash this check." She held it up so Charley could see it.

He squinted. It looked something like $600 but the numbers were fuzzy. He blinked. "Look at this, Ed. What does that look like to you? It's got too many zeros, ain't it?"

Ed's eyes opened wider. "Yeah, I count three of them. It looks like six thousand dollars."

"That's right," Nancy said, pocketing the check.

"Six thousand? That for sure ain't legal." Charley said.

Nancy smiled. And Ed clapped him on the back. "It's legal," Ed said. "You're sitting on the top of the heap now."

"It's too damn much," Charley said, shaking his head. "I'm goin' out fer a smoke."

The show exceeded Nancy's dreams. She was ecstatic. And Charley was glad for her sake, and when he got over the shock, he enjoyed it tremendously himself. People treated them like royalty, invited them to fancy dinners and parties, and when they went, they were the center of attention.

He wallowed in it like Jake must have when he found all that gold on Gold Creek. But thinking of Jake reminded him of home. He'd had enough wallowing and was ready to return to the sane life in Great Falls. Nancy bought a trunkful of new clothes and another trunkful of presents for their friends. She was in a rare mood when they started for home. But the train hadn't even reached Ohio before he realized she was not going to rest content with this success. Now she was talking about more shows, and about *getting a cook!*

Charley gasped first, then laughed. If it made her happy, why should he object? She did work awfully hard. Why not a cook? Then she would have more time to enjoy their friends who came to visit.

"And I'd like to buy an automobile," she said.

"What?" That was too much. "A skunk wagon?" he spat.

"An automobile," she said. "Riding inside a machine would be much nicer than riding a horse in bad weather. We could carry more with us. We could drive through the country where the train doesn't go."

"A horse is the best transportation in the world. A man can trust his horse. I don't want a damned skunk wagon." He smacked back the unruly locks of hair that had fallen over his forehead.

"But I'd like one."

By the time they were back in Great Falls, he had about resigned himself to the idea of Nancy having an automobile, although he would absolutely not have anything to do with it himself. A horse was good enough for him, and damn the weather.

Talk of a cook and a car stopped abruptly when Nancy opened her mail. Buried in the stack of correspondence was a letter from the Governor of Montana. "I wonder what he says," she whispered.

Charley was interested. For several years controversy over commissioning a large mural for the capitol building in Helena had raged. Nancy wanted the commission for Charley, and this was one time he was just as eager as she was. He believed he was probably the best-qualified artist to paint an authentic Montana scene. But some of the legislative committee members preferred Remington, or at least someone who had experience in painting murals. It was true, Charley had never painted anything so large or so important, but he loved his Montana, its history, its grandeur. And he wanted that commission. He didn't have Remington's prestige, though. So he put the commission out of his mind. But when Remington died suddenly, Nancy wrote again, asking the committee to award the commission to a Montana artist. But it wasn't as simple as that. Several well-known muralists from the East came to Helena to present their own qualifications to the committee, and Charley wouldn't do that. If they wanted him, he'd give it his best, but if they wanted an Easterner, he wouldn't interfere.

Charley heard from his friend Frank Linderman that most of the committee members opposed granting the commission to Charley because of his lack of experience in doing murals, but the Secretary of State, favored him. Now, as Nancy opened the letter, Charley wondered what it contained.

Nancy scanned the letter. "They want you to come to Helena and talk to the Senate Committee," Nancy said.

Charley frowned. "I'm no good at tooting my own horn. And I sure as hell ain't goin' to run down another fella's work."

"You don't have to say anything against anybody else. Just tell them you can do it and you want to. That's all. Remember, you just came back from New York where your small paintings sold for more money than the mural will bring."

Charley went to Helena. But when he entered the Capitol, he wished he hadn't come. Standing before a senate committee to talk about himself was going to be an ordeal. If it hadn't been for Frank Linderman, an aid to the Secretary of State, Charley would have turned around and gone home. "Don't worry, Charley. They just want to hear what you would do if you were given the commission."

Charley and Frank walked to the chamber of the House of Representatives and looked at the wall area behind the speaker's platform. "That's such a lot of space to cover," Charley said. "Everybody sittin' in here and up in the galleries will *hafta* look at the speaker's platform and the mural."

Frank nodded. "And the people elected to come here would rather see a real Montana scene than cupids and flowers drifting around a little mountain landscape."

The very thought of cupids and flowers in that space incensed Charley. "I'll talk to them," he said, though he felt his throat constricting with nervousness.

Frank took Charley to the meeting room and introduced him to the group. Charley tried to remember the things Nancy told him he ought to say. They had sounded sensible. But all of a sudden he couldn't remember a word of it. He took a deep breath and looked over the heads of the committee. "I'm a Montana man and nobody loves this state more than I do. I've painted it for two thirds of my life now and I know these mountains and the men who rode the trails. I've tried to know the history of both the white and the red men and I've tried to bring it to life in my work. I brought some photographs of my paintings so you can judge for yourself how successful I've been. I sure would like to paint the mural for the capitol, though I know I'm not the only one who would. If you want cupids and angels, give this New Yorker the job. If you want a western picture, I hope you'll give it to me."

When he said that, he looked at the committee and at Frank and left the room. It wasn't much of a talk, but it was over and he swore he'd never talk to a bunch of people like that again.

Walking away from the capitol, he intended to forget about the project until he heard what the final decision was, but all the way home, ideas were roiling around in his head. It should be a scene of real historical significance to Montana, not a collection of vignettes. The Bozeman Trail, early trading posts, Lewis and Clark. He couldn't stop thinking about it. And always in the back of his mind was the thought of an outsider painting something irrelevant to Montana.

At home he sat in the kitchen and told Nancy all about the meeting. She was satisfied and confident. "Surely they've heard what the *New York Times* said about your work. And don't think for one minute that doesn't make a difference in Helena."

Charley shrugged, though he did not share Nancy's opinion that the *New York Times* was held sacred in Montana. Then a tall thin girl appeared in the doorway.

"Oh, Charles," Nancy said, standing. "I want you to meet Polly. She'll be staying with us, fixing meals and doing the laundry."

Polly was a gangly brown-haired girl with a shy smile. "Good to know you, Polly." She lowered her head and muttered a greeting he couldn't quite hear. "You won't have to bother to cook breakfast for me," he said. "I like to get up early and fix my own. But I never pass up a dish of cookies before lunch."

He was still adjusting to Polly living with them when Nancy had more news. As they sat down to lunch, Nancy flicked her napkin onto her lap with a flourish and looked up. "Charley, a Mrs. Stanhope was here this morning." Nancy's voice was

rather sharp. "And since she was so anxious to see her *dear* old Charley, I asked her to come back."

He pretended to have missed the cutting edge in Nancy's voice. "I don't remember Mrs. Stanhope," he said. "What did she look like?"

"She looked to be about forty. Her hair was graying red; she wore too much rouge; and she had a high-pitched laugh. Oh, but the main thing was what she carried in her knitting bag."

"What was that, Mamie? A skull? She sounds like a witch the way you describe her."

"That isn't *quite* what I had in mind."

"What did she have in her knitting bag? You might as well tell me."

"A flour scoop, painted with a sweet little mountain scene and yellow flowers."

"Ah, a flour scoop," Charley said. He'd given a lot of girls souvenirs in his wilder days.

"Mrs. *Sallysue* Stanhope?" Nancy said.

"Oh Sallysue." She must have gotten married. He remembered clearly the pink checked ruffles in her room at the parlor house. "Gee, what did she say?"

"Only that she had heard about your success in New York and now she wants you to touch up the painting on her flour scoop and sign it."

"I guess I can do that. She was a nice gal, Mamie."

"I think I know what she was. And you're not to sign that flour scoop. We don't want things like that showing up at public exhibitions, and that's just what could happen."

"Mamie, don't be so cold-hearted. How can I turn my back on a friend?"

Nancy glared. She put down her teacup and went to the sink. She was not going to budge and wouldn't be happy until Sallysue was out of the house. He wondered if the flour scoop ever hung in a yellow kitchen. He'd like to see it again, see how bad the painting was and improve it for her.

Sallysue came that afternoon. Charley wouldn't have known her if he'd seen her on the street. She'd put on pounds, and her face had lost its prettiness. But she looked healthy and had laugh lines at the edges of her eyes and mouth. She lived on a ranch near Conrad. He guessed she'd done all right. Her life may not have been an easy one, but a good one. When she presented the flour scoop, he was surprised at how detailed the painting was—a fawn, the Snowy mountains and grass dotted with yellow flowers.

"And do you have your yellow kitchen?"

Sallysue smiled. "Sure do."

"That's nice. Well, I'll just take this to the studio and see what I can do with it."

Nancy sat with Sallysue in the parlor. Charley took the scoop to the cabin and worked quickly as he figured it wouldn't do to stay away too long.

When he brought the flour scoop back, Sallysue's gasp of delight at seeing the brightened landscape was the best kind of payment he could have had.

"Thank you, Charley," Sallysue said. "It's lucky I saw that piece about your show in New York."

So the Folsom Gallery show had brought her. He hadn't believed it would be noticed so far away from New York.

A few days later, he was again struck with the impact the Folsom show had when he received an invitation to exhibit at the next Calgary Stampede. "What do you think, Mamie. Do we go to Calgary?"

She laughed. "Of course. I can see by your face, I couldn't keep you away, and it'll be great. Your reputation won't stop at the United States border. You'll be internationally known." She laughed and took the invitation. "I'll reply to them today."

Nancy was never idle. She taught Polly the finer points of cooking, just as Binnie Roberts had taught her. She was kind, but firm, demanding top performance, but Polly thrived and began to smile more. Her thin body filled out, and with Nancy's coaching her about clothes and hairstyles, she became a more attractive woman.

When Nancy wasn't showering attention upon Polly, she took care of the business correspondence, learned ballroom dancing and bridge, and was taking a business course in typing and shorthand.

Her business courses had a purpose, Charley found out when she handed him a package of neatly typed pages. "What's this?"

She smiled proudly. "It's *The Savage Santa Claus*—the story you told to the Calverts when they were here for dinner a week ago."

Charley read the first lines: "Talkin' about Christmas," said Bedrock, as we smoked in his cabin after supper, an' the wind howled as it sometimes can on a blizzardy December night, "puts me in mind of one I spent in the '60s. Me an' a feller named Jake...."

"How'd you get this?" he asked. "Sounds exactly like what I might have said, but you weren't even here. You went over to Triggs...."

"I was behind that curtain, listening and taking everything down in shorthand. You'll probably have to read it over and fix it up, but if we can get a dozen or more of the stories together, and you do some illustrations, I think it would be a good book."

"A book?"

"I know it'll be a lot of work, but I've thought about it a lot lately whenever I hear you telling a story, and I see everybody hushed and listening. Well, I want to do it. "It'll be our baby." She paused looking down at her hands, which she

squeezed together in her lap. "Oh, I'm sorry. I try not to think about that. But sometimes I can't help it. Did you know Mrs. Stanhope had three boys?"

"No, I didn't." He lifted Nancy's chin and saw tears welling in her eyes.

"Don't mind me," she whispered.

"Couldn't we adopt a baby?"

She blinked. "I wonder. I used to think there was plenty of time—but I'm past thirty now, and...."

He nodded.

"We can't have everything," she said. "I know that, too. It's just that...well, Polly told me she is engaged. And she happened to say that when they married, they weren't going to wait to have children. She must have thought we were deliberately waiting. Anyway, it started me thinking about how long we've hoped for a baby."

He held her for a moment, then she drifted away, leaving him with the typed story she had gone to so much trouble to bring to him. He sat down to read it.

Chapter 29

On a hot July day in 1911 Charley painted a watercolor of an Indian journeying alone to his place of meditation. All the while he longed to be journeying to his own place, the cabin at Lake McDonald. But he'd put off going while he waited for a decision by the mural committee. Now, after weeks of waiting, he was weary of it and decided to leave anyway if word didn't come soon.

He looked around at the walls of his log cabin studio. He had paced it off a dozen times, and had to face it: if he were lucky enough to win the mural commission, he would have to enlarge the cabin, though to Charley it was perfect the way it was with the dimensions of a pioneer's cabin. As he painted here, the old days hovered close around him, allowing the images to be drawn out of the atmosphere.

The town of Stanford came alive for Charley again as he hunkered over the coffee pot. It was just before roundup—cowboys were filling up on good times, rushing the saloon, not bothering to get off their horses first, guns smoking as they announced their arrival, the boardwalk breaking under the weight of a horse. Action. The wild mood.

He was ready to paint it, to be a kid again, in the West that had past. *In Without Knocking*, he'd call it.

Sometimes it was as though the images formed out of the flames in his fireplace. This cozy cabin was his place to dream, but if it had to be enlarged to accommodate getting around a 25 foot mural, much of the magic would be lost. Maybe he'd be glad if they gave the job to one of the New Yorkers.

At noon Nancy came out to the cabin dressed for town in a dark blue frock and a straw hat, but her face was solemn. "Guess what I found in the mail when I came back from the butcher's."

"A letter maybe?"

She bit her lip and handed him a crisp white envelope. "It's from the Governor's office."

Their eyes met in shared hope. No matter what it cost him personally, he wanted to do that mural. And they would soon find out who had been chosen. He ripped the envelope open as Nancy moved close to his side. He held the letter between them so they could both read it. Scanning over the preliminaries, his eyes paused when he read: *the board has decided to commission you to execute the mural.* The sight of those words set his hands trembling. That space in the capitol was his to fill. Nancy cheered and leaned against him. He sat down and looked at the cabin's interior again.

"We'll have to knock out a wall or two and make this place bigger," he said matter-of-factly. "What else does the letter say?"

"It says they prefer the Lewis and Clark theme you mentioned in your written proposal. But they want to see sketches before you begin the mural."

"Fair enough." With the granting of the commission, Charley set aside his desire to get to the cabin on the lake. The only thing in his mind was that mural. He had read accounts of Lewis and Clark's meeting with the Flathead Indians in Ross' Hole and saw that as historically significant.

That day he started studying the journals of the explorers noting every detail of description. This was not something he could draw out of his memory. Everything had to be right. He read, thought, took notes, made sketches, and reread until he could *see*, if only dimly at first. After weeks of study and note-taking, he closed the last book, stood and stretched. "We're going to Ross' Hole to make sketches," he told Nancy.

It was a journey of several hundred miles by train to Darby, the nearest town. When they arrived in Darby, they rested, bought supplies and hired a buckboard to drive to the site where they set up a camp. Here Charley sketched. Here the ghosts of the explorers and the Indians floated across the photographic image that was developing in his mind. Sometimes he could almost hear the distant conversations, see the dust and patches on the clothes the explorers wore. When he had sketched exhaustively, he decided it was time to visit the Flathead Indians, talk to the oldest men who would remember what had been told to them about the incident. It was not a meeting the Indians would have ignored.

Charley and Nancy rode to the Indian reservation. While he talked to the Chief and the old men, Nancy bargained for a buckskin skirt and some other Indian made articles she admired. On the way back to their camp near Ross' Hole, Charley told her what he had learned from the Indians. "I think I'm ready to paint it now," he said. "I see it differently after today."

Nancy turned away from the scenery to look at him. "Why? You didn't tell me anything to change what we already knew about it. What made you see it so differently?"

"The Indians," he said. "I saw it through their eyes today. They were here first. The explorers were strange and unexpected. I know Indians and I can ride with them on that day and see what they saw."

Nancy looked at him with her most knowing look. "Now, let's hope the studio is finished when we get back home."

Charley's heart thudded. His precious cabin would be nearly doubled in size. "It couldn't be helped," he said, "but I'm sure going to miss having it the way it was."

"Everything changes. Everything grows—if *we're lucky*." She looked off toward the snow-capped mountains as she rode. "Your studio hasn't grown half as fast as your reputation has. You should be proud and happy."

"I'd be just as happy without any more reputation."

"Well, I wouldn't," she said defiantly, eyes squinting off.

"Why? Just give me one reason why we need any more."

She took a deep breath and shot him a fiery glance. "Because I never want to be alone and afraid again. I never want to be so hungry I have to suck rocks to get to sleep." She sighed. "You can't just lie back and let the waves wash over you on their way back out to the sea. You have to keep on so nothing will wash away and leave us like that again."

"Hey, I promise you nothing will. We're doing great."

She took a deep breath and gazed off at the horizon. "I know we're doing fine *now*," she whispered, "but you can't step back. High prices and invitations to exhibit in better and better places mean you're getting to that safe place where people know and respect you. I want the whole *world* to know. And we've a ways to go yet." She raised her chin, snapped her reins, and trotted off ahead of him, leaving him thinking about a little girl sucking rocks.

Back in Great Falls the construction work on the log cabin studio was almost complete. The new wing was in place and the structure had been painted dark brown to make the old seem to belong with the new. "We'll get used to it," he said.

By the time he finished the preliminary watercolor sketches, he was anxious to begin. The first phase of the mural went swiftly. But once the drawing was blocked in, he deliberately slowed his pace and approached every small section with precision. Each horse and rider were important, but the effect of the whole painting was uppermost in his mind. As he painted, he imagined himself as an Indian, riding with the other braves and watching the strange white men from a distance.

Then when he put down his brush and looked at the canvas critically through a reducing glass, he became a visitor in the House of Representatives.

Frank Linderman, a lanky slow-talking writer, came often to sit with him and watch the mural's progress. Sometimes they remained quiet for long stretches. Then Charley would work on the grass in the foreground and talk a while. They planned their next hunting trip, and Frank talked about Indian culture, the passion Charley and Frank had in common. Frank was writing a book on the subject and it was understood that Charley would illustrate it. The time went smoother with a good friend nearby.

The children from the neighborhood looked in, and asked questions. "What is that Indian doing? Why is he holding his lance like that? What is the interpreter saying to the Indians? Are Lewis and Clark scared? Is that an Indian dog or a wolf? What happened next?

Most of the times he answered, though sometimes he waited until he finished a demanding passage. This was the most challenging painting he had ever done. He had never taken so much care or entered into the scene quite so fully before.

After many months of work, he finished it, and nothing had ever given him such a deep sense of satisfaction.

Charley asked Dick Jones to crate it and ship it to Helena. Dick had already given the matter some thought, and as he entered the cabin, he described ways to haul the crate to the railroad station, but he stopped talking in mid-sentence when he glanced up and saw the painting. He gasped as his eyes traveled around the picture.

"I've seen 'most all your paintings, haven't I, Charley? I always liked 'em, too—because they're so real. But this isn't like anything else. It's bigger and better than life."

"The only thing is," Dick said, rubbing his chin and looking worried. "Lewis and Clark don't look like they'll ever make it into a history book. Looking at this, you kind of wonder how they ever made it as far as they did."

"It took courage," Charley said. But he too was uneasy about his portrayal of Lewis and Clark. It was too late now to change it. This was planned as carefully as he had ever planned anything.

Still Charley worried. Would the design stand up from the back rows of the gallery? Would there be enough light? He agonized over hundreds of problems. Then Frank Linderman sent word that the crate arrived in perfect condition. The date for the formal dedication was set. Charley was anxious to see how the mural looked in the important space behind the speaker's platform.

The day before the dedication Charley and Nancy took the train to Helena for the formal ceremony. Nancy was in her gayest mood, smiling constantly. This was really her victory, he thought, taking her hand in his. She was the one who went after this commission for him. "You're lookin' so pretty, nobody's goin' to take their eyes off you long enough to see what I painted. I could've painted garbage cans stacked in a row and nobody'd notice."

He squeezed her hand and didn't let on how worried he was. "What do folks do at acceptance ceremonies?"

"I'm not sure, but they probably introduce the committee and somebody will say a few words about the picture and about Lewis and Clark meeting the Indians; then they will unveil it, and we'll go to the reception. Somewhere along the line you'll get your check. I can hardly wait to see the mural hung. It's a perfect place for a masterpiece."

"None of that high-falutin' talk. It's jest a damn big illustration."

Nancy had seen to it that he dressed well for the occasion in a new white shirt, his Stetson cleaned and blocked, boots shined, his suit and best voyageur sash cleaned and pressed.

When they walked down the aisle to take their seats at the joint session of the House and Senate, Charley saw more of his friends than he expected, people he had forgotten were elected, people who were guests for the occasion. He was glad

to see his friends. Without their faces out there, with such a crowd in such a formal atmosphere, he would be looking for the exits.

Frank showed them to their seats and when they were settled, he noticed the curtain draped over the mural. That made him more nervous. When the curtain was removed, what would happen? Maybe people would politely clap their hands. He was beginning to wish he could escape. Why hadn't he thought of coming the day *after* this ceremony? Too late, Nancy sat on one side and Frank Linderman on the other. Neither would let him leave, besides there was no way to go without being a spectacle. He was trapped. He closed his eyes and waited.

The speeches started. And they were painfully dull, "...on this memorable occasion...." He listened for a while and wished they'd yank the goddamn curtain off and let him out. "Ladies and gentlemen, our faith in our fellow Montanan was well-placed...." Charley turned the rings on his fingers. It was getting hot, the air was stifling, hard to breathe. Everybody was waiting to see if it was worth getting all fixed up to come down here. How were some of these civilized town boosters going to like a mural that was mostly Indian, seen entirely from the Indian's viewpoint, with Lewis and Clark as small figures in the middle ground while the majesty and vigor belonged to the Indians and the land itself? It was his view—but would it really please this crowd? He doubted it. State politicians tended to think of Indians as poor folks on a reservation. As the words poured out of the speaker at the platform, Charley began to feel feverish. Would there be a stony silence when they lifted that curtain? Would Nancy be humiliated? His friends embarrassed? And would Frank be looked down on for having encouraged the committee to commission Charley? "...takes us back to the beginning of this magnificent state...." When would he stop?

As the speaker's words droned on, Charley lowered his head. Then there was silence. He looked up and saw two men at the curtain. Nancy took a deep breath. The crowd was still now. The curtain parted and was swept back, revealing the mural.

A hush surrounded him as he saw the mural. He caught his breath, but his ears rang, and he couldn't tell how it looked. He'd seen it too much, even now he wondered if he should have lightened a gray spot on a white horse's back—too late—oh, but he was exhausted with it. A shuffling sound began; then grew louder. Were they angry, insulted, outraged? He reached for Nancy's hand. Frank clasped his shoulder. A gasping sound behind him, a bravo, and polite applause. A steady noise like the rumbling of a river, and then the crowd stood, and the sound boomed even louder. Shouting. Charley looked at Nancy. Tears were streaming down her cheeks. He was confused. All that applause, all those people looking at him! Frank took his hand and shook it hard.

The speaker's dignified voice cut through the noise. "Mr. Russell, you make us humble. Would you join me here on the platform?"

Applause exploded again. "No," he whispered. "I can't. Frank, I can't do that. Nancy."

"Just walk up there and say thank-you," she said, and kissed his cheek.

He shook his head. He wanted to protest; his heart had never pounded so, but someone had hold of his arm, and he felt himself being pulled out into the aisle. "Speech," he heard someone yell. "But I can't."

Yet he was propelled toward the platform. And in a moment he stood next to the speaker in front of the senators and representatives of the State of Montana and the many people gathered in the galleries. He went cold and numb. He cleared his throat, but knew he couldn't speak. He raised his arm but it felt stiff. "Thank you," he tried to say, but no sound registered. He tried again and found his voice. "Thank you... for honoring me." He wanted to tell them how much he loved this land and how he hoped they would rule it well. But he couldn't. He couldn't say anything more. He raised his arms and bowed his head and made for the exit in a run, his heart beating wildly.

It was a relief to get back to his big empty studio and take up a book-illustrating project. After the hugeness of the mural the small line drawings were a relaxation. Nancy had a backlog of work waiting. He painted a new oil for the Calgary Stampede exhibition, and as he worked on it, he remembered the winter on the High River with the Bloods. The scenes came back, the women working in front of the lodges, the hunts, the bitter cold, the mounties, Sleeping Thunder, Swan Watcher...but all that was so long ago. That kind of life was gone now.

In Calgary, Nancy stayed at the exhibition room, and Charley promised to meet her there after the parade and rodeo. The Calgary Stampede was a festive time, beginning with a parade, flags flying, bands playing, fancy horses prancing and Indians in their best regalia. Charley loved parades, and this one had everything, matched horses, glittering costumes and pounding drums and cymbals.

Before the rodeo he walked around and looked at the animals. The snuffling sounds of the calves, the fiercer snort of the bulls all brought back his days on the range. Two cowboys dressed in their town shirts stopped and talked to him a while. Later in the crowded grandstands the smell of hot dogs vied with the pungent animal smell near the chutes where Charley stood to watch the events. Calf-roping was his favorite. One of the cowboys he had talked to earlier was the winner of the event, and Charley shook his tough cowboy hand.

Thoughts of his exhibition were far from his mind until the rodeo events were finished, and the crowd muscled its way out of the grandstand. Charley waited, looking over the fence where the action still echoed. He took out his sketchbook and made one more drawing before going back to see how Nancy was doing.

She frowned when she saw him. "What's the matter, Mamie?"

She groaned. "You're one big pile of dust. Where were you?"

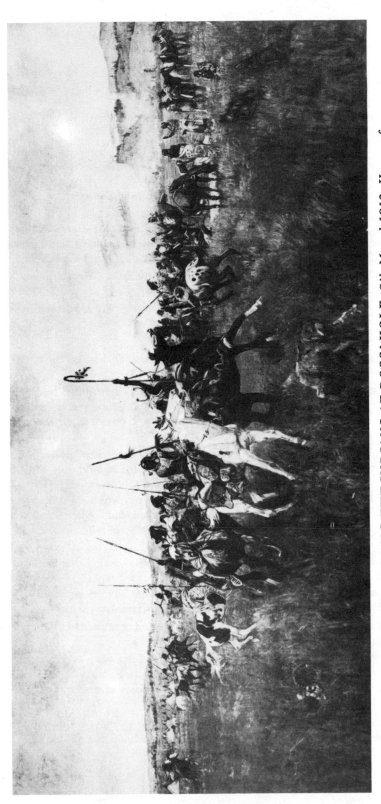

LEWIS AND CLARK MEETING THE INDIANS AT ROSS' HOLE, Oil, Mural 1912, House of Representatives, Montana State Capitol. Courtesy of the Montana Historical Society, Helena, MT.

He looked down at his pants and boots. "That's rodeo dust. It'll shake out." He noticed there were only a few people milling about and imagined how dull it must have been for her. "How'd things go around here?"

"You should've been here. I met some mighty fine people. Some liked your pictures and wanted to meet you."

Her tone of voice was accusing. He didn't understand. He wasn't on display. His pictures were.

"They were English," she went on, "and one man, Sir Henry something or other is coming back tomorrow at four o'clock, which is when I told him he could meet you. But it won't do for you to come in here looking like a mud pie."

"This Sir Henry must have some bright shiny halo. Why is he so all-fired important?"

Nancy twisted the button on the cuff of her dress. "He said some interesting things."

"Like what?"

Instead of answering she shrugged and slapped at the dust on the elbows of his shirt.

The next afternoon Charley left the rodeo grounds early and dusted himself off before going to the exhibition hall to talk to the folks Nancy told to come back. When he arrived, Nancy was standing with a well-dressed, middle-aged man. Nancy saw him and waved. "Here he is now."

"I'm Henry Pellat." Charley shook his hand. "I am absolutely fascinated," Henry said. "You're painting life we've read about in England, but can't hope to glimpse. I have dozens of questions about these. Do you mind?" Henry walked toward one of the paintings. "Your wife was very kind when we talked yesterday, but she said I must get the details from you, my good man. What about this! Now really? Could something like this have happened? Your wife tells me it isn't a burglary, but rather a celebration of some kind."

They were looking at *In Without Knocking*, cowboys shooting up outside the saloon, one cowboy riding through the swinging doors, another stepping off his horse whose leg had crashed through the boardwalk. Charley smiled and told the story to Henry as he had heard it from Pat Tucker twenty years ago.

"They'd never believe it back at the palace?" Henry mumbled. "Or at the club for that matter unless I show them this painting."

Charley told the stories behind all the paintings Sir Henry asked about, and as they talked, Sir Henry's enthusiasm grew. "I envy you, Russell," he said. "To have witnessed the West like that. I still insist that you must exhibit in London."

"Oh, Sir Henry," Nancy put in, "I wish we could."

Sir Henry bought five paintings at prices that dismayed Charley when he learned about them later that evening back at their hotel room. "Seven thousand dollars is way too much for any painting," he objected.

"I thought we agreed that you painted them and I sold them," Nancy said firmly as she brushed her hair.

"But those are dead men's prices. I ain't paintin' nothing worth that kind of money."

"If it was too much, Sir Henry would only have bought four, or none at all."

"But how can I look people square in the eye?"

"Quit thinking of yourself as a cowboy artist and think of yourself as a great artist, which you are."

He shook his head. "I just try to get things right, but I'll never be seven thousand dollars worth of great."

"Seven thousand, ten thousand, who knows? Sir Henry is the commander of the Queen's Own Rifles. And he promised to see about having a gallery in London write to me. Just think Cha'ley, *London*."

"No." He shook his head again. "I'm jest a dirty damn cowboy who likes to draw horses and Indians."

"And I love you. We're going to Winnipeg next."

"I'm goin' straight to Lake McDonald and then I'm ridin' off to the reservation a while and after that I'm goin' back to Great Falls where everybody knows exactly what I am. Come on to bed. You're pretty enough."

Chapter 30

Charley still wasn't used to the idea that they were really going to London. He pushed it out of his mind until Nancy announced that exhibit dates were set. Then he read all the books on England Nancy had brought home from the library. England was an interesting country, he admitted, and it was true, his forebearers had been English. Well, he *would* like to see it.

He promised to write to Trigg and the boys at the Mint. He told Josephine he'd sketch the Tower of London for her. The Calvert kids were going to look after his studio and feed the horses.

Then one day they were packed up and sitting on a train headed for New York where they would board a ship to England.

The steamship was more a floating hotel than a boat. Charley was seasick enough to want to stay belowdecks and read. In the afternoon when the winds were calm, he walked on the deck and wished he felt good enough to sketch the ocean. "I'll never do this again," he moaned.

London was gray and dull when they landed, the air damp, but nothing dampened Nancy's spirit. "Look, Cha'ley, spring is starting here." Charley looked at the trees with their swollen buds, and felt the excitement spring always brought him.

At dawn the next day he stood up and felt steady on his feet once more. "All right, Mamie, I'm ready to take this burg on."

Nancy rolled over and moaned sleepily, but in another hour she was up and dressed, too, and they set off for the Dore Galleries to make final arrangements for the exhibit. When he saw the place, he was amazed again that such a splendid gallery wanted to exhibit his western paintings. The director showed them through the rooms, taking them first to see the old religious paintings the galleries were famous for. The tour ended in an elegant salon where they had tea with the Director and his assistant.

After tea they left the gallery, and walked down Bond Street to St. James Park. It wasn't Lake McDonald with all its primitive beauty, but it was damn pretty. Purple and yellow crocuses bloomed along the edge of the lake.

Sir Henry and a party of his friends arrived in a flurry at the opening of the exhibition. Henry asked questions about the paintings and drew Charley into story telling. At first it seemed strange talking about cowboys and grizzly bears to people who looked and sounded so elegant. But before long it felt as natural as it was back home. As he told a story Jake Hoover used to tell about his wild prospecting days, Charley wondered what Jake would say if he could be here now.

Nancy had never looked prettier. Style had become part of her nature. Even among Sir Henry's sophisticated and bejewelled friends, she looked lovely. For this opening she was wrapped in a soft clinging gown of palest pink, her hair in the loose upswept style she preferred. The total effect was of classic beauty, perfect in any time, any place. As he watched her from across the room, Charley realized how much she had changed over the past decade and a half. The shy backwardness was gone. Her unsure grammar and fervent candor had been replaced with polish and charm, but the spark he had seen in her in Ben Roberts' kitchen was the same.

Toward the end of the evening Sir Henry brought two ladies to meet them. Charley had noticed them earlier lingering a long time at each painting. "May I present Queen Mother Alexandra and her sister, Dowager Empress of Russia."

"How do you do." Nancy smiled.

Charley didn't know how to greet a Queen Mother and a Dowager Empress. He bowed slightly. "I'm honored."

"I have been admiring your *Wild Horse Hunters,*" the Queen Mother said, "but could you tell us more about *Jerk Line*?" She smiled in that direct way Mama Trigg sometimes did when she asked for explanations.

Charley strolled with them to his painting of a wagon train ascending a hill along the Missouri River near Fort Benton. Charley explained. "The jerk-line is this rein that stretches from the side of the lead animal's bit and runs along the backs of the whole line of horses to the hand of the jerk-line man." The women nodded, their gaze following Charley's pointing finger. "This is the man directing the movements of the whole string. Here, in this picture the wagon boss, riding his horse alongside, is using his bull whip to keep the horses moving up the hill. The driver is about to jerk-line the team back onto the road so's they can make the curve with the wagons lined up right."

"Fascinating," the Dowager Empress said. "The colors are so majestic, it seems a fairyland."

"Not exactly," he said.

The next day Nancy and Charley breakfasted in their room and searched the London newspapers. Nancy read the reviews to him, her voice becoming more and more excited.

Charley leaned forward in his chair, elbows resting on his knees, his graying hair hanging over either side of his forehead. Here they were half way around the world, and this! "Mamie, did you ever think when you were a runt kid suckin' pebbles, you'd be shakin' hands with the Dowager Empress of Russia and the Queen Mother? Could you've even imagined it?"

For an instant Nancy's eyes took on the look of a frightened wolf, but then she shook her head. "No, I dreamed of riches, but at the time it only meant a warm bed and a hot meal."

"An' when I sat cross-legged in front of Jake Hoover's fire, drawin' pictures, I wondered if I'd ever draw well enough to have a fella pin a sketch up by his bunk. If any damned fool had said, Charley, I'll see you on Bond Street in London in nineteen fourteen, I'd a said he'd drunk too much booze."

Nancy sighed. "It wasn't always easy. I nagged at you. Some days I felt like an awful shrew, but I thought...I believed your work was meant to be known."

"You never stopped believing. You're the one who got us here." He looked into her eyes, then he chuckled. "And now that you got me here, we have to see the Tower of London. I promised Josephine a sketch."

The show was crowded every day and enough pictures were sold to make the trip a profitable one. But when the exhibition drew to a close, Charley looked forward to going home. It was spring in Montana. "As long as we're so close, we ought to go to Paris," Nancy said. "What for? London has everything Paris has. Let's go home."

"Paris has some of the greatest art of all times."

"I've already seen all the great art I can take in."

"Cha'ley, when are we ever going to get another chance to go to Paris? It's the art and fashion center of the world." She looked at him pleadingly, and he could see how badly she wanted to go. Well, he wouldn't have minded seeing those museums himself if he wasn't so homesick. Nancy's eyes pleaded eloquently.

They went to Paris. They visited the Louvre, and he admitted it was worth the trip across the channel, but after that, everything palled. Nancy bought clothes. Charley visited a few galleries, which only hardened his dislike for modern French art.

"What was so objectionable?" Nancy asked.

"The guy showin' me around was like a piece of soap, and the paintings were worse. Trees looked like watercress, and people looked like wooden Indians painted red. There's nothin' here for me. I want to go home."

This time he was stubborn. He was too homesick to give a damn.

Two days later they boarded the Lusitania for America. Every day on board the ship, Charley wrote letters home. He could already picture the faces of his friends. He could hardly wait to be among them, to get back in the saddle, to build a fire in his log cabin studio.

"This damn ship's as big as Lewistown," he said to Nancy as they strolled along the deck. "But Lewistown don't pitch and roll so damn much. Never knowed it to pitch at all for a sober fella like me."

They docked in New York and stayed long enough to see a few friends and invite them to visit at the lake this summer. Bill Krieghoff said he'd like to come. Will Rogers, too, and some of the others said they'd drop a line. Charley wanted to see them all and hoped they'd come, but he didn't want to waste another day in New York.

On the train heading for home, he delighted at leaving the cities behind and steaming through farm country. And when farm country and little towns turned to prairie, he almost cried.

Home and his cabin studio had never looked better to him. He picked up an illustrating project he'd started before leaving for London. The pen felt right in his hand, and the pine fire in his fireplace smelled heavenly.

The boys at the Mint wanted to hear Charley's stories about England, and he wanted to hear everything that went on while he was gone.

Toward the end of June, they moved camp to the cabin at Lake McDonald. Charley had enlarged the main cabin and had several guest cabins built to accommodate friends he couldn't resist inviting. His nook on Lake McDonald was too beautiful a place to keep to themselves. The cabins were nestled in the woods, set back from the shore of the lake. Nancy hired a cook to come with them as they might have twenty people at one time.

The cook had a young son Charley called Skookum, who delighted in playing Indian and darting around the woods near the cabin. Charley reined up one day when the boy crossed the riding trail. "Come and ride with me," Charley said, offering his hand. He pulled Skookum up into his saddle and rode him around the trails. Over the campfire at night, he sometimes told his stories especially to Skookum. Nancy took the boy to the lake and helped him find pretty rocks.

More people than usual came to visit at the lodge, Skookum's mother was very busy frying fish and making lemonade. It was hot and Skookum was playing in the kitchen. Charley was just outside modeling a hawk and talking to his friends.

He didn't see what happened in the kitchen, but he did hear the cook screaming. "Skookum, No!" There was a crash. "Now look what you've done. You ruined everything. You always ruin everything—always underfoot...why can't you go away and stay away." Charley's fingers stopped moving over the clay. He recognized the frustration in the cook's voice. A minute later, Skookum walked outside, and with his head down, wandered off by himself and sat by a pine tree. He rubbed his eyes and looked like a crumpled heap. Charley went over and picked him up, pressed him close. "How'd you like to see a hawk I'm makin' jest for you?"

"For me?"

"Yes. Did I ever tell you the story about Little Hawk. He was a blackfoot boy about your age...." Skookum dried his tears and waited for Charley to go on.

When the story was finished, Skookum leaned against Charley's side. "I wish I had a Dad like you."

"And I wish I had a boy like you," he said, putting an arm around Skookum. A moment later he noticed Nancy staring at them, and understood her wistful longing gaze. He smiled at her to tell her they shouldn't forget how lucky they were to have each other, but as she watched him and Skookum, that look on her face became determined.

They were aware of the cook's burden, having to earn a living and raise a child. She was a nervous woman and the responsibility bore heavily on her. "I wonder," Nancy said to Charley that night, "if she wouldn't like to be relieved of the responsibility of caring for Skookum. Maybe she would let us take care of him. Oh Cha'ley, we both love the little tyke."

"I know—but wait...do you mean?"

"Let's ask if we could adopt him."

"But she wouldn't, would she? She might be insulted."

"I thought of that, too." She sighed.

They didn't talk more about it that night, but the next morning, Charley stayed in bed at sunrise instead of getting into his clothes and walking by the lake. "Mamie," he whispered, "maybe there wouldn't be any harm in just talking to her about Skookum."

Nancy opened her eyes, totally alert. She took Charley's hand. "We'd love him. We'd be good to him and we can give him everything he needs."

"Let's talk to her."

"Let you adopt Skookum!?"

"We love him," Nancy said. "And of course, you could see him any time you want."

Her eyes opened wide. "But I couldn't. He's my son. Even if he'd be better off with you. It wouldn't be right. God gave him to me. It's my duty to keep him."

Nancy nodded and patted the cook's hand. "We don't want to cause you any trouble. We only thought it might work out for everybody. I hope you understand."

The girl looked up into Nancy's face with an understanding Charley wouldn't have expected from one so young. "There are plenty of other children you could adopt," she said cheerfully. "Babies, that would get to know you from the beginning as Mother and Father."

Nothing more was said on the subject that summer, but when they returned to Great Falls, Nancy asked questions and found out how people go about adopting a child. Charley liked the idea. They sorely wanted children, but hadn't seriously considered adoption until Skookum.

Charley painted as busily as before. Buffalo hunts, Indians riding on the plains, men and horses. Sometimes he felt that all of life was a dream in colors and space. Nancy arranged shows and sold his paintings at higher prices than ever.

Then one morning the news came. A baby boy. Charley felt a tightness in his throat. Nancy looked as though she would faint. But she recovered, hired a nurse to help, at least for the first month or so, and they drove out to see him and bring the baby home.

Nancy's eyes filled with tears when the nurse put the baby in her arms. Charley looked down at the little round red face and wondered what they were

going to do with him. He squirmed and stretched and Charley touched the little hand with his big finger. They'd learn what to do.

That first night in the house on Fourth Avenue, the baby slept in a wooden cradle in their bedroom upstairs. Nancy and Charley spent most of the night staring down into that cradle. What if he gets sick, Charley wondered. What if he quits breathing? It was a relief when the baby woke up and cried for his feeding. That meant everything was normal. Charley warmed the bottle while Nancy walked with the baby held up to her shoulder. The nurse supervised everything.

After a week, Jack Cooper Russell was part of the household. It was impossible for Nancy and Charley to look at him without seeing a bright future. Charley worked harder with more zest than ever. Nancy sent pictures off to exhibitions in Chicago, New York, and San Francisco, but they stopped all travel and arranged their lives around their baby boy.

Nancy had wanted to go to California but dropped the idea when Jack came into their lives. The only other project she pursued was the collecting of Charley's stories. It was something she could handle nicely while overseeing Jack.

The thrill of Jack's first steps and first words was like no other. Charley carved toys for him and when he was walking steadily, made him a hobby horse from a broomstick and scraps of wood and cloth he found. As he watched Jack ride it around the living room, he imagined the boy a little older on a fine pony of his own.

New York beckoned, but was postponed, and invitations to visit California were steady and appealing. Many of their friends were there. Ed Borein urged them to come many times. Con Price had moved there and raved about the scenery and warm winters. Will Rogers and Bill Hart worked there in moving pictures and offered to show Charley the picture lots if he came down. To all of them Charley and Nancy replied that they would love to come as soon as Jack was old enough.

When Jack was three Nancy decided he could travel to California for a combination winter vacation and exhibition venture. They rented a place in Pasadena, close to friends. Nancy believed that California would be an ideal place for Charley's work to be seen. Moving pictures were filming western stories by the dozens and creating a new interest in the authentic West—at least Nancy had gathered that from her conversations with Will Rogers and Bill Hart at the cabin the summer before.

As soon as they were settled, Charley looked up his old friends, and Nancy arranged for an exhibition.

"I think the work in this show is your very best, Cha'ley."

He looked up worriedly. "I hope that doesn't mean you're going to raise prices again."

Her eyes flashed. "You just leave prices to me," she said. "And I do wish you'd quit complaining about how much everything costs here. It makes you look like a hick."

"You never saw a truer hick than me. I don't like gettin' skinned every time I'm expected to pay up. Every palm tree has a stage robber behind it, only they don't bother to carry a gun."

"Hush now. You're here for a vacation. You're going to the movie set to meet Bill Hart and Doug Fairbanks. A sensible man would be happy about that. It ought to be fun."

He nodded. She was right. He wished he could take Jack along, but he needed his nap.

Movie-making surprised Charley. The buildings were artificial, so were the trees. Guns fired rubber bullets. Even the hitching rail was made of cardboard. But when Charley went along with the crew out to the hills to watch the company shoot distant riding scenes, the artificiality dropped away, except for one important thing. When they were supposed to be shooting a picture of Bill riding a horse down a dangerous incline, Bill stood next to Charley and watched, too. A substitute did the tricky riding.

Charley grew restless after three weeks. Nancy ignored his talk of going home. Jack was doing fine, and the wild-spending, celebrity-rich Los Angeles society had proved to be a bonanza at the exhibition.

Nancy sold a painting for $10,000, and that convinced her that California could be as important for them as New York. But even Nancy didn't expect the price to become a standard. She was as amazed as anyone when three other canvases sold for the same amount. Charley was no longer that western artist from Montana. He had become as much of a celebrity as the purchasers of his work.

"It's called fame," Will Rogers said one evening after Charley tried to make his way through a group of people to get to Will, but at every step, someone stopped him to talk. Finally, Will came to the rescue. "A lot of folks enjoy it."

"Some embarrassing, ain't it?" Charley said.

"So's poison ivy, but it goes away. This will, too. There'll be an ebb and flow and you'll get so's you don't notice it."

"Let's go home," he said to Nancy, a few days later.

She smiled. "I was expecting that. Whenever you sit down for three hours in a row writing and illustrating letters to your friends at home, I know you're going to start nagging, but we can't go before Will Rogers' party, now can we?"

At the party Charley told a couple of his stories and promised to come back next year. And Doug Fairbanks promised to visit at the lake.

Nancy didn't want to leave California, but Charley needed to get back to his log studio, and to stroll down Central Avenue to the Mint saloon to say hello to his Montana friends.

Back in Great Falls, Nancy's work on collecting stories reached the point where she asked Charley to put aside his other projects and begin the illustrations. He took the project lightly until he sat down and read the tales. Then he walked back

in time and relived those exciting days. The stories were all told by the fictional cowpuncher, Rawhide Rawlins, but *he* was Rawhide and always would be. He started by making one illustration for each story, but some stories had to have more. It was *his* life he was illustrating.

On the day he completed the last drawing for the book, he came in for lunch early, and sat at the kitchen table munching cookies.

"You've done more work on this book than I have," he said, "though I get the credit for being the author and illustrator."

She smiled. "I've helped. I feel like it's part mine, but it isn't really. I could never think up a story like you do."

· "It's a book about Montana, Mamie. I'd like to have it printed right here, and sell it for about a dollar."

"But Cha'ley." She frowned her disapproval.

"I know. You worked hard. But folks around here ain't rich. If the stories are goin' to give anyone a laugh, the price ought to be low enough so's folks who think a dollar's worth a dollar will get their money's worth."

· "But it's too good to put out in a cheap edition."

"People tell me they can't afford to buy my pictures. I wish they could. This is different—but it's the cowboys and ranchhands these stories were built for. And I want them to be able to get the book easily for a dollar in any Montana saloon."

Nancy pursed her lips, and he could see resistance in the way she held her shoulders, but she didn't answer right away. She called Jack in and they all had their lunch. Afterwards Charley stretched out on the sofa for a ten minute nap before going downtown. When he opened one eyelid, he saw Nancy seated on the straightbacked rocker, her hands folded and her jaw set. He rubbed his eyes and pushed himself up. "Somethin' on your mind?"

"I just wanted to say...well, it really is your book, and you should have it printed the way you want."

"Oh Mamie, that's good. I was afraid you wouldn't like my idea."

"I didn't say I liked it. But I know what it's like to scratch for a dollar, don't I? And later, there'll be another book—as soon as I get more stories ready. Next time we'll do it fancier. Is that fair enough?"

"I'd say it was, yes." He was wide awake now, and reached over and kissed her. "You ain't such a bad ol gal, after a nice lunch."

She laughed, and hugged him.

The dollar book was reprinted four times the first year, and Nancy continued to collect more stories. When the second volume was ready to be printed, the publisher asked Charley to write a few words about himself. Charley groaned, but this time Nancy was going to have her way. She sent him out to the cabin one morning with a tablet of lined paper. "Fill up three pages," she said, "that's all."

Charley built a fire and rubbed his hands together. He sat on a chair with the tablet on his knee and a pencil in his hand.

A Few Words About Myself, he wrote at the top of the page, then stared at the fire a minute before putting his pencil to paper.

> *The papers have been kind to me—many times more kind than true. Although I worked for many years on the range, I am not what the people think a cowboy should be. I was neither a good roper nor rider. I was a night wrangler. How good I was, I'll leave it for the people I worked for to say—there are still a few of them living. In the spring I wrangled horses, in the fall I herded beef. I worked for the big outfits and always held my job.*
>
> *I have many friends among cowmen and cowpunchers. I have always been what is called a good mixer—I had friends when I had nothing else. My friends were not always within the law, but I haven't said how law-abiding I was myself. I haven't been too bad nor too good to get along with.*
>
> *Life has never been too serious with me—I lived to play and I'm playing yet. Laughs and good judgment have saved me many a black eye, but I don't laugh at others' tears. I was a wild young man, but age has made me gentle. I drank, but never alone, and when I drank it was no secret. I am still friendly with drinking men.*
>
> *My friends are mixed—preachers, priests, and sinners. I belong to no church, but am friendly toward and respect all of them. I have always liked horses and since I was eight years old I have always owned a few.*
>
> *I am old-fashioned and peculiar in my dress. I am eccentric (that is a polite way of saying you're crazy). I believe in luck and have had lots of it.*
>
> *To have talent is no credit to its owner; what a man can't help he should get neither credit nor blame for—it's not his fault. I am an illustrator. There are lots better ones, but some worse. Any man that can make a living doing what he likes is lucky, and I'm that. Any time I cash in now, I win.*

Epilogue

Charles W. Russell died in his Great Falls, Montana home on October 24, 1926 following a heart attack. His wife Nancy and his doctor were with him. Until the end of his life at age 62 he painted actively with undiminished skill.

Russell received extraordinary acclaim during his lifetime, and his reputation continued to climb after his death. Today, his paintings are highly valued. His bronzes are prized for their vitality, dramatic action and artistic feeling.

Museums and collectors all over the world have acquired Russell paintings and bronzes. Significant collections of his work are housed in museums in Tulsa, Oklahoma; Fort Worth, Texas; Cody, Wyoming; Great Falls and Helena, Montana and Shreveport, Louisiana.

The Montana Legislature authorized a statue of Russell to be placed in the Capitol of the United States, the only person so honored by the state. The U. S. Post Office commemorated the 100th anniversary of Russell's birth with an official postage stamp. In 1989 the U.S. Postal Service again paid homage to Russell, the artist, when it issued a commemorative stamp honoring Montana's statehood centennial. Russell's painting, *Russell and his Friends* was chosen to represent the spirit of the occasion. The stamp shows Russell in the foreground on a black horse, extending his arm toward a Big Sky scene with five mounted friends riding toward him.

After Russell's death Nancy Russell continued to exhibit her husband's art and generously shared her mementos and recollections with historians and Russell's admirers. She collected illustrated letters which Russell had written to his friends over the years and worked tirelessly to see that the collection was published in a character-revealing volume entitled "Good Medicine" a tribute to the wit and wry philosophy that was so much a part of Russell's personality.

Nancy lived her remaining years in Pasadena, California with her son, traveling often to Montana. She never remarried, and like her husband, died at the age of 62. She was buried at her husband's side in Great Falls, Montana.

The C. M. Russell log studio has been preserved as a memorial to Russell's life and art. In 1953 a museum was constructed on the adjoining property owned by the Triggs, Russell's longtime friends and neighbors. The Russell home has also been renovated and opened to the public, giving summer visitors another intimate glimpse of this artist who portrayed so magnificently the old West he loved.

"Nature has been my teacher," Charles W. Russell said. "I'll leave it to you whether she was a good one or not."

Bibliography

1. *The Charles M. Russell Book,* Harold McCracken, Doubleday: Illus., 1957.
2. *Good Medicine,* Charles M. Russell. Intro. by Will Rogers, biographical notes by Nancy Russell, Illus., Doubleday: 1966.
3. *Trails Plowed Under,* Charles M. Russell, Doubleday: 1978.
4. *Charles M. Russell,* Frederic G. Renner, NAL, Illus., 1966.
5. *Charles M. Russell: Paintings of the Old American West,* Louis Chapin, Illus., 1978.
6. *Recollections of Charley Russell,* Frank Bird Linderman, Univ. of Okla. Press: 1963.
7. *Charles M. Russell, The Frederic Renner Collection,* Phoenix Art Museum, Illus., 1981.
8. *Charles M. Russell, The Cowboy Artist,* Ramon F. Adams and Homer Britzman, Trail's End Publ. Co.: 1948.
9. *Charles M. Russell, Cowboy Artist,* Austin Russell, 1957.
10. *Charles Marion Russell, Cowboy, Artist, Friend,* Lola Sheldon Klaue.
11. *Riding the High Country,* Patrick T. Tucker.
12. *C.M. Russell,* Robert Gale, Boise St. U.: 1979.
13. *Trails I Rode,* Con Price, Trails End Publ.: Pasadena.
14. *Paper Talk, Charles Russell's American West.* Dippie, Chas. Ed., 1979.
15. *Boyhood Sketchbook of C.M. Russell,* R.D. Warden, Publ. Treasure Prod.: Bozeman, MT, 1972.
16. *C.M. Russell, A Legendary Man* (brochure).

Plus periodicals, newspapers and personal interview with Miss Alice Calvert, longtime neighbor and friend of C.M. Russell.

About The Author

JOAN KING (nee O'Mahony) was born in Washington, D.C. in 1930, the second of seven children. Her parents were Montanans and she absorbed an interest in the West from them. She loved visiting Washington's museums throughout her growing-up days, often going alone or with a friend.

At 18, she traveled to Great Falls, Montana for a taste of the West and to attend college. Her grandfather took her to the Mint Saloon to see the Charles Russell paintings there. The Mint was a smokey, true-west saloon full of men in Stetsons drinking beer and telling stories—just like it was when Russell was there. It made a lasting impression.

King married and settled in Montana where her five children were born. The family moved to Minnesota in 1968. King earned her degree in creative writing at the University of Minnesota. She began publishing short stories and articles in the 1970s and novels in the '80s. She lives in Burnsville, Minnesota with her husband John.